FOR VIVIENNE & AMANDA

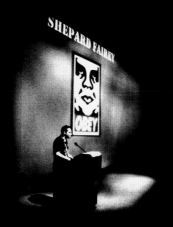

INTRODUCTION

When I made the first Giant stickers in 1989, I never thought I was beginning a project that would inspire and permeate most of my art and career for the next 17 years and counting. At 19, I had no idea what I would be doing a week later, much less a decade or two. Putting up stickers was fun, and that was enough to get the ball rolling. The act of getting out there for the journey without a brilliant plan or destination opened my eyes to the world as a participant, not a voyeur. Part of the success of Obey Giant has been its organic evolution based on my constant dialogue with the public and my broadening perspective through my experiences. Rather than being constrained by Obey Giant, I've molded it to reflect my personality and my interests as they've progressed over the years.

When I was younger, I bought into the typical black–and–white, us–versus–them simplification of things: provocation and silliness can't mix, a job has to be drudgery, passion is reserved for nights and weekends, and art can't be pure if it has a commercial facet. All that began to seem less valid as every small accomplishment with Obey Giant made it seem increasingly possible to do things my way.

It hasn't been an easy path. I almost titled this book *By Any Means Necessary*, because even through financial struggles, failed relationships, a lack of resources, and 13 arrests, I was always determined to keep the Obey Giant project growing. I eventually decided on the title *Supply and Demand* because I feel it encapsulates so many of Obey Giant's sociological implications. Essentially, I succeeded at building something from nothing and creating a demand for it by exploiting the semiotics of consumption.

From the beginning, Obey Giant opened my eyes to many facets of capitalism and consumer–trend psychology that revolve around supply–and–demand economic theory. Some examples ("I want a sticker because I like the way it looks") are relatively straightforward, while others ("I want a sticker because my rebellious friends have it") reflect the complex irony of conforming to an image of rebellion to gain acceptance. The Obey Giant images have raised many issues around the concept of value: as they gained more exposure and familiarity, their value increased to marketers wishing to capitalize on the rebellious cache of street art; conversely, they became less valuable to those who prided themselves as rebellious outsiders who used Obey as a secret handshake to enter an elite club. Observing the cultural arc of Obey Giant and the variables determining who embraced or rejected it along the way has been the most valuable aspect of the project.

I knew early on that, more than being just a vehicle for my art, commentary, and mischief, Obey Giant could provide a "case study." The hardest thing was for me to decide when I had enough material to release a complete case study, especially when the accumulation of art and experiences showed no signs of slowing. After 15 years I decided it was time to get this book underway. It's taken two years to finally complete. Enjoy. Keep your eyes and mind open, and question everything.

– Shepard Fairey
January 10, 2006

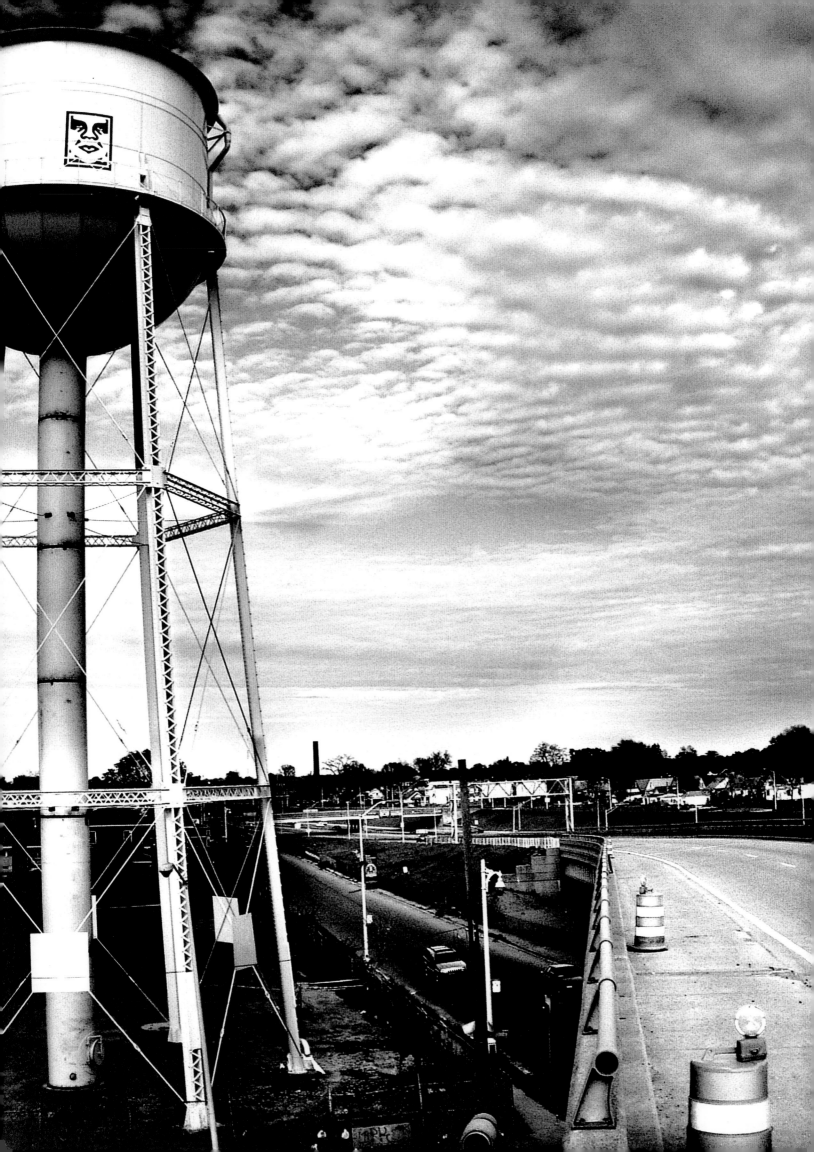

OBEY

SUPPLY & DEMAND

THE ART OF SHEPARD FAIREY

SHEPARD FAIREY / ROGER GASTMAN / STEVEN HELLER / CARLO MCCORMICK

HELEN STICKLER / KEVIN TAYLOR / ROB WALKER

Published by Gingko Press in association with Obey Giant

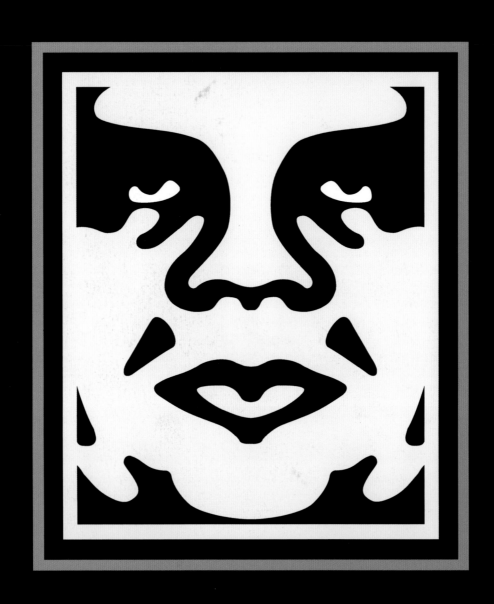

MANIFESTO

A SOCIAL AND PSYCHOLOGICAL EXPLANATION

Shepard Fairey, 1990

The GIANT sticker campaign can be explained as an experiment in Phenomenology. Heidegger describes Phenomenology as "the process of letting things manifest themselves." Phenomenology attempts to enable people to see clearly something that is right before their eyes but obscured; things that are so taken for granted that they are muted by abstract observation.

The FIRST AIM OF PHENOMENOLOGY is to reawaken a sense of wonder about one's environment. The Giant sticker attempts to stimulate curiosity and bring people to question both the sticker and their relationship with their surroundings. Because people are not used to seeing advertisements or propaganda for which the product or motive is not obvious, frequent and novel encounters with the sticker provoke thought and possible frustration, nevertheless revitalizing the viewer's perception and attention to detail. The sticker has no meaning but exists only to cause people to react, to contemplate and search for meaning in the sticker. Because Giant has a Posse has no actual meaning, the various reactions and interpretations of those who view it reflect their personality and the nature of their sensibilities.

Many people who are familiar with the sticker find the image itself amusing, recognizing it as nonsensical, and are able to derive straightforward visual pleasure without burdening themselves with an explanation. The PARANOID OR CONSERVATIVE VIEWER, however, may be confused by the sticker's persistent presence and condemn it as an underground cult with subversive intentions. Many stickers have been peeled down by people who were annoyed by them, considering them eyesores and acts of petty vandalism, which is ironic considering the number of commercial graphic images everyone in American society is assaulted with daily.

Another phenomenon the sticker has brought to light is the trendy and CONSPICUOUSLY CONSUMPTIVE nature of many members of society. For those who have been surrounded by the sticker, its familiarity and cultural resonance is comforting, and owning a sticker provides a souvenir or keepsake; a memento. People have often demanded the sticker merely because they have seen it everywhere, and possessing a sticker provides a sense of belonging. The Giant sticker seems mostly to be embraced by those who are (or at least want to seem to be) rebellious. Even though these people may not know the meaning of the sticker, they enjoy its slightly disruptive underground quality and wish to contribute to the furthering of its humorous and absurd presence, which seems to somehow be antiestablishment or anti–societal–convention. Giant stickers are both embraced and rejected, the reason behind which, upon examination, reflects the psyche of the viewer. Whether the reaction be positive or negative, the sticker's existence is worthy as long as it causes people to consider the details and meanings of their surroundings in the name of fun and observation.

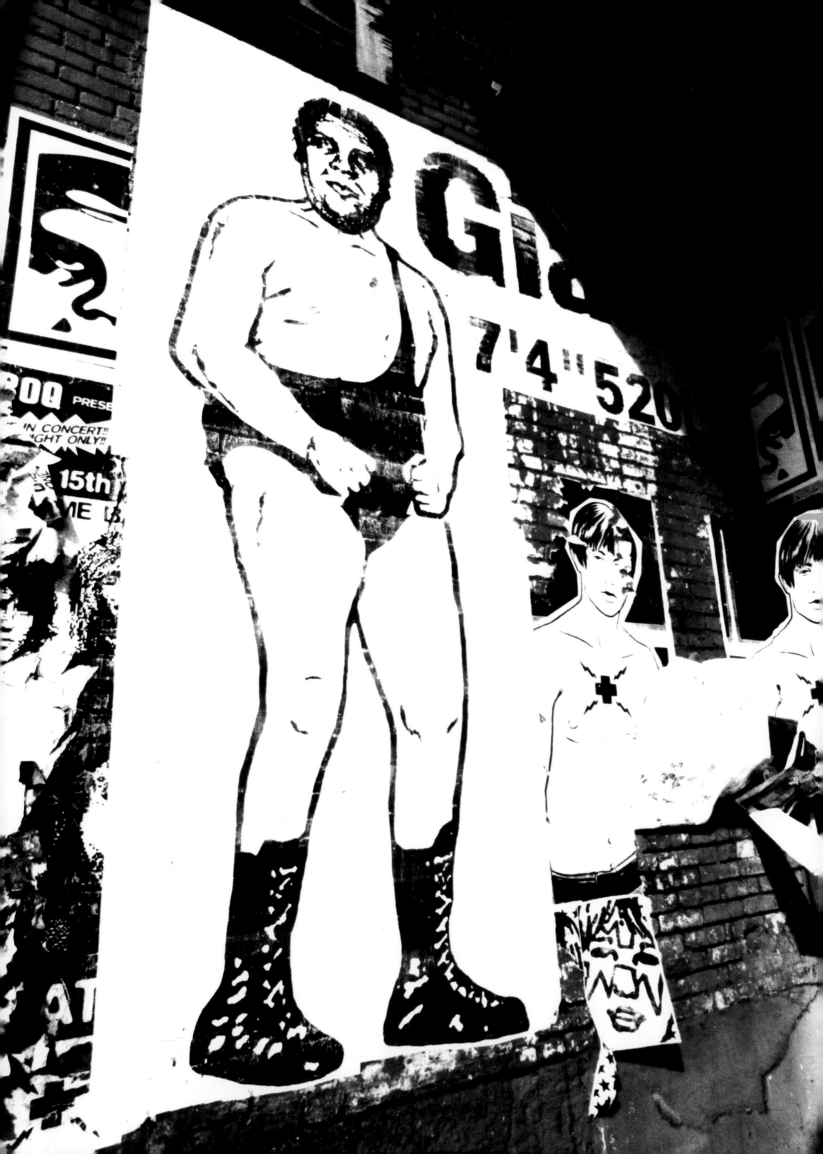

CONTENTS

10 **SHEPARD FAIREY: CIRCULATIONS**
CARLO MCCORMICK

13 EARLY WORK

15 **STICKERS RULE**
SHEPARD FAIREY

27 **WELCOME TO THE JUNGLE RAMP**
KEVIN TAYLOR

35 **ANDRE THE GIANT HAS A POSSE**
HELEN STICKLER

37 REPETITION WORKS

41 **MARKED TERRITORY**
ROGER GASTMAN

87 PROPAGANDA

89 **STILL OBEYING AFTER ALL THESE YEARS**
STEVEN HELLER

135 **EDUCATION OR EXPLOITATION**
SHEPARD FAIREY

181 THE MEDIUM IS THE MESSAGE

183 **THE MEDIUM IS THE MESSAGE**
SHEPARD FAIREY

227 SURVEILLANCE

229 **WOULD DA REAL GIANT GUY PLEASE STAND UP...**
SHEPARD FAIREY

251 MUSIC

253 **MOST OF MY HEROES DON'T APPEAR ON
STAMPS (OR IN ART GALLERIES)**
SHEPARD FAIREY

311 COMMERCIAL WORK

313 **ABSOLOOT SPONSORSHIP**
SHEPARD FAIREY

321 **SURFACE EFFECTS**
ROB WALKER

335 T-SHIRTS

342 BOOTLEGS

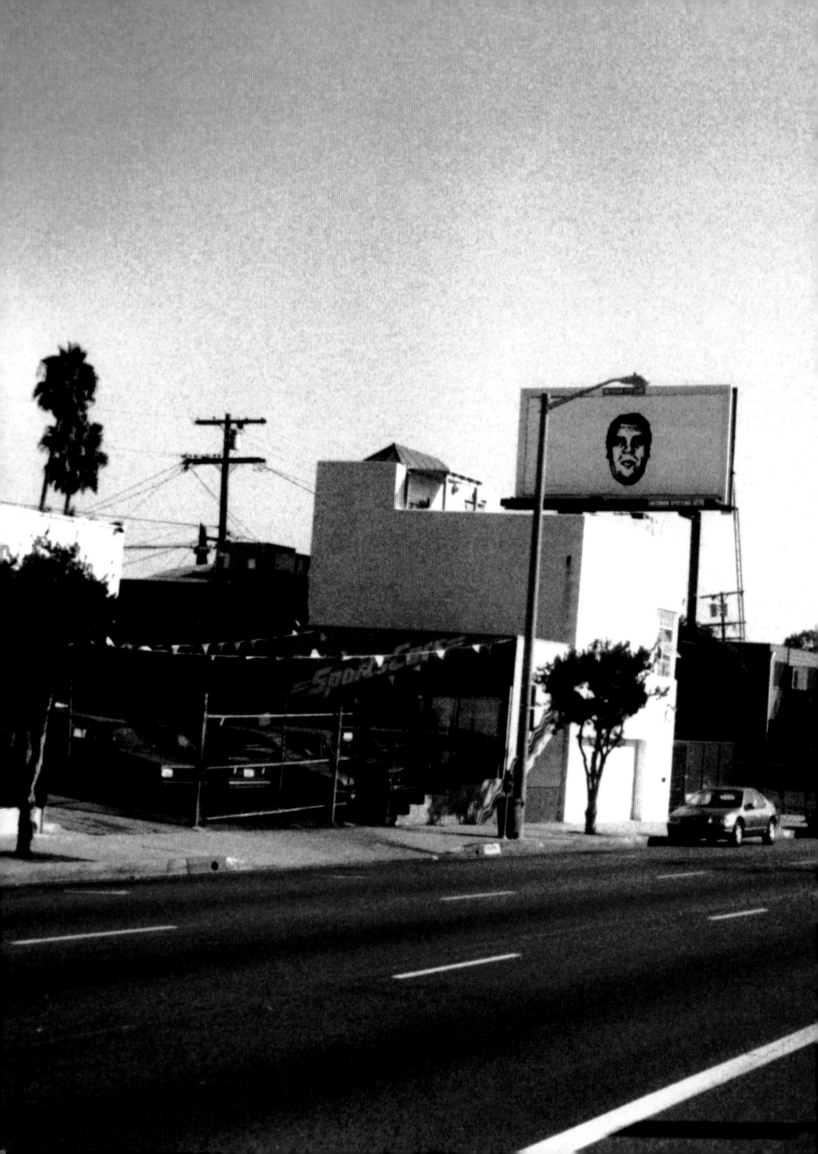

SHEPARD FAIREY: CIRCULATIONS

Carlo McCormick

We live, by necessity, in the moment, running on a treadmill of insatiable desire and proliferate productivity. Shepard Fairey understands this dynamic: it is not only his studio practice; it is the architecture of transmission that his work as a whole so deftly maps. A ring master in the circus of signs, Fairey makes meanings jump through flaming hoops, hucksters like a true carnie the tinctures of an impossible cure, and stomps his way through the public spectacle like the herd of elephants coming to town. Shepard Fairey understands the moment at hand as the temporal amalgam that it is, accumulated iconography, ironies and misappropriations, honesty and heart, and each passing second renewed, freshly painted over with a patina of novelty. Perhaps, if only for the futility of it all, we might consider Fairey's art out of time. No, none of that nonsense about its place in history, but rather, what will this look like to people in the future, long after all our speculations cease? What will Shepard Fairey's art tell future generations, not about the artist but about us?

More than most any media out there, Shepard Fairey records this particular place in time with an acuity that is both acerbic and loving. When he began his epic Andre the Giant has a Posse project of stickering the planet with an emblem devoid of the marketing agenda it so freely played with, my assumption was that here was a great absurdist trope—a sign that signified nothing, an advertisement for a product that did not exist (except as an ad for itself), a meme without meaning and, most radical of all, an artist finding signature and identity through a semi–mythic figure of a dead pro wrestler who was a star in that most beautifully bogus of action fictions. Indeed, everything about this low–res, DIY mimesis of how the terms of youth culture are adopted as visual strategies by mainstream marketing spoke of a great emptiness, a chasm of communication that almost anything could fill. What proved to be the case otherwise was that Fairey was not simply marking the boundaries of the void—and quite certainly not just filling it as part of our pathological horror vacuum. His emptiness was one of the densest compressions of absence ever registered in the urban environment. If this artist has continued to evade the didactics and declamations of determination, the space he provides is an effect, the surface of things unfettered by their materiality, and now when you look at his work you feel the charge, the kinetics of ever–shifting topographies of desire and dread. This is a record of our ambivalence, the ambiguity of truth, and the conflictive emotions by which we adore and abhor the very same things.

Currency is not just the measure by which Shepard Fairey stays fresh: it is the economics of a career navigating the monetary terms by which any job—commissioned or illegal, branding or personal—gets done. Most significantly, however, it is the fluidity and motion of an ongoing discourse between who we are and who we are supposed to be. Fairey thrusts demographics into the unruly lexicon of democratic availability. He doesn't tell you what to think: he merely offers situations in which the very modes of our mindlessness are turned into opportunities for us to think. Working vandalism as a formal-

1. **First Andre Silk Screen Frame,** 1989 (14 x 14")

ist revision of public art, commanding us to obey as a reflective and reactionary anthem for disobedience, paying for it all by collaborating with the enemy like some double–agent mole subverting from inside the belly of the beast, and measuring his success by his capacity to enable others (especially artists and musicians), the conundrum of Shepard Fairey's work always seems to come down to the question of what, exactly, is for sale. It's not just that he may graft his pictorial language like some hyper–subjectivity on the abject immateriality of our material promotion of objects, or that in his own work he bombards our commodified landscape with branded paradigms of experience that can not be owned but only shared; Shepard makes stuff for everyone to look at and submits that, if you absolutely have to have it, he will craft it as a fine art on an accessible and affordable scale that puts the art world proper to shame.

1.

An auteur, a giant (we'll avoid capital letters in this), and, not too far beneath the surface, a fan–boy, Shepard Fairey makes the kind of stuff that we want for the simplest of reasons: he wants them too. These multiples lie beyond the formal serializations of Pop; they are at once a metastatic extension of the self in correspondence to the community (we are not alone if we share the same fixations) and an ephemeral embodiment of our most tangible and visceral social condition: desire. No matter how far Fairey may go, both personally and culturally, in addressing this need/greed dysfunction by which affection, longing, and ownership collapse in the vertigo of consumerism, he can't, by the very nature of the beast, go far enough. As good as he gets at this, the course of novelty will always demand more. If by chance he could ever exorcise any single demon by the mere force of representation, are there not always other sirens on the horizon, a plentitude still in the pantheon, more unquellable appetites yet to be discovered? The market will always demand, and his success can only be attained by such terms as a matter of excess. As unnatural as it may seem, it is the nature of collecting. If this alone is not enough of a conundrum, as long as parodistic misappropriation is the only fluent language by which media may be subverted from within, the built–in hegemony of communications will always dictate that anything which is nonconformist to its authority can, and will be, co–opted. And if we know all this already, we can be sure that Shepard does too. His art anticipates the final moment of full disclosure. It lives in dread of knowing better.

Whenever an artist has some unwholesome taste for the fine art of persuasion, well, honestly you have to wonder. Fairey's investigation of these negative spaces—marketing, branding, or propaganda, fashion or fascism, Agitprop or advertising—in terms of both style and effect, is dubious. Both tribute and trespass, Fairey's art is cleft, with idolatry as iconography and ambiguity couched as didactics. He plays with simple notes, but the composition pops in your head with a weird kind of reverb. Call it the double take of a visual lampoon, the allure of the uncanny, a misdirection of funds, the dialogue of symbiosis, some insider/outsider dyslexia, or simply the questioning of authority; the bounce is feedback. We're finally talking to ourselves, and Shepard Fairey is the translator of our cultural schizophrenia who can at least explain those other voices in our head. More than the mighty reclamation of public space, he's doing whatever possible to point out how it is so much a psychological space. Wherever that happens, however, it's still non–specific. We get to see his art in so many places and guises it's hardly a matter of drawing a map or predicting a direction; just ask the scarecrow who's dreaming of a brain which way to go whenever you hit a fork in the road.

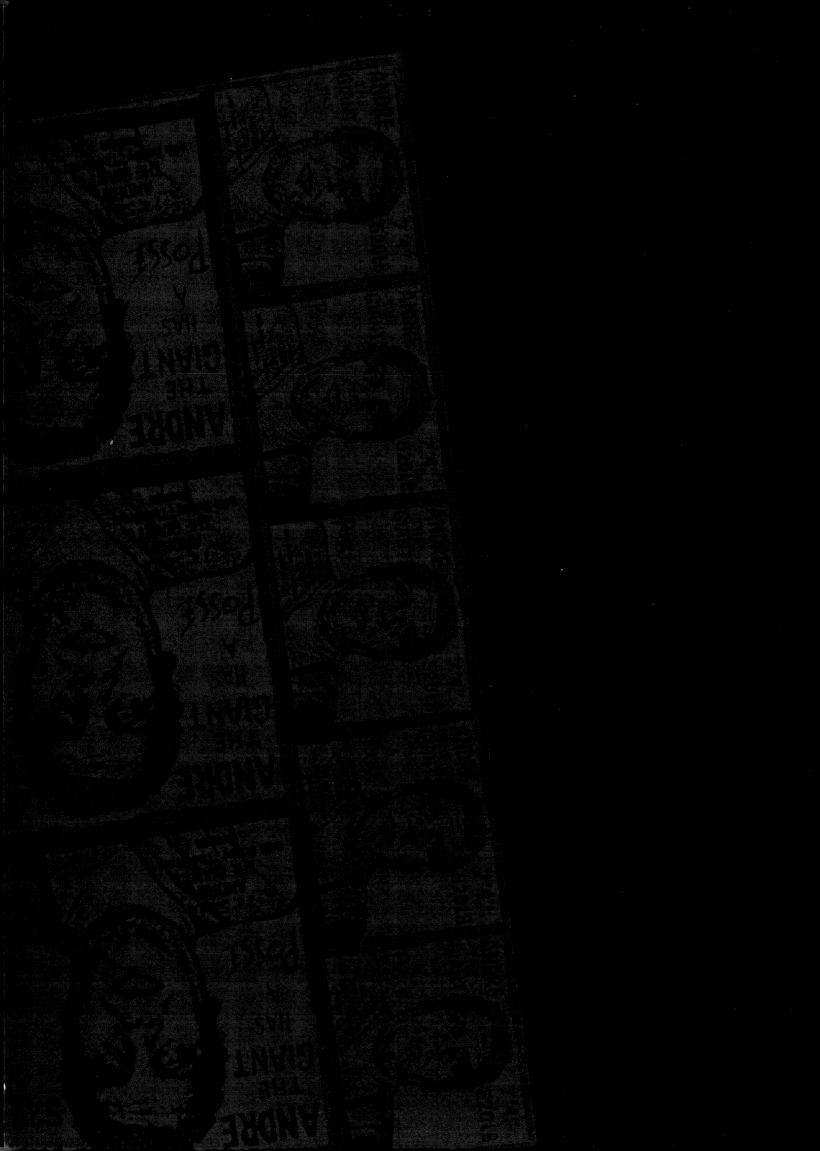

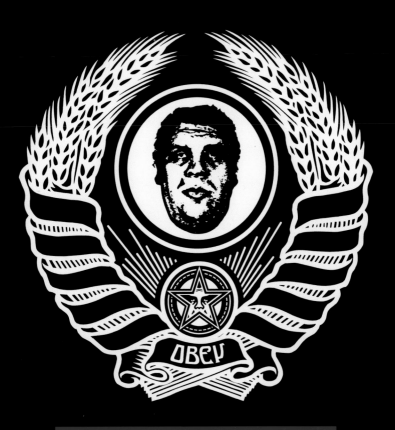

EARLY WORK

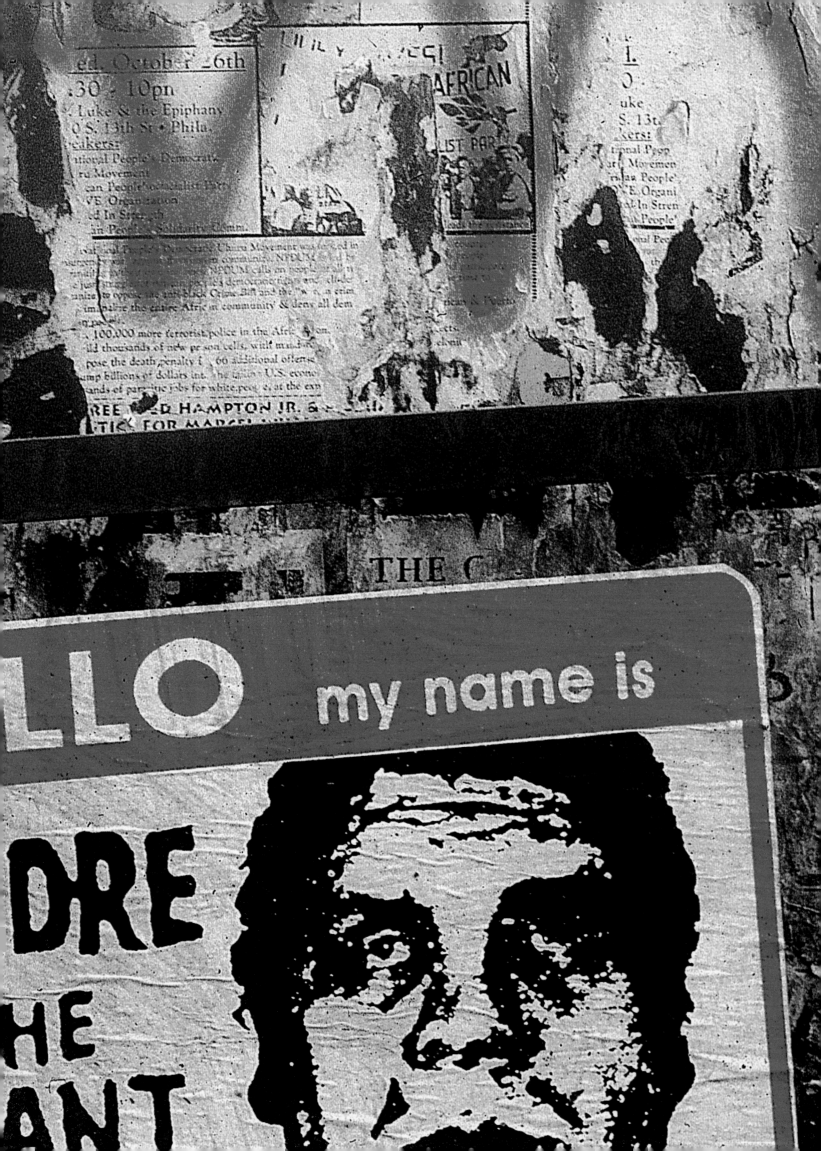

STICKERS RULE

Shepard Fairey

Stickers rule. When I pause to think about it, stickers have changed my life. It's hard to believe that paper and vinyl with adhesive backing can do so much. Repetition works, and stickers are a perfect medium to demonstrate this principle. As long as stickers are being put up faster than they weather or are cleaned, they are accumulating. For cities, it's a constant maintenance battle. Simple fact is, it's a lot easier to put stickers up than to clean them off. People also seem unable to resist the urge to stick them on their belongings: car, stereo, skateboard, guitar, and the list goes on. What's on stickers doesn't even have to be that cool; they still manage to make their way into every nook and cranny on the planet.

My introduction to stickers as graffiti was not through the aerosol art graffiti scene. I grew up in South Carolina where graffiti was non–existent, with the exception of the usual "Darnell loves Shanice" or "Go Bobcats." I did, however, start to notice skateboard and punk rock stickers here and there as soon as I took interest in these two things at the beginning of 1984. Since my friends were into punk and skateboarding as passing fads (only momentarily distracting them from their paths as respectable preps), I found sticker sightings an encouraging sign that there were more dedicated proponents of punk and skate culture lurking somewhere in the city. Stickers were evidence that I wasn't living in a total void. I wanted stickers as badges of my culture.

At first, I would just buy skate stickers and put them on my stuff. I couldn't even figure out how to get punk stickers, so I learned how to draw all the band logos. Then my mom bought a copier for the business she ran out of our house. It was on. I could copy graphics from my skate mags and album covers onto Crack 'n' Peel and make my own stickers. Pretty soon, everything I owned was covered with them. At the same time, I was making paper–cut stencils of skate and band logos for spray paint and silk–screen application. These activities continued through high school, less as a way to make art than as a way to avoid actually having to pay for stickers and t–shirts, many of which were not available in South Carolina anyway. Besides, my parents had expressed their dislike of anything skate– or punk–related, and would provide no financial support for additions to my wardrobe in these categories.

In 1988, I moved to Providence, Rhode Island, to attend the Rhode Island School of Design. I immediately linked up with all the punks and skaters. Stencils and stickers were business as usual, but with the addition of some more personalized alterations of the graphics I would rip off. Providence had a tremendous art and music scene compared to what I was used to, and stickers were everywhere. There were tons of band stickers, political cause stickers (mostly college activism), and, most interesting to me, a few art stickers and "hello my name is" tag stickers. A lot of the art stickers beckoned the question: "What is this about?" The tag stickers made me want to know whom the pseudonyms belonged to. It was at this point that I began to ponder the sticker as a means of expression and communication for an individual, instead of just representing a band, company, or movement.

For years, I had defined myself through associations with things that

2.

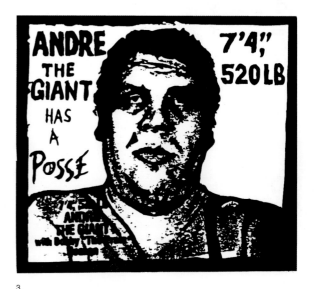

3.

2. ***Crosswalk Plate,*** 2002

3. ***OG Sticker,*** 1989
(2.5 x 2.5") Xerox on paper

4. All through high school, the only thing I considered art was drawing or painting, and my criterion for what made good art was how closely it approximated a photograph. I made this redrawing of a photograph I took during my first semester at RISD, and spent about three weeks and close to 100 hours on it. When I finished it, I thought it was great because it looked like a photograph, but then I started to question whether it was actually superior to a real photograph, and I started to question the merit of just being a draftsman and reproducing an image. Later on, I lent the drawing to a friend, who spilled some silk screen emulsion on it by accident. He thought he ruined it, so he sent it back to me. When I opened it up, I thought it looked much more interesting than before, given the peculiar contrast between a tight, technically sound drawing and the sticky chaos.

4.

5. The same week that I made the Andre sticker, I also made the "Gerber Baby with a Mohawk" sticker, based on one of the kids I skateboarded with who had a pudgy face and a mohawk, earning him the nickname "Gerber Baby with a Mohawk." Some of my friends preferred the Gerber Baby sticker, and recommended that I abandon the Andre sticker and focus on Gerber Baby.

5.

represented skate and punk culture. This path to forming an identity appealed in high school, but did little to alleviate the existential problem of anonymity once I had left high school and entered into an art school environment full of "alternative" people just like me. I liked the idea of having my own sticker, but couldn't think of something clever enough to be worth executing. I looked at it almost as seriously as getting a tattoo. I paid very close attention to stickers and I would try to figure out who and what was behind any sticker I saw. I even started photographing fliers, stickers, and other forms of graffiti. During a museum trip to New York that freshman year of college, I saw graffiti in risky places that gave me new respect for the dedication of the writers. Stickers and tags coated every surface in New York City. I left the city inspired, but I was somehow convinced graffiti was something you had to be born into, like a Black or Hispanic mafia, and a pale cracker like me could never be accepted in that culture. I did, however, think that I could make stickers and accomplish some of the same things.

That summer, I was working at a skate shop in Providence called The Watershed. The boss liked my homemade t–shirts and asked me to design some stickers and tees for the store. I was amazed: people actually liked my crude "Team Shed" designs more than the stuff my boss had made professionally. This provided some artistic validation, but I was still looking for my own thing.

Everything fell into place somehow when my friend Eric asked me to teach him how to make paper cut stencils, I stumbled upon a funny picture of Andre the Giant, and I told Eric that Team Shed was "played" and he should make a stencil of Andre so we could be Andre's "posse." He tried to cut the image with an x–acto knife, but aborted the mission in frustration. I finished the job and wrote "Andre the Giant has a Posse" on one side, with his height and weight, 7'4", 520 lbs., on the other side. The first Giant sticker was born, with many more to come.

The Andre stickers started as a joke, but I became obsessed with sticking them everywhere both as a way to be mischievous and also put something out in the world anonymously that I could still call my own. Just as I had been made curious by many of the stickers I'd seen, I now had my own sticker to taunt and/or stimulate the public. The sticker takeover of Providence only took that summer. The next fall, the local indie paper printed a picture of the sticker, offering a reward to the person who could reveal its source and meaning. The sticker campaign had worked so quickly locally that I decided to strike out for Boston and New York, both within driving distance. The ball had begun to roll, but the amazing thing is that I almost lacked the self–confidence to try to put something of my own out there. I didn't even think I could make an impact in Providence, and it's somewhat of a fluke that the Giant sticker stimulated me to try. However, once the first domino fell, I was addicted and had my sights set on world domination through stickers.

It amazed me just how liberating and easy stickering was. At first, I would just run off a few hundred stickers a week at a copy center, using their sticker material. Then I figured out that I could get sticker material at an office supply store for half the price. Paper stickers were good for indoor use, a nightmare to remove, but weathered too quickly outdoors. I was taking some screen–printing classes, so I decided to look into making vinyl stickers. I bought vinyl ink and vinyl from a screen print supply wholesaler in Boston. The vinyl ink was ill toxic, but by printing them myself, the vinyl stickers

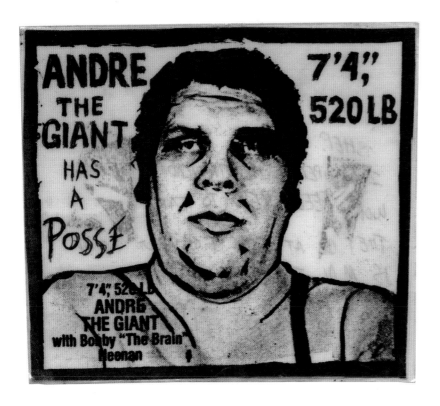

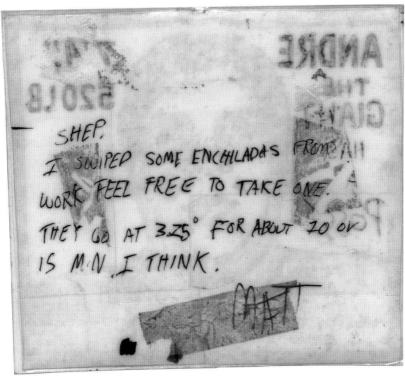

6.

7.

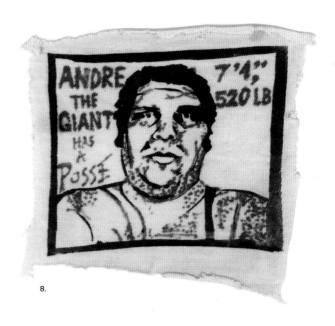

8.

6. I never thought the Andre sticker would amount to more than a short–lived joke. Obviously, my roommate who left me a note on the back of the original sticker Xerox did not see it as particularly sacred. His message about swiping enchiladas from work appropriately reflects the "get by, by any means necessary" mentality that I had as an artist. I sold homemade bootleg band shirts and rigged Xerox machines to give free copies to keep my creative endeavors alive.

8. This section of t–shirt fabric is the first screen print of Andre the Giant has a Posse. The print was made using the actual newspaper cutout stencil that the first sticker was Xeroxed from.

The writing and stippling were added with a Sharpie marker to look like the Xeroxed sticker. This is the only print ever made with that stencil.

4. **Photo Realistic Interior,** 1988
(25 x 40") chalk and charcoal on paper

5. **Gerber Baby with a Mohawk,**
1989 (1.5 x 2.5") Xerox on paper

6. **Original Andre Artwork
(front and back),** June 1989
Xerox, ballpoint, and lamination

7. **Bootleg Metalica T–Shirt,** 1989
screen print on t–shirt. Courtesy of
John Mathot

8. **First and Only Screen Print from
Original Andre Paper–Cut Stencil,**
June 1989 (4.25 x 4.5") screen print and
Sharpie on t–shirt swatch

9. At the end of the summer of 1989, I designed the "All work and no play makes Jack a dull boy" t-shirt for a skateboard clothing company called Jobless Anti-Workwear. The shirt accounted for 25% of the company's sales. I was paid $50 for the graphic. I spent the summer of 1990, ironically, working for Jobless, where I screen-printed t-shirts and did shirt graphics. After gaining experience and confidence working for Jobless, I decided to start my own screen-printing and t-shirt company called Alternate Graphics, or A.G., which intentionally shared the same initials as Andre the Giant.

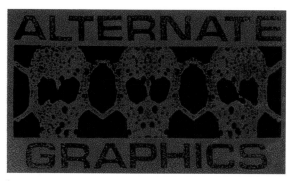

9.

10. The dog with the mailman was a piece I did at RISD. I appropriated this image but made the dog look more maniacal, as though it were seeing straight through to the mailman's bones. Prior to my sophomore year, I looked at drawing as art and photocopy manipulation as goof-off, fun stuff. This was one of the first pieces I made after realizing that you can take found imagery, Xerox it, and paint back into it, and it's still valid as artwork because it's been manipulated and re-contextualized. It was a step in the mixed media direction in which my art was headed, and it also informed a lot of the Andre designs I was doing.

10.

9. **Alternate Graphics Sticker,**
1990 (1.75 x 3") screen print on vinyl

10. **Mailman,** 1991
(18 x 24") mixed media

11. **Prevent Police Boredom,** 1989
(11 x 14") screen print on paper

12. **Jobless Jack,** 1989
(3 x 5.5") screen print on vinyl

13. **OG Sticker Sheet,** 1989
(8.5 x 11") Xerox on sticker paper

worked out to be way cheaper than the paper ones. I also liked the confusion factor with having a low-fi image printed on the more professional vinyl material. Every sheet of stickers I printed felt like I was making the world a little smaller: I mean, all those stickers were gonna end up somewhere. The only thing that sucked was cutting the sheets into individual stickers. At first I used scissors, but then I gave in and bought a paper cutter and would just watch a movie and cut stickers. This process of production continued from '89 to '96, yielding over a million hand-printed and cut stickers. When I moved to California I decided I needed to keep the brain cell I had left, so I stopped printing with vinyl ink and started sending my stickers out to a printer.

As my production methods improved, so did my distribution. I began sending stickers to several enthusiastic friends who had caught sticker fever. Some writers only want their stickers to track their actual footsteps. For example, I printed some stickers for Phil Frost and he got mad at me for putting them up for him. Phil got a call from TWIST reporting that he'd seen some Frost stickers in San Francisco and asked if he'd been there. Phil figured I'd put them up and told me he only wanted his stickers on the street as a document of where he'd traveled. I just wanted my stickers to go as far and wide as possible, so I would supply stickers to my friends who lived all over the country. I also began to run cheap classified ads in *Slap* skateboard magazine and the punk zine *Flipside*. The ads just had my images and said, "Send a self-addressed, stamped envelope for stickers and the lowdown." I was building a great grassroots network of people who wanted stickers. The only problem was that I was losing money on all of the stickers and ads. The stickers were always intended as an art project, and part of the charm was that there was nothing for sale, but I had to make some money back to keep producing. My solution was to ask for a mandatory donation of five cents per sticker (a price I basically maintain for black-and-white stickers to this day) and to produce some t-shirts to sell. That's how my humble sticker and t-shirt business got started. Almost every art and financial opportunity in my life has stemmed from my stickers and their poster and stencil relatives.

The art of stickers isn't just about what's on them, but also how they are integrated into the environment. The most common placements are poles and crosswalk boxes at eye level. These are also the fastest places to be cleaned. Climbing a couple feet higher really weeds out the city workers and vigilante citizens who aren't dedicated to their jobs. Slightly bigger stickers are great for these high spots. Necessity is the mother of invention, right? I got so sick of my stickers being peeled that I looked into the kind of vinyl that the government uses for registration stickers so they can't be stolen off of license plates. The stuff is called destructible vinyl, and flakes off in teeny pieces when you try to peel it. It costs about twice as much, but is very worth it in some cleaner cities. People have come up with other great ideas, like the tags on the adhesive side of the sticker stuck on the inside of newspaper boxes facing out. Making stickers that are camouflaged keeps them running, too. In New York, locksmiths put small contact info stickers in all the doorways. ESPO made some of his own, which blend right in to most of the public but stand out to writers. I've made take-offs subverting the typical "You are under surveillance" stickers. They look so official; they usually stay up, even in conspicuous places. I also made fake California Department of Weights and Measures stickers like the ones that

go on all the gas pumps – they only change them once a year. The possibilities with sticker placement are endless.

The fact is, if you want to make stickers but aren't making them, you're just lazy. Hand–drawn stickers are time–consuming but free. Photocopied stickers can be made in small quantities – I used to get my fix just making a couple bucks worth at a time. Offset–printed stickers on a roll with standardized shapes are super cheap if you do a bunch of them. Screen–printed stickers have expensive setup costs, but if you split up a sheet with friends and make only square or rectangular shapes that don't have to be die–cut, you can bring the cost down per person, especially when you run volume. Ask printers about volume price breaks. In my opinion, stickers are the most effective promotional tool possible for the price. Don't sleep on 'em.

11. During the summer of '89, I also made many other stickers, including "Prevent police boredom, skateboard" which was my reaction to police harassment of skateboarders. This image also became my first screen print on paper – essentially my first "art" poster.

12.

11.

13. In the summer of '89, I decided I wanted to take advantage of the standard 8.5 x 11" sticker sheets sold at office supply stores, which can be run through a copier and then cut with scissors or a paper cutter. I sent proof sheets to some of my friends across the country and started to get a grass–roots proliferation of the stickers going, based on the ease of working with that template.

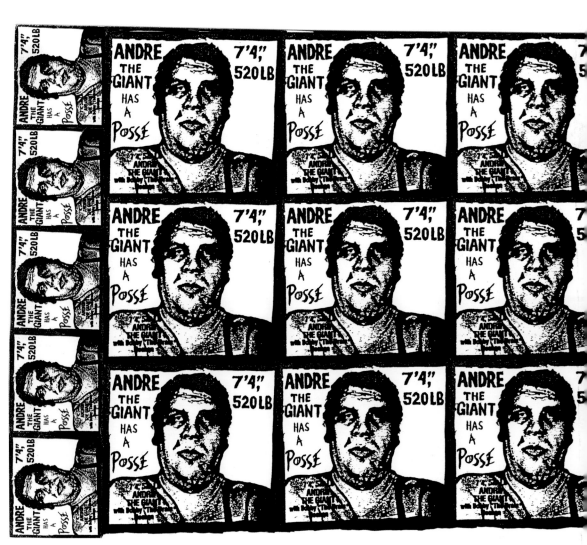

13.

14–15. When I first started making really loud, colorful, attention–getting stickers, I researched a lot of psychedelic poster art because of the really aggressive color combinations they used. I was really attracted to the Filmore posters that were done in the late '60s. One of the most iconic ones was an image of Jimi Hendrix with a squig- gly–haired afro, done by John Van Hamersveld. Before I hijacked that image, I had really been afraid to introduce the Andre face into any other environment. This was a big step, because my fascination with psychedelic art led me to experiment with that style. It also became the first Andre fine art screen print I made.

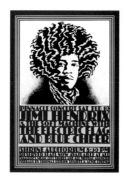

14.

16.

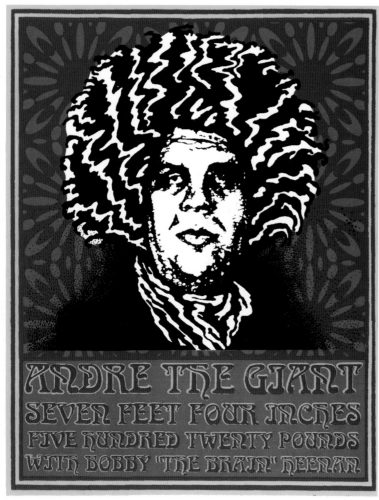

15.

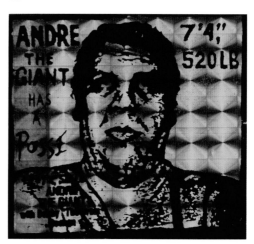

17.

16–17. After making black–and– white stickers for a couple years, I wanted to mix things up a bit. I never felt like changing the original Andre design, because I considered it a "happy accident" I couldn't improve upon. However, I felt that introducing colors and goofy patterns to the background could be fun. I used leopard skin, wood grain, flames, silver, pris- matic, clear, and black–on–black. I was especially fascinated by the simultaneous attraction and repulsion of psychedelic patterns and color combinations, which I felt mirrored the ugly but strangely charming original Andre sticker. My fascination with psychedelic art wasn't inspired by rave culture, but ravers embraced the psyche- delic stickers. Though good for quick t–shirt sales, raving ended up being a culture I didn't want to be linked to, prompting me to dis- continue the psychedelic stickers.

18. If I wanted to make a bill-board−sized image, I had to Xerox up the smaller images in sections, because they didn't have the oversize copiers they do now. I would cut out chunks, blow them up 200%, then take those copies and blow them up another 200%. Going from a 3 x 3" sticker to a 6 x 6' image took several shots.

The pieces would get so abstract that I had to number each one by where it went on the grid, because it became impossible to tell where each one was supposed to go. The first really huge one that I did covered the Cianci billboard, and that was 64 (11 x 17") copies all tiled and taped together.

14. *Original Hendrix Fillmore poster by John Van Hamersveld,* 1967

15. *Andre Hendrix Fillmore,* 1993
(11 x 14") screen print on paper

16. *Psychedelic OG Sheet 1 and 2,* 1992 (10 x 7.5") screen print on vinyl

17. *OG Sticker,* 1994
(2.5 x 2.5") screen print on prismatic vinyl

18. *OG Multipanel,* 1991
(36 x 3'6") Xerox on paper

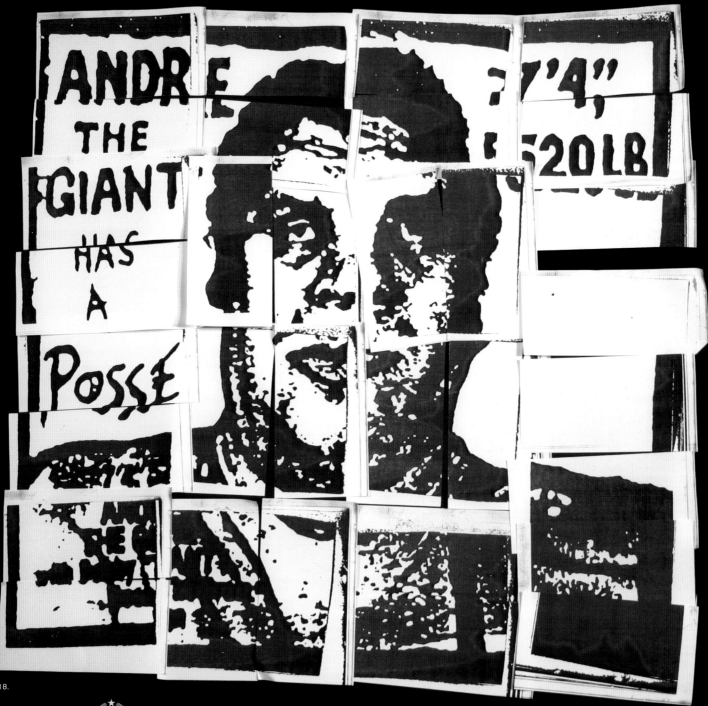

18.

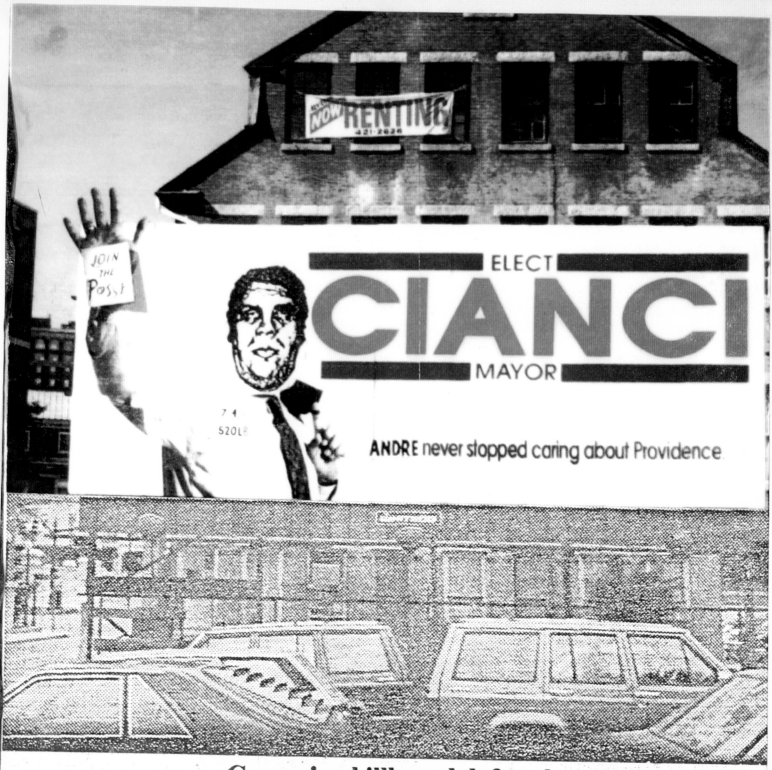

Campaign billboard defaced

A sign promoting the candidacy of former mayor Vincent A. "Buddy" Cianci at South Main and Angell Streets in Providence, bears the mark of vandals yesterday.

"To affect the quality of the day is no small achievement"

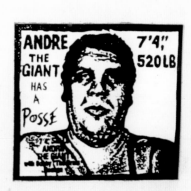

19. After doing the sticker thing for a while I decided I wanted to hit a billboard, and I had my eye on one in particular. It was September 1990, and I had recently started a new semester at RISD. The billboard in question was located at a busy intersection at the base of a hill near campus. It was a campaign ad for Buddy Cianci, who was running for mayor of Providence. His picture on the billboard was relatively small compared to the text above it: "Cianci: He never stopped caring about Providence." I thought it was kind of ridiculous – his head was maybe four feet high and the letters of his name were probably twice as big. I was taking an illustration class, and our first assignment was to open a

fortune cookie and illustrate whatever it said. Mine read: "To affect the quality of the day is no small achievement." I figured I would affect the quality of the day with humor by pasting Andre's face and name over Cianci's.

My class was on a Friday, and the following Monday I went down to the billboard and spent five minutes measuring the head. I came back around nine in the evening, pasted up the four-foot head, and changed "Cianci" to "Andre." By Wednesday, Cianci's people had fixed the name and covered the picture with another one twice as big, with Cianci's waving hand sticking out from the billboard. Of course, I had to hold down my spot, so I went back and mea-

sured the new head–eight and a half feet–and went off to Kinko's to make a new Andre head. I had never done any kind of pasting before; I mixed some Elmer's glue with water in a jar, and brought a rolling pan and some tape to hold the pieces of paper together. I called up a couple friends: one to help me put it up, another to look out for cops. I also made a sign that said "Join the Posse" and put it over the hand, changed "Cianci" back to "Andre," and put "7'4", 520LB" over the lapel button.

The next day, the story was all over the news–radio, TV, newspaper, everything. People at RISD were going crazy. It was just a prank, but people thought there was some political or moralistic

motivation behind it. I didn't even know it, but it turned out that Cianci had been the mayor years before, and was kicked out of office for beating up his ex–wife's lover and putting a cigar out in the guy's eye while city cops held the him down. Everyone figured the image of a wrestler was supposed to be a way of calling Cianci a brute. Although I didn't intend to make a statement, the incident opened my eyes to the power of propaganda. An ambiguous image can stir up so much curiosity that it functions as a sort of Rorschach test by stimulating interpretation and discussion.

20.

21. The Church of the SubGenius was a pseudo–cult created in the late '60s based on the fictional character J.R. "Bob" Dobbs, a piece of '50s clipart of a man smoking a pipe. The name essentially means that anyone who's not a genius is welcome to join; they were big on humor and irony,

so anyone who joined could anoint themselves pope or anything they wanted. I had seen the "Bob" icon stenciled around RISD and a few other places, and it was inspiring to see something already out there that utilized some of the same tactics that I was using for Andre.

21.

19. *Editorial Illustration Class Project,* 1990 (18 x 24") mixed media

20. *Newspaper Clippings*

21. *J.R. "Bob" Dobbs*

Dear Shepard,

My name is Marc Gore, and I am a freshman at Clemson University. I work at WSBF, Clemson's very own alternative radio station. During my show the other night, my friend, Kevin Gray, showed me the new Spore CD. Neither the band nor the music intrigued Kevin or I. It was that marvelous artwork on the CD and the CD insert. An Andre the Giant has a Posse logo was affixed right in front of my own eyes.

I first became acquainted with the Andre the Giant phenomenon during my eleventh grade year at the South Carolina Governor's School For Science and Mathematics. A particular student began placing Andre the Giant stickers all over campus. My friends and I idolized the image being affixed on just about everything. We did some investigation and found that one of our friends, Eric Frey, was the one with the stickers. He quickly armed us with stickers of our own, and we plastered the campus with the stickers. It was not long before the stickers had become a problem around campus. The administration finally had to ask us to quit placing the stickers. Our operations were forced underground, and the stickering continued. It was not long before we decided to print up t-shirts with the Andre the Giant logo. One of our friends had an uncle who made custom t-shirts. Our shirts arrived soon thereafter. Our only regret was that the image on the shirt was an artist's conception of the Andre the Giant logo, not the original Andre the Giant logo. Still, our shirts became quite a fashion statement around campus, and we felt that the shirts set our particular organization of stickerers apart from other groups.

My particular reason for writing to you is concerning the history of the Andre the Giant phenomenon. Our friend, Eric Frey, often claimed that the sticker was invented at Porter Gaud High School, a private school in Charleston South Carolina. My friends and I had trouble believing this was true, and were told that the sticker was actually developed at the Rhode Island Art Institute. Judging from your address, this information seems to be correct. I have also wondered about the group of people who developed the sticker. I have always heard that the inventors were avid skateboarders. Also, was the design an original or copied from some outside source. I have heard theories that the design was originally featured in a skateboarding magazine or that a wrestling sticker was doctored to create the design. As an avid wrestling fan, the second theory seems quite plausible, but I am not sure.

I would also like to inquire about the lettering in the top right corner of an Andre the Giant Sticker. The lettering reads 7'4" with an additional comma under the double quotation marks. I have often thought that this was some type of mistake, but I can also see it as a division between the Giant's height and weight. Just a note, I

recently read a message on Internet that listed Andre the Giant's height at a mere 6'10" at his death.

I would also like to inquire about the various Andre copycat movements that have arisen. I know that in Charleston, South Carolina, a particularly anti-Andre faction was begun. The John Travolta has a Leisure Suit stickers were a direct copy of the Andre stickers and even featured the phrase "Andre Can't Dance". I met the founder of this movement. His name is Holmes, and he said that he invented the sticker as a result of an incident he had while skating. Apparently, a kid was stickering when Holmes skated by. The kid told Holmes that he didn't like skaters. Holmes became offended and told the kid that skaters were the ones who invented the Andre stickers in the first place (this fact is debatable, as I mentioned before). Holmes supposedly rushed home and created the John Travolta stickers by scanning photos off of the Saturday Night Fever Soundtrack. Holmes is quite the quality freak, and he always demands that his stickers are printed on high quality paper, sometime even on silver paper. His printing costs were outrageous the last time I saw him. I am unaware of Travolta's current standing. I have also heard reports of Star Man and Ross Perot copycat stickers. Though I have never seen either of these, I have heard eyewitness reports of their existence.

Finally, I would like to request a favor. The Andre the Giant proofs and stickers that I own are clearly many generations old. The best estimate to their age that I know of says they are at least five generations old. I have seen stickers that appear to be fairly new. This is evident by the clarity of the phrase "Andre the Giant with Bobby the Brain Heenan". I will enclose some of my stickers so that you may see how distorted this portion is. If you could find it in your heart, I would love to see a first generation copy of an Andre the Giant sticker. My friends and I would be eternally grateful for your gratitude.

Shepard, I can only say nothing but thanks to you concerning your mission to place Andre the Giant's likeness all over. I know of stickers that have been placed in New York, California, and even Denmark. You have truly done a great service to the youth of America.

A loving fan,

Marc Gore
P.O. Box 8844
Clemson, SC 29634

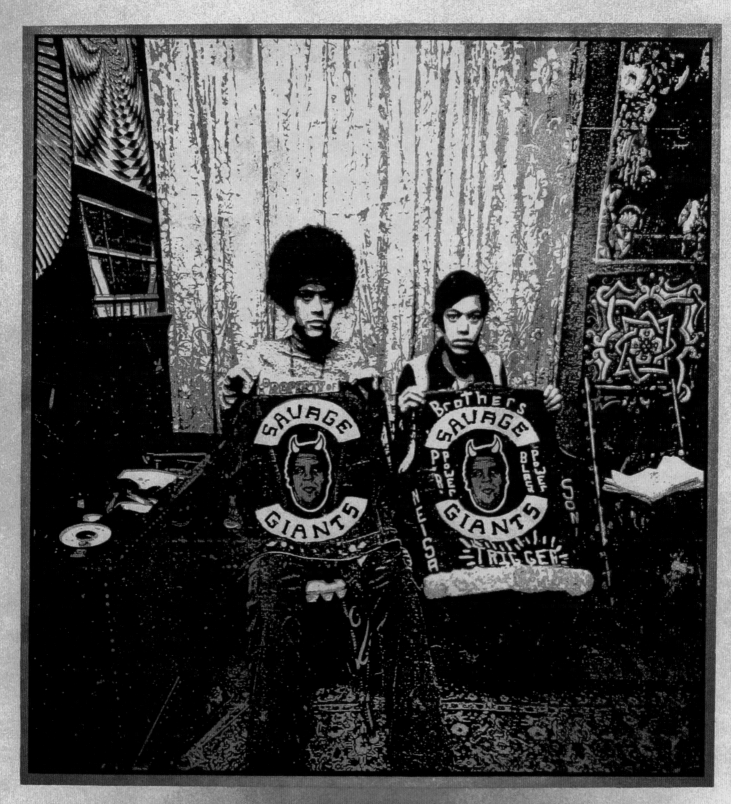

WELCOME TO THE JUNGLE RAMP

Kevin Taylor

I met Shepard Fairey around 1985 at the Jungle Ramp in Carly Orvin's back-yard. Shepard was maybe 16 and I was probably 12, an ultra grommet blasting slob airs one foot over the broomstick coping, straight into the flat–bottom of the ramp. I can still remember that day vividly: Shepard's surf–skate punk haircut draped over one eye, his neon pink Tony Hawk board, Suicidal Tenden-cies exploding from the crap–ass boombox that was covered in a collage of stickers and duct tape. I could never have imagined the future we were forging for ourselves.

The first Andre the Giant has a Posse image I saw was on the tailgate of Shepard's infamous "Shepmobile," a vehicle known for its extreme stealth on late–night construction–site "wood–borrowing" raids, skill in escaping furious rednecks, and capacity for packing in herds of skaters for full days and nights of sessions. The year was 1990, I believe, and it was around this time that Shepard had gone off to California for school or something and left Jason Fili-pow and myself down south in Charleston, South Carolina. Jason and I had started a zine called *Streetscribe*, and Shepard would keep us regular on what he was doing by sending photos and stuff. (Dare I say that *Streetscribe* may hold the claim to the first "published" Andre image?) We soon started getting all these Andre the Giant has a Posse stickers, and we were just like, "Cool, man." No big deal, just another one of our creative skater friends' latest obsessions. No one, not even Shepard, could have foreseen how well that image would come to be known.

Regardless of Shepard's consciousness about what he was doing then, it was he alone who saw the power in the image – a sleeping Giant, if you will. It spoke something about how we felt. It somehow manifested the attitudes of skaters growing up in the '80s. Born from a parody to confuse synthetic hipsters, it was obnoxious, mysterious, hilarious, creative, ridiculous, and still somehow incredibly thought–provoking. That's the part that is so ironically monumental: Shepard took something that promoted absolutely nothing and made it represent something simply by promoting it. Consciously or not, it's brilliant!

When I see the sticker today, it's great. A couple of times I have been in a far–away, unfamiliar place, not knowing anyone, and I'll come across an Andre sticker or poster and get this weird feeling of comfort. For me, I guess, it's say-ing my friend was there. It's the same way it was that day at the Jungle Ramp, pink Tony Hawk and all. From that day forward, Shepard Fairey has continued to inspire me, whether through skating, music, art, or simply determination. For that reason, I give him 15–years worth of official props and encouragement towards further realizing his ultimate vision with the Andre the Giant has a Posse campaign.

23. It must have been '84 or '85 when I was walking down a crowded public–school stairwell and I noticed an unidentified older kid just ahead of me. He was wearing a hand–me–down tweed sports coat with some slightly oversized khakis and a ragged–out pair of light blue Vans high tops (the kind I had wanted for months and months). What stuck out in my mind the most, however, were the meticulously hand–ren-dered skateboard industry logos adorning the sides of those shoes: Independent. "Cool," I thought.

The unidentified older kid turned out to be Shepard Fairey. About a year passed before I befriended him. Even back then, he was well known for a few peculiar things: hand–drawn bootleg t–shirts; out-rageous driving skills behind the wheel of a thrashed, baby–blue station wagon (particularly when exiting the school parking lot, but also on the narrow streets of downtown Charleston) and an always amazing ability to talk him-self out of almost any potentially dangerous situation.

– Jason Filipow

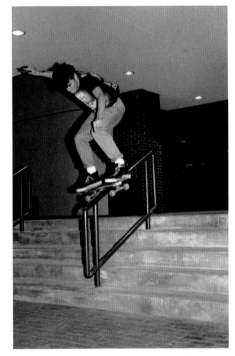

23.

22. The Savage Nomads image was an early screen print I did, which also started as a t–shirt. I changed around the images on the jackets that these gang members are holding – another instance of hijacking something with cultural relevance and switch-ing it up. One important thing about that poster was that all the backgrounds had hand–painted, gold spray paint, so each one was unique. Now I do that a lot, but that was the first experiment in introducing something chaotic that was consistent with the stencil, so the posters shared common elements but still diverged from one another.

22. ***Savage Nomads,*** 1994
(17 x 21.75") screen print on paper

23. ***Shepard Ollie Boardslide,*** 1988

24. I made this Johnny Rotten pop art piece in the fall of '89. It was one of the first screen prints I made where I used some tricky separation techniques. I grew up as a punk rocker and a big fan of the Sex Pistols and PiL, so I decided to do a tribute. The Sex Pistols are probably the most recurrent characters in my work, outside of Andre of course, and shaped a lot of my beliefs about rebellion and counterculture.

24.

25.

26.

24. *Early Rotten,* 1989
(11 x 14") screen print on paper

25. *'70s Giant Rock Shirt,* 1994
screen print on t-shirt

26. *Giant Subliminal,* 1995
(17.5" x 19.5") screen print on paper

27.

29. In 1994, the Coca-Cola Company came out with OK Soda, designed to look like an underground, upstart soda brand. They chose Daniel Clowes and Charles Burns, underground comic book artists, to design graphics for three different cans. I didn't know anything about OK Soda, but one day while I was visiting my parents, my dad said, "Hey, Shep, I saw this article in *Time* and left it on your bed. It looks kinda like the stuff you're doing. Maybe you should contact this company and do some work for 'em." The article was about this new soda that was riding the "grunge" wave. I was really insulted by OK Soda because it was manipulative: they didn't want people to realize it was Coke. I felt like it was intruding on underground culture, trying to exploit it. I thought there was going to be a national campaign, but it was actually just test-marketed in nine cities, and by coincidence, one of them was Providence and another was Boston. I decided I would make a mockery campaign to sabotage what they were doing, and since the graphics were in *Time* but the product wasn't out, I figured I could beat them to the punch and totally confuse people. Instead of "OK" I used "AG" and changed the copy from "the more OK you consume, the more OK you feel" to "the more AG you consume, the more AG you feel." I measured the placards in the subway in Boston, and made my posters to fit in over the real OK Soda ads. One time when I was out postering in Providence, some guys drove by and asked me what I was putting up. I held up my poster, and they shouted, "OK Soda!" It only confirmed my suspicion that people don't pay very close attention to anything.

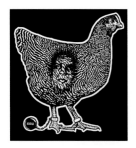

28.

27. *Giant Heavy Metal,* 1994
(9 x 24") screen print on paper

28. *Giant Chicken of Turin,* 1993
screen print on t-shirt

29. *OK Soda / Giant,* 1994
(20.5" x 21.5") screen print on paper

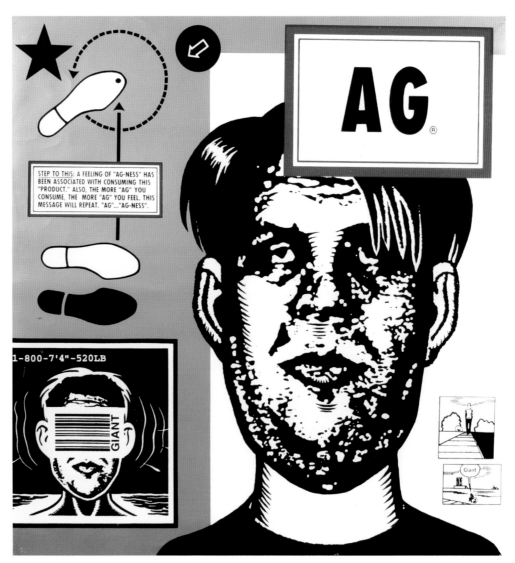

29.

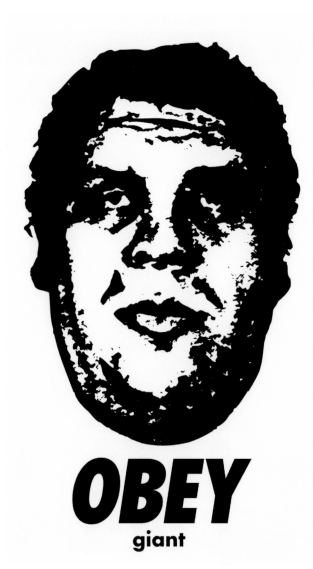

OBEY

giant

30.

31.

33. A lot of the ideas for the Obey campaign came from John Carpenter's movie *They Live.* In the movie, Rowdy Roddy Piper plays a laid-off construction worker who goes to live in a tent camp with some weird but benevolent people. After cops come and tear down the camp and kick everyone out, Roddy goes back and finds a box of sunglasses amid the rubble. When he puts them on, everything turns black-and-white, and he sees that all the rich, authoritarian people in the world are actually aliens. He looks at the billboards, and instead of "Hawaii Vacation" they say "OBEY" or "CONSUME." He looks at someone holding money, and the money says "THIS IS YOUR GOD." It was totally campy, but I really liked the subversive elements of it, how people don't realize they're slaves to consumerism because everything is glossy on the surface. People are just sleepwalking through life, and Obey is my way of splashing cold water on their faces.

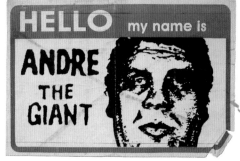

32.

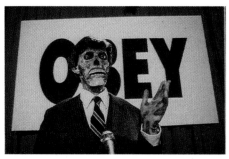

33.

30. ***First Obey Poster,*** 1995
(24 x 36") screen print on paper

31. ***Giant Many Heads,*** 1994
(8.5 x 11") Xerox paste-up

32. ***Hello My Name is Andre the Giant,*** 1995
(11 x 17") two-color Xerox

33. ***John Carpenter's They Live movie still,*** 1988

34. Skateboarding culture was a huge influence on my work, especially in the way stickers are such an important decorative element of the culture, and eventually skaters started embracing my work into their culture. Skateboard videos were a major medium for promotion, so I decided I would sponsor a team and lure people in under the guise of a skateboard video, but it was really embedded with conceptual propaganda. I'd never really thought about doing stuff with motion, but I was excited because I like movies and television. I realized that posters, stickers, and t-shirts were on one level with social commentary and indoctrination, but television and movies were more engaging since they have more facets to assault the senses.

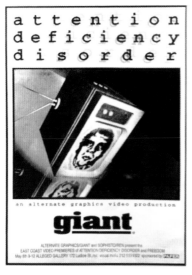

34.

35.

34. *Attention Deficiency Disorder,*
1995 (8.5 x 11") screen print on metallic paper

35. *Giant Devil Wallpaper,* 1995
(25 x 40") stencil on wallpaper

36. *Obey OG,* 1996
(24 x 36") screen print on paper

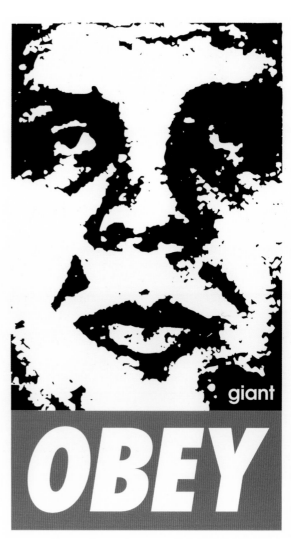

36.

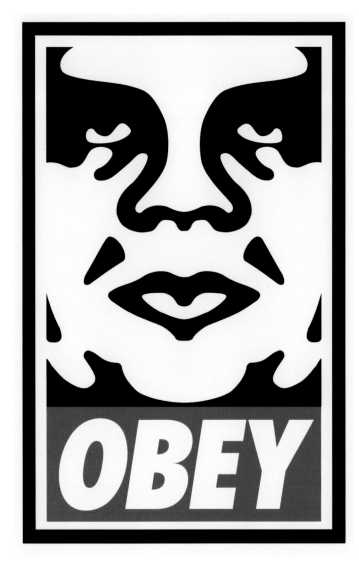

37.

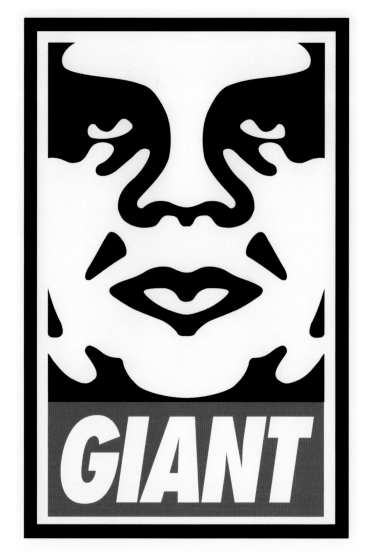

38.

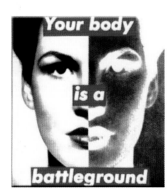

39.

37. **Obey Icon,** 1996
(25 x 38") lithograph

38. **Giant Icon,** 1996
(25 x 38") lithograph

39. **Barbara Kruger's "Your Body is a Battleground",** 1989
(112 x 112") screen print on vinyl

40. **Icon,** 1996
(8.5 x11") Xerox and rubylith

41. **Andre Warhol,** 1994
(18 x 24") screen print on t−shirt

42. **Giant Lichtenstein,** 1994
(18 x 24") screen print on t−shirt

43. **Obey 3 Face Series 1 2 3,**
1996 (18 x 24") screen print on paper

39. This is an image of Barbara Kruger's about reproductive rights. A lot of her work was political and feminist in nature, but it also was based on juxtaposing slogans that might not relate to the original intent of an image but ultimately change its meaning. When I first started the Obey campaign, I wanted to borrow Kruger's style, not as a direct homage to her but to set something up that was dynamic and made people think that there was a message behind it. The irony was that I didn't have a message at all: the lack of a message was part of my idea that people can be manipulated just by a stylistic approach − style over substance.

40. The Obey icon face evolved at the end of 1995 out of the desire to move further away from the association with Andre the Giant and toward a more universal "Big Brother" (as in George Orwell's *1984*) image. I had become fascinated by the power of the streamlined graphic approach of the Russian Constructivist poster and wanted an icon that would integrate into work of this style. Where before I had been generating propaganda using pop culture associations, I now became more interested in commenting on propaganda with work having a direct stylistic parallel. The Obey star was created during this period, as well as the "Obey" red box logo. The concept behind "Obey" is to provoke people who typically complain about life's circumstances but follow the path of least resistance, to have to confront their own obedience. "Obey" is very sarcastic, a form of reverse psychology.

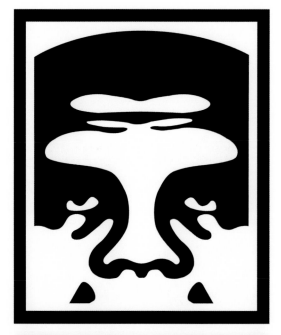

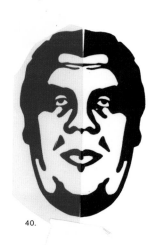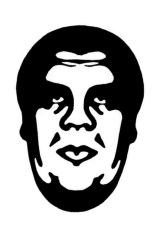

40.

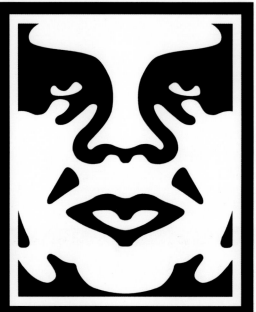

1. **Alternate Graphics.** *Wigs.* 1994. Oil silkscreen on cotton, 4x8" (11.5x20.1 cm). Private collection.

Giant

41.

4.**Alternate Graphics.** *Magnifying Glass.* 1994. Oil silkscreen on cotton, 4.6 x 5.2" (11.8 x 13.2 cm). Private collection.

42.

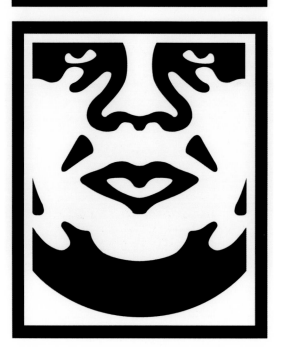

43.

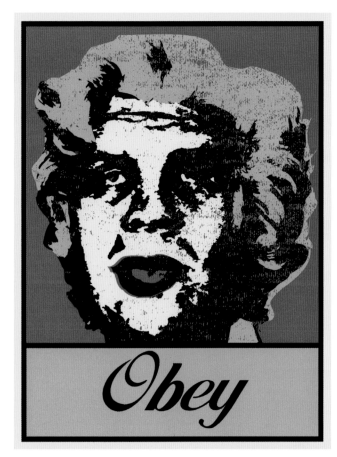

44.

44. Andy Warhol was a big inspiration because he made a mockery of the fine art world, taking press stills and household items and turning them into high art. I felt like what I was doing was pop art in a similar vein, but I was taking it even further outside the institutions and straight to the street. I remember when I was making t–shirts, somebody said, "Isn't it amazing that you're taking one of the ugliest images ever and putting it on a shirt, and people are buying it up as fashion?" I had the idea of taking that a step further by taking Marilyn's sex symbol face and changing that into Andre's ugly face. Andre wasn't a handsome man and he's even a more hideous woman, but people loved the humor of the poster and snapped it up anyway.

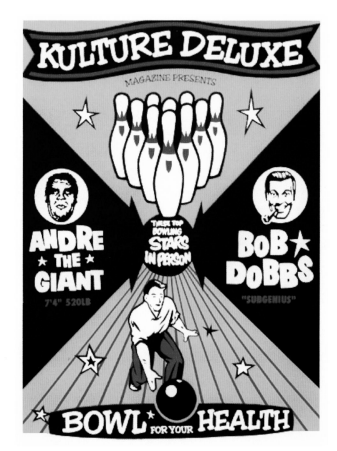

46.

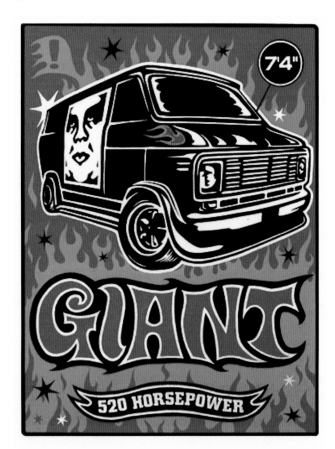

45.

44. **Marilyn Warhol,** 2000
(18 x 24") screen print on paper

45. **Giant Van,** 1997
(18 x 24") screen print on paper

46. **Giant Kulture,** 1997
(18 x 24") screen print on paper

47. **NY Smog,** 1997
(18 x 24") screen print on silver spray–painted paper

48. **Andre the Giant has a Posse,** 1995
documentary short by Helen Stickler

ANDRE THE GIANT HAS A POSSE

Helen Stickler

I first noticed Shep's original black–and–white sticker on a light box at RISD in Providence, Rhode Island, in 1989. I remember cynically thinking that the use of the word "posse" was another attempt by the suburban bourgeois to mimic hip–hop culture, because there weren't too many kids from the 'hood at that school. But because the sticker was absurdly idolizing a professional wrestler, the clash of cultures and adoption of trends was one of the points it made.

Later, I saw Shep's giant Andre face over the mayor's election campaign billboard, and was impressed – the scale was significant, and alignment with a political gesture was subtle social commentary.

In 1994, I finished debuting my short *Queen Mercy* and wanted to follow it up. At the same time, Shep was plastering Providence with a parody of Coca–Cola's ad campaign for a new product called OK Soda (a test product now off the market).

Shep's wheat–pasted poster campaign had spread off campus, a bold move for most art students at that time. At one intersection Shep placed an OK poster on a light box, and as I sat at the red light looking straight at it, my eye traveled the short distance to the original Coca–Cola OK billboard high in the sky. The commentary was direct and inescapable, creating a heightened awareness of the environment we take for granted every day – the white noise of commercial advertising.

A few weeks later, I went to Shepard's studio in Olneyville, introduced myself, told him I wanted to make a documentary about him, and we shot the first scenes that night on a trip to Boston to post OK parodies on the subways.

The doc was completed in about three months, and debuted to great success in March 1995 at the New York Underground Film Festival (at that time run by it's founder, director Todd Phillips). At the time, not many people knew who Shepard was, but many had seen the campaign or would start to notice it after watching the film.

I spent the next two years relentlessly searching out every underground venue, film festival, micro–cinema, museum, college, bar, gallery, punk–rock tour, and art–house theater across the country that would screen it. I made dubs in my living room and lived at Kinko's and the post office. Eventually I managed to get the doc in the Sundance Film Festival in 1997, where it took off to a new level. *Andre the Giant has a Posse* has continued to screen for over 10 years now. It was described in 2003 by *Village Voice* critic Ed Halter as "legendary … a canonical study of Gen–X media manipulation. One of the keenest examinations of '90s underground culture."

In many ways, the short influenced my first feature documentary, *STOKED: The Rise and Fall of Gator*, which was also about an urban legend among underground skateboard culture but of an entirely different sort. I was very happy that Shepard was able to do the graphic design for the poster for that film.

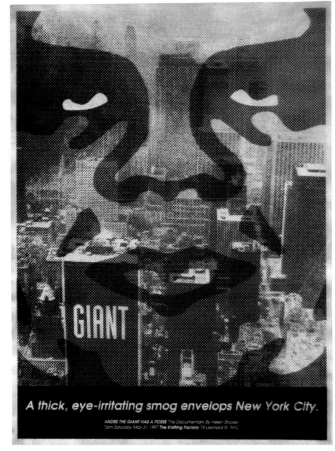

A thick, eye-irritating smog envelops New York City.

ANDRE THE GIANT HAS A POSSE The Documentary By Helen Stickler
7pm Saturday May 31 1997 The Knitting Factory 74 Leonard St. NYC

47.

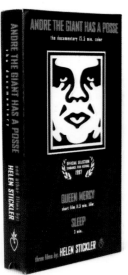

48.

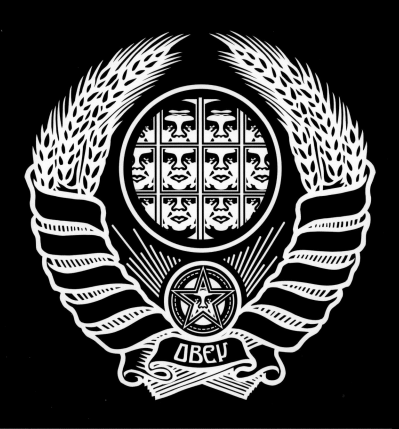

REPETITION WORKS

MARKED TERRITORY

Roger Gastman

Graffiti, in the traditional sense, has been with us since CORNBREAD picked up a can of spray paint in Philadelphia in 1967. Though gangs and individuals had previously asserted their presence on walls, CORNBREAD became the first true graffiti writer, one who wrote his name with repetition and style, and achieved renown for his ubiquitous signature. Soon, other graffiti writers began to appear in droves, following CORNBREAD's lead in the hopes of attaining some degree of fame.

By 1970, graffiti had migrated 100 miles north to New York City's transit system, where it would remain for nearly two decades. The subway trains were galleries in motion, carrying elaborate pieces of art, creating legends, launching art careers, inspiring books and movies, and spawning subsequent generations of graffiti writers who would take the style to new levels yet again. Writers such as ZEPHYR, REVOLT, DAZE, CRASH, and many others painted beautiful graffiti that helped the growth of the movement in the early '80s and subsequently ushered graffiti into the art gallery world. New York's influence on global culture helped spread graffiti to cities worldwide.

The presence of gang graffiti in most major U.S. cities since the early '60s has left a nasty black cloud that follows graffiti to this day. To the un-trained eye, real graffiti is indistinguishable from gang–oriented markings and random acts of vandalistic scrawling. But to the graffiti enthusiast, real graffiti exists in countless forms and styles. Of all the elements of graffiti, the motion of the letterform or icon is and will always be foremost among them. Graffiti writers derive their fame and respect from their names or icons, creating typography that no type master could even begin to imagine.

Graffiti is a lifestyle, a mindset, and a culture that has spawned several subculture offshoots. Sure, countless writers have come and gone to and from the game throughout its 30–plus–year history, some leaving a more significant mark than others. In becoming a writer, one learns that graffiti is all about the spot: visibility is supreme. Each act of graffiti is an act of defiance, and by making it highly visible, a writer flaunts the presence of something that's not supposed to be wherever it is. The riskier, the ballsier, the more in–your–face of a mark that's made, the more it will be noticed and respected by other graffiti writers.

By 1989, New York's graffiti–covered trains, the icons of graffiti's glory days, had been removed from service, forcing many writers to early retirement. New generations of writers came to find the streets, highways, and freight trains around them as their new landscape to decorate. At the time, graffiti was virtually nonexistent in Providence, Rhode Island. Enter Shepard Fairey and a ridiculous homemade sticker of the professional wrestler Andre the Giant. Shepard was not, in any sense of the word, a graffiti artist; he was an art student. But no one starts out as a graffiti writer. No one wakes up one day and says, "I'm going to be a graffiti writer now." People are inspired by what they see, and they evolve to fit into their surroundings. Shepard was a quick learner.

The first six months of the Obey campaign were like a young teenage graffiti writer who just came up with his first tag and stole his first paint

OPPOSITE: REVS and COST were a big inspiration for me, because they were graffiti guys who started doing paste–ups, and their coverage of New York City was unbelievable. At first, I assumed that "REVS and COST" was some sort of political thing, because it was so pervasive that I never would have thought it was possible for just two guys to be doing it. The images of mine that are below theirs are two 11 x 17" Xeroxes, just some images I came up with to be run through a copier with red and black toner. I wanted to express how I was inspired by them and how I progressed in that same direction.

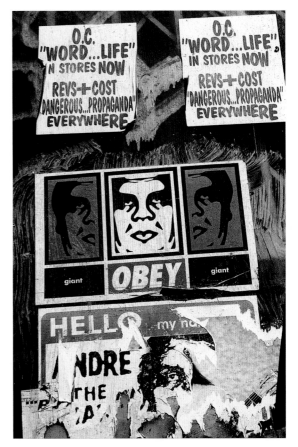

49.

49. *Soho NYC,* 1996

*I found the Obey Giant campaign repetitive and nause-
ating. I thought it wasn't really what you could call
"art," because it didn't change much and it was so
overbearing on its surroundings. For some reason, that
fucking face always seems to jump out at you even
from the smallest little sticker. But if you listen to house
music for a straight 10 hours on drugs, the smallest lit-
tle change becomes very significant. And after a while,
you don't ever want that music to change. Somehow,
I got sucked into the wrestler's fat little face and now I
don't want it to do anything else at all.*

*If Shepard Fairey comes to your town, every
single graffiti writer gets uptight. We don't like Shepard
because he makes us feel scared and lazy. I am ab-
solutely positive he has made more reaches than any
graffiti writer in history ever has done or ever will. And
that means he's won. Anyway, I once got to go gam-
bling with his wife and she's very lucky.*

– BANKSY

50.

marker, not yet ready for spray paint. Wanting recognition yet still feeling invis-
ible, he puts his tag everywhere, without considering who will see it or whether
it will even be visible by the next day. It's a trial–and–error endeavor, with the
errors becoming increasingly obvious as time passes, while the successes only
become apparent when the body of work reaches a critical mass.

Eventually, people, no matter who they are, start to notice those suc-
cesses: graffiti and, yes, Shepard Fairey's homemade stickers staring at them
from the back of stop signs, restroom urinals, and just about every place imag-
inable. People were talking. Shepard noticed, and was hooked. What had begun
as an experiment in attention–getting became a full–fledged aesthetic assault on
Providence, Boston, New York, and everywhere in between.

Like a writer outgrowing the marker and eye–level spots, Shepard's work
found its way into bigger and better places. Wheat paste and large–format
printouts of the "icon" face were taken to new heights, and the fame
and folklore spread. Within five years of its inception (by accident, don't for-
get), the Obey campaign had spread around the country like a rash.

In the truest meaning and age–old tradition of the graffiti writer, the
"spot" itself became an art form. Marshall McLuhan's "the medium is the mes-
sage" theme had been appropriated, and new slogans and graphics created in
the Shepard Fairey signature style were created and pasted on water towers,
rooftops, and ledges that would make a mother faint at the thought of her son
standing on them. Just creating the art was not enough; beating it into people's
heads over and over again was the addiction. One after another, unsuspecting
passers–by came to find the Obey emblem burnt into their retinas as if they had
stared into the sun for far too long.

Graffiti, by nature, is not the most accepting and nurturing subculture.
Graffiti writers can often be pretty egotistical, competitive, violent, and
private. Once you enter their world, you better put up or shut up. If one writer
bites, disses, or goes over another writer's work, it's often a sign of the latter's
prominence, since the perpetrator's intent is to absorb some of the victim's
fame. When this happened to Shepard, it was a sign that he had arrived, and he
responded as any good graffiti writer would, by re–marking his territory every
time it was desecrated. Shepard has, without a can of spray paint, reached
the tallest buildings, bombed cities repeatedly, regulated his spots, and re-
mained true to his original message, which he has spread worldwide several
times over.

In the late '90s, graffiti saw a huge resurgence in commercial advertising
and the art gallery world. For true graffiti and street artists that had put in years
of work in the trenches, it was well deserved. Shepard hadn't intended
his "street" images to be digested by this budding new art world, but in reality
it was a scene that he had helped to create. Just as he had borrowed some of
his methods from graffiti to get noticed and gain respect, once he accomplished
those feats the graffiti writers then turned to him for inspiration.

Despite their overlap, Shepard's work and traditional graffiti are each
unique circles in the Venn diagram of art. Is Shepard Fairey going out at night
with a bag of spray paint and scaling a building to paint the rooftop? No.
He's scaling it with an eight–foot extension pole, large–format posters, and a
big–ass bucket of wheat paste. That makes Shepard more than a vandal, more
than an artist, more than a graffiti writer: it makes him a pioneer and the

most influential quasi–graffiti artist to yet emerge.

Any graffiti artists who disagree with and disrespect what Shepard Fairey has achieved have doubtfully climbed the amount of buildings he has, run from the police as many times as he has, and simply dominated as many cities as he has with their names. Shepard's work and traditional graffiti are very different, but they coexist and mesh to create a raw energy of rebellion to inspire and broaden. Remember, graffiti has no boundaries, and neither does Shepard Fairey.

50. **BANKSY Stencil,** 2003

51. **Copenhagen Denmark,** 2004

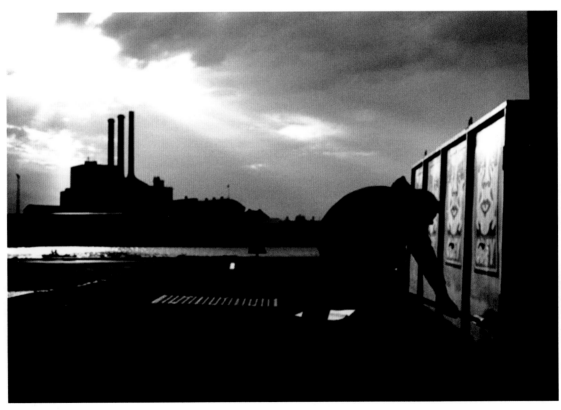

51.

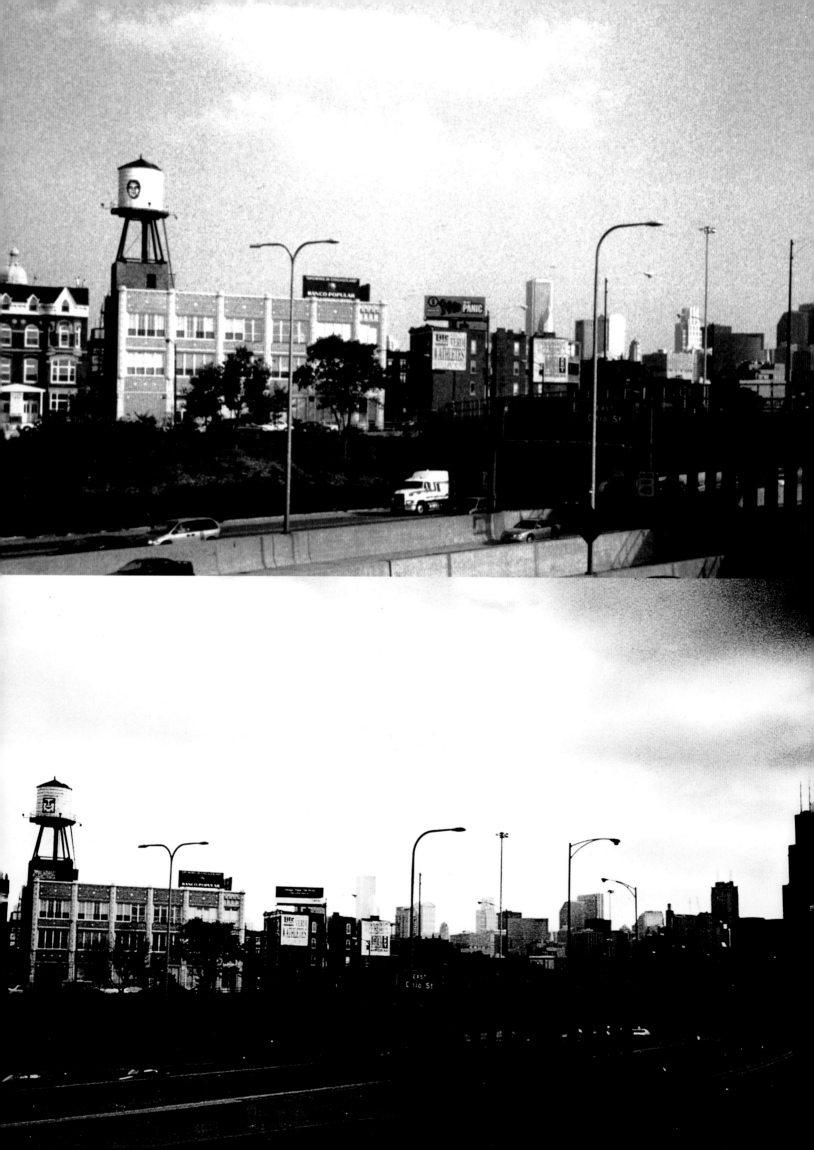

OPPOSITE.: This water tower is in Chicago; I hit it in '99 with the old–school Andre face and again in 2001 with the streamlined icon face. The bridge on the right is Chicago Ave. and the freeway is right below it, so this water tower is at a great intersection of two major thoroughfares, and it was blank at the time. I had to climb up the fire escape on the building with my bucket, but it was such an awesome spot so it was worth the effort. I was told that it stayed up for about four months until the weather finally got to it, so when I went back in 2001 I wanted to hit it again. After I did the spot and I was on my way down, this big, burly guy was standing at the bottom and yelling, "Don't come down, the cops are on their way." I tried to talk to him, but he thought I was just some Chicago hoodlum and he seemed really pissed off. So the cops showed up, and I was stuck on the fire escape, trying to convince the guy not to press charges. The cops were like, "How do you know this guy was just planning to do graffiti? He could have also been planning to break into your home and steal all your stuff." Of course, there was no logic to that at all. I tried to explain that I was from out of town, that it was such a great spot and it was just blank, and I didn't think anyone would care. The guy was starting to warm up to what I was saying, but the cops convinced him to press charges. I went to jail and posted my bail, and then the next day I went back to the guy's place and talked to him. I showed him some stuff online and his kids were really into my stuff, so I promised to send them some t–shirts and posters. I told him that I was willing to pay whatever it cost to clean the water tower, which ended up being $300, and he let it stay up for three months. Best of all, he didn't press charges, so I never had to fly back to Chicago to go to court.

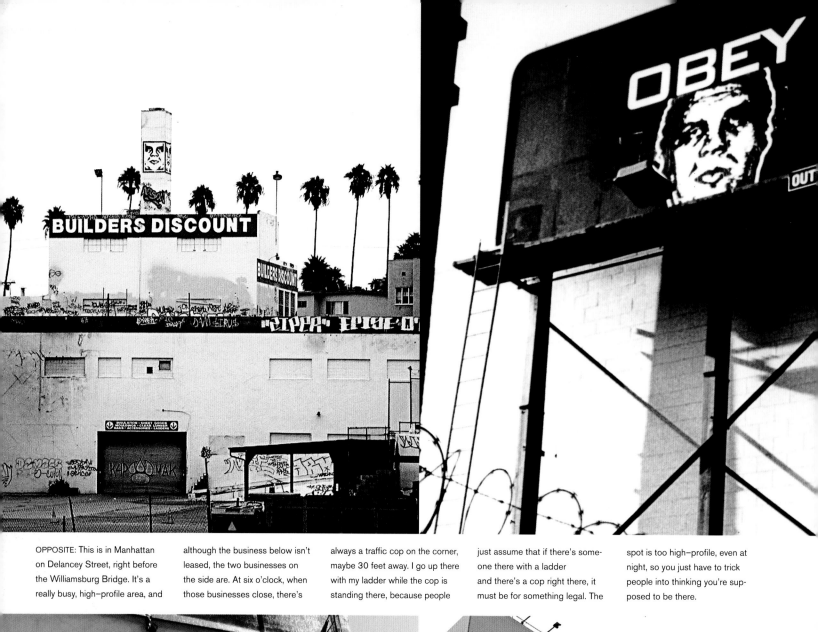

OPPOSITE: This is in Manhattan on Delancey Street, right before the Williamsburg Bridge. It's a really busy, high–profile area, and although the business below isn't leased, the two businesses on the side are. At six o'clock, when those businesses close, there's always a traffic cop on the corner, maybe 30 feet away. I go up there with my ladder while the cop is standing there, because people just assume that if there's someone there with a ladder and there's a cop right there, it must be for something legal. The spot is too high–profile, even at night, so you just have to trick people into thinking you're supposed to be there.

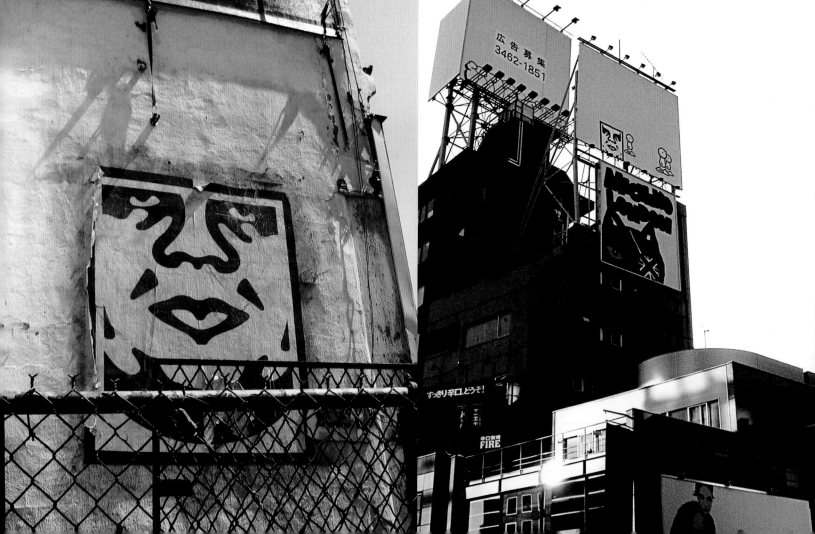

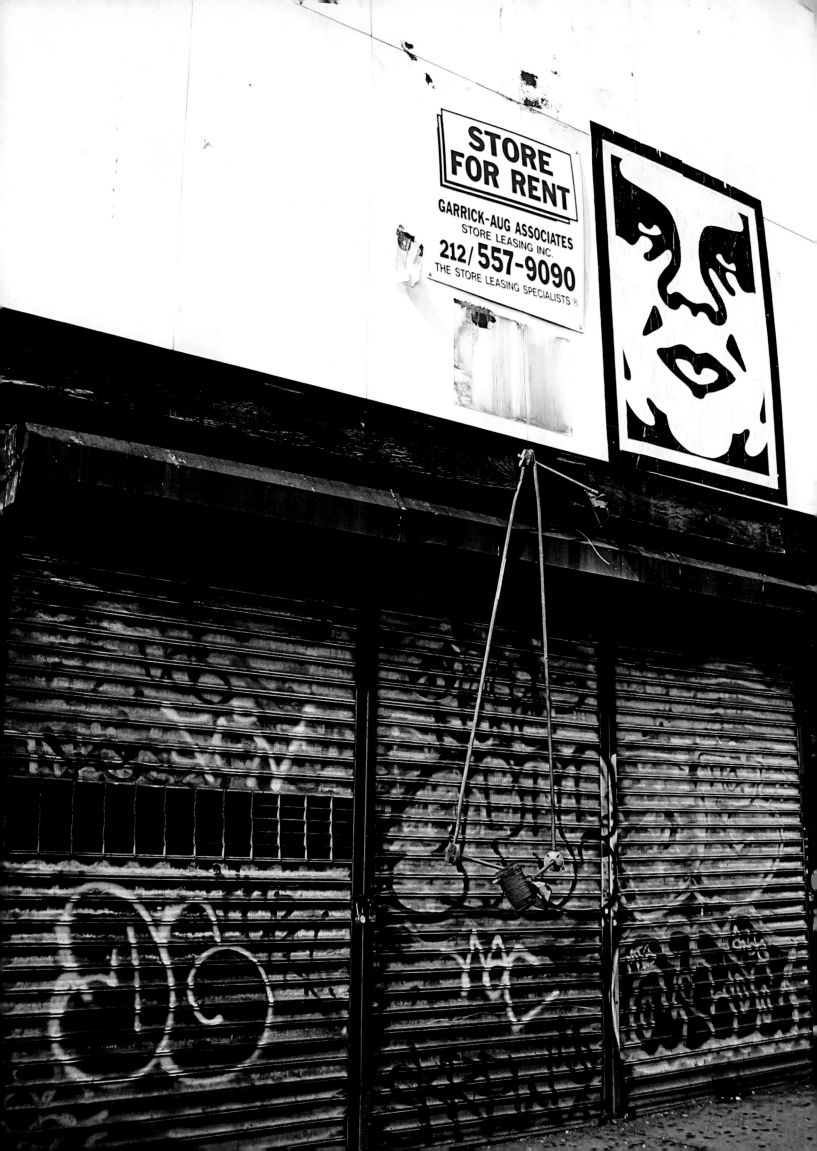

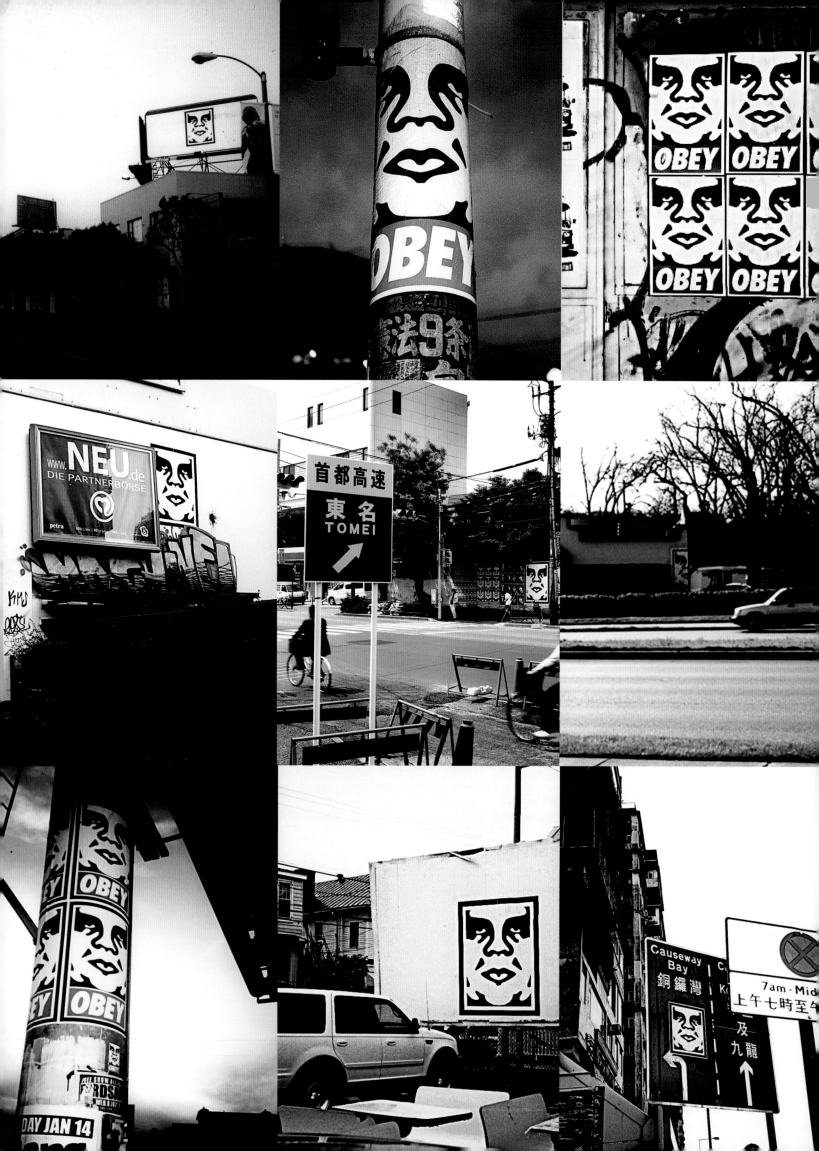

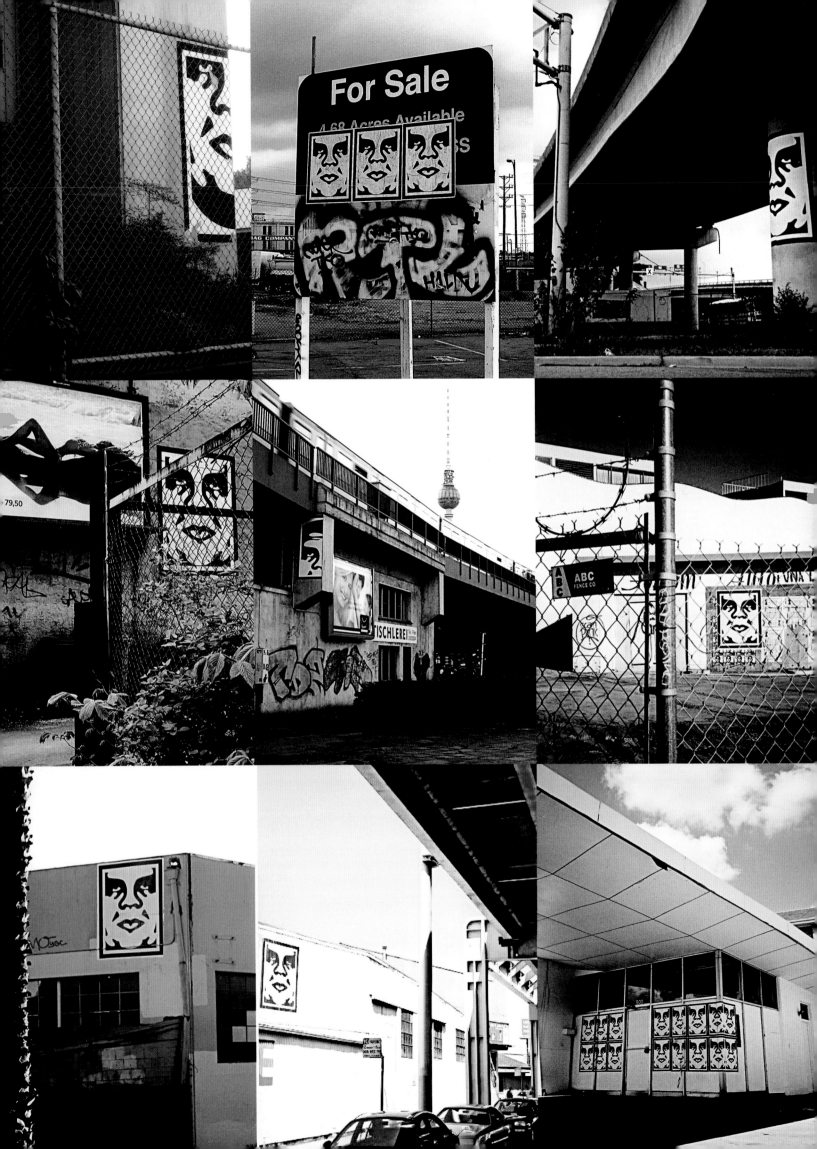

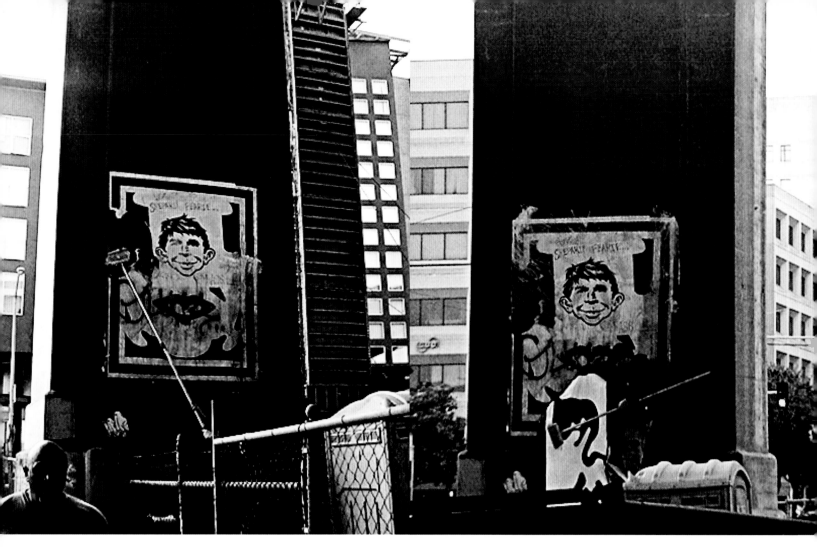

ABOVE: This first spot is a great spot in San Francisco on 3rd Street, near the Yerba Buena and the MoMA. I hit it years ago, but somebody wrote some stuff on it and pasted an Alfred E. Neuman image over it, so I went back and redid it. I've had to regulate a lot of good spots, because people will go over my work or it'll get weathered. It requires a lot of persistence.

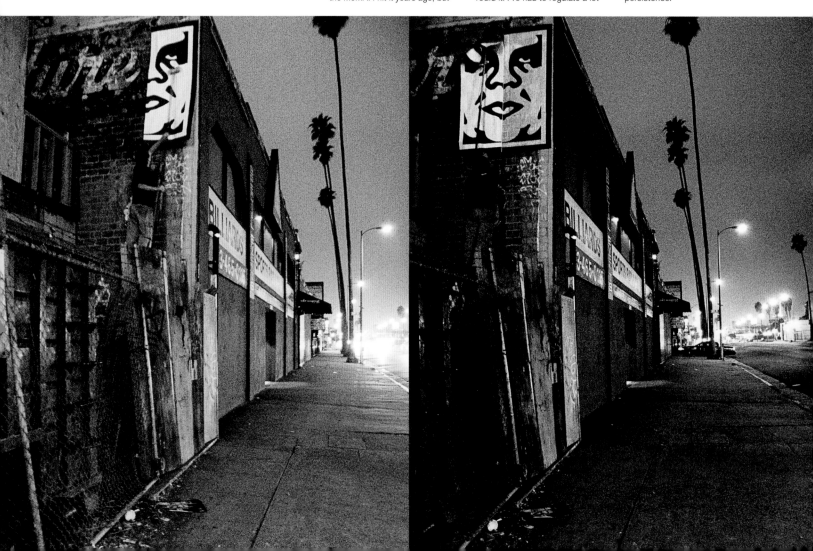

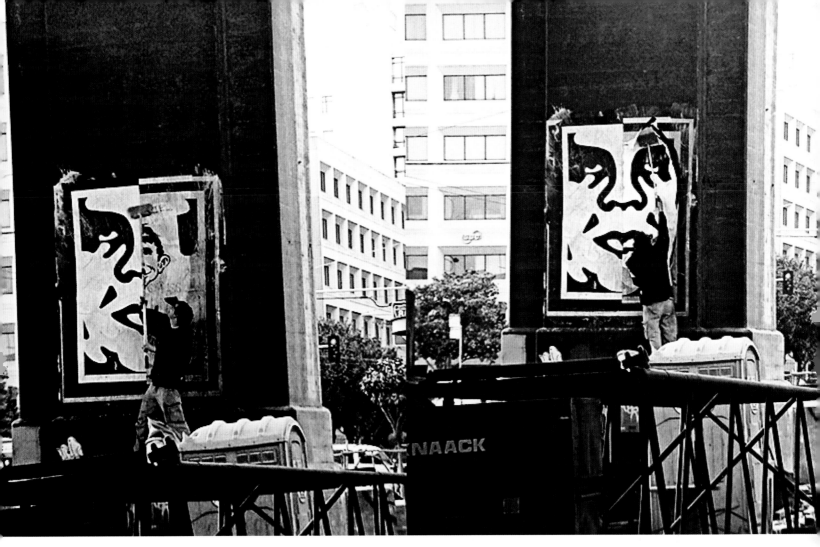

BELOW: This is on Hollywood Boulevard in Los Angeles. I noticed that there were some small posters that had stayed up for a really long time, which probably meant that no one really cared about this building, so I brought my folding ladder out there and hit it. It's been up for eight months; who knows how much longer it will stay up?

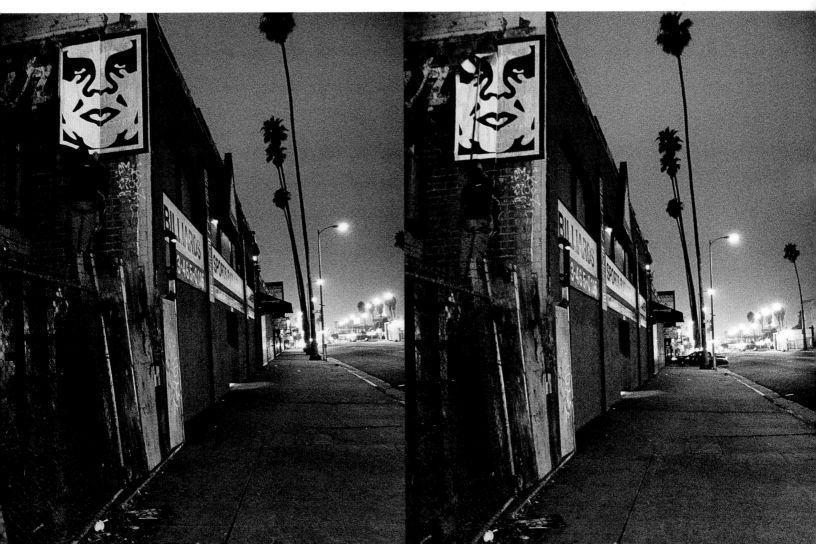

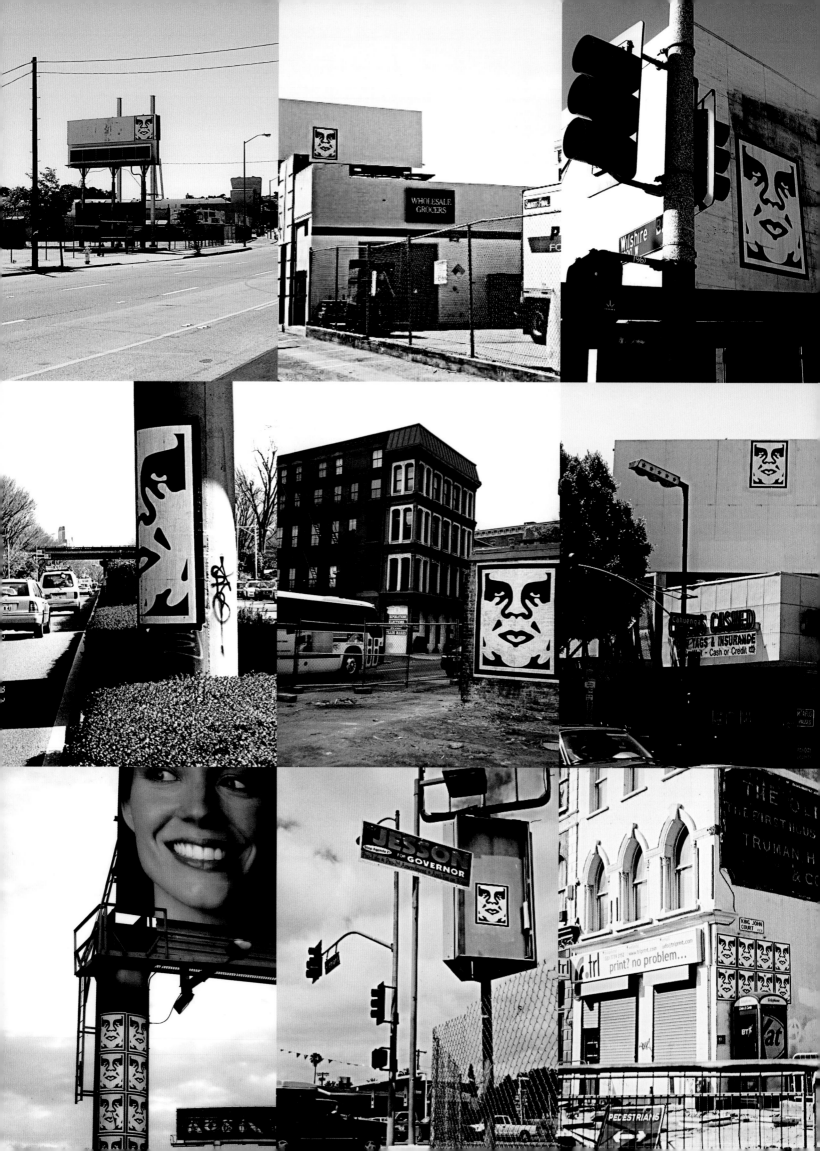

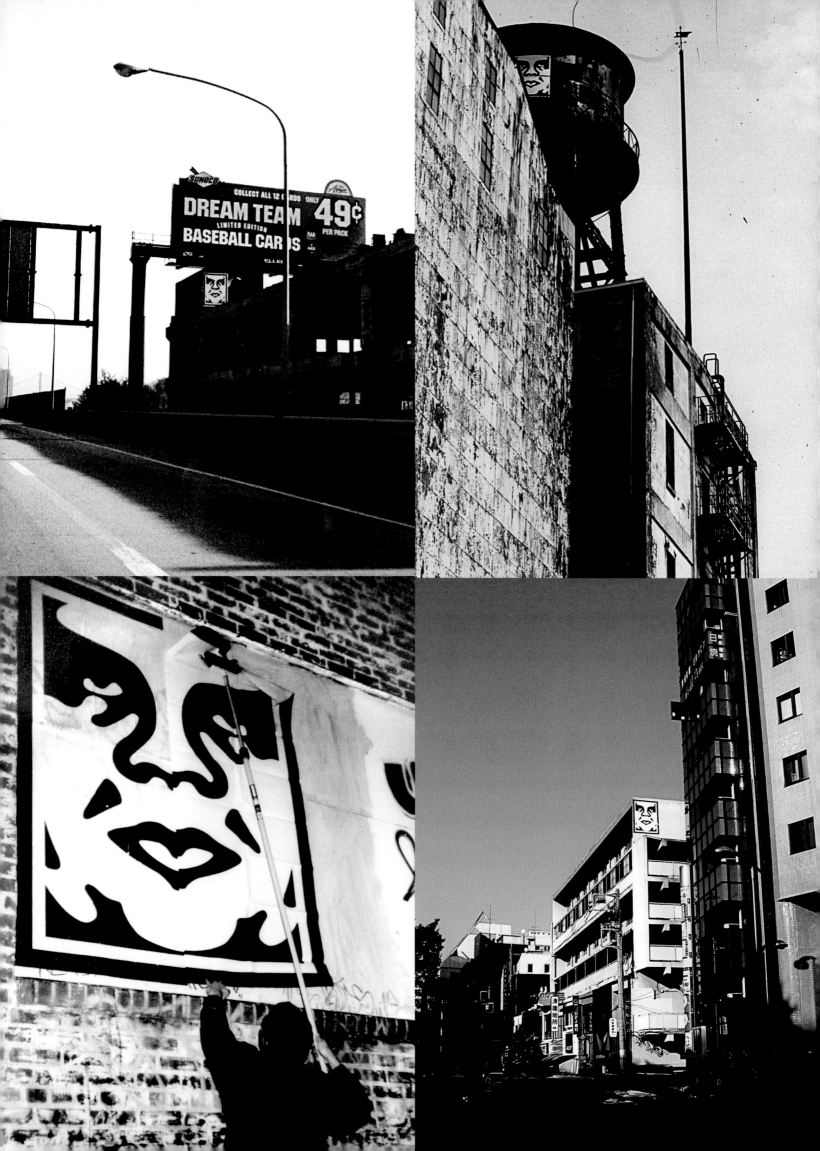

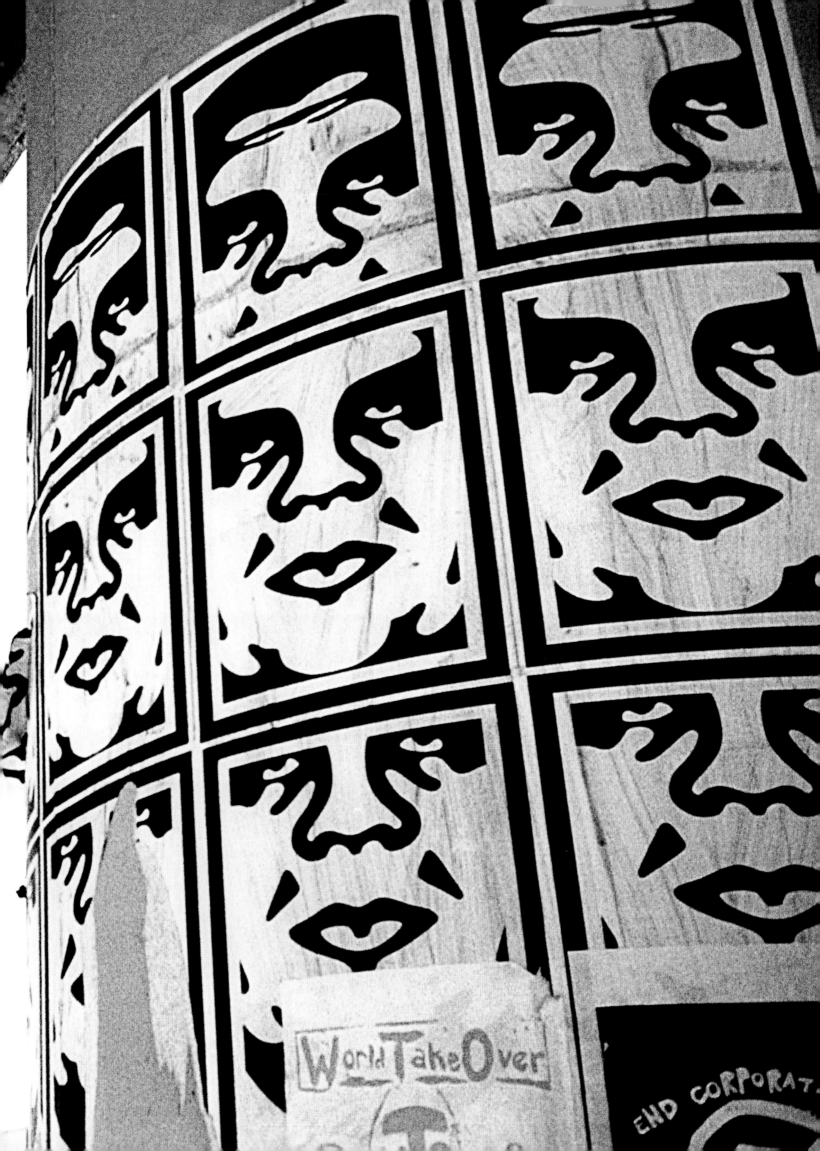

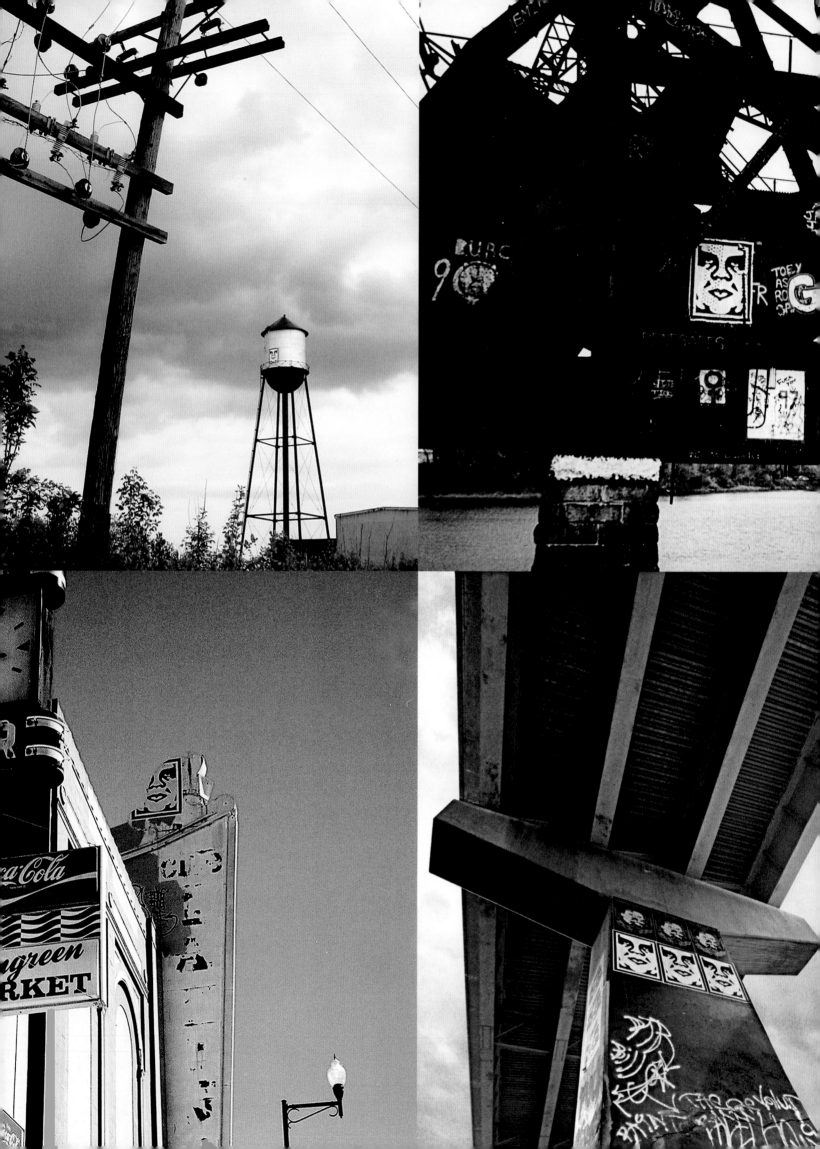

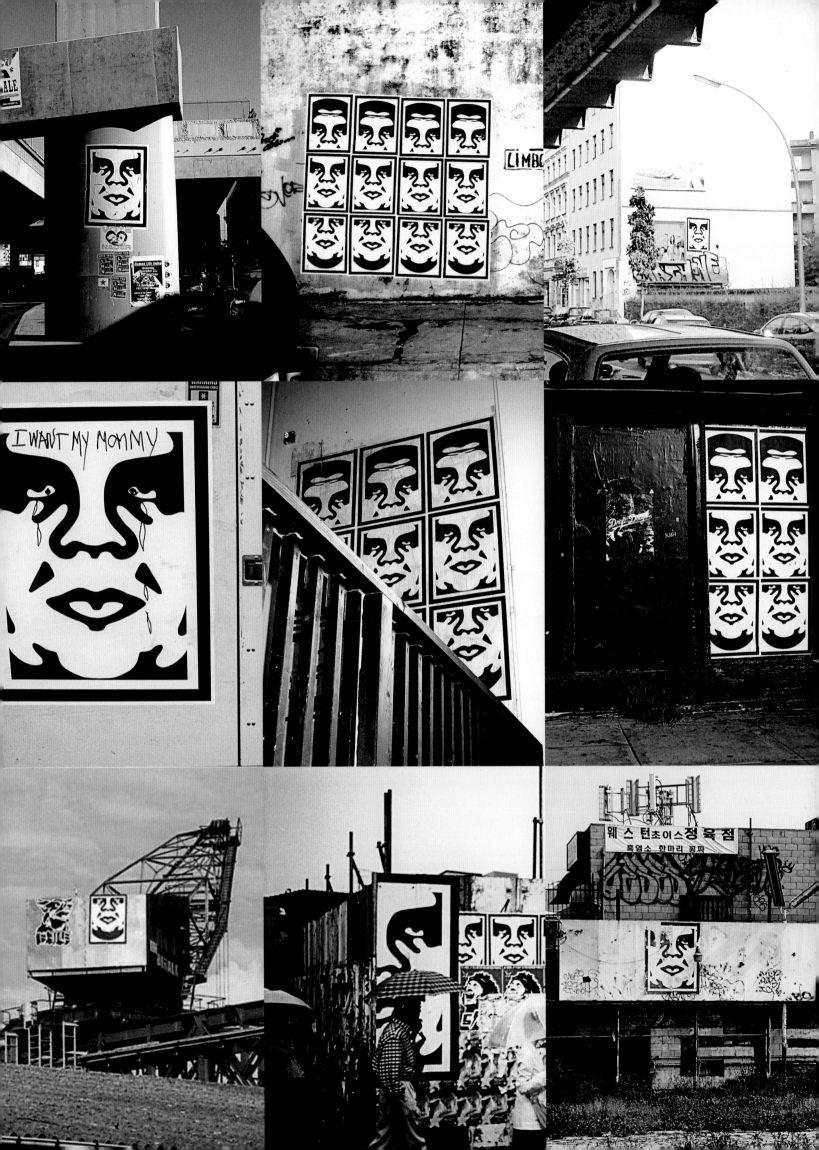

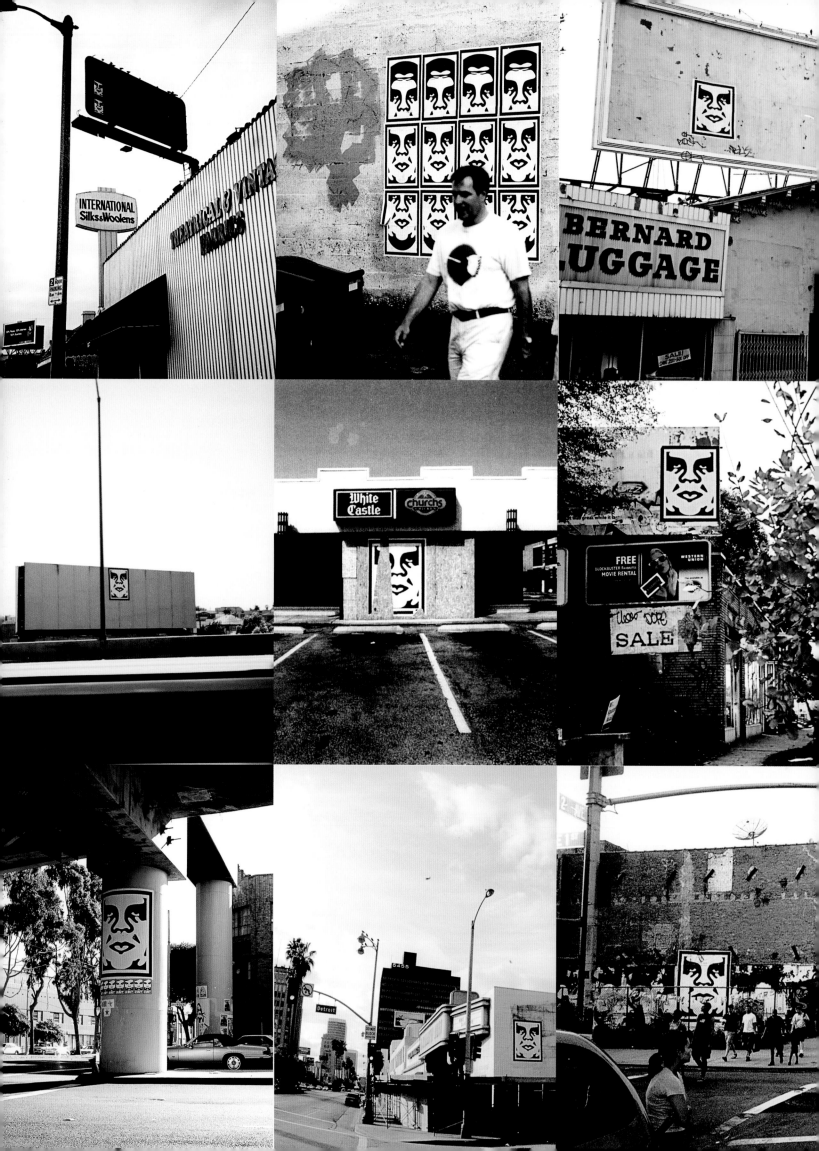

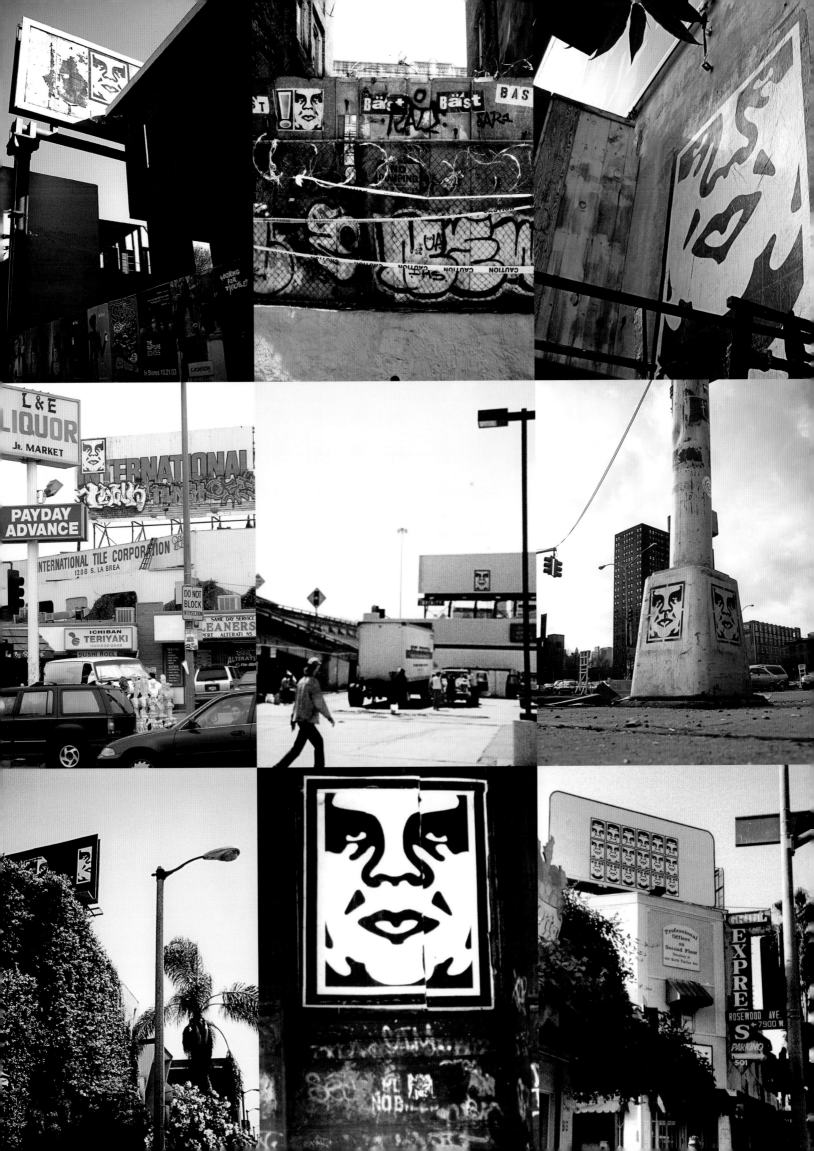

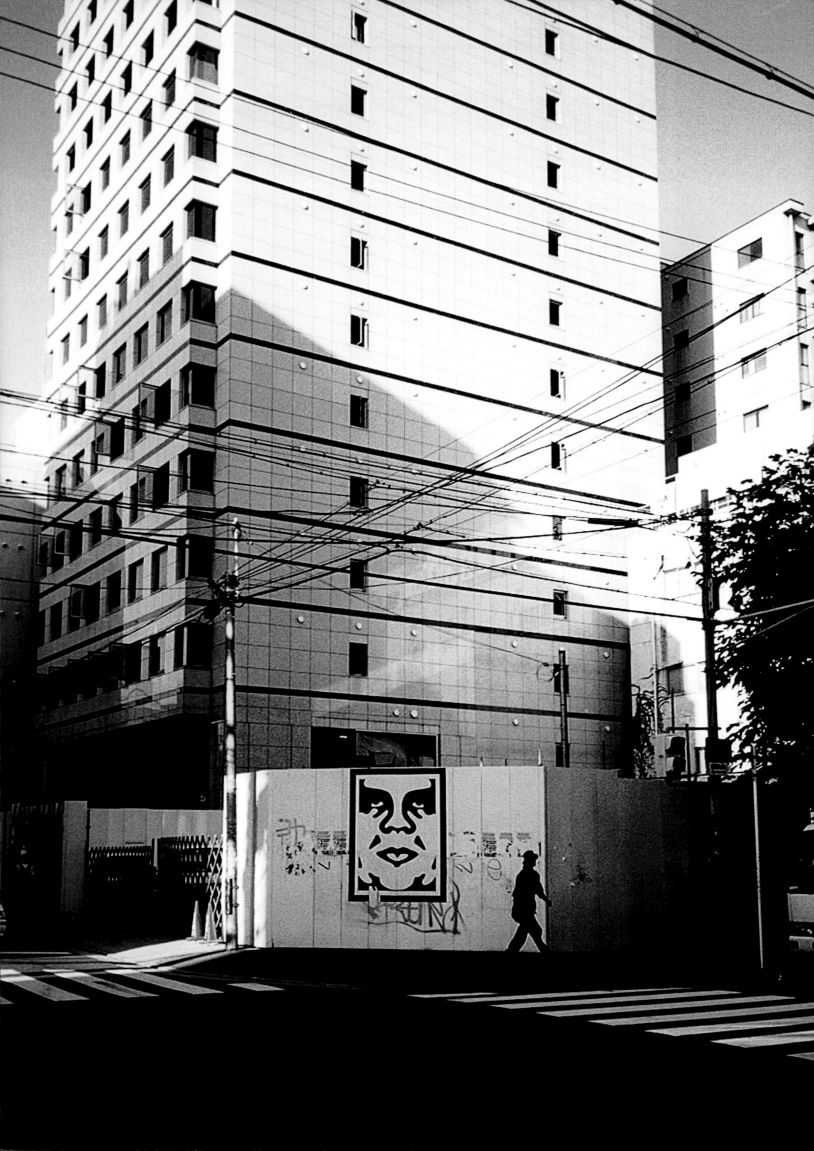

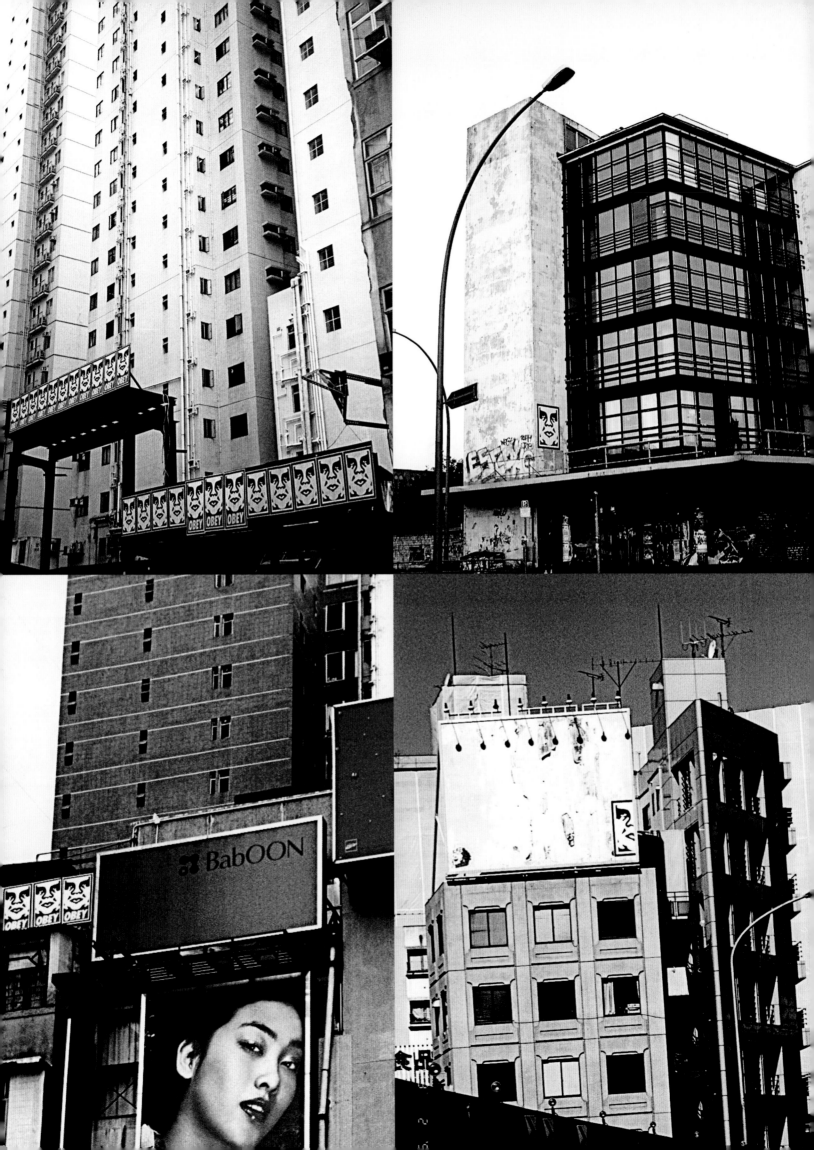

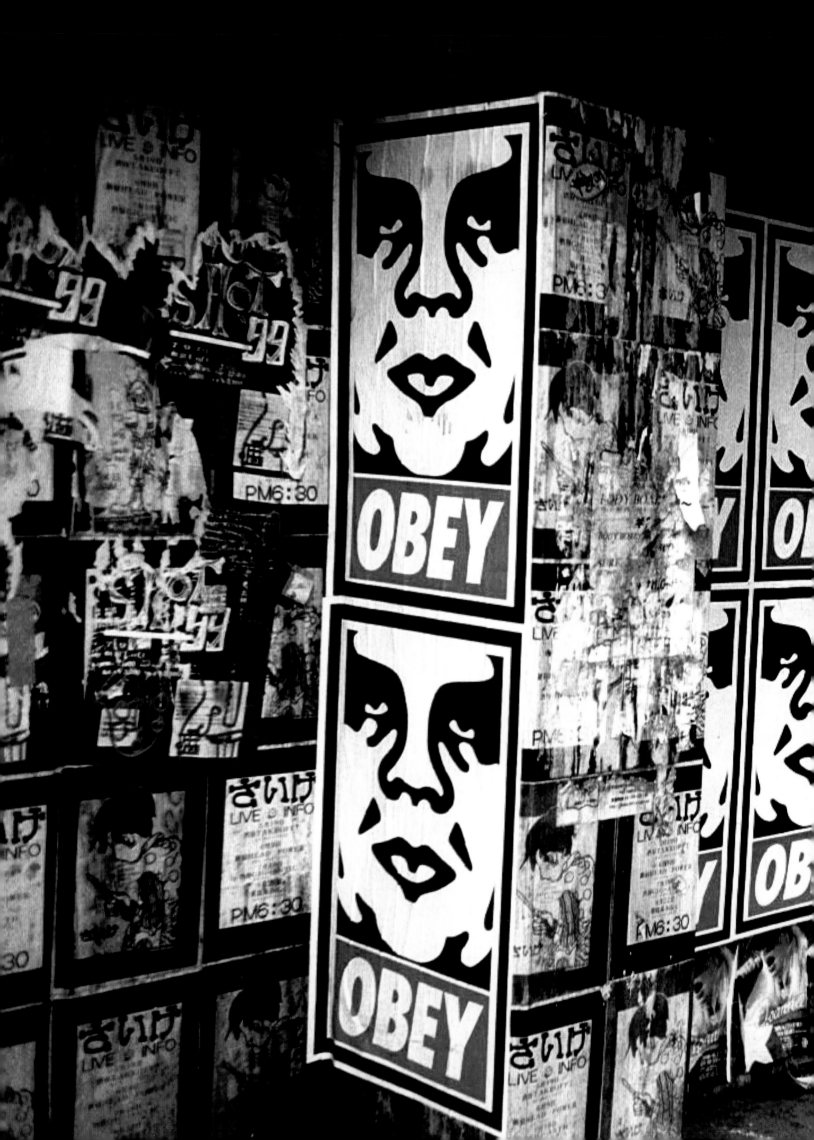

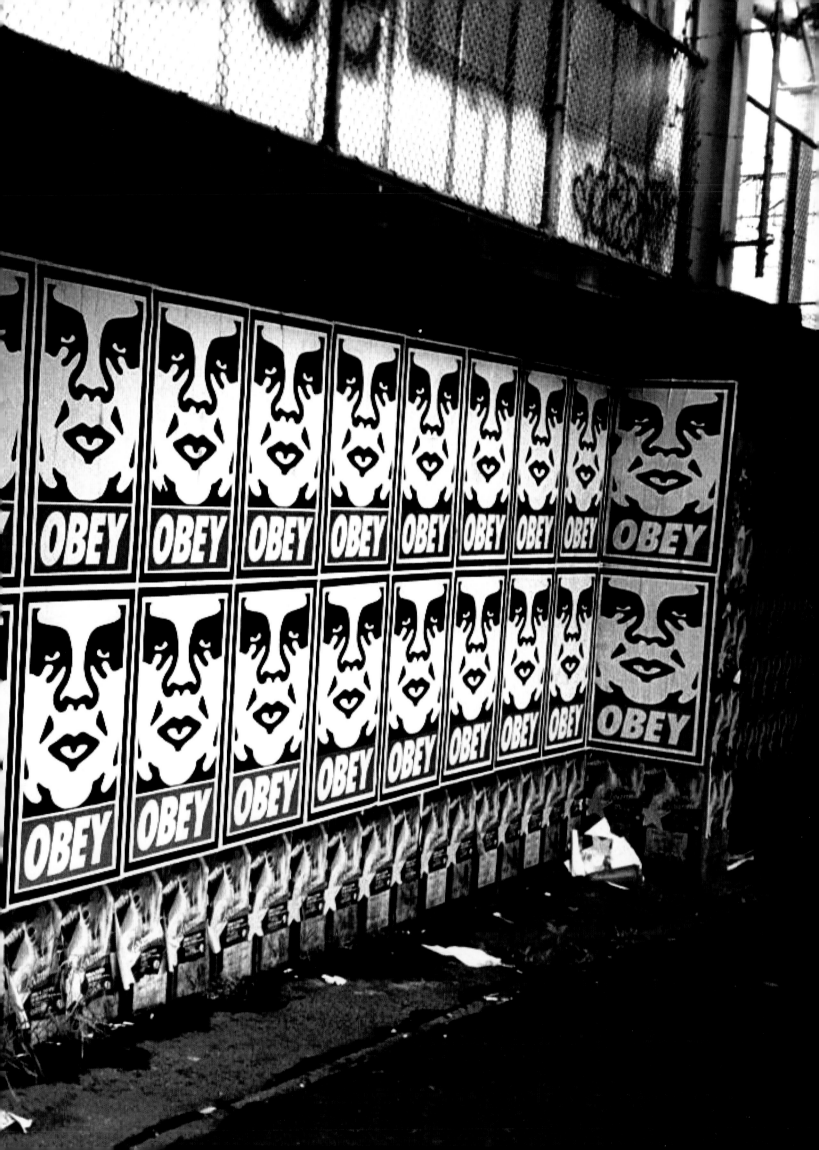

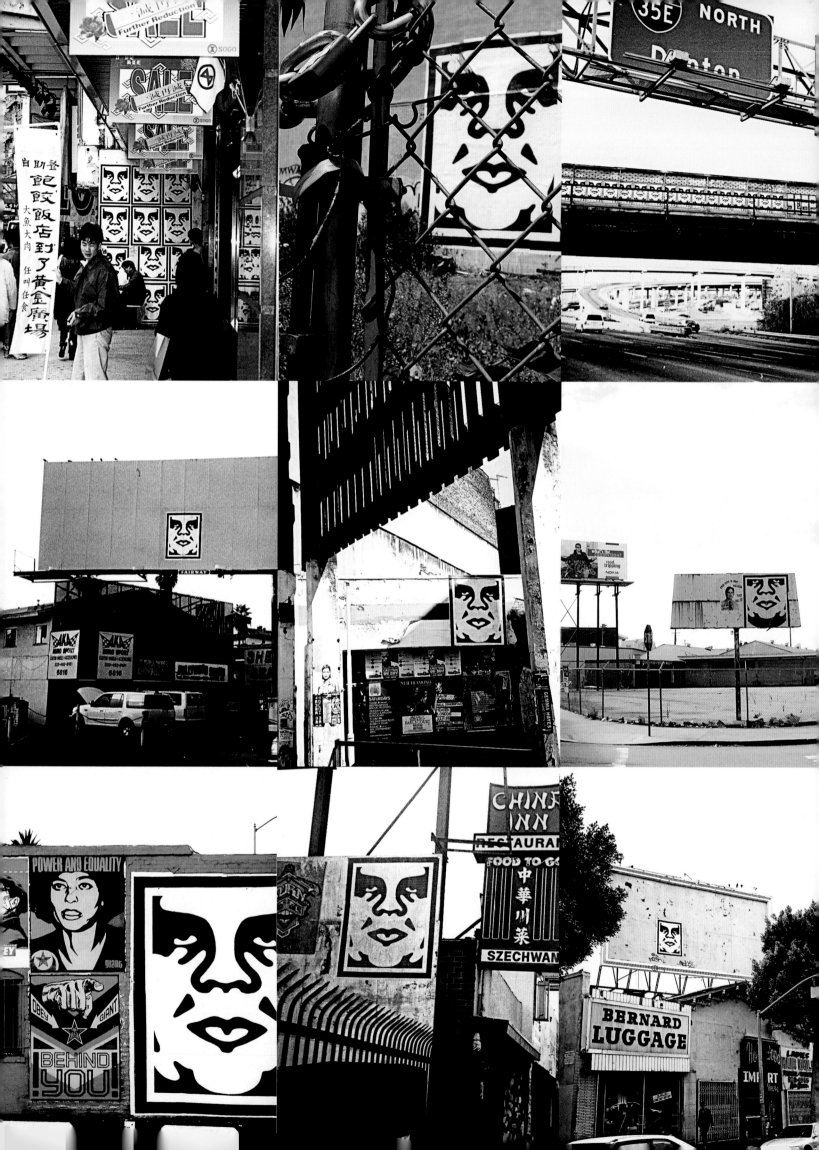

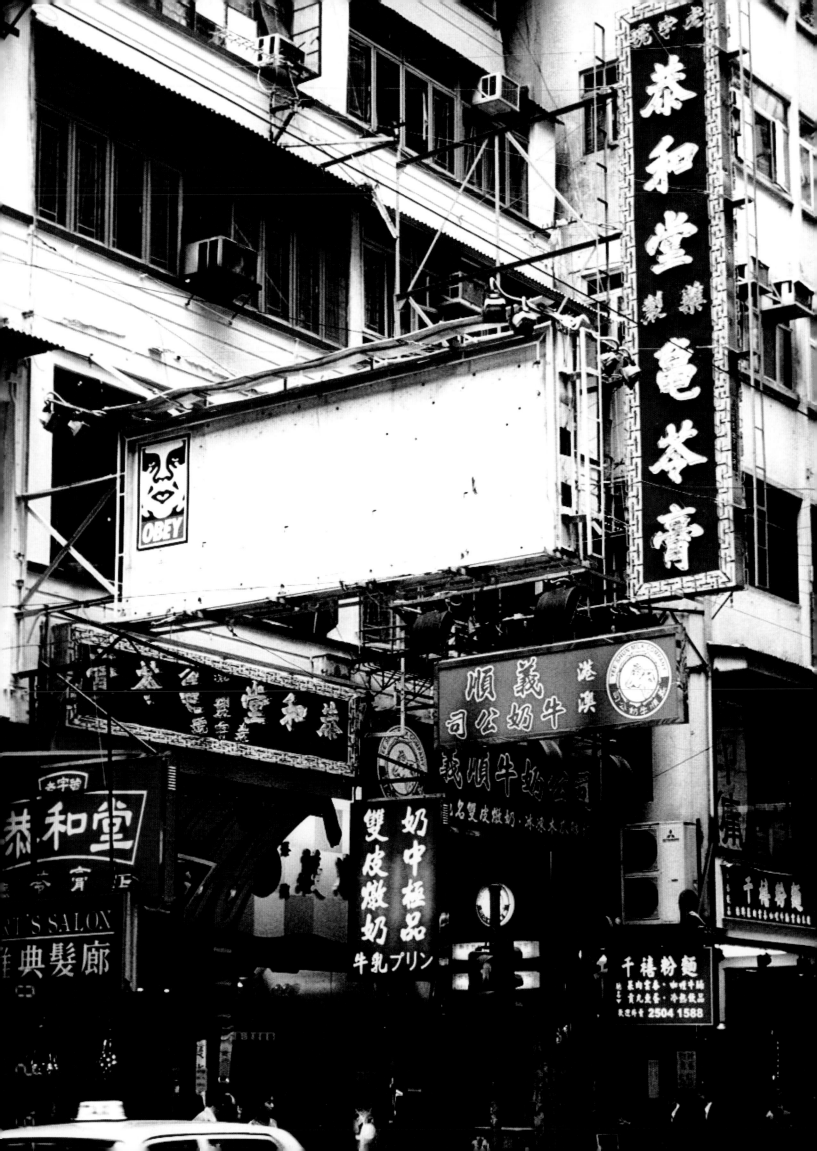

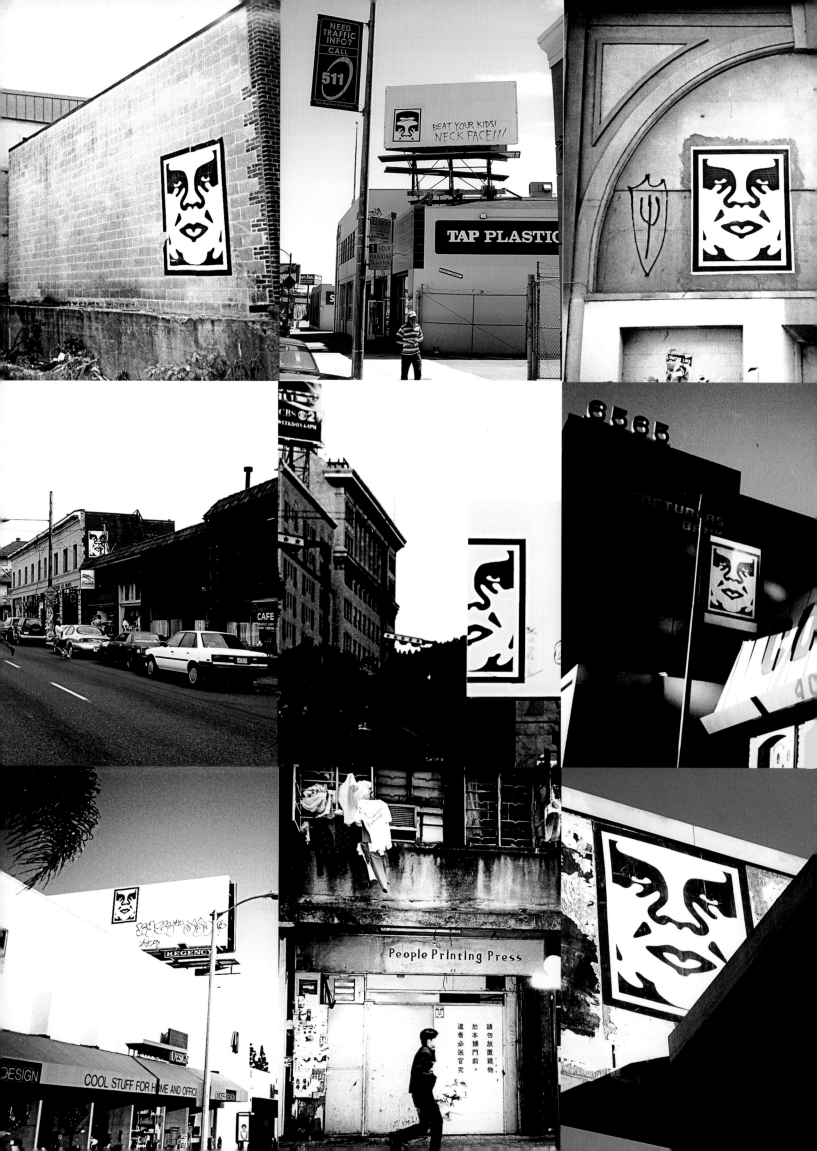

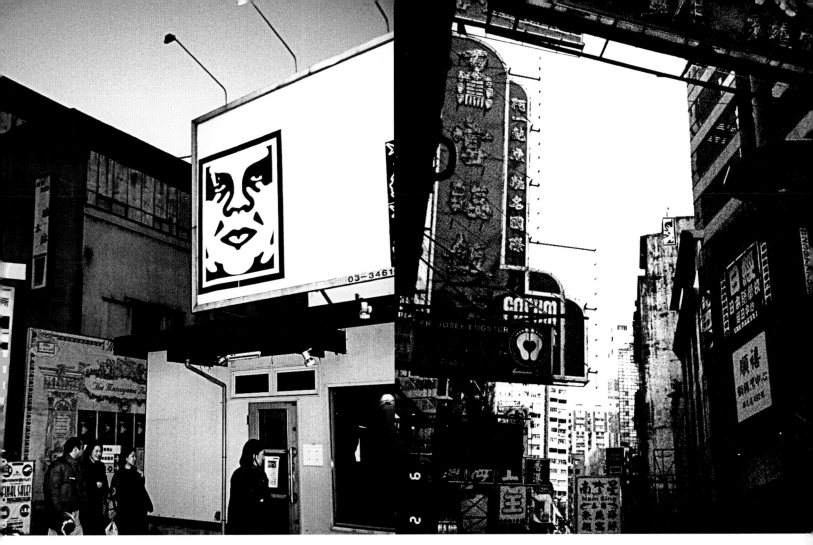

BELOW LEFT: This is in San Francisco, right off the Bay Bridge when you're coming in from Oakland. I've done the spot a couple times; the first time I did it, the guy called the cops and they surrounded the building. I was two stories up, and the only spot where I could get down was the far corner, where I had to jump five feet across to a light pole and then slide down the pole. I was staying a few blocks away, so I walked back to my friend's place and came back for my car later when the cops were gone.

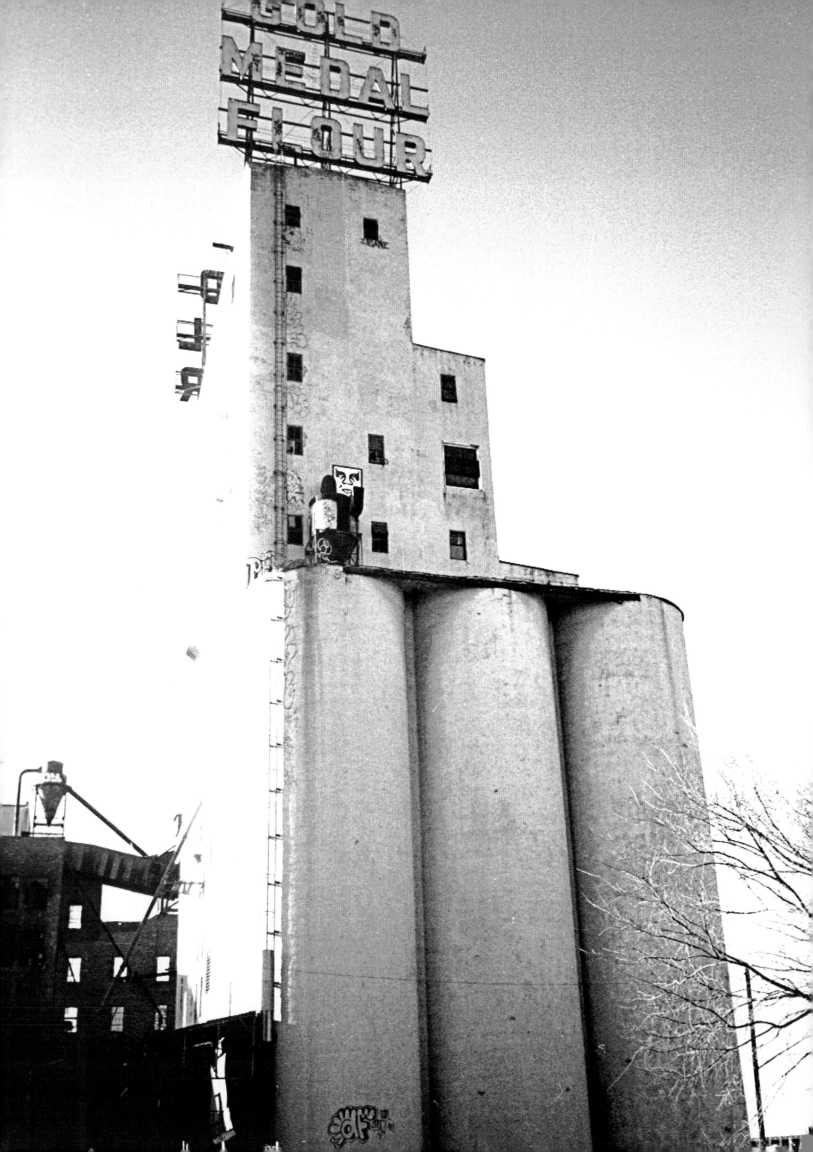

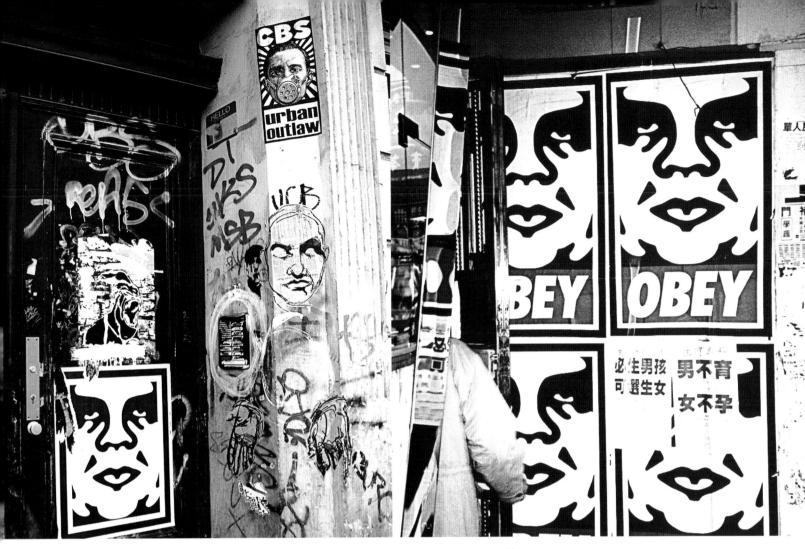

OPPOSITE: This is the Gold Medal Flour Building in Minneapolis, which has been restored into hipster lofts. It's a great spot right downtown, but the only way to get up there is a ladder on the outside of the building. I brought a 100-foot piece of rope, and when I got up to the top tier I lowered the rope to Amanda (my wife) so she could tie my bucket to it, and the rope was just barely long enough.

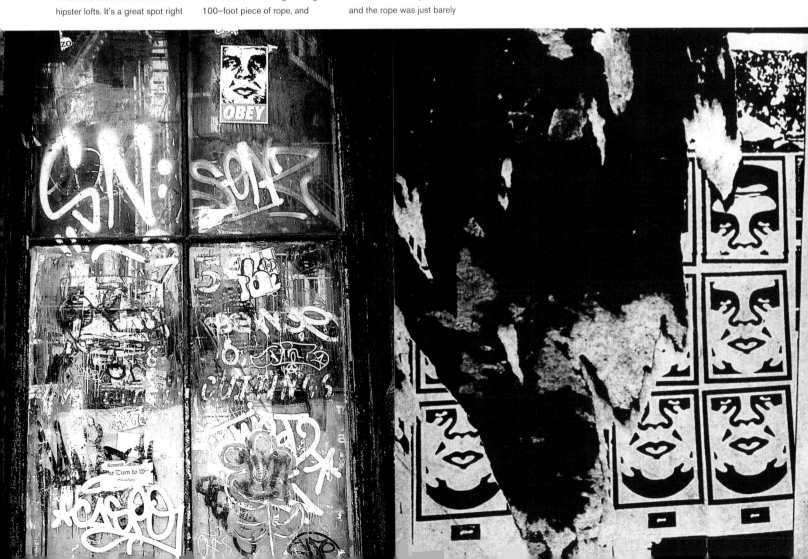

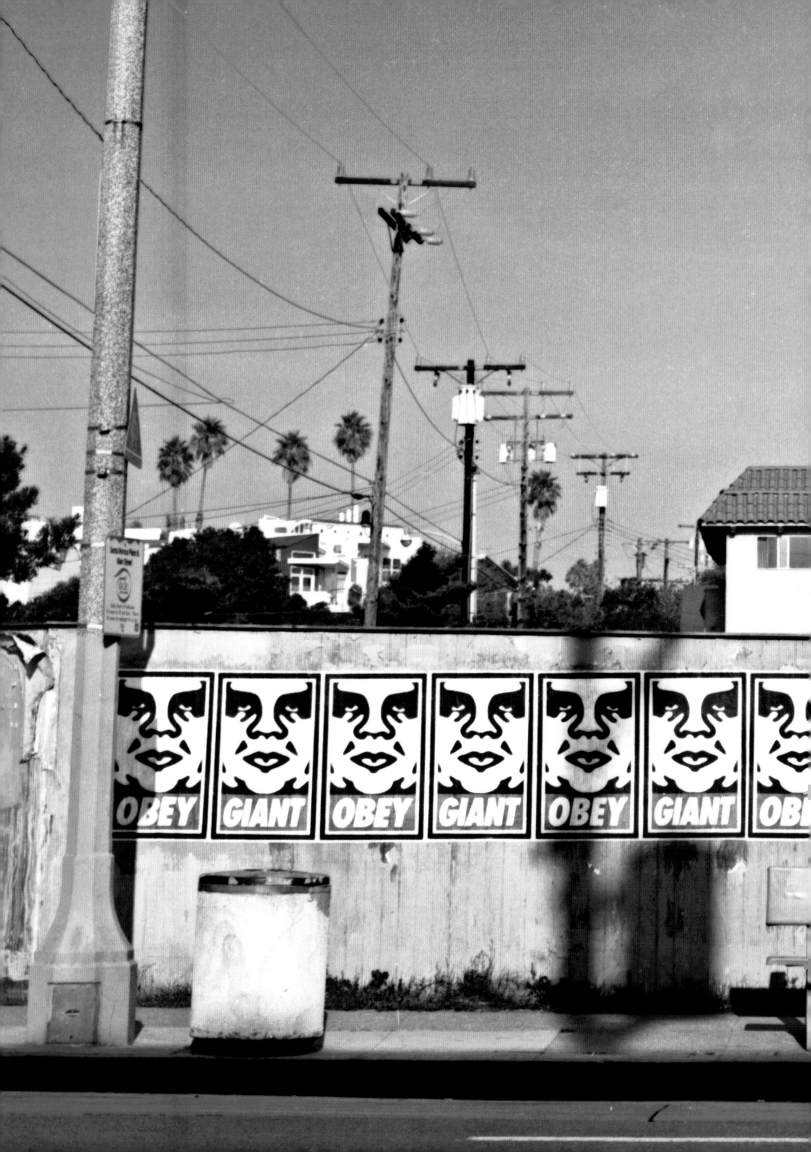

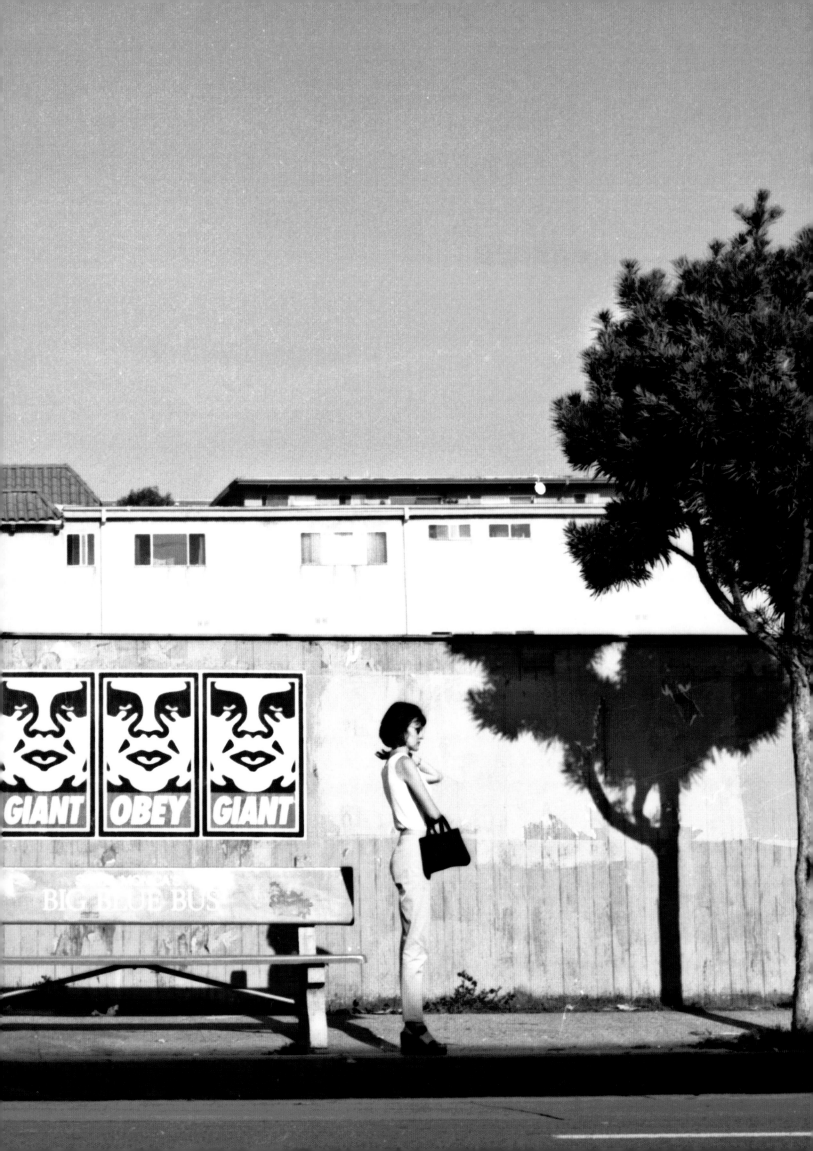

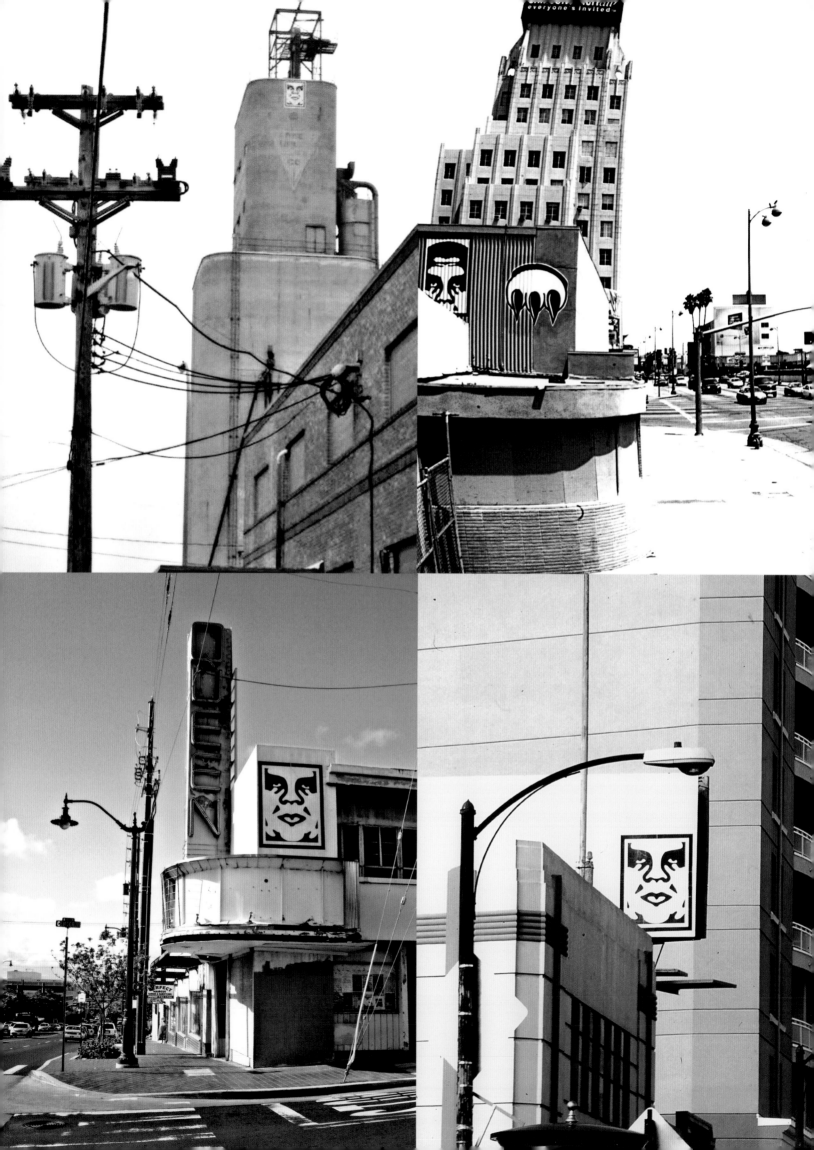

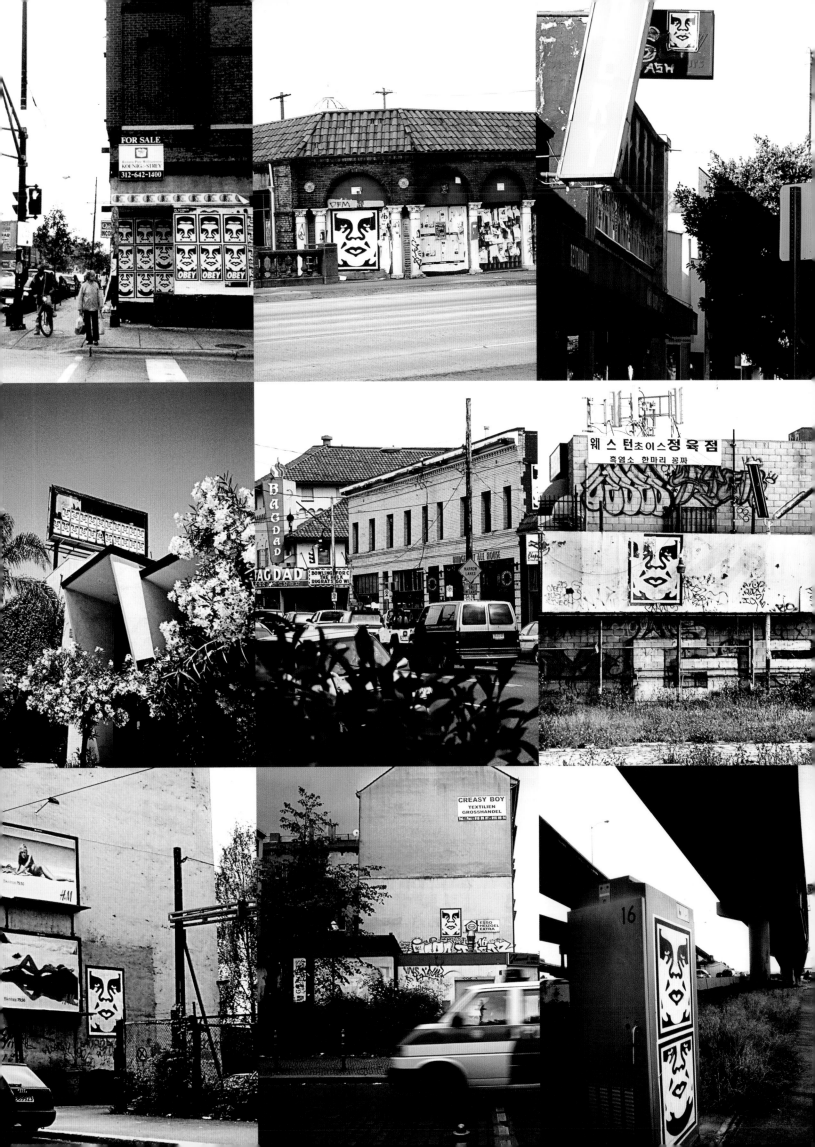

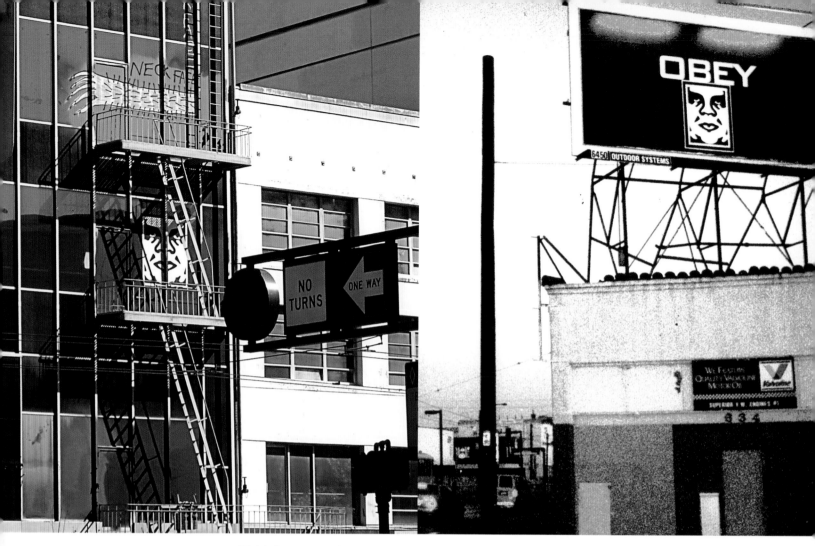

ABOVE RIGHT: This is in San Diego, the first Sprite billboard I did. It was right across the street from our office so I had to look at it every day, which prompted me to start subverting the Obey Your Thirst billboards. I ended up changing 13 of them: three in San Diego, seven in L.A., and three in San Francisco. A lot of people thought that Sprite took the slogan from me—they even used a typeface that I've used in my work—but that's not the case. Of course, they just made it all too convenient for me to take over.

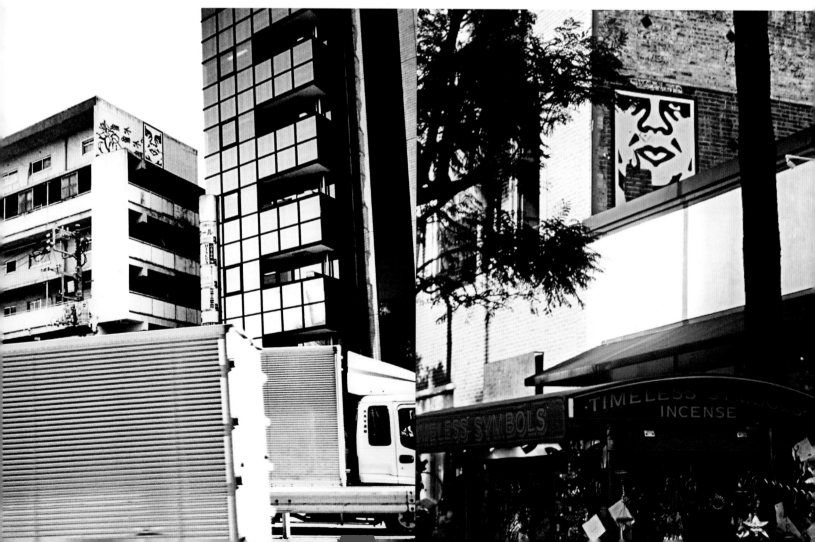

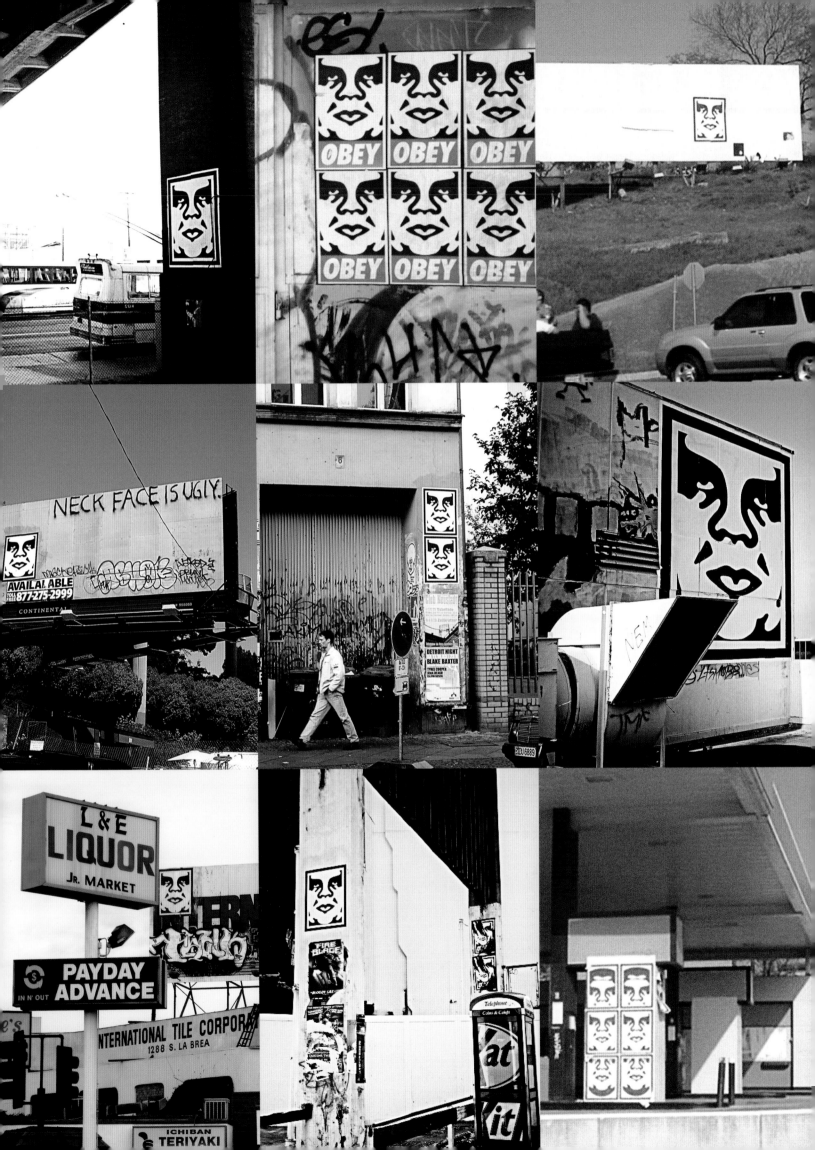

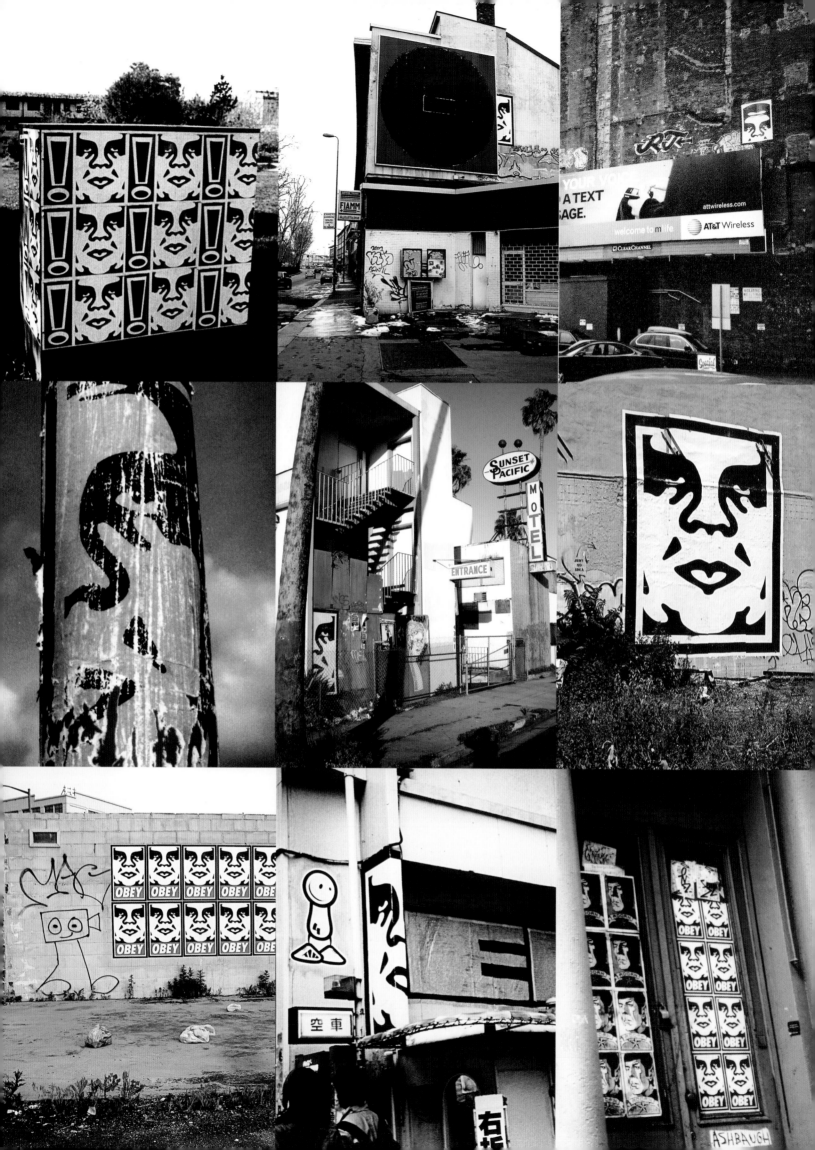

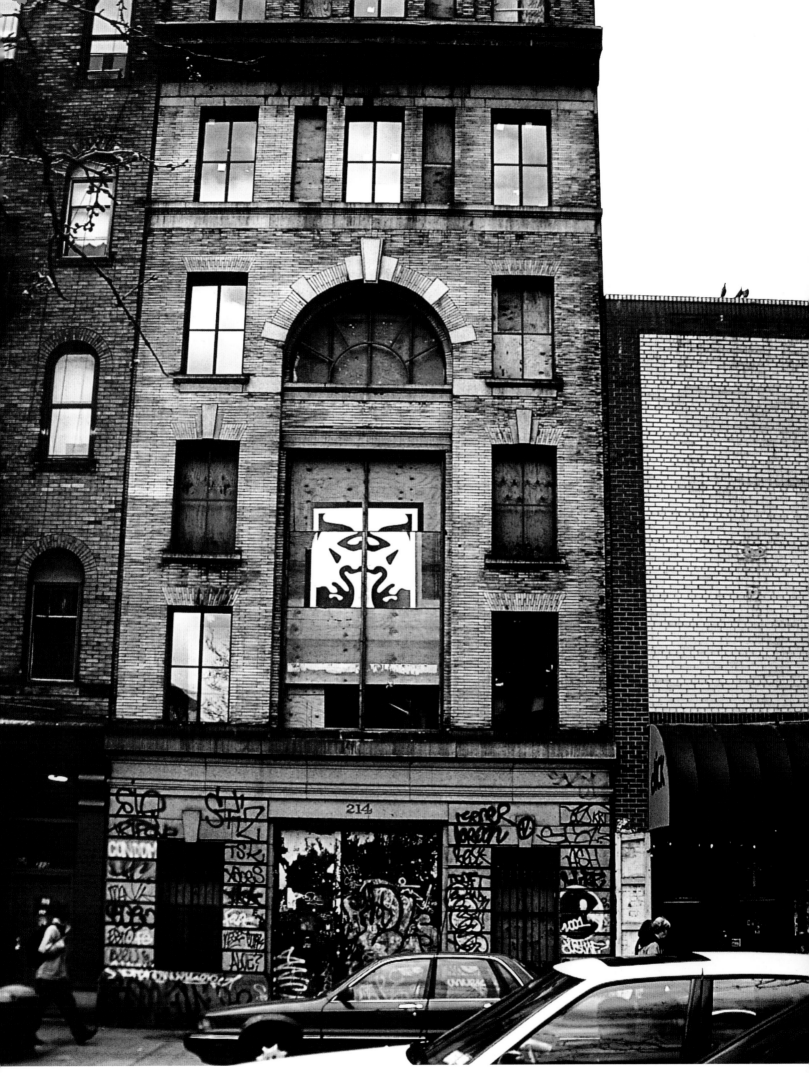

ABOVE: This is in New York on Lafayette Street. I was out bombing with my friend Eric, and we saw this great spot where there were some windows boarded up with four sheets of plywood. We didn't realize that the people who were working on those windows were taking the plywood down every day, so when we went back the next day to photograph it, the guys who were working there had put the plywood back up with the face upside down. The face stayed up for the duration of the construction project, and it was pretty neat to go by and see it arranged differently, like shifting puzzle pieces.

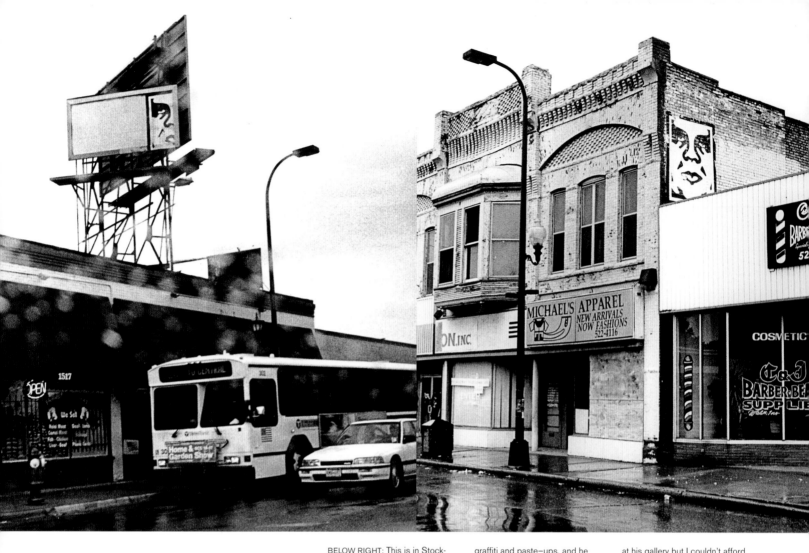

BELOW RIGHT: This is in Stockholm, where a guy called AK had a gallery called Laboratoriet. He's a street artist who had done some graffiti and paste-ups, and he was really the first person to crush a city with Obey stuff without me actually being there. I had a show at his gallery but I couldn't afford a plane ticket to make it out there, so I really appreciated that he was bombing on my behalf.

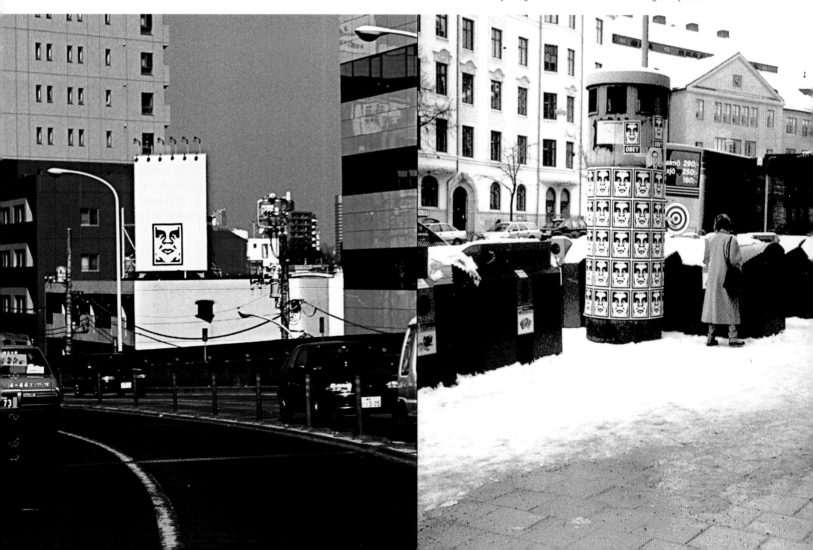

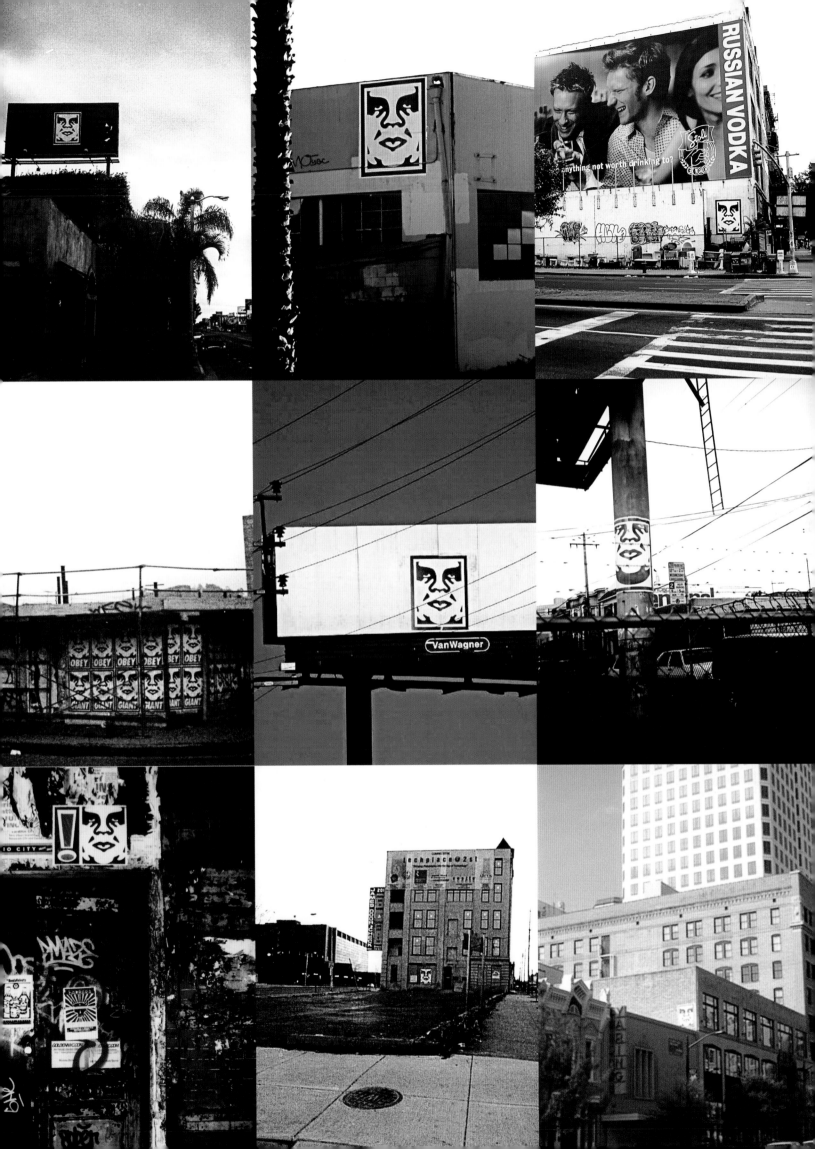

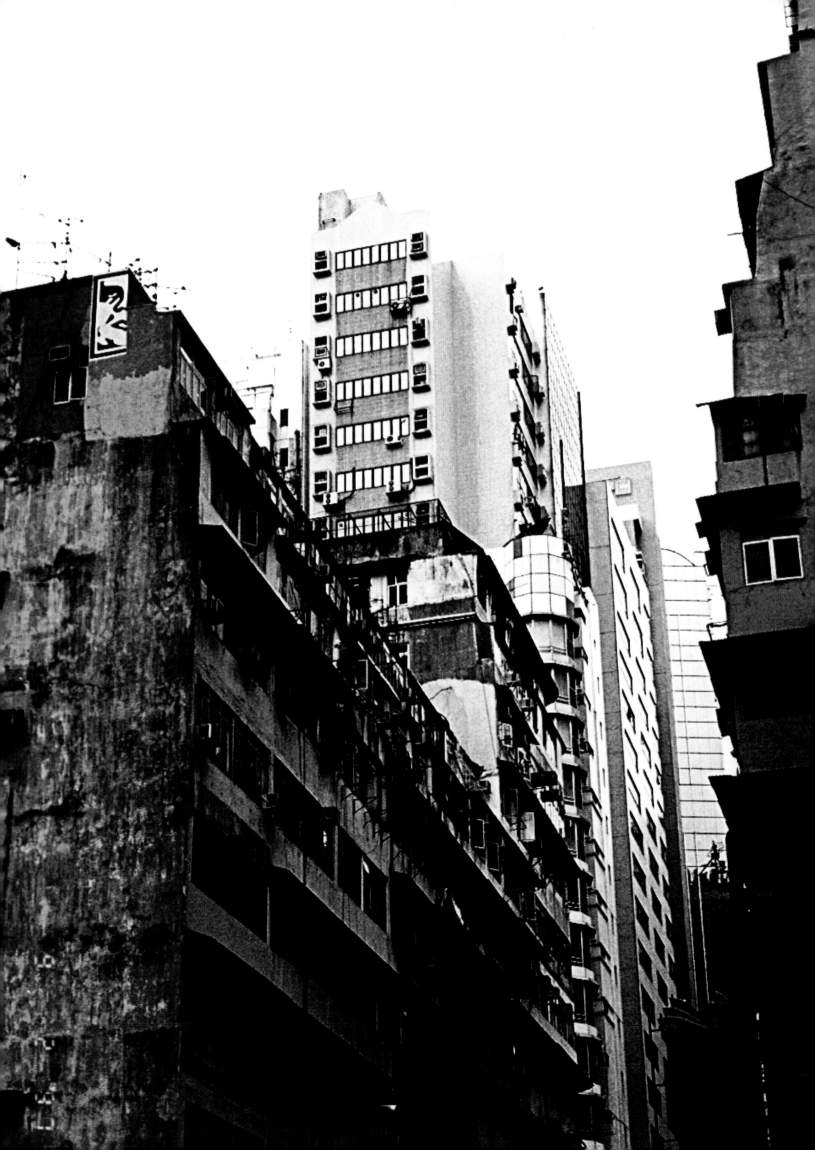

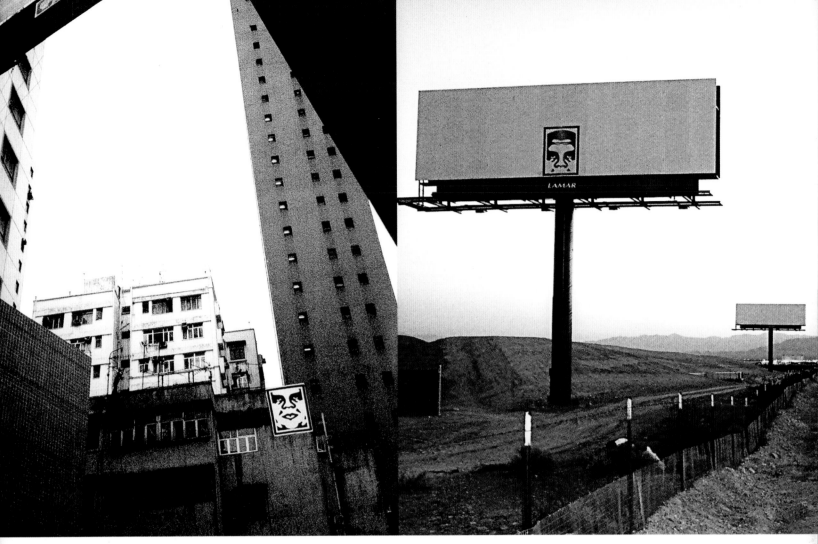

OPPOSITE: This spot is in Hong Kong, where almost all of the old buildings are walk–ups (no elevators) with the staircases on the side, so you can access all the rooftops just by walking up the stairs. Because Hong Kong is communist now, they employ everyone who would otherwise be unemployed as street cleaners, so everything at street level gets taken down. But if you hit stuff higher up, it will stay up for a while.

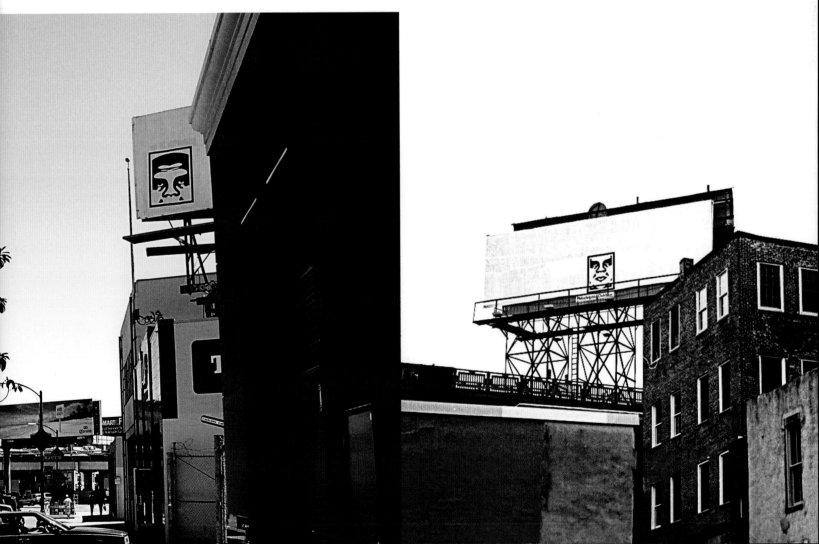

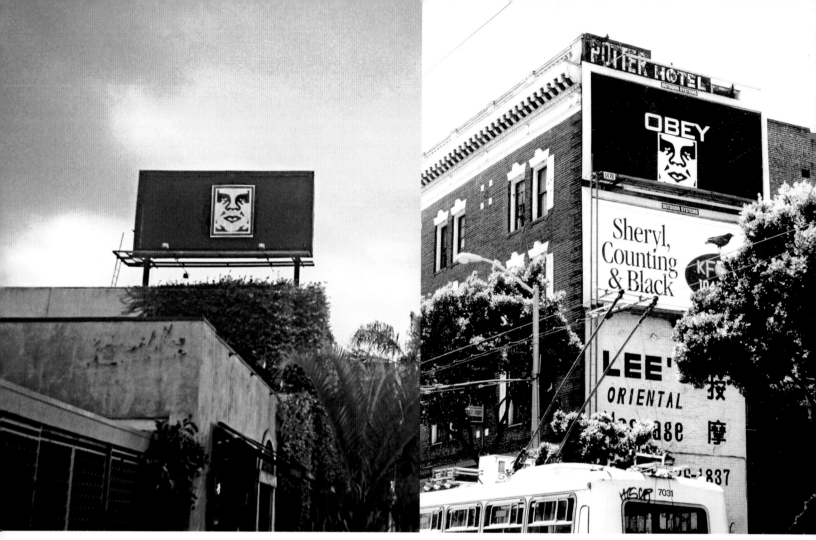

ABOVE RIGHT: This is on Mission Street in San Francisco; it had previously been a Sprite billboard that said "Obey Your Thirst" on a black background with a Sprite bottle on the right side. I had measured it so I could make an icon face that would fit between the word "Obey" and the bottom of the billboard. I went up there with black spray paint and sprayed out "Your Thirst" and the bottle. The billboard stayed up for four months, I guess because Sprite had rented it for four months, and the billboard guy never noticed it had been changed.

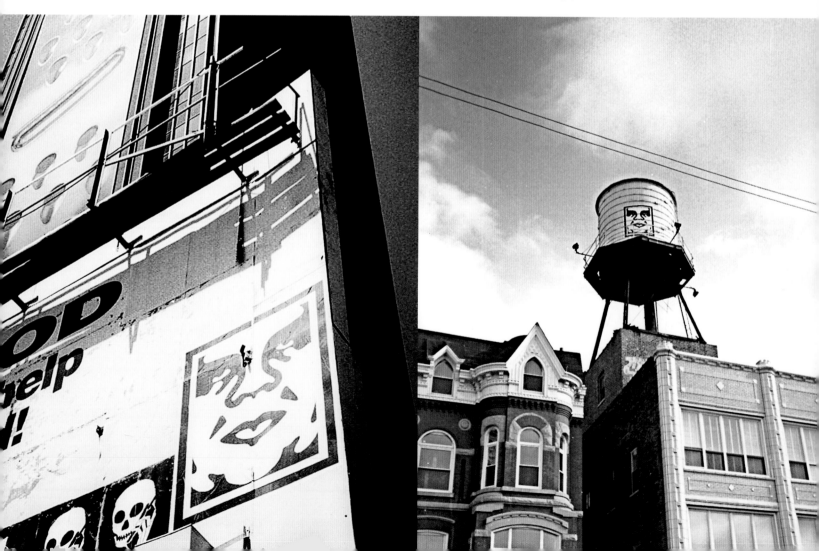

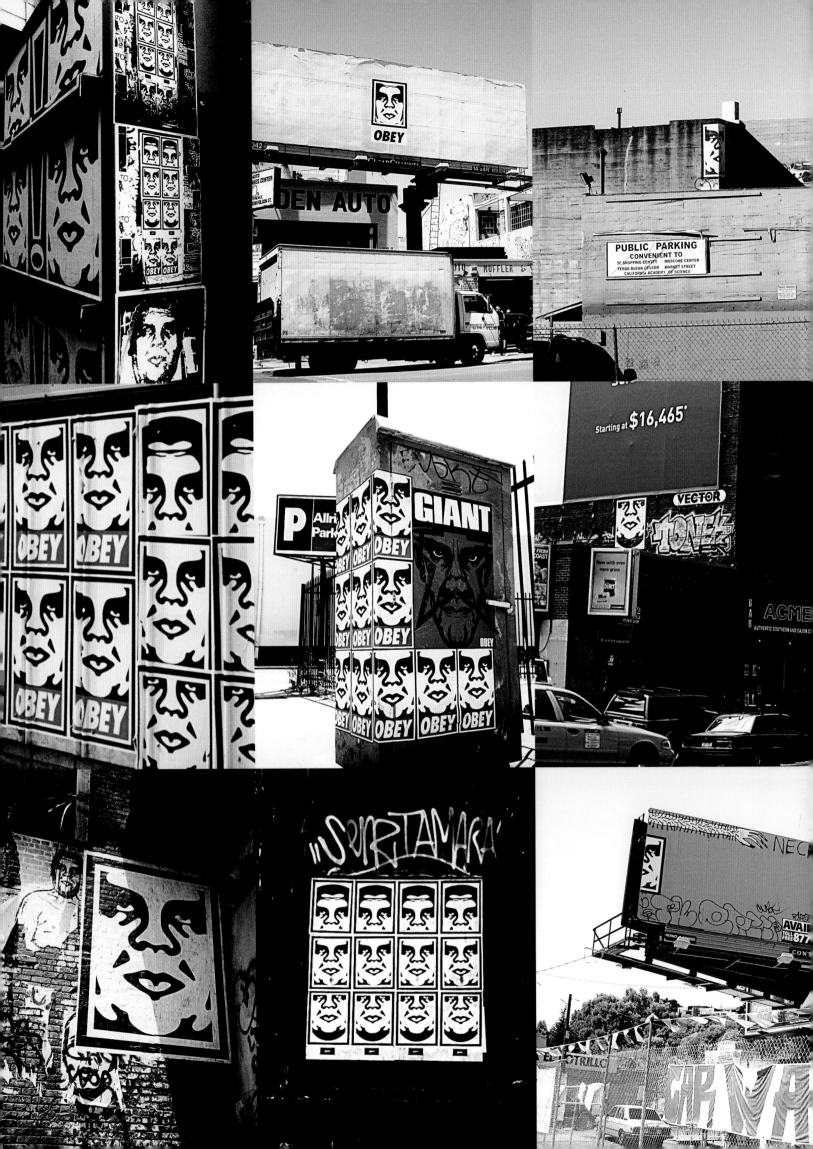

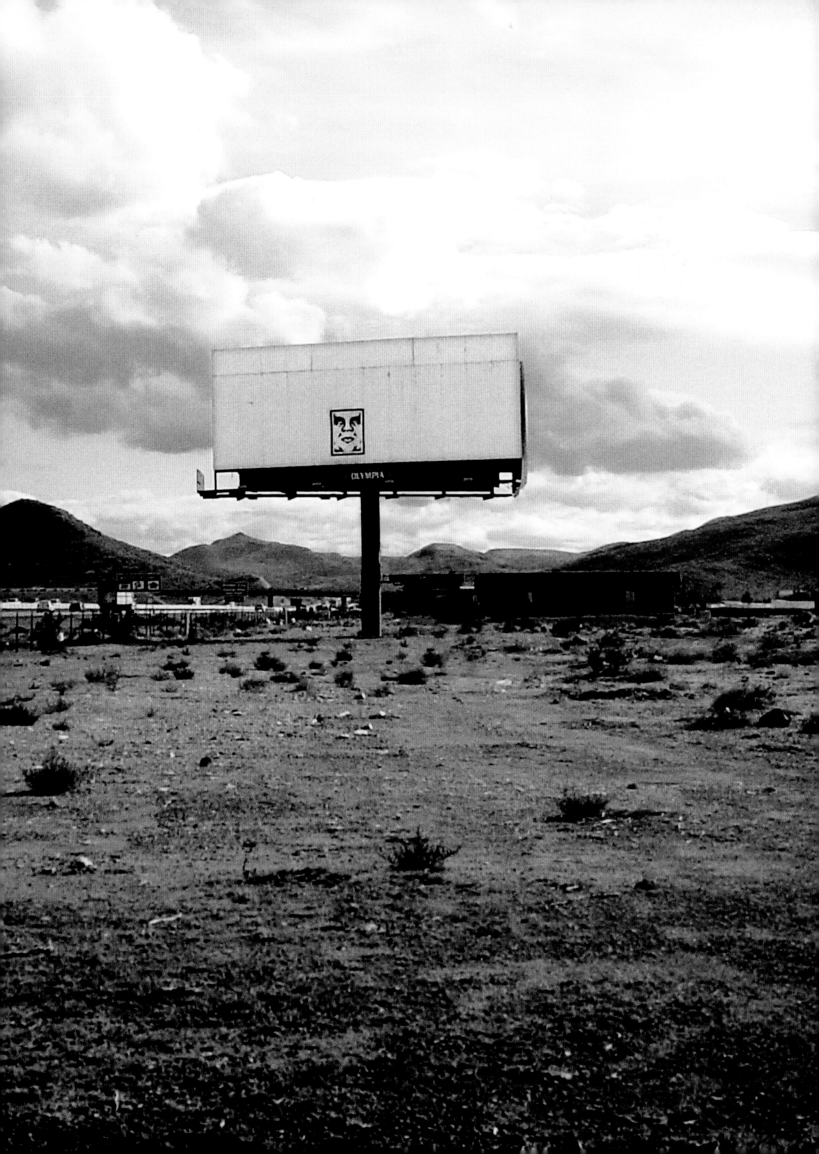

PROPAGANDA

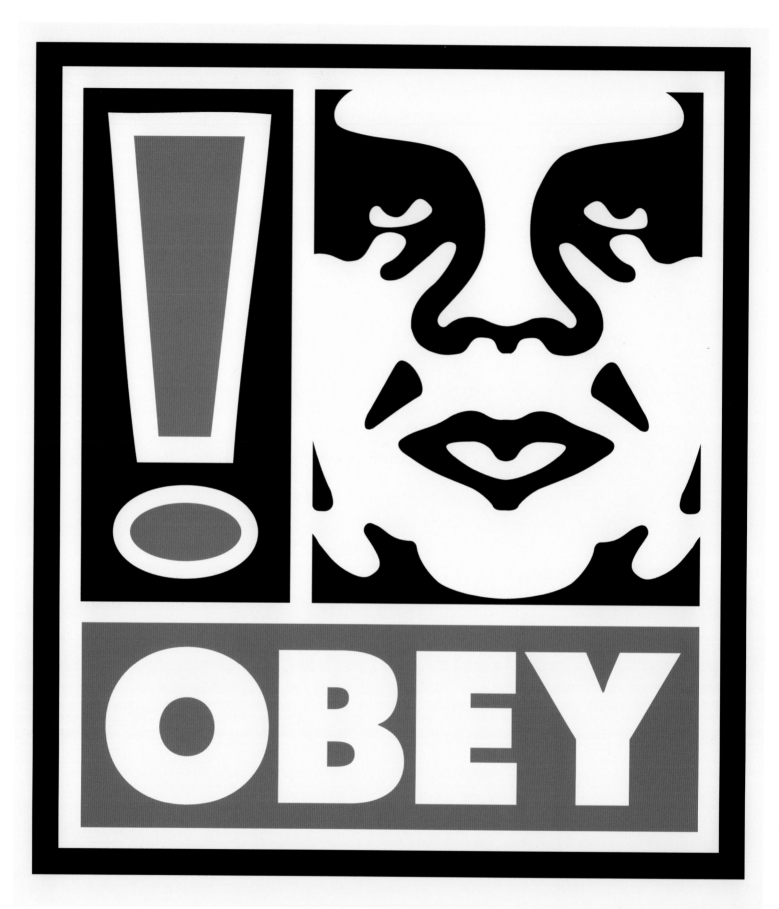

STILL OBEYING AFTER ALL THESE YEARS

Steven Heller interviews Shepard Fairey

HELLER: It's been 15 years since Obey Giant hit the radar screens and cata-pulted you into both design notoriety and entrepreneurial activity. Could you have imagined its impact when you began?

FAIREY: In 1989, when I first began the Obey Giant campaign, which was originally just a sticker that said "Andre the Giant has a Posse," I thought it would only be a few weeks of mischief. At first, I was only thinking about the response from my clique of art school and skateboard friends. The fact that a larger segment of the public would not only notice but investigate the unexplained appearance of the stickers was something I had not contemplated. When I started to see reactions and consider the sociological forces at work surrounding the use of public space and the insertion of a very eye–catch-ing but ambiguous image, I began to think there was the potential to create a phenomenon. At the time, I thought about all this in purely hypothetical terms because I didn't think I had the resources to create the kind of image saturation it would require to make it a reality anywhere other than Providence, Rhode Island. I became obsessed with the idea of spreading the image further and was surprised by how many people were willing to spread the stickers to other cities based on the template established in Providence or an explanation of the concept. I think a lot of people liked the idea of "fucking with the program" in a society d ominated by corporate imagery. The stickers were a rebellious wrench in the spokes, a disruption of the semiotics of consumption. Eventually, five years or so in, the stickers spread enough for national media to notice. I considered the coup successful at that point. Now that I make posters and t–shirts that are for sale, some people consider the entire project invalidated. I don't think a lot of people consider that it costs a lot of money to produce posters and stickers that are sacrificed to the street.

H: Obviously, RISD, where you went to art school, was a heady place and doubtless influenced your version of culture jamming, but were you politically motivated when you started producing Obey? Did you believe this would have political resonance?

F: Actually, I didn't look at Obey Giant as political at all at first. In college, I had been producing some work based on the concepts of abuse of authority, racism, and first–amendment rights. Though these works were cathartic, I realized the actual result was limited to me achieving greater status in the liberal club I was already a member of. I saw the political angle for Obey Giant as "the medium is the message." When something is illegally placed in the public right–of–way, the very act itself makes it political. My hope was that, in questioning what Obey Giant was about, the viewers would then begin to question all the images they were confronted with. I was very hesitant to

53. This is the first poster I ever made of the star image, designed around the concept of the star as an icon of Soviet propaganda, which is also why the whole face is red except for the eyes. After I created the streamlined Andre face, I cut out a star from a piece of paper and used the paper as a window to see how I could fit the face inside the star. The height and weight spelled out below mimics the Soviet propaganda style, where type becomes just a design element and it doesn't even matter what it says.

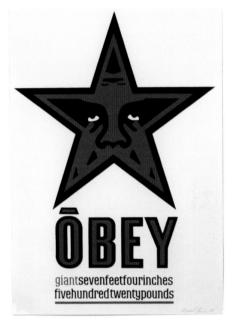

53.

54.

52. ***Obey Exclamation,*** 1996
(24.2 x 36.6") screen print on paper

53. ***Obey Star,*** 1996
(18 x 24") screen print on paper

54. ***Obey Star Graphic Mock–Up,*** 1996
(8 x 8") Xerox on paper

55. ***Giant Arrow (next page),*** 1996
(18 x 24") screen print on paper

56. ***Giant Orange (next page),*** 1996
(18 x 24") screen print on paper

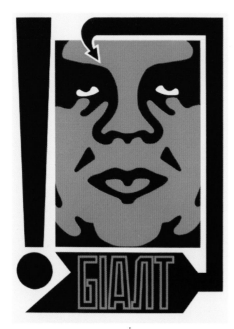

55.

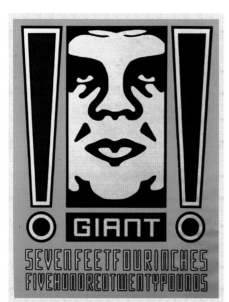

56.

make any literal political statements with my images, because I felt the mystery of the project elicited a variety of honest reactions that were a reflection of the viewer's personality in the same spirit as a Rorschach test. I also did and do not feel I have all the answers, though I do have opinions. I want people to question everything.

H: Part of the allure of Obey has been its ambiguity. There is an Orwellian quality in this Big Brother figure that is contrasted by the inherent humor in the goofy Andre visage. Do you feel that such ambiguity has served you well?

F: Yes, I do feel that the ambiguity of Obey has served me well. To get back to what I was saying before, all my didactic slogans and left–wing rhetoric would only be embraced by people who shared the same opinion, and be instantly rejected by anyone who saw it as issued by the enemy. Obey seemed to get under people's skin because they didn't know what to make of it. This ambiguity promoted a debate about the intent of Obey and got a lot of issues out on the table that people would not have discussed if they were able to classify and immediately ignore it. I think the Obey icon image finds a balance between goofy and creepy, humorous and monolithic. I consider the image the counterculture Big Brother. I'd like to think of it as a sign or symbol that people are watching Big Brother as well. I've had people, ranging from anarchists to the president of the National Reserve Bank, embrace my work, and I think the more diverse the audience is, the more potential for interesting dialogue there is.

H: Why did you become an active—and illegal—wild poster?

F: I became active as a street artist because I felt public space was the only option for free speech and expression without bureaucracy. The Internet was not developed at the time I started, and though it does level the playing field for some things, it still filters out those who do not own a computer. I also didn't really consider what I was doing art, and considered the art galleries too elitist anyway. I also found the whole idea that you could be arrested for stickering or postering as something I wanted to rebel against. In my opinion, the taxpayers are the bosses of the government. I'm a taxpayer: why can't I use public space for my imagery when corporations can use it for theirs? I was baffled by the idea that companies could stick thousands of images in front of people as long as they were paid ads, but that I couldn't put my work in the street without being told that it's an eyesore or creates a glut. For the most part, I think the merchants and the city governments don't want the public to realize there can be other images coexisting with advertising. This is the exact example I'm trying to provide.

H: How do you determine what to attack with your posters and stickers, and on what venues they will appear (or deface)?

F: I use common sense. As a taxpayer, I feel that public property is fair game as long as I'm not covering text on street signs. I use the backs of signs, electrical boxes, and crosswalk boxes. I try to be as respectful to private property as possible. I mostly only hit private property if it's abandoned or boarded up. If a building has a lot of graffiti on it already then I might hit it. Unfortunately,

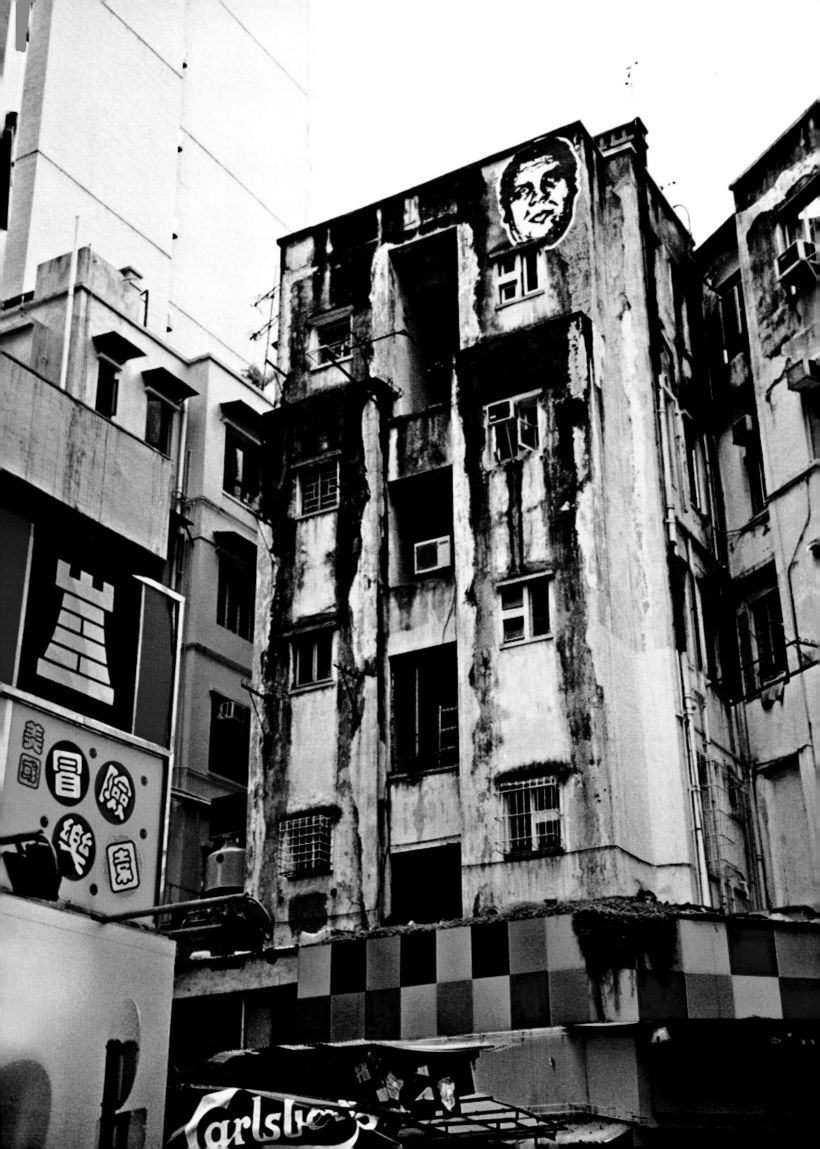

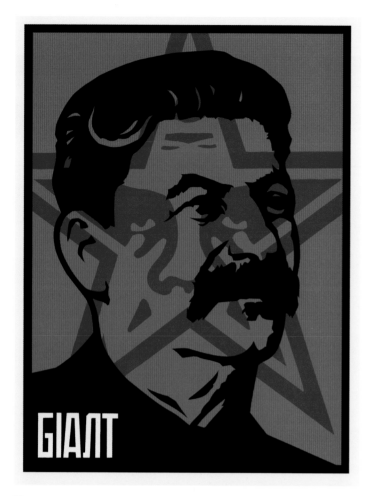

57.

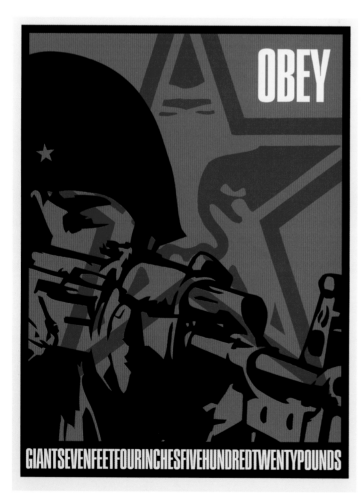

GIANTSEVENFEETFOURINCHESFIVEHUNDREDTWENTYPOUNDS

58.

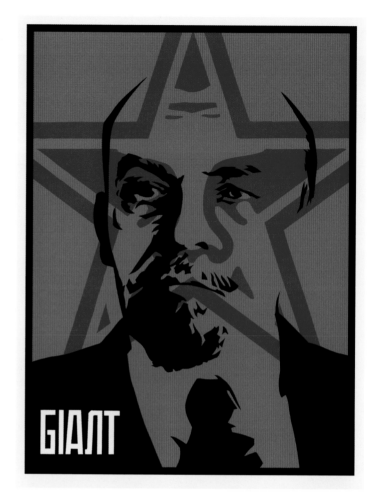

59.

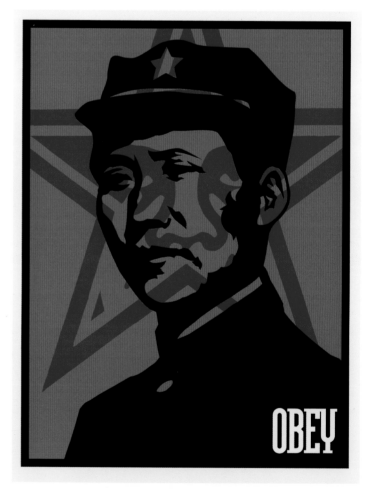

60.

the cities are usually more aggressive about prosecuting art on public property than private, which often pushes graffiti artists to hit things like storefronts. I don't approve of this, but I understand why many artists have been pushed in this direction. My opinion about street art is the same as free speech: I'd rather hear or see the occasional thing I was offended by than not have the right to express myself in a way that others might find offensive. I have experienced that there is a silent majority of people who are more open–minded about street art than public policy would suggest.

H: Speaking of ambiguity, how do you reconcile your business, which counts some big corporations as clients, with your wild snipping? Is this the Robin Hood effect?

F: Yes, I would consider my inside/outside strategy toward corporations some-what of a Robin Hood effect: I use their money, which becomes my money, to produce stickers, posters, stencils, etc. This strategy was, however, the result of my acceptance of the reality of things. One of the most jarring realizations this project has brought about for me is the complete inevitability of sup-ply–and–demand economics in a capitalist society. I will explain, but I must also emphasize that I believe in capitalism with some checks to chill out the evil, greedy element. Capitalism is a way for hard work to yield rewards. When I first started Obey Giant I owned a screen–printing shop, and used that equip-ment to produce my own work as well as doing work for paying customers. Printing is a difficult business, and I got frustrated with it. I work as a graphic designer these days, which came about because the work I was putting on the street created enough of a buzz that companies began to feel it would resonate enough to be used for marketing. I had created a demand for my style of work that meant that if it was not supplied to the corporations by me, it would be supplied by other hungry designers. I decided that in doing graphic design I could keep my design skills honed and make enough money to pump even more Obey Giant materials out in public, which I consider truly subversive. This method of financing my campaign also keeps me from having the content of Obey dictated by fine–art market forces. Plus, I've been able to convince some of the corporations to invest in the cultures they try to exploit, helping to create a more symbiotic relationship between the creators and harvesters of cul-ture. It's not an easy game, but I'm making the best of life without a trust fund.

H: As one weaned during the '60s (which makes me a weanie), I have long been sensitive to the notion of "selling out" and of "being co–opted" by profiteers. By running your own business, you control how much you're being co–opted, but for you what is the definition—or line in the sand—of selling out?

F: To me, selling out is doing things purely for the money without concern for the consequences to integrity. Let's face it though: money is freedom. For some, it's freedom to buy cocaine and cars. For me, my design earnings give me free-dom to produce my propaganda work and travel to other cities to put it up. It also gives me freedom to keep an art gallery open that's never profitable. People often accuse anyone who does not fulfill their image of "fine artist as suffering martyr" of being a sell-out. After 10 arrests and getting physically assaulted by the cops and deprived of my insulin on several occasions (I'm diabetic), I can

59. This portrait of Lenin was the first image where I tonally super-imposed the Obey star behind a portrait so that the two lined up, and it actually works really well, where you almost feel like the star is part of the Lenin portrait. The power of suggestion, once the two are superimposed over each other, is just another form of manipulation: after a lot of people saw this poster, they assumed that the Obey star was an original aspect of the Lenin portrait. Part of what I'm trying to do is get people to question their assumptions. Since they make assumptions through associations, I try to cre-ate new associations incongruous with those assumptions.

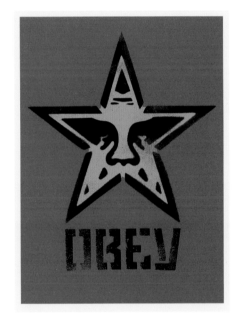

61.

57. **Giant Stalin,** 1998
(18 x 24") screen print on paper

58. **Obey Korean Soldier,** 1998
(18 x 24") screen print on paper

59. **Giant Lenin,** 1997
(18 x 24") screen print on paper

60. **Obey Mao,** 1997
(18 x 24") screen print on paper

61. **Obey Star Stencil,** 1998
(18 x 24") screen print on paper

tell you that it is very possible to make money and be a suffering martyr!

H: I know you put your body where your work is, and have been busted by police in a few cities for your contraband activities. This is admirable, but I have to ask: is it worth it? In other words, do you feel that there is a quantifiable result? And if so, what is that?

F: To get back to the martyrdom issue, I spend the money and take the risks I do because I want to, and I don't feel that anyone owes me anything. I do feel sorry for myself when I'm sitting in jail, but overall I feel it's all very worth it. I feel it's worth it because of the positive feedback I have received from people. Many people feel powerless, and my goal is to show that one person can have an effect on things even with limited resources. Whether this manifests itself with people in the form of street art or a magazine or a band, I'm hoping to encourage DIY ethics. These things are hard to quantify until they pass the tipping point, but I've seen satisfying results.

H: So, after so much "brand" exposure for Obey, do you feel it still has legs, or has it run its course? Is it time for other approaches or does it still get results?

F: I do still think Obey has legs, but the longer it's out there and the more popular it gets, the more it becomes absorbed into the dominant paradigm, even if it's fighting the whole way. In some ways, Obey can run parallel to the system, utilizing aspects and subverting others, but eventually its familiarity will render it impotent – it will become wallpaper. There are examples of how this has already been demonstrated. I was regarded as a vandal when I was living in Providence, but I was recently asked to be in a museum show of "Rhode Island treasures." People have also told me how they felt comforted by signs of subculture when they traveled to a conservative place and saw my stickers existing there.

H: Currently, you are producing more decidedly overt political messages. Is the coming election and the increasingly mucked–up war in Iraq your inspiration? Can Obey, which certainly sounds like it could be the current administration's mantra, function in this environment? Or have you decided that a more polemical route is a better strategy?

F: I actually have always thought that the command to "obey" would cause people to do the exact opposite, or at least question obedience. A lot of my work, even before the Bush administration, has dealt with dictators and the consequences of the public giving them their obedience. The funny thing is that the people who have reacted most violently towards the dictator images are the people most like them – it's like their cover has been blown or something. Most people seem to intuitively get that my project involves a lot of questioning authority. The reason that I have become more direct and overtly political is that I feel we are in a time of a crisis and there's no time to be wasted allowing people to have epiphanies about authority, conspicuous consumption, and the control of public space at the rate that best suits them. I hate behaving like a paternalist, but I feel it is my only choice right now. I have an audience that listens to me already and plenty of other people to reach, who, for the sake of the future of the planet, I hope I can convince not to elect Bush.

(continued on page 97)

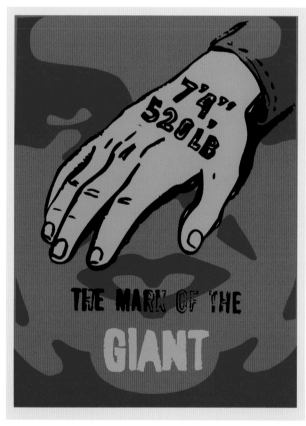

62.

63. The Che Guevara photo, taken by Alberto Korda in 1960, is probably the most clichéd image of rebellion worldwide. I stole it not so much to endorse what Che was about or what he did, but to demonstrate that symbols become easy to manipulate after they have a life beyond their real history. I see lots of kids with Che t–shirts who probably know nothing about him besides his rebel status. I tried to capture some of the essence of the original Che photograph, but it's clearly not Che's face – it's Andre the Giant's face. After this picture sat in the window of a San Diego art gallery for three months, a clerk across the street pointed at my Andre icon face t–shirt and exclaimed, "Che Guevara! I too am a fan of Che Guevara." It just shows how people's memory can be reconditioned through imagery.

62. **Mark of the Giant,** 1997
(18 x 24") screen print on paper

63. **Gigante,** 1997
(18 x 24") screen print on paper

63.

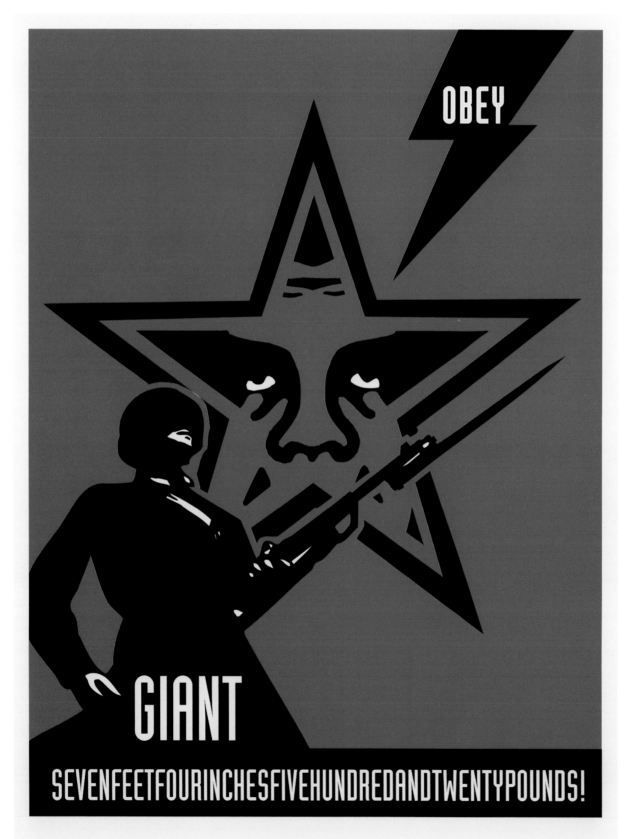

edge this is a short–term solution, and my goal is to get people to scrutinize things so in the future people like Bush could not thrive because people would not fall for their fear tactics. I'll probably continue to make posters like "More Militerry Less Skools" because that's not attacking anyone specific but a mentality. Attacking individuals is playing catch–up. I'm more into preventative medicine. The two–party system is flawed, but then again, I don't know how to fix the country. I think the constitution has some good ideas in it, and questioning creative reinterpretation of it could be a good place to start. We've got some *Animal Farm*–meets–*1984* shenanigans going on right now.

Steven Heller is art director of the New York Times Book Review *and co–chair of the MFA/Design Program at the School of Visual Arts. He has written and co–authored over 80 books on graphic design and popular art. In 1999, he received the AIGA Medal.*

66.

65.

64. **Soldier Star,** 1997
(18 x 24") screen print on paper

65. **Obey Blackaon Black,** 1996
(18 x 24") screen print on paper

66. **Obey Chinese Soldier,** 1997
(18 x 24") screen print on paper

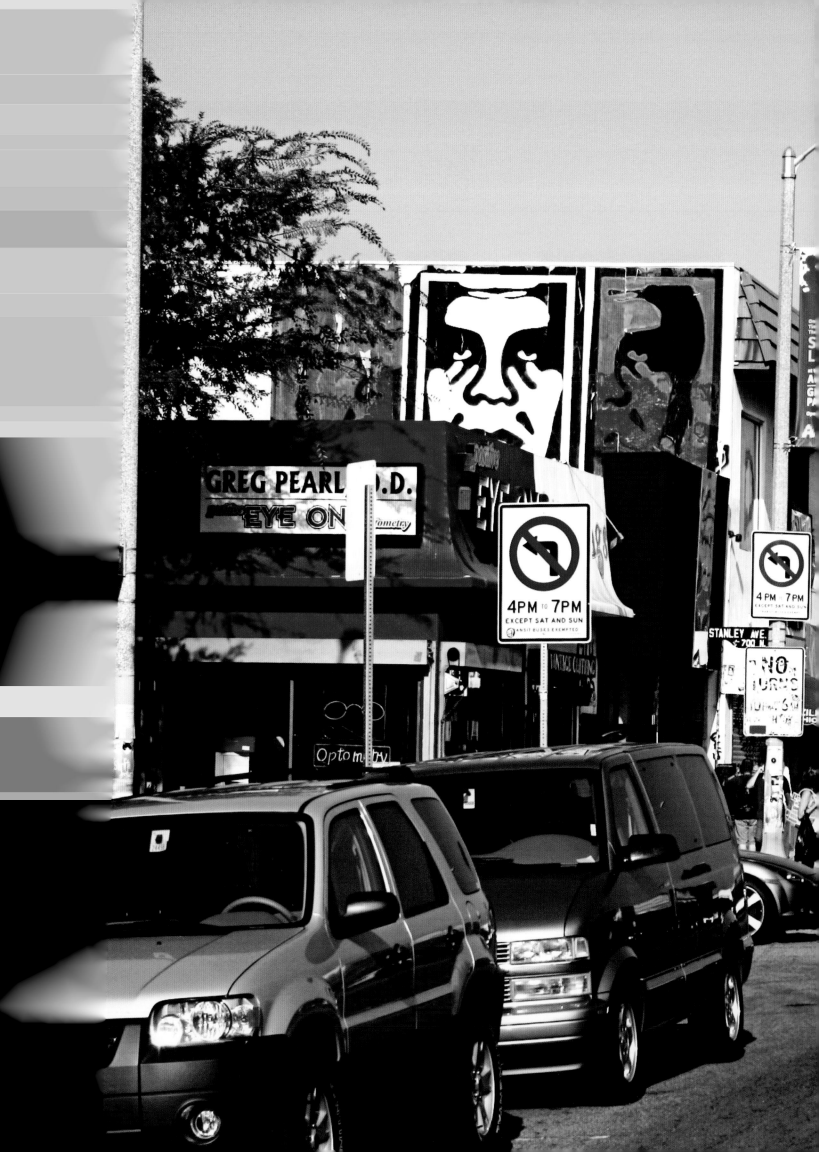

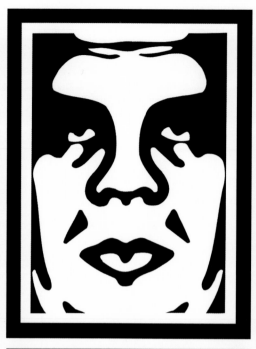

67.

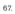

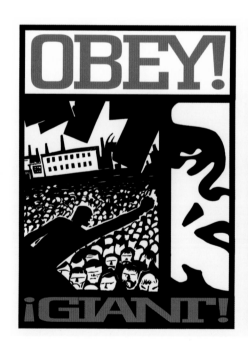

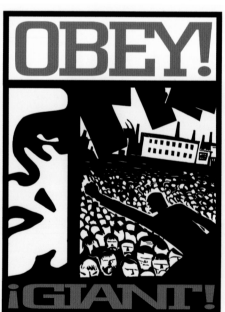

68. 69.

67. *Obey 3 Face Horizontal,*
1996 (24 x 18") screen print on paper

68. *Giant Crowd Left,* 1998
(18 x 24") screen print on paper

69. *Giant Crowd Right,* 1998
(18 x 24") screen print on paper

70. *Giant Leninist,* 1996
(18 x 24") screen print on paper

68, 69. For the propaganda series, I wanted to create symmetrical images that could be spread across two posters horizontally. Since I could only print 18 x 24" images by hand, I wanted to make larger images—diptychs—that could cover more space. It also saved money, because I could make just one piece of film for the image, print it, then flip the film for the mirror image but cut out the type so it wouldn't read backwards. Essentially, I got two posters for the price of one.

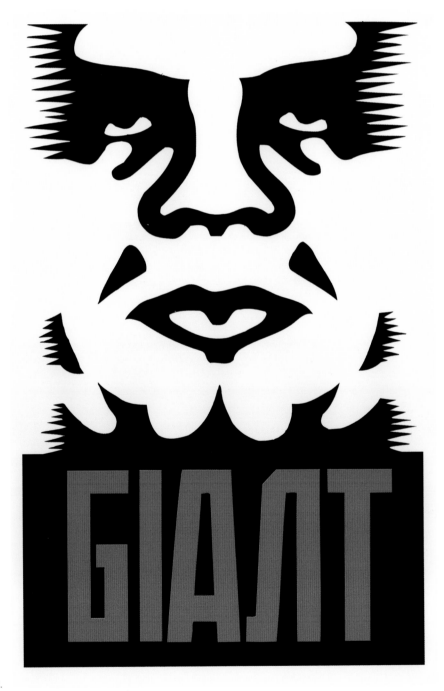

71. *(next page) AK–47 left,* 1998
(18 x 24") screen print on paper

72. *(next page) AK–47 right,* 1998
(18 x 24") screen print on paper

70.

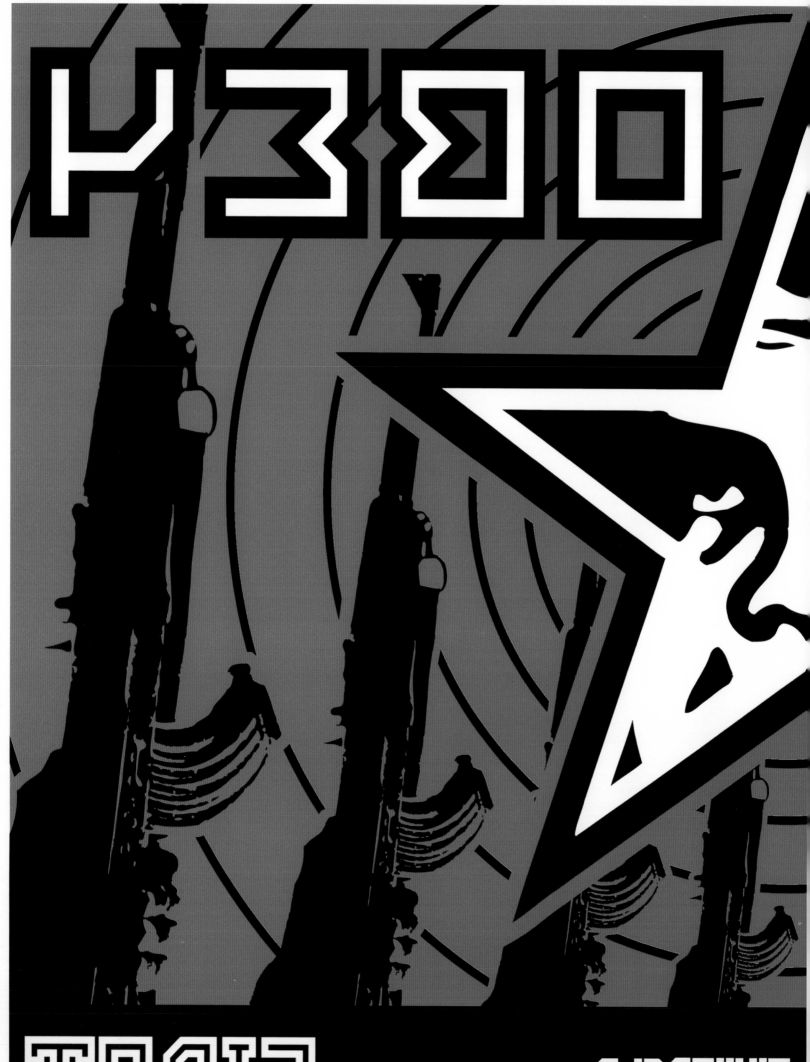

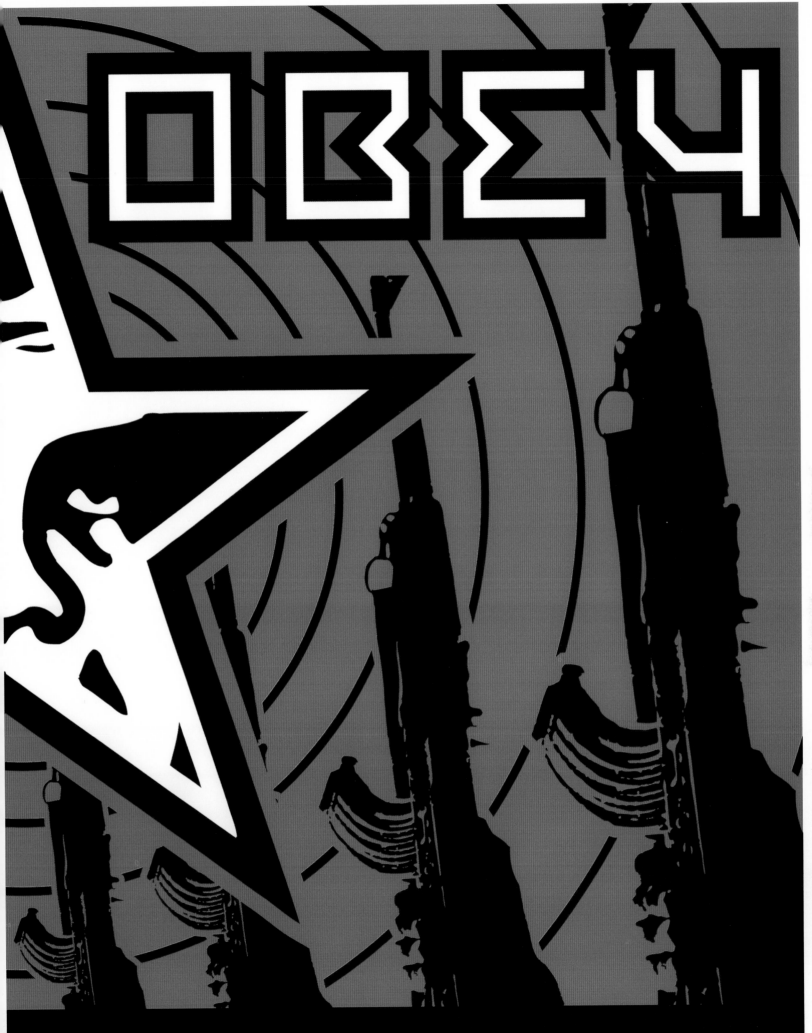

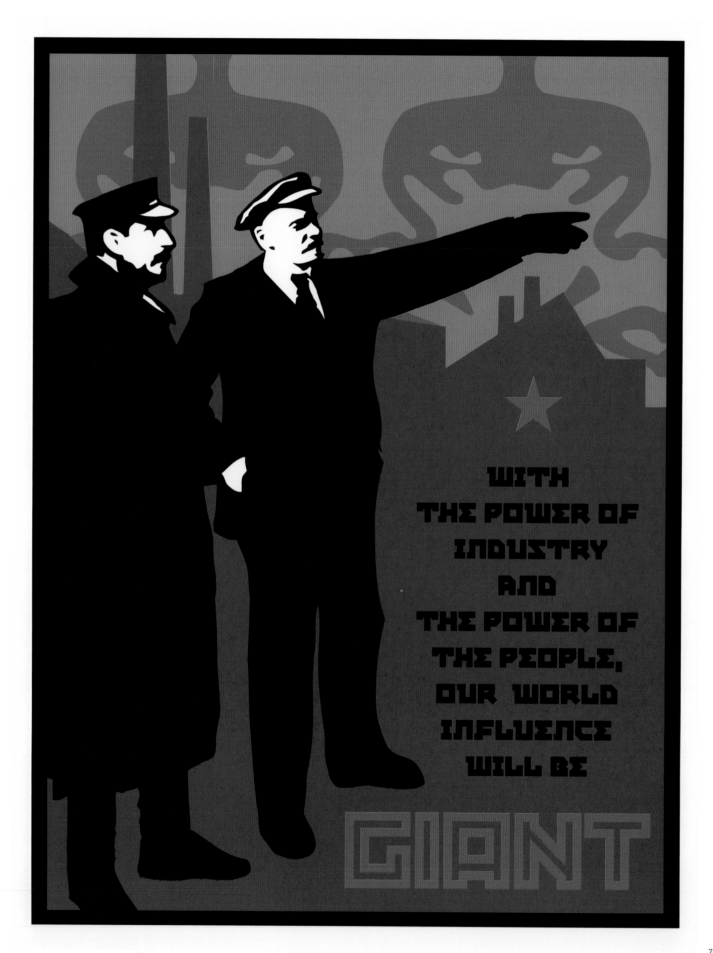

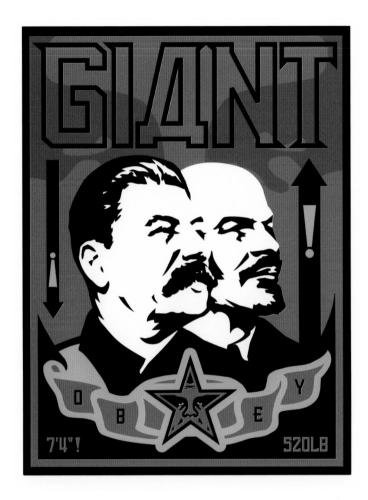

74

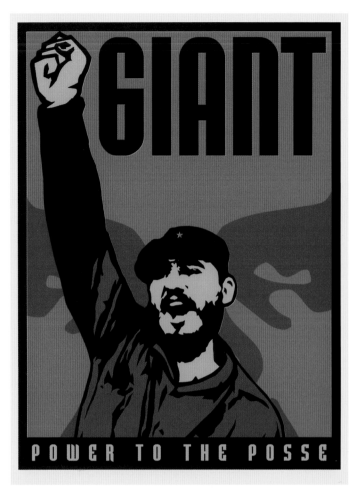

75.

73. **World Influence,** 1998
(18 x 24") screen print on paper

74. **Stalin Lenin Banner,** 1998
(18 x 24") screen print on paper

75. **Castro,** 1998
(18 x 24") screen print on paper

76. **Obey Metropolis,** 2001
(18 x 24") screen print on paper

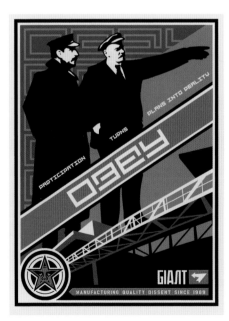

76.

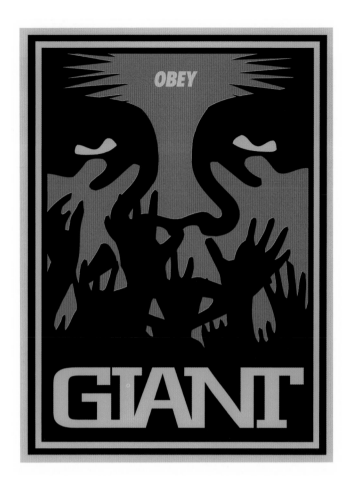

77.

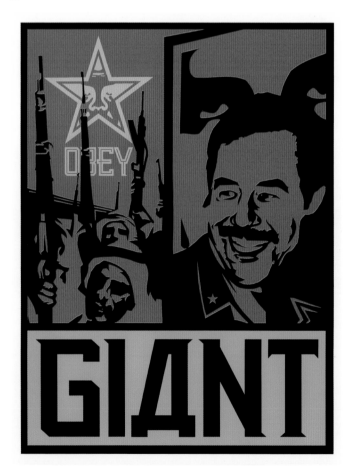

78.

78. I made the Saddam Hussein image in 1997 based on a photo I found in a magazine. In the photo, a crowd of soldiers carries a portrait of Saddam, in which he's smiling and looks very benevolent and fatherly. I found it interesting to see the contrast between the ways he's presented in Iraq and the U.S., where he's glorified on one hand and vilified on the other, and I can only imagine that the truth lies somewhere in the middle. Looking at the picture over the past few years, I've often thought about the similarities between representations of Saddam and George Bush in their respective countries versus their images abroad, and how everything gets manipulated for the sake of political goals. A lot of people didn't really get that, though. They thought it was supporting Saddam, because the mere use of an image causes people to presume that the perpetrator of the image endorses its subject matter.

79.

77. **Giant Worship,** 1997
(18 x 24") screen print on paper

78. **Saddam,** 1998
(18 x 24") screen print on paper

79. **Giant Bomber,** 1996
(24 x 18") screen print on paper

80. **Obey Zeppelin,** 1997
(18 x 24") screen print on paper

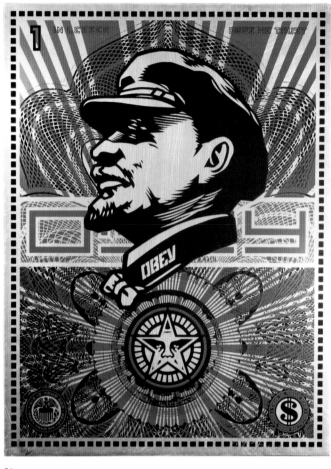

81.

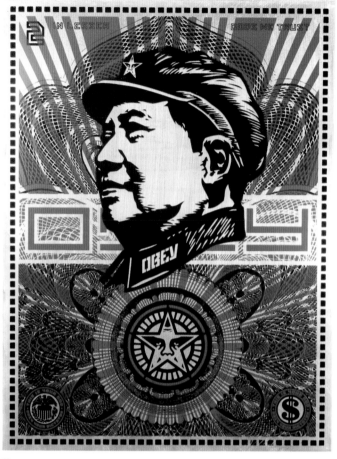

82.

81. **Obey Lenin Money,** 2002
(18 x 24") screen print on metal

82. **Obey Mao Money,** 2002
(18 x 24") screen print on metal

83. **Obey Mao,** 2002
(35 x 47") screen print on paper

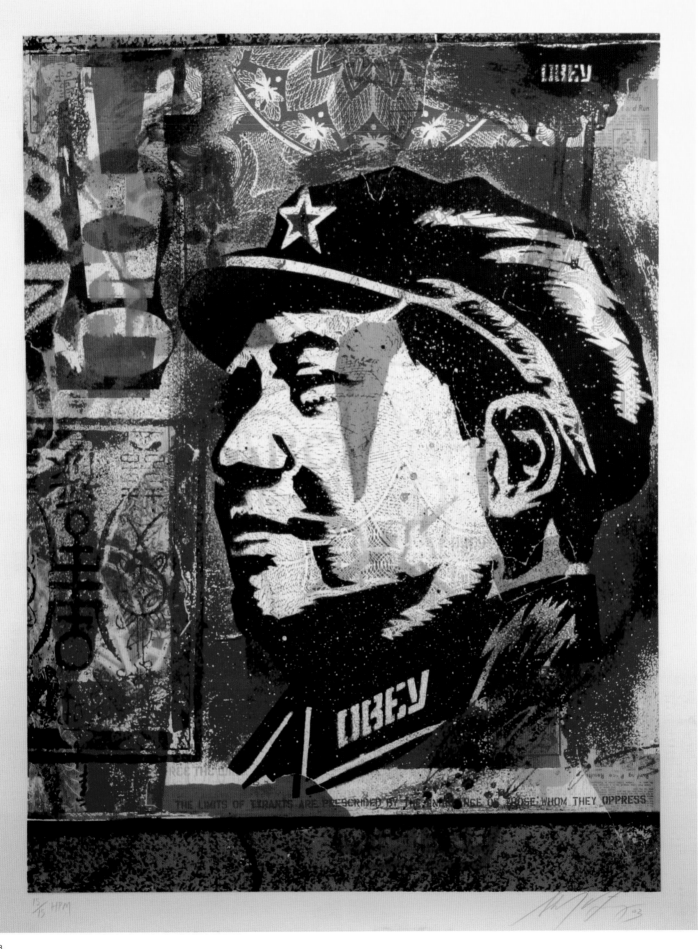

83.

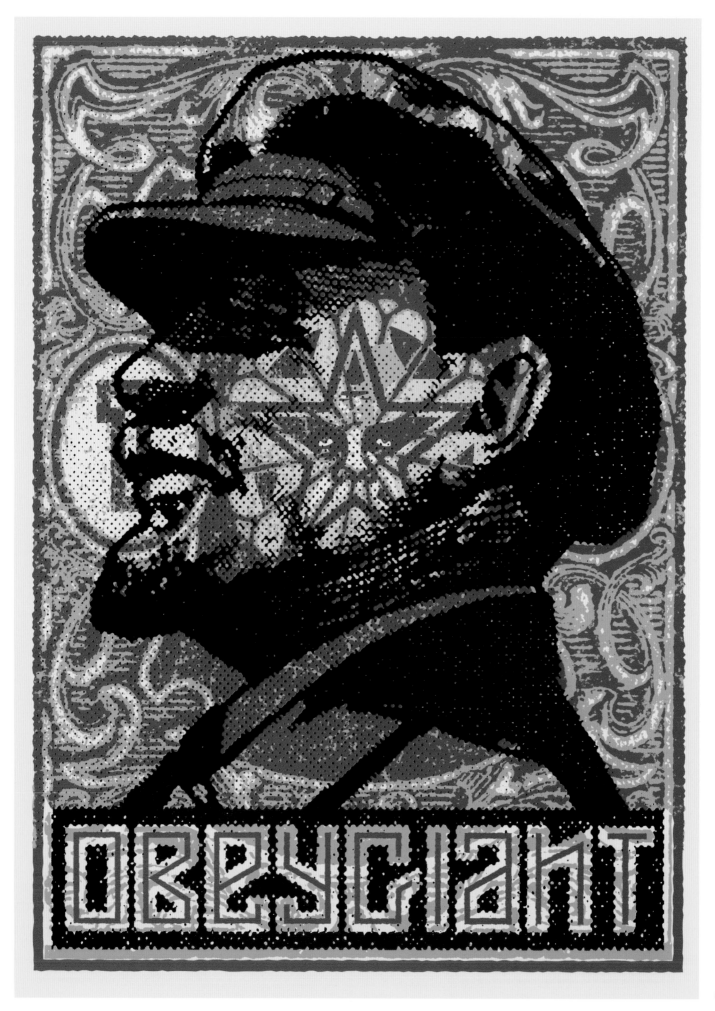

84.

85.

86.

84. **Lenin Stamp,** 2000
(18 x 24") screen print on paper

85. **Mao Stamp,** 2000
(18 x 24") screen print on paper

86. **NIxon Stamp,** 2001
(18 x 24") screen print on paper

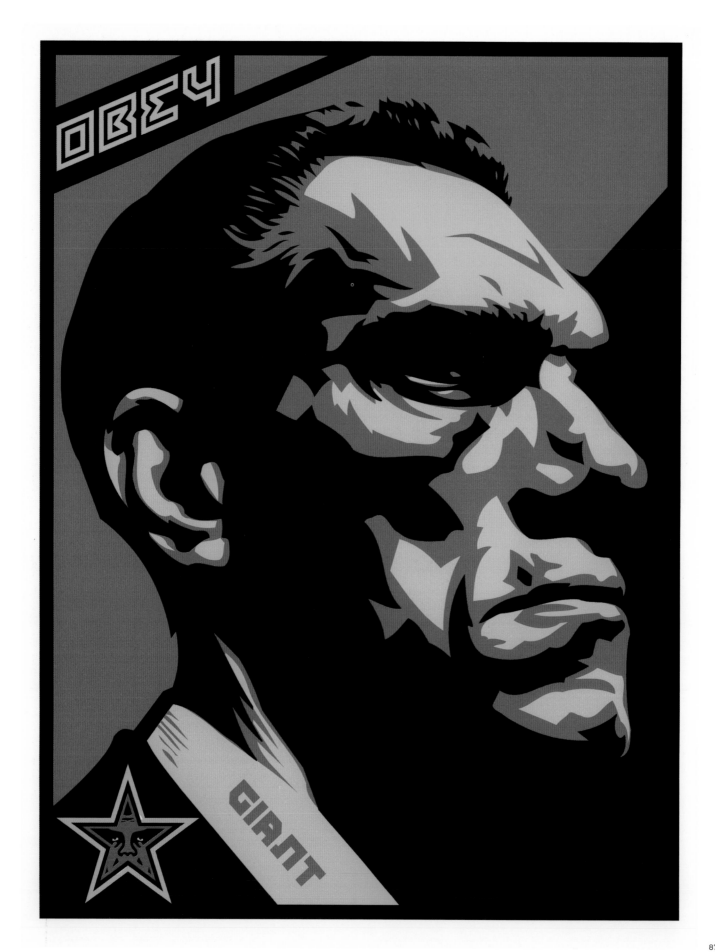

The first time I really noticed the Obey campaign was when I moved to New York in 1998 to study graphic design at FIT. I had just gotten my first job in the city working at Pearl Paint down on Canal Street. I first noticed the stencils on street lamps. As time passed, I started to notice the stickers. I noticed that all of them were not the same, and it was not trying to sell me anything. It got me curious and I really liked them, so I would carefully peel off the new ones as I found them and I would collect them. I really had no idea what Obey was all about until much later. Some had the dude from Flash Gordon and others were from the Black Panther series. The Obey campaign really turned on my street sensors to what was going on, art–wise, in the streets. From Obey, I learned that there could be a new option after graduation. I might not have to work for someone else in some shit ad house after I graduated. I really had no idea how it would work out, but it inspired me to start working on the streets (with an experiment called FAILE) and see where it would take me. I always liked graffiti but felt totally disconnected from its roots, language, and culture, having grown up in the middle of nowhere in Canada. What was inspiring about the Obey art experiment was that it used graffiti methods in a graphic context, something that I could understand and identify with. I can say without a doubt that Obey was the busy bee that pollinated FAILE and got the collective started.

– Patrick McNeil

87. **Big Brother Profile,** 1999
(18 x 24") screen print on paper

88. **Authoritarian,** 2000
(18 x 24") screen print on paper

89. **Lenin Collage,** 1999
(18 x 24") screen print on paper

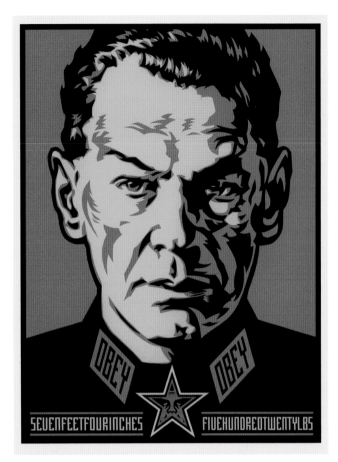

88.

89.

90.

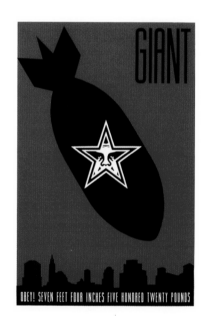

92.

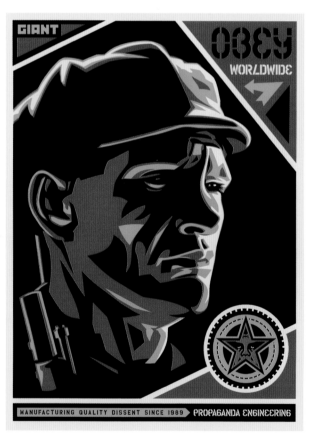

91.

90. **Giant Juxtapoz,** 1998
(18 x 24") screen print on paper

91. **Giant Worker Poster,** 2000
(18 x 24") screen print on paper

92. **Giant Bomb,** 1996
(18 x 24") screen print on paper

93. **Giant Tanks,** 1997
(18 x 24") screen print on paper

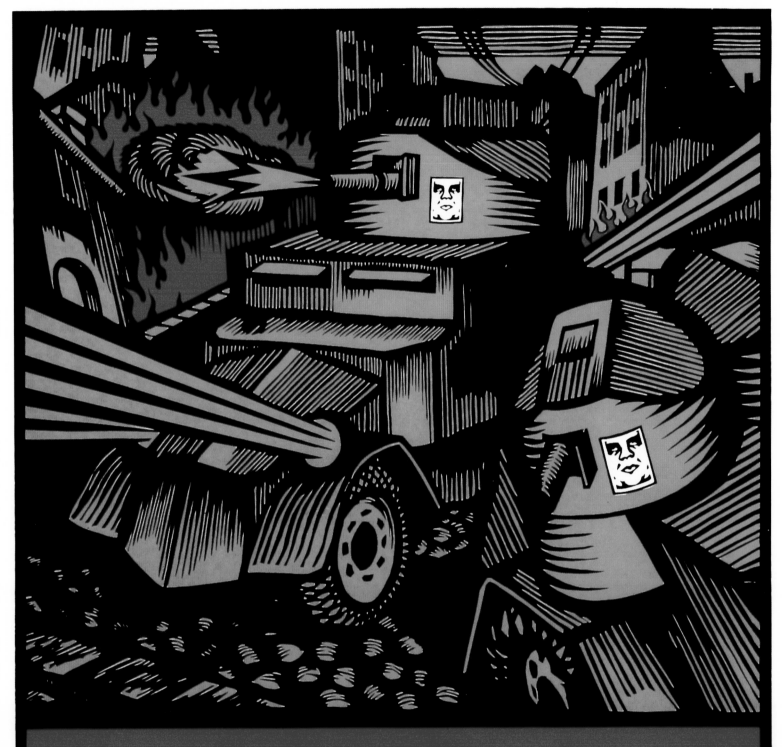

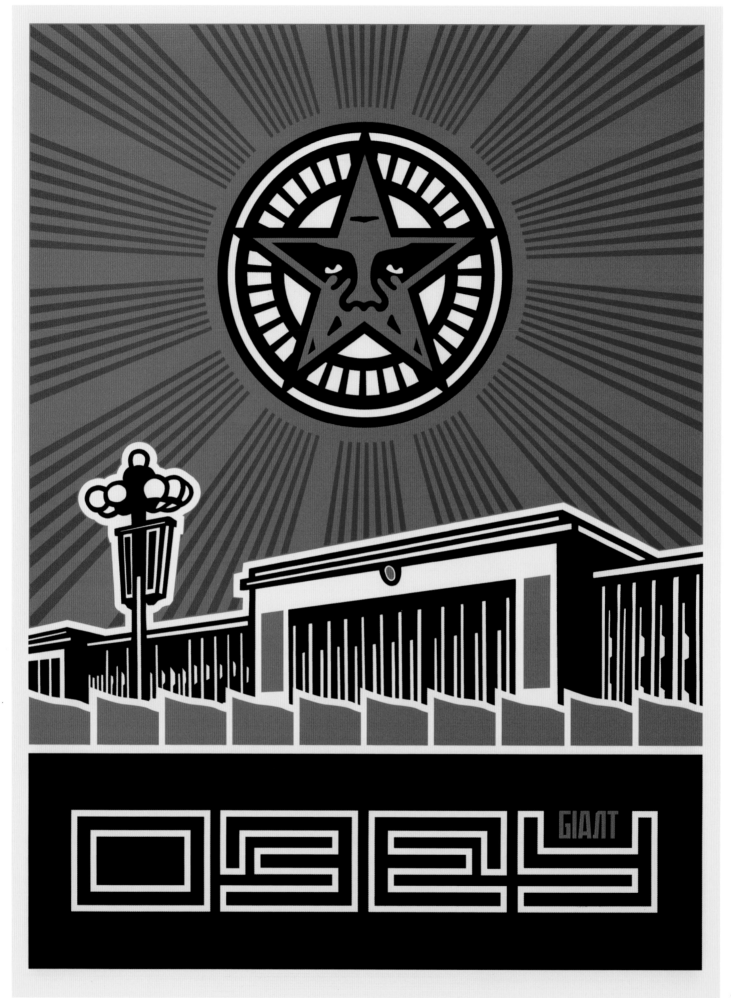

94.

118

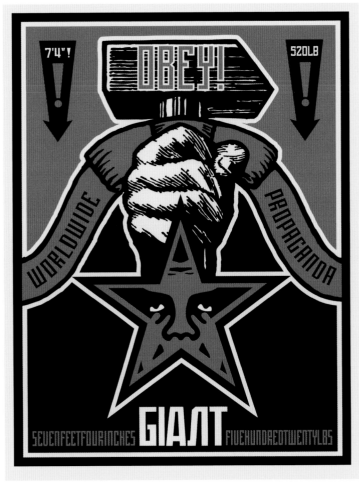

95.

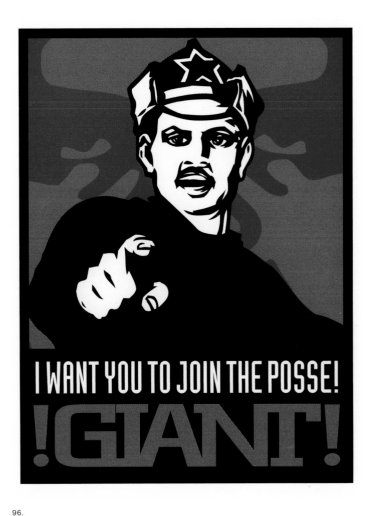

96.

94. **Chinese Building,** 2001
(18 x 24") screen print on paper

95. **Giant Hammer,** 1999
(18 x 24") screen print on paper

96. **Join the Posse,** 1997
(18 x 24") screen print on paper

97. **Giant Power to the Posse,** 1996
(18 x 24") screen print on paper

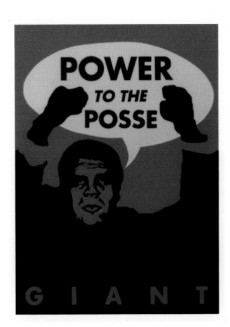

97.

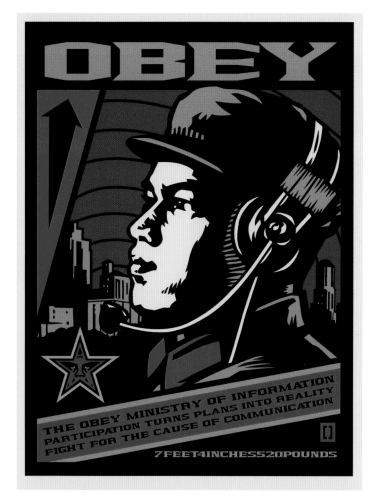

98.

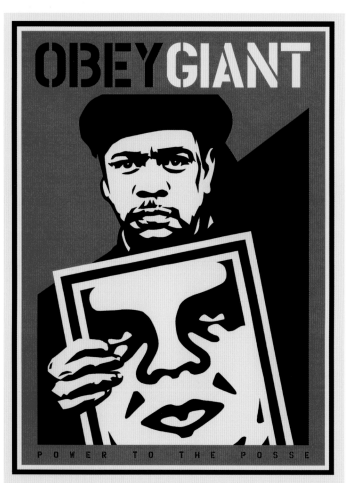

99.

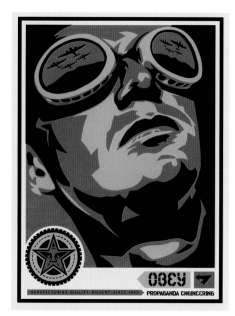

100.

98. *Obey Ministry of Information,* 2001
(18 x 24") screen print on paper

99. *Obey Protest Nubian,* 2000
(18 x 24") screen print on paper

100. *Obey Goggles,* 2000
(18 x 24") screen print on paper

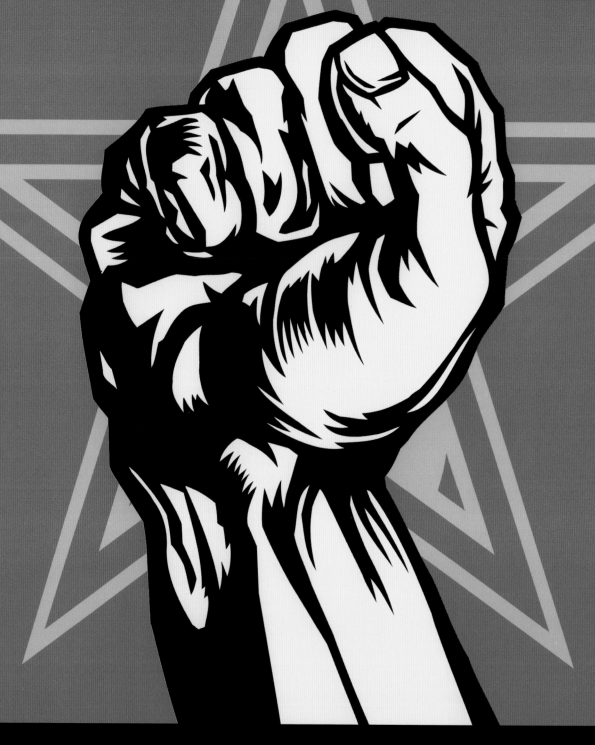

Obey has tremendous value as an art project – that's plainly
evident. But it's grown into a symbol of something more. It
serves as proof that a person can live out his or her dreams
and achieve his or her goals. It shows that determination
and sacrifice can pay off in unimaginable ways. And it proves
that no matter how ridiculous other people may deem your
artistic vision to be, you should never give up on yourself or on
your self-expression. Obey is more than a project, more
than a statement, more than an image, more than a starting
point for debate, more than an experiment, more than a Ror-
schach test, more than urban renewal, and more than
graffiti. It is a vibrant and concrete example of what it is to
dream something, and then actually live it.

– Jeff Penalty, lead singer of Dead Kennedys

102.

101. **Obey Fist,** 2000
(18 x 24") screen print on paper

102. **Gigante Free GKAE,** 2000
(18 x 24") screen print on paper

103. **Obey Revolution,** 1999
(18 x 24") screen print on paper

103.

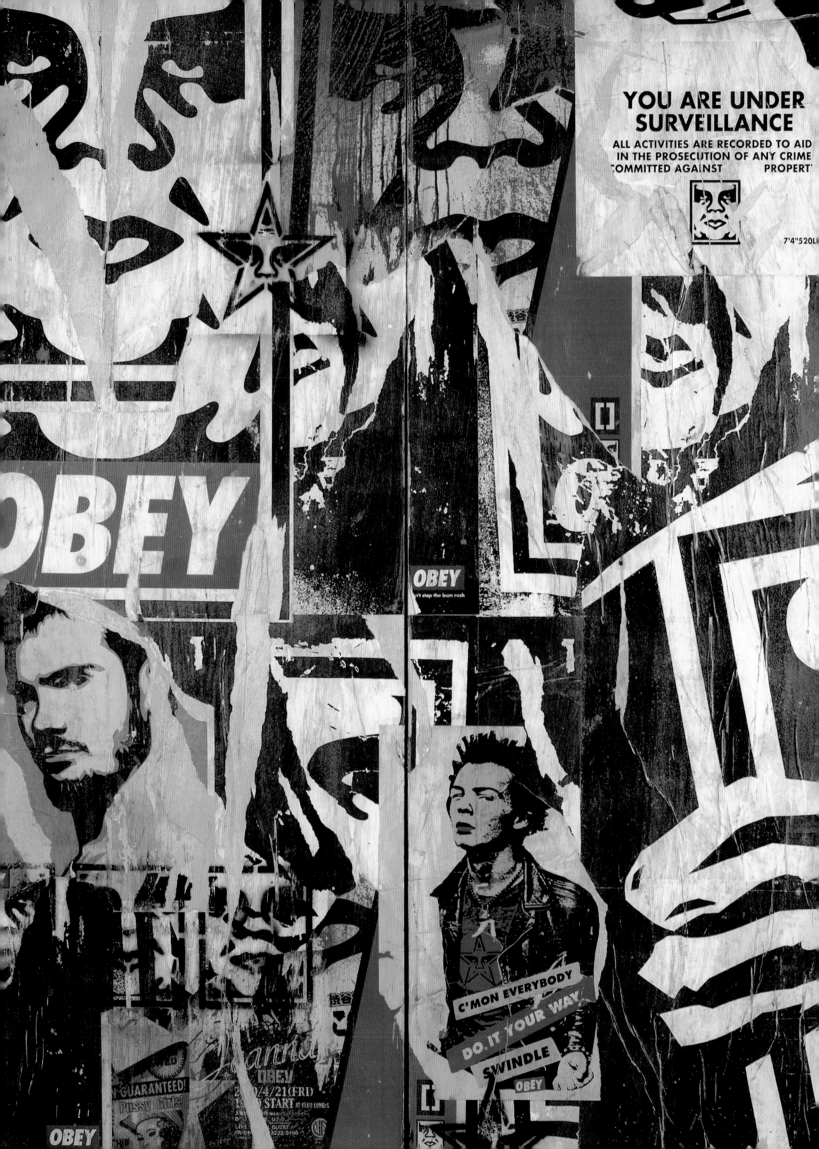

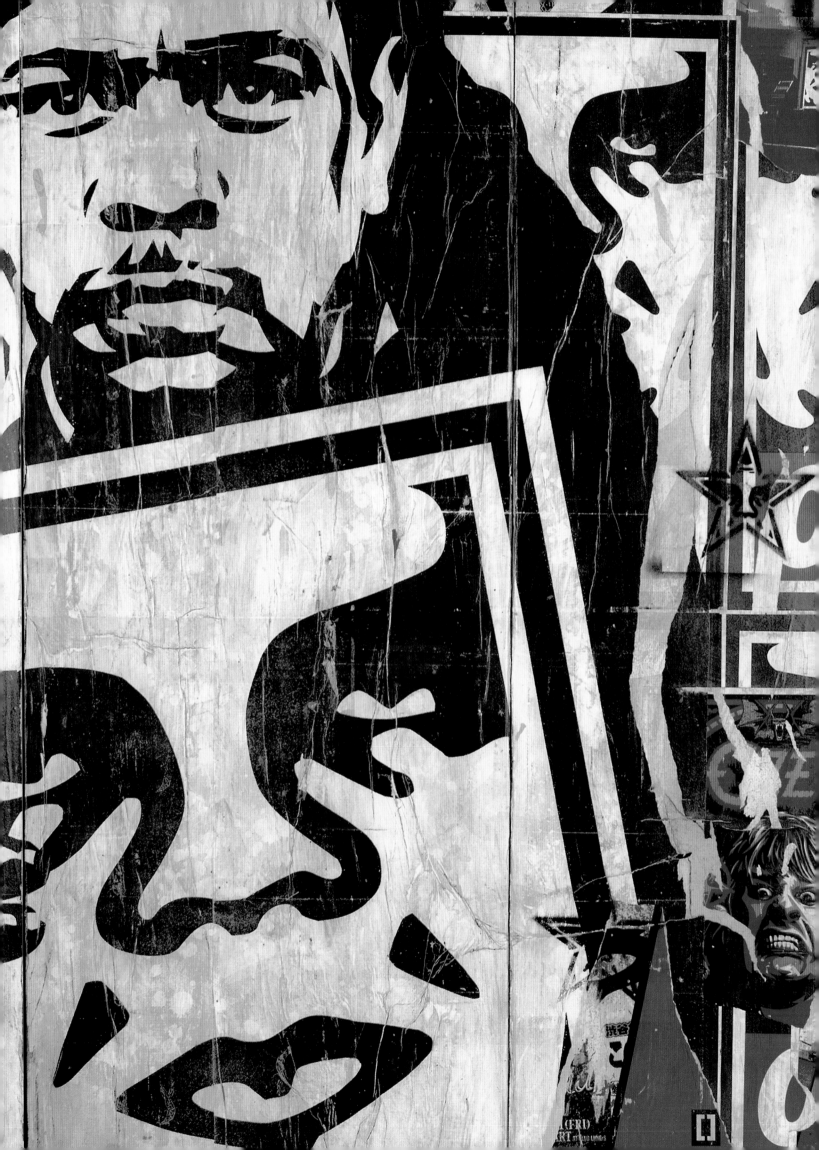

104.

105.

FREEDOM FIGHTERS VS. DICTATORS

SHEPARD FAIREY

Powerful leaders throughout the ages have been both revered and feared, often depending on whose propaganda system they have been filtered through.
I have several reasons for presenting these figures. People often become symbols that don't represent their real ideas or behavior. Advertising functions in a similar fashion by representing a romantic ideal that the use of a product will almost never yield. By juxtaposing the absurd Obey Giant imagery with the leaders, I'm hoping to show that symbols are often appropriated to champion or sell things or ideas they originally had no relation to. With a lot of the dictators, I'm saying "beware" or "obey with caution."

The dictator's history speaks for itself. I'm also making a joke about the paranoia many people have about Obey Giant. The Obey Giant association with feared dictators is absurd, but it pushes the buttons of reactionary people who don't scratch beneath the surface before making a judgment. Maybe once they learn about Obey Giant, they will take a closer look at things the next time.

The *Brown Power* series represents freedom fighters I support, including Angela Davis and Jesse Jackson. I have, however, slipped a few unknown impostors into the series that people assume are famous ethnic leaders. Merely through presentation that mimics a style, people assume something is what it is not. This shows how ingrained the tendency to interpret something based on symbolism and not actual content is. Lastly, there are leaders who started as idealists and became corrupted by power along the way. Che and especially Castro are excellent examples of this. They fought for what they thought would be a better system for the Cuban people, but had to tyrannically crush any opposition to enforce their new system.

Lenin, and to a lesser extent Stalin, used unjust methods to force people to conform to their system which they felt would better the nation. The results with these leaders were obviously mixed and many people regretted giving them absolute power. This happens to a lesser, but still dangerous, degree in the U.S.

106.

107.

104. **Obey Film Strip,** 1997
(18 x 24") screen print on paper

105. **Mission Fist,** 2000
(18 x 24") screen print on paper

106. **Make Art Not War,** 2004
(18 x 24") screen print on paper

107. **Giant Chicano,** 1998
(18 x 24") screen print on paper

108.

109.

108. The "Giant Nubian" poster was set up to look like a Black Panther or Black Power image, and people often asked me if it was a picture of Huey Newton or Eldridge Cleaver or Bobby Seale. In fact, it's just a guy from a '70s haircut book. Simply creating a poster of the guy makes him seem like someone important, and the colors and the slogan evoke a sense of the Black Power movement. The symbols are far more important than the actual person in the image, and I try to get that point across by tricking people but also informing them.

110.

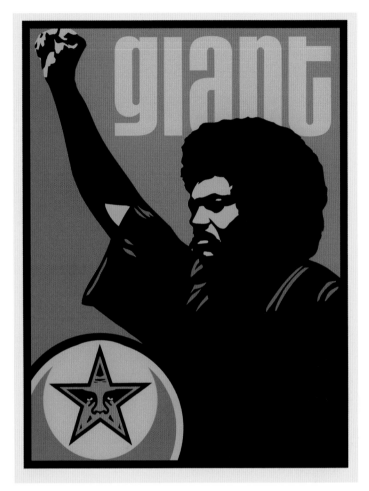

111.

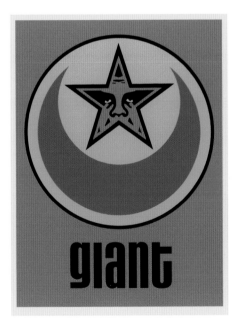

112.

108. **Giant Nubian,** 1997
(18 x 24") screen print on paper

109. **Giant Never Trust the Devlis,**
1998 (18 x 24") screen print on paper

110. **Giant Angela Davis,** 1998
(18 x 24") screen print on paper

111. **Giant Jesse,** 1998
(18 x 24") screen print on paper

112. **Giant Islam,** 1998
(18 x 24") screen print on paper

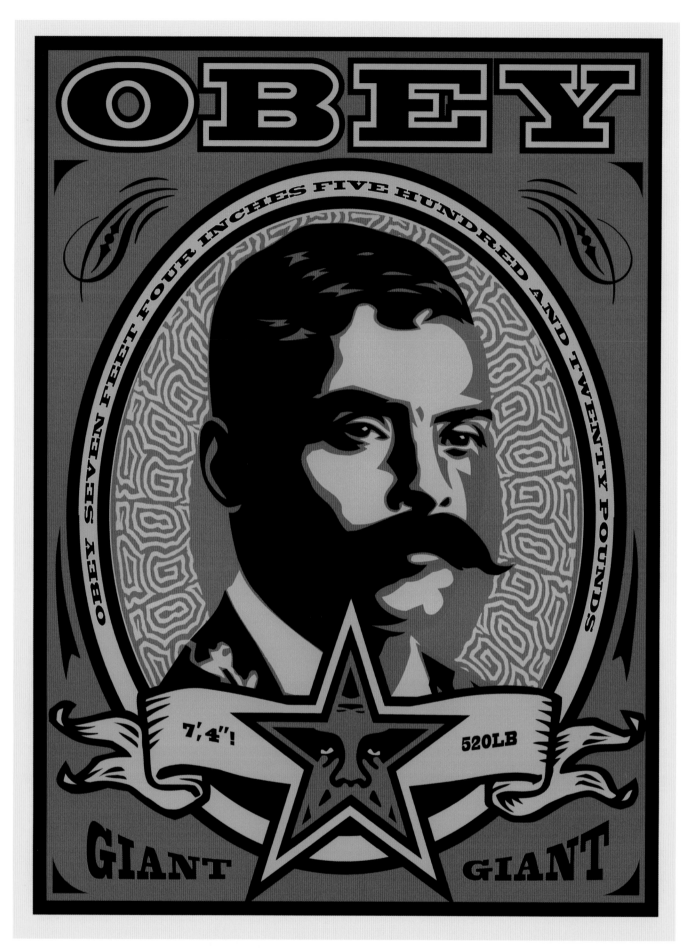

113.

115. The subject of this image was often mistaken as Anton LaVey, the founder of the Church of Satan, perhaps just because it seems so sinister. Ming the Merciless was a character from the Flash Gordon comics during the '30s, a period when there was a lot of paranoia about communism in China. It seems like world politics often dictate what the villains look like in the entertainment media. It's another example of the use of symbols to manipulate people, in this instance to generate fear.

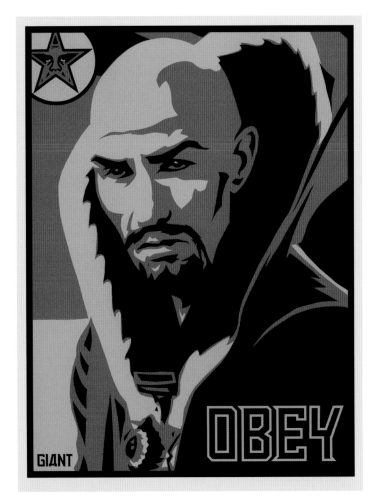

115.

114.

113. **Obey Zapata,** 1999
(18 x 24") screen print on paper

114. **Obey Zapata Album,** 2003
(12.25 x 12.5") spray paint stencil
and collage on album

115. **Obey Ming,** 1998
(18 x 24") screen print on paper

116. **Giant Dictator,** 1998
(18 x 24") screen print on paper

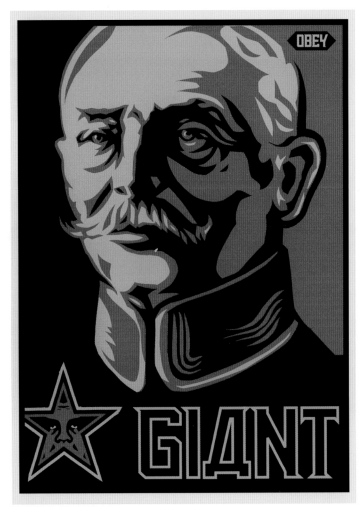

116.

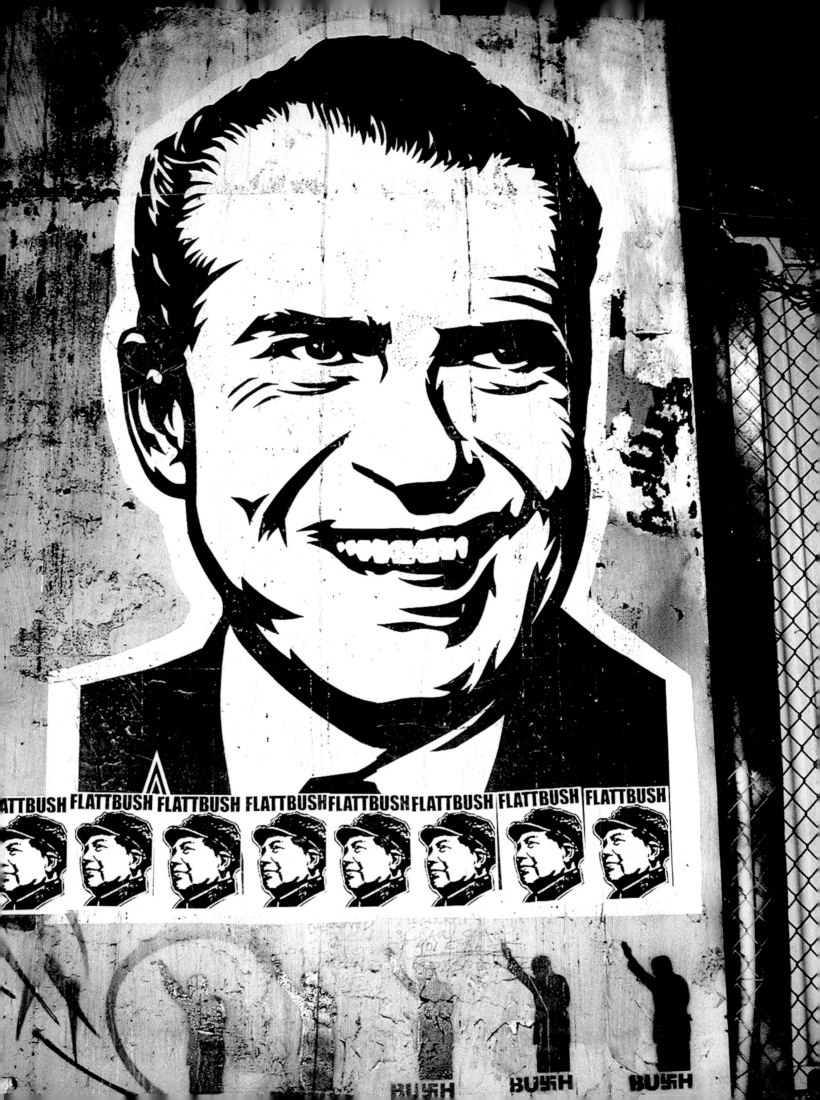

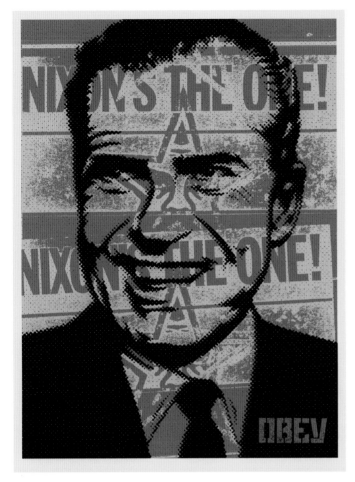

117.

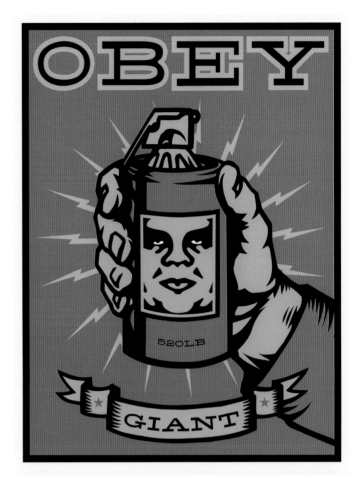

118.

119.

117. **Obey Nixon's the One ,** 2001
(18 x 24") screen print on paper

118. **Obey Grenade,** 1998
(18 x 24") screen print on paper

119. **Obey Nixon Album,** 2003
(12.25 x 12.5") spray paint stencil
and collage on album

PUNK OBEY

SINCE 89

MANUFACTURING QUALITY DISSENT

WORLDWIDE

Noam Chomsky

I lived with the system and took no offense until Chomsky lent me the necessary sense.

sung to the tune of "the Magnificent Seven" by the Clash

120.

EDUCATION OR EXPLOITATION

Shepard Fairey

I make a very public body of art using stickers, posters, and stencils. I put these works on the street in order to send some static interference out into the world's sea of images and messages. The images I use include historical propaganda, Black Power, parodies of authority, and tweaks of popular culture icons. What's the point? Well, aside from satisfying my compulsive need to produce art, these posters are designed to start a dialogue about imagery absorption. Powerful and seductive images have historically been used for a variety of reasons, some noble, some sinister, some both, depending on subjective interpretation. My work uses people, symbols, and people as symbols to deconstruct how powerful visuals and emotionally potent phrases can be used to manipulate and indoctrinate. There is no specific political affiliation behind what I do, only the philosophy "question everything," which is why I can use Jesse Jackson and Joseph Stalin in the same body of work. I also use the word Obey in much of my art as a form of reverse psychology. Though most people wish they were independent, many obediently follow the path of least resistance and are uncomfortable with confronting the word Obey. As disconcerting as the word Obey may be, when not attached to any further command, it poses no threat beyond forcing viewers to face their feelings about obedience.

Though my art may make some people uncomfortable, I've always felt that provocation, stimulating debate, is much more desirable than ignoring sensitive issues to avoid hurting anyone's feelings. People's feelings seem to get hurt very easily. Sometimes I'm attacked by people who tell me I have no business using this leader, or that activist, or this word, in my art. What surprises me most is that sometimes those who criticize my use of symbols aren't the ones that lived through McCarthyism and have a programmed fear of communism or anything radical, but those who claim to be radical. Many of these so called "radicals" have adopted the politically–correct doctrine that says white people have no right to try to relate to, or comment on, other cultures. I think this is a dangerous mentality that discourages inter–culture relations and understanding. Sure, a white person can't truly relate to what it's like not being white, but the sentiment to try is at least a positive step. Che Guevara and Bobby Seale both embraced the assistance of those gringos or crackers that genuinely understood their causes and wanted to help. Distrust of those who have oppressed is natural, but intentional isolation only fuels racial tension. Does the Latin community own Che? Does the Black community own Angela Davis? Does the white community own Eminem? Should hip–hop and graffiti be kept only in New York City? My point is that someone or something's influence can often cross cultural boundaries and grow beyond the control of groups who would like to keep this person or thing as a symbol solely of their cause or culture. Figures are used symbolically for groups' agendas, simplifying them in a way that can never truly reflect the complexity of the individual. I use figures in my work who I feel are used and abused as symbols, but without telling the viewer how to feel about them. I hope people that don't know the backgrounds of these leaders, radicals, pop icons, or movements

121. When I first started coming to L.A., I was putting up a lot of large–format, hand–painted posters, and one of those was the Andre/Che Guevara image. A graffiti artist named MEAR happened to be dating an outspoken Mexican girl, who felt that Che was a Latin culture icon and that I, as a white person, was desecrating her culture. She sent me an email saying, "Che is my compañero," even though Che wasn't Mexican, he was Argentine. MEAR (who I might add is white), as a defender of his girlfriend's honor, went around writing "capitalizing other people's culture" and "southern white settler" on my stuff. As long as you're a street artist there will always be critics, but it's just something you have to deal with.

121.

120. ***Obey Punk Chomsky,*** 2001
(18 x 24") screen print on paper

121. ***Backlash,*** 2001

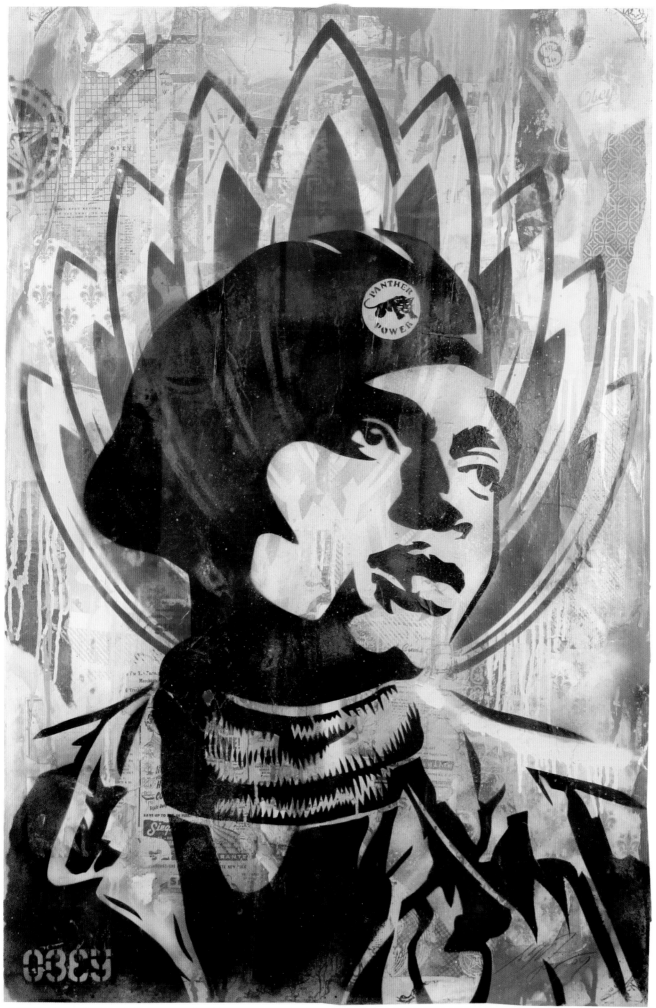

122.

will take the initiative to learn about their history.

I apologize to anyone who feels my work desecrates something they hold sacred, but things aren't always as black–and–white as some folks wish they were. Digest this: Che Guevara was from an upper–class family of pure Spanish descent and considered himself white, yet he took on the mission to empower mixed and native Latin Americans. Che struggled to free Latin Americans from European and American oppressors with whom he admittedly shared a common lineage. Fortunately, P.C. rhetoric didn't make Che feel he lacked the racial credibility to be outspoken about his causes. This anecdote leads to my advice to myself and others: investigate and deconstruct everything, because a person and the simplified symbol they have become aren't always the same thing.

123.

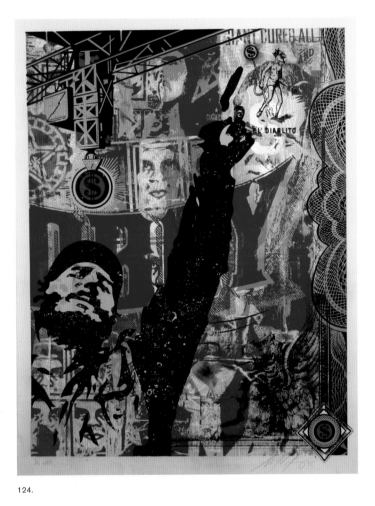

124.

122. **Obey Black Panther,** 2005
(30 x 44") spray paint stencil and collage on paper

123. **Obey Angela Rough,** 2003
(18 x 24") screen print on paper

124. **Obey Castro,** 2003
(35 x 47") screen print on paper

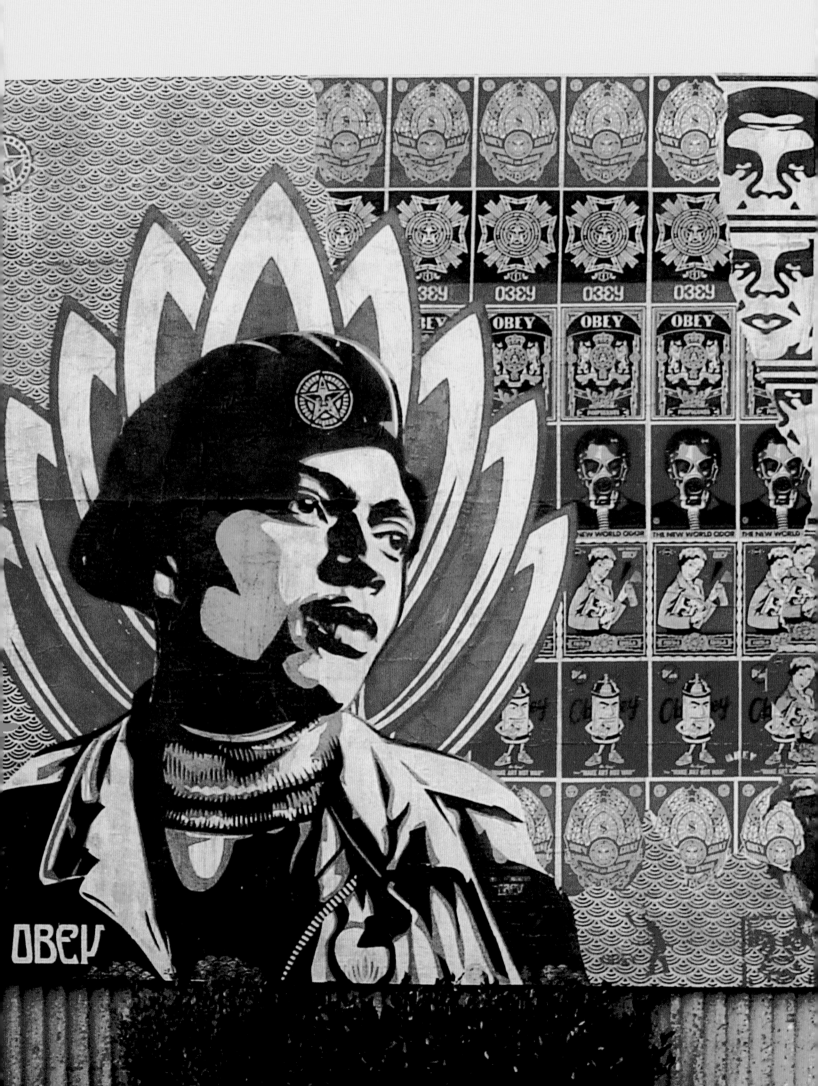

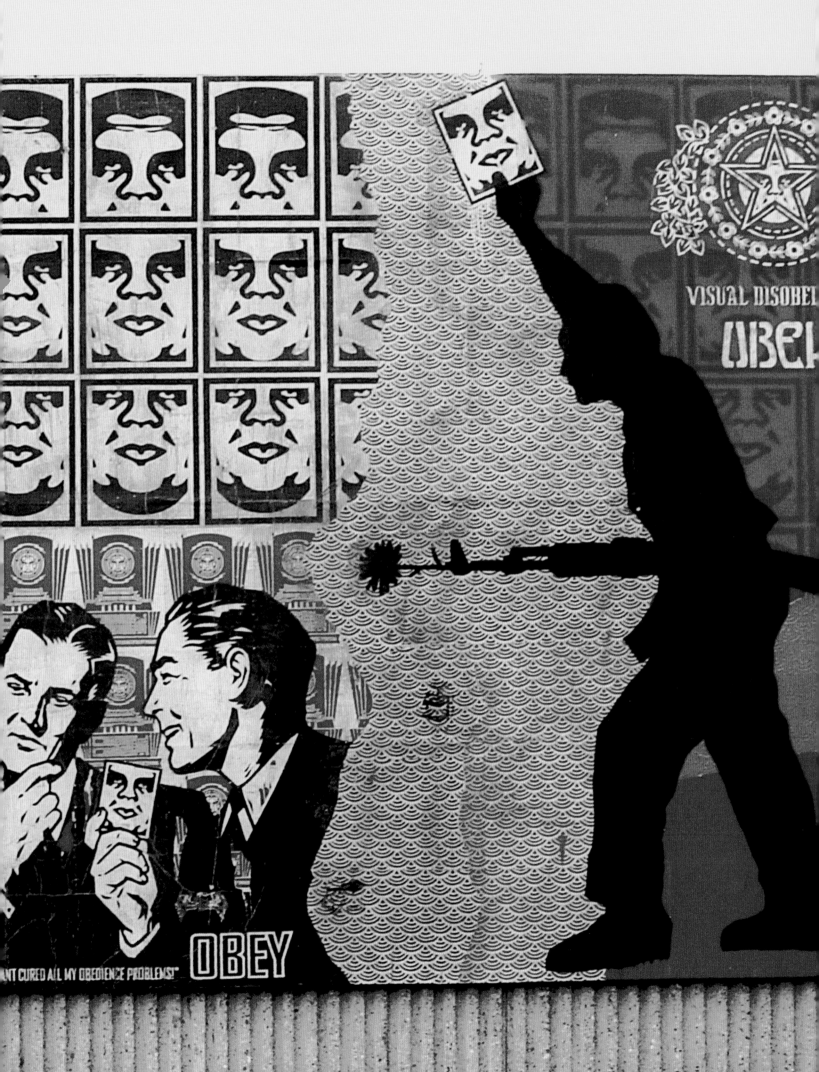

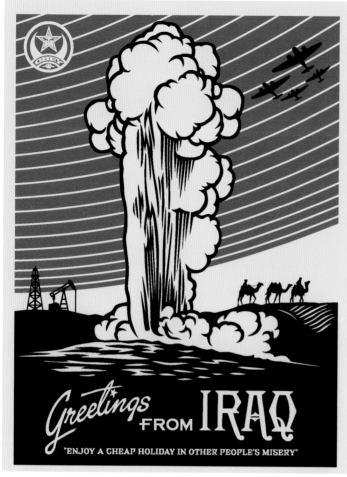

125.

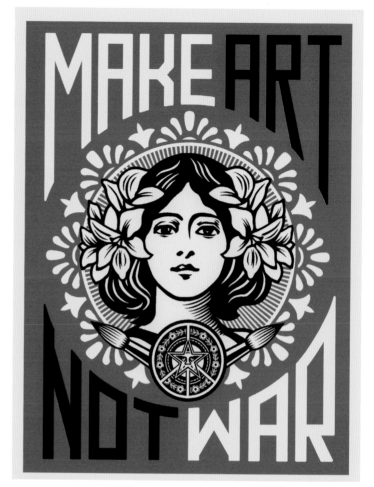

126.

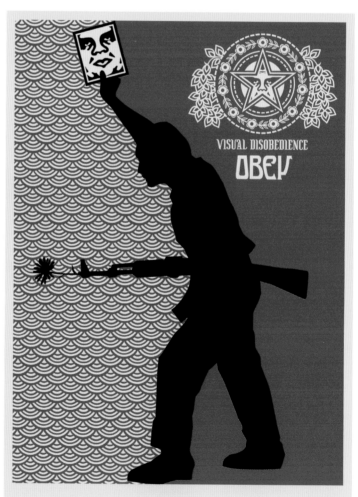

127.

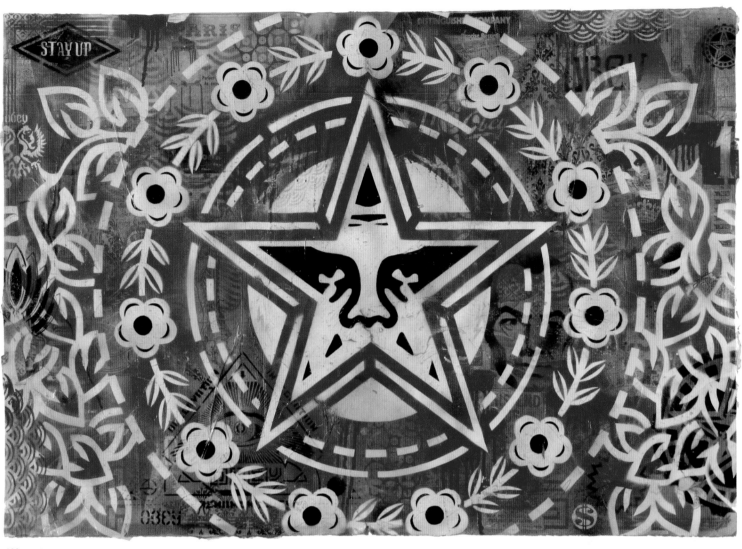

128.

125. **Obey Iraq,** 2005
(18 x 24") screen print on paper

126. **Obey Peace Girl,** 2005
(18 x 24") screen print on paper

127. **Obey Visual Disobedience,**
2004 (18 x 24") screen print on paper

128. **Obey Flower,** 2005
(44 x 30") spray paint stencil and
collage on paper

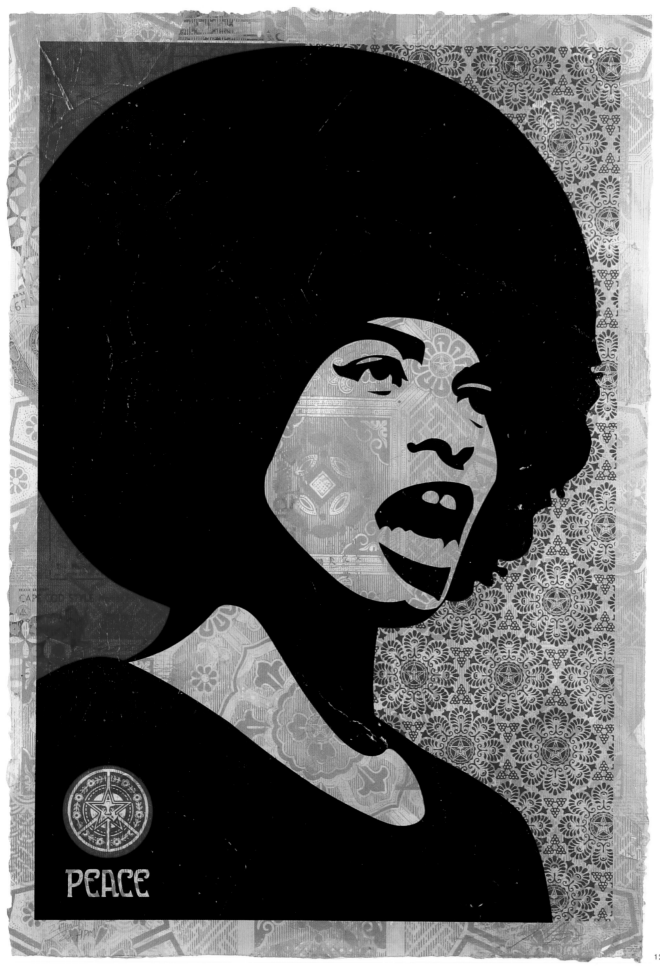

PEACE

129.

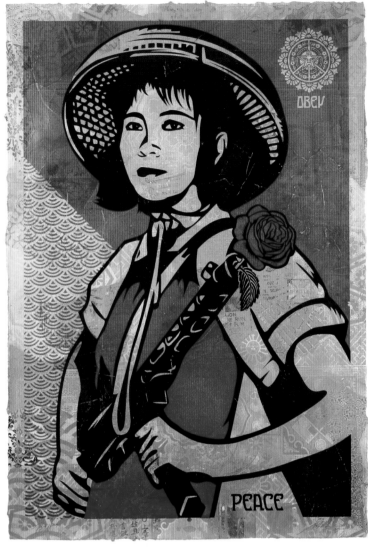

130.

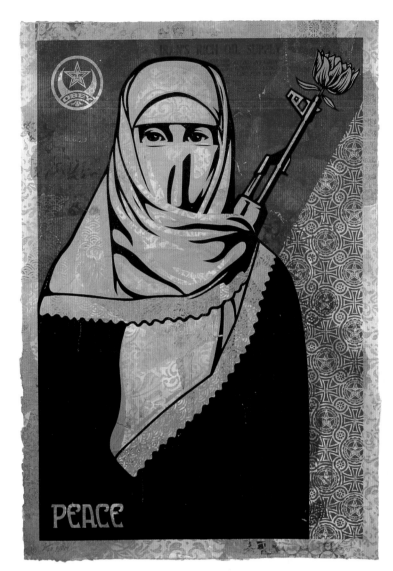

131.

132.

129. **Obey Angela Davis,** 2005
(30 x 44") spray paint collage and
screen print on paper

130. **Obey Revolution Girl,** 2005
(30 x 44") spray paint collage and
screen print on paper

131. **Obey Female Muslim,** 2005
(30 x 44") spray paint collage and
screen print on paper

132. **Shepard Fairey (signing)
and Richard Duardo in
Duardo's Studio,** 2005

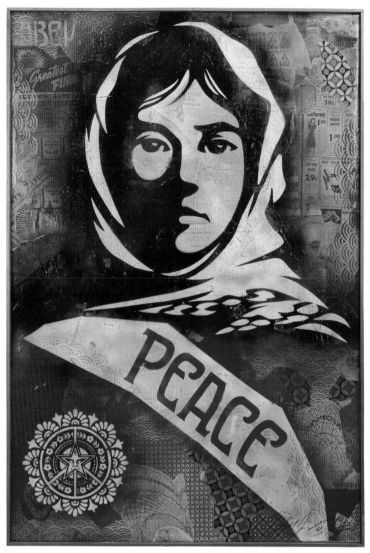

133.

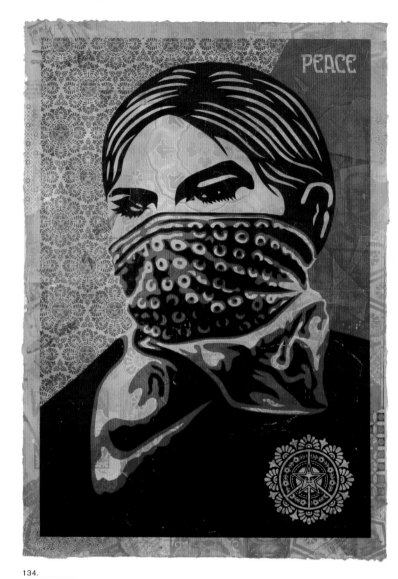

134.

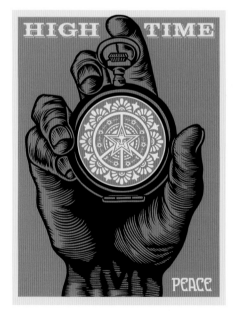

135.

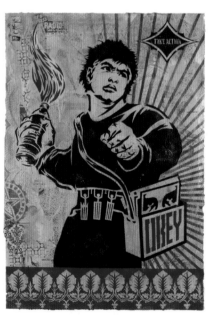

136.

133. **Obey Peace Woman,** 2005
(30 x 44") spray paint stencil and
collage on canvas

134. **Obey Zapatista Woman,** 2005
(30 x 44") spray paint collage and
screen print on paper

135. **Obey High Time for Peace,** 2005
(18 x 24") screen print on paper

136. **Obey Molotov,** 2005
(30 x 44") spray paint stencil and
collage on paper

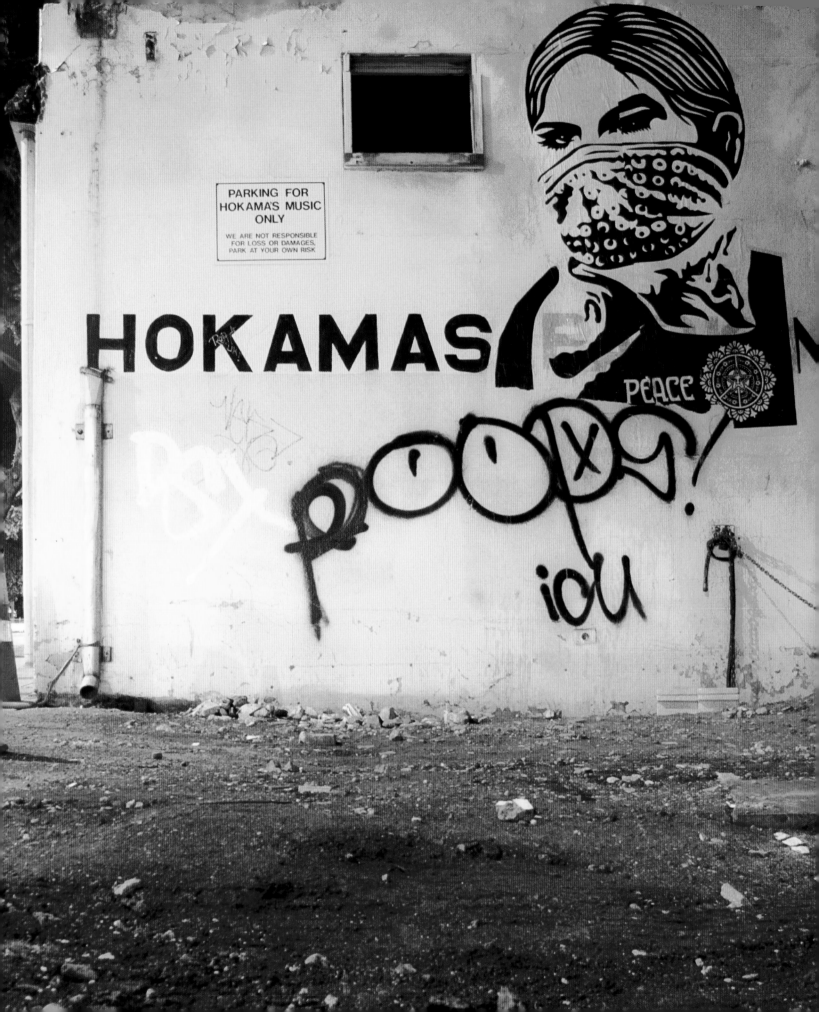

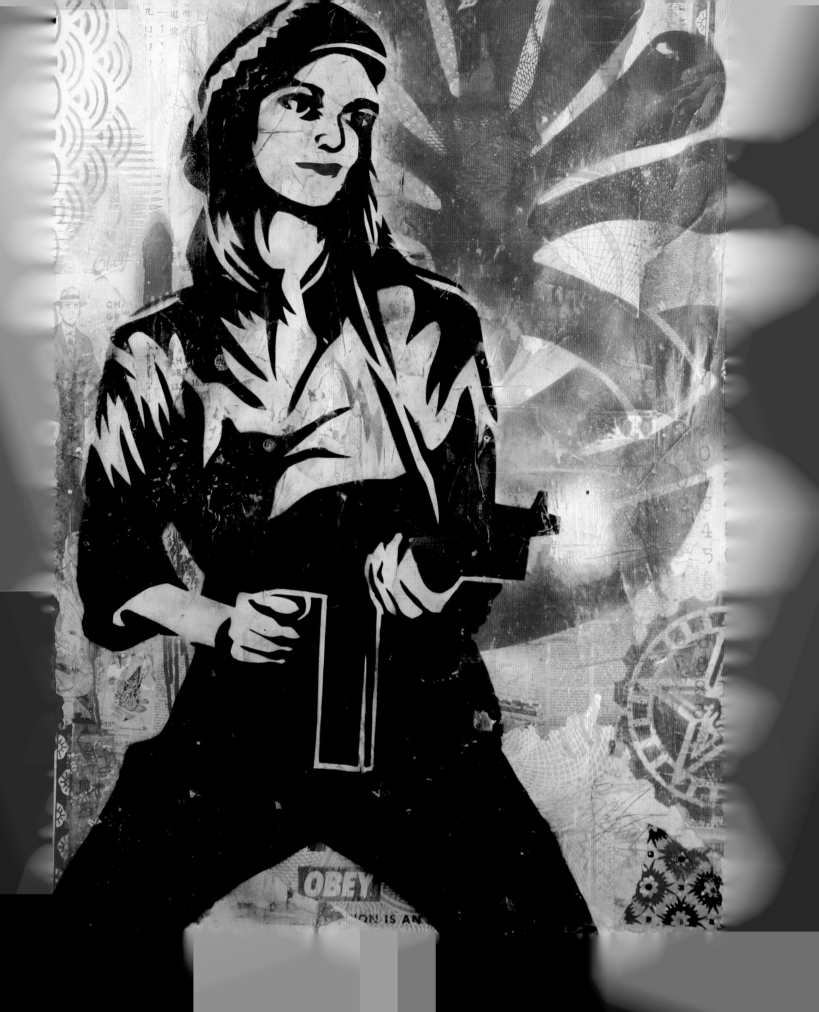

On February 4th, 1974, 19–year–old Patricia Campbell Hearst, granddaughter of legendary newspaper magnate William Randolph Hearst, was kidnapped at gunpoint from her Berkeley, California, apartment by two black men and a white woman who identified themselves as members of the Symbionese Liberation Army (SLA). They demanded that Patty's father distribute millions of dollars worth of food to the poor and publish their propaganda, though his compliance never led to her release. The SLA's leader, Donald DeFreeze, ultimately converted Patty to his cause; whether she did so willingly or was brainwashed may never be known. Two months after her kidnapping, Patty and four other SLA members held up the Hibernia Bank in San Francisco. Her family and the public at large were shocked by her renegade behavior.

SHEPARD'S COMMENTS

I always found this story fascinating because it raises lots of issues about people being products of their environment and what constitutes brainwashing. My dad once told me, when I was feeling betrayed by a friend, that "people always act in their own best interest in any situation." Obviously, after Patty was kidnapped her situation changed, and what was temporarily in her best interest changed. Maybe, as Patty Smith suggests in her version of Hendrix's "Hey Joe," Hearst was pulling the ultimate rich, white girl rebellion move and "getting it from a black man every night." Everyone had their own spin on the story, but only Patty Hearst and the SLA know what really happened.

DR. MARTIN LUTHER KING, JR.

CIVIL RIGHTS LEADER AND PACIFIST

Dr. Martin Luther King, Jr., was born in 1929 the son of an Atlanta pastor, and was himself ordained in 1947. He became minister of a Montgomery, Alabama, Baptist church in 1954, the same year the Supreme Court desegregated America's schools. King spearheaded the nation's civil rights movement through nonviolent civil disobedience, and led the historic March on Washington in 1963, where he delivered his famous "I Have a Dream" speech. On April 4, 1968, King was assassinated while standing on the balcony of his motel room in Memphis, Tennessee. In 1986, his birthday became a national holiday.

SHEPARD'S COMMENTS

Martin Luther King, Jr., is probably the greatest example of living by the Golden Rule—do unto others as you would want done unto yourself—even if others don't reciprocate. King was harassed by redneck cops

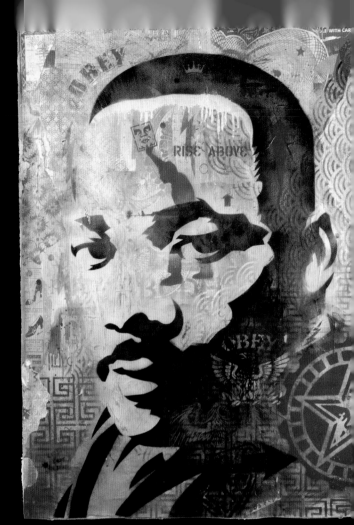

138.

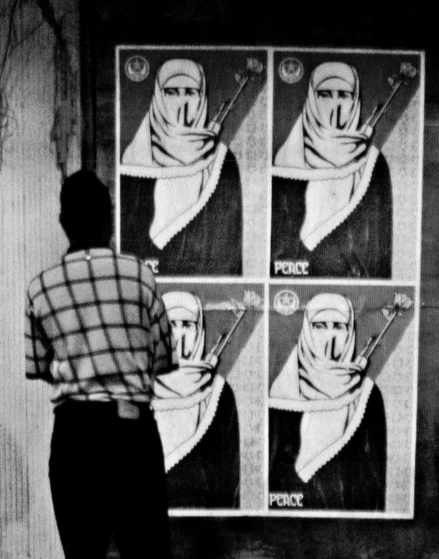

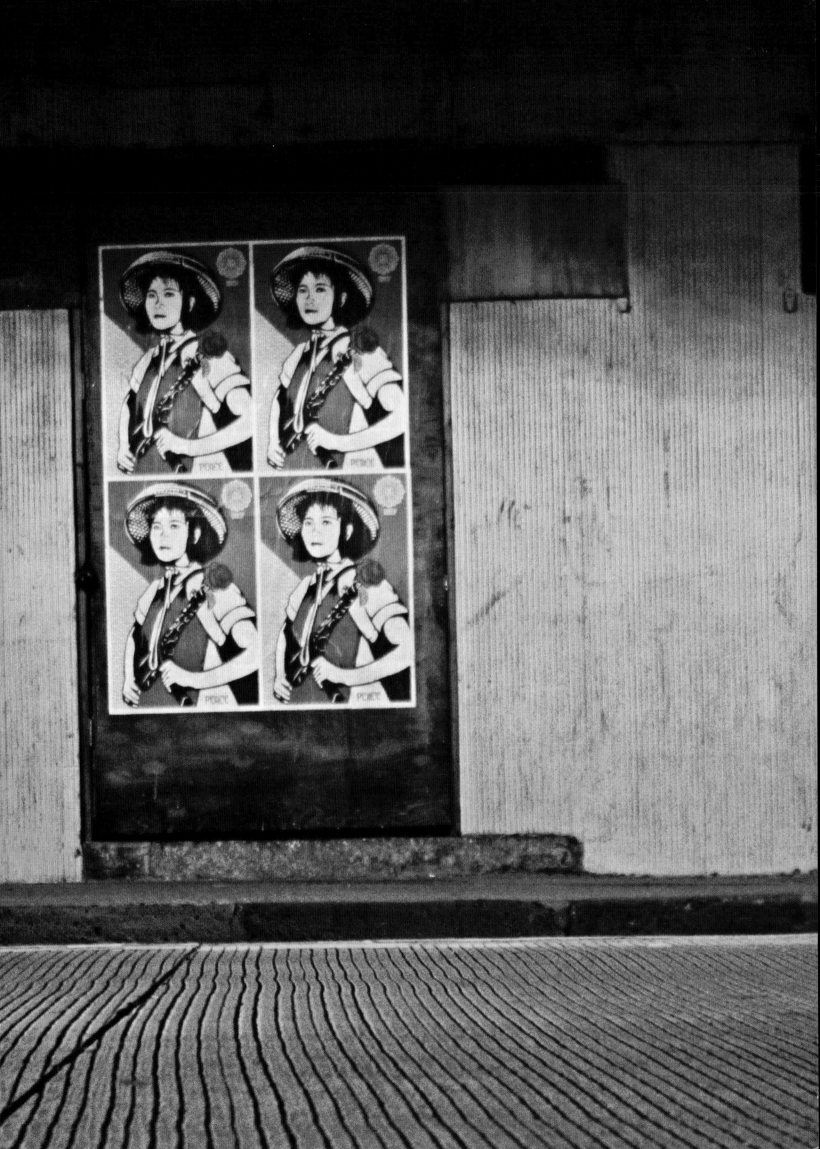

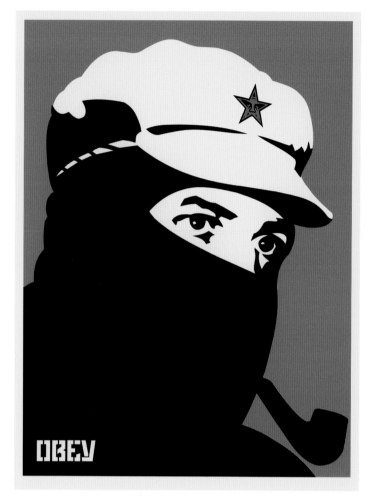

140.

140. Subcomandante Marcos is the leader of the Zapatistas, who are fighting against the Mexican government because of years of unfair treatment of the people of the state of Chiapas. Ten percent of the sales of Marcos imagery will go to the Chiapas Media Project, which provides cameras to members of the Chiapas communities to document the unjust actions of Mexican government soldiers. Without the media, the Zapatistas would have been violently eradicated without the rest of the world even knowing.

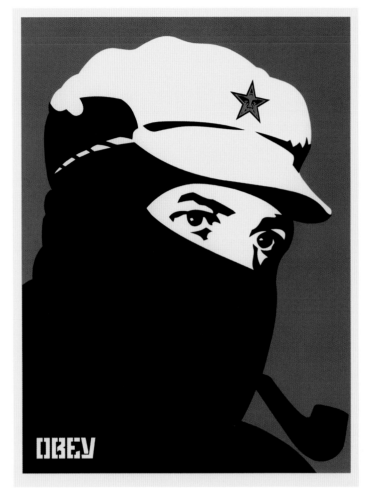

141.

142.

140. **Obey Comandante 1, 2, 3, 4,**
2002 (18 x 24") screen print on paper

141. **Obey Marcos Profile Album,**
2003 (12.25 x 12.5") spray paint stencil
and collage on album

142. **Obey Comandante Album,** 2003
(12.25 x 12.5") spray paint stencil and
collage on album

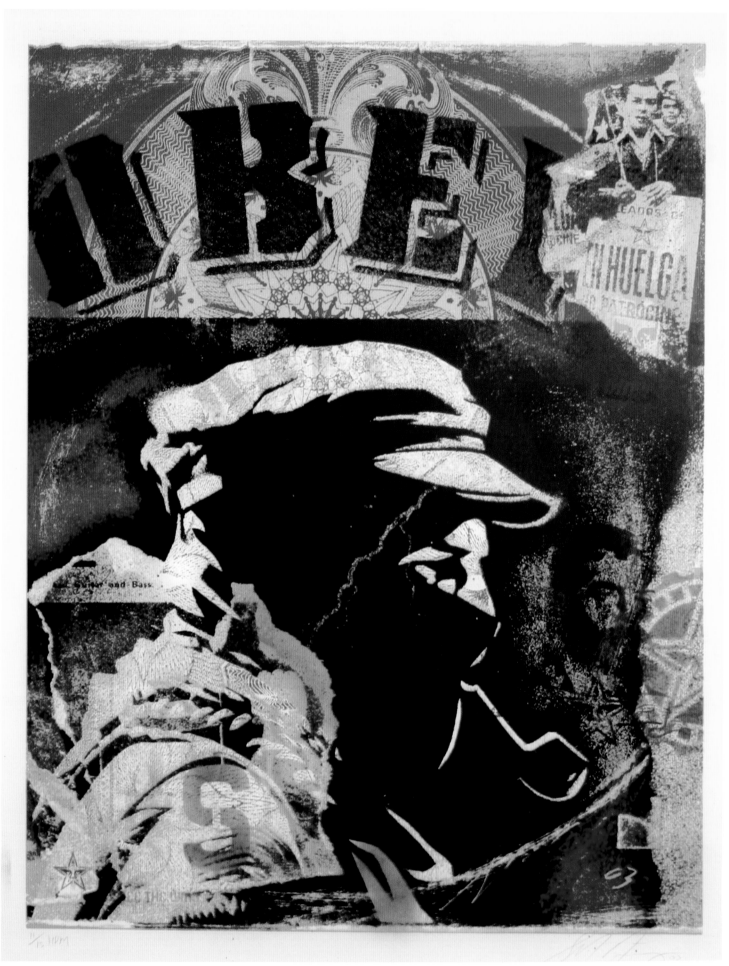

143.

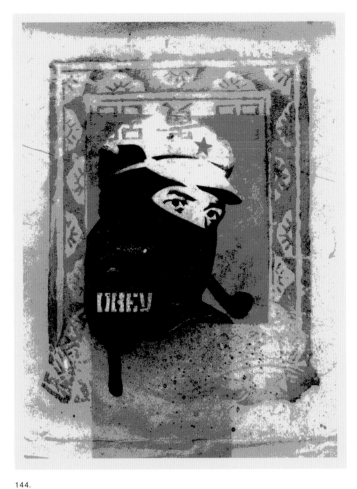

144.

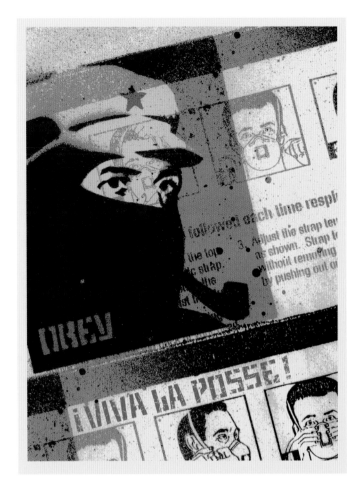

146.

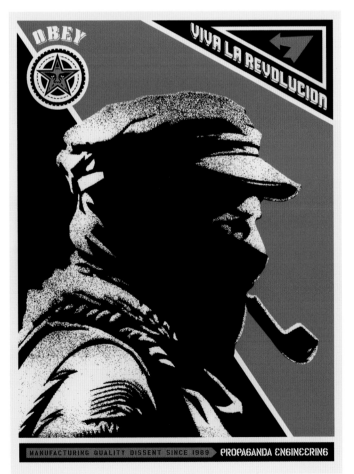

145.

143. **Obey Marcos Profile Stencil,**
2003 (18 x 24") screen print on paper

144. **Obey Marcos Stencil,** 2003
(18 x 24") screen print on paper

145. **Obey Marcos Profile,** 2002
(18 x 24") screen print on paper

146. **Obey Marcos Diagram,** 2003
(18 x 24") screen print on paper

147.

147. **Obey Lenin Album,** 2005
(18 x 24") screen print on paper

148. **Obey Zapatista,** 2001
(18 x 24") screen print on paper

149. **Obey Lenin 4–Album Stencil,**
2004 (24 x 36") spray paint stencil and
collage on albums

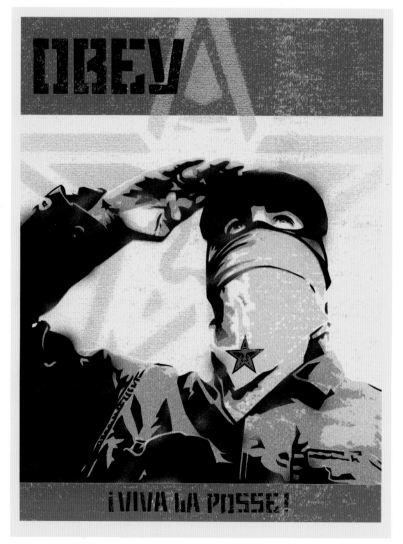

148.

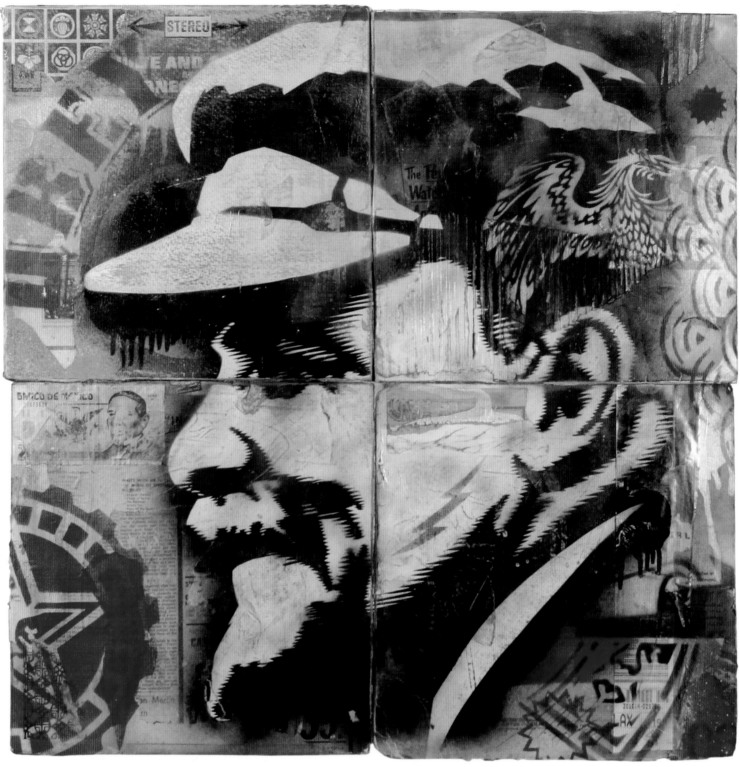

149.

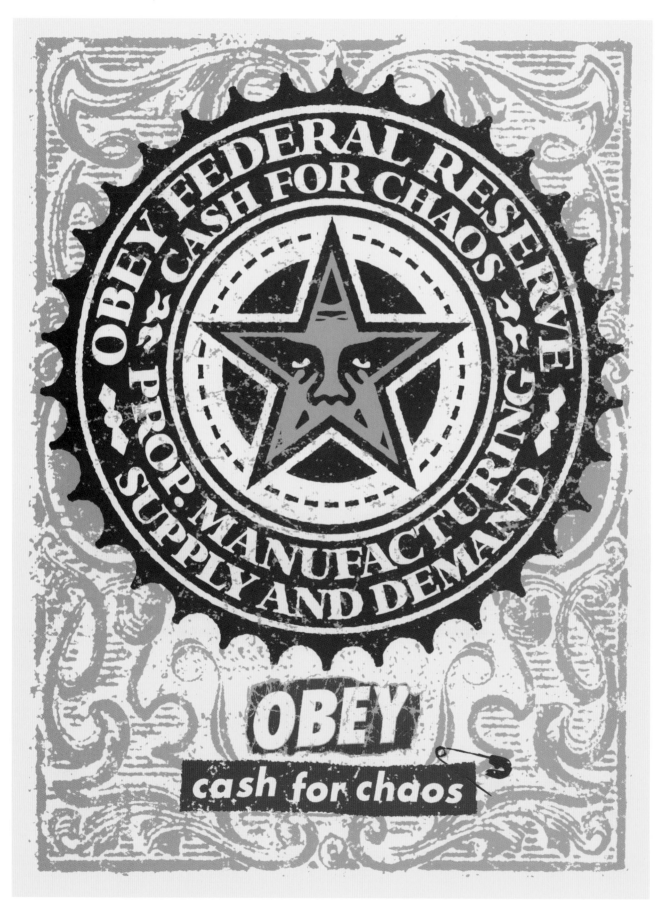

OBEY
cash for chaos

THIS IS YOUR GOD

SHEPARD FAIREY

The This is Your God show in 2003 at the Six Space gallery in downtown L.A. was an opportunity to showcase the sociopolitical message of the Obey campaign by paying homage to John Carpenter's *They Live*, which was a major source of inspiration and the basis for my use of the word "obey." The movie has a very strong message about the power of commercialism and the way that people are manipulated by advertising. One of my main concepts with the show (and the campaign as a whole) was that obedience is the most valuable currency. People rarely consider how much power they sacrifice by blindly following a self–serving corporation's marketing agenda, and how their spending habits reflect the direction in which they choose to transfer power. In *They Live*, the protagonist discovers hidden messages lurking behind billboards and anything commercial, and the money says "THIS IS YOUR GOD" on plain white paper. I designed a graphic that looked somewhat like real money but with that slogan, which we used for the invitations and a billboard I rented on the corner of Sunset and Hollywood to promote the show.

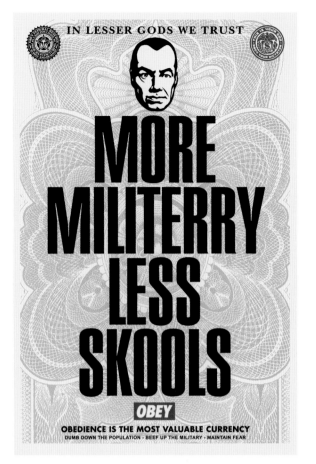

152.

151.

150. *Cash for Chaos,* 2001
(18 x 24") screen print on paper

151. *Obey Dollars,* 2003

152. *Obey More Militerry,* 2003
(25.5 x 36") screen print on paper

153. *Obey This is Your God,* 2003
(25.5 x 36") screen print on paper

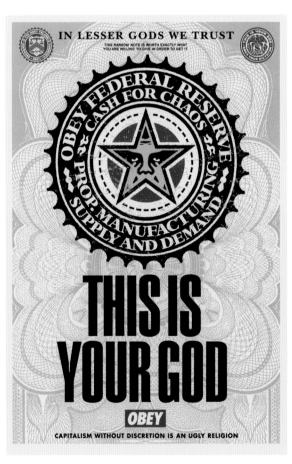

153.

154. Winston Smith did all of the graphic work for Dead Kennedys, a punk band that was a catalyst for me to start thinking about whether the government really had my best interests in mind. Their lyrics, stuff like "Cowboy Ronnie comes to town and forks out his tongue at human rights" and "the Peace Corps builds us labor camps when they think they're building schools," taught me a lot of things about U.S. foreign policy, puppet dictators, and government hypocrisy. Their music was an influence on me, and I always associated the art with it. I think Winston was the perfect person to make art for them, skewering the American Dream visually as much as Dead Kennedys did so musically.

Around 1995 or '96, I was driving in the South of Market area in San Francisco one day when I saw a black–and–white poster wheat–pasted to a pillar under the freeway. I never do this, but I just had to pull over and double–park so I could get out and take a photo of this image, since I'd never seen it before. When I got the photo back, I enlarged it on a photocopy machine and I put it up on my wall. It was at least a year or so later when I realized this image was part of a global graphic campaign. A friend of mine knew Shepard and kept telling me I had to meet him, but it wasn't till a couple of years later that Shepard and I met at the Culture Cache gallery in San Francisco and I was able to tell him how I'd acquired his image out of pure compulsion, long before I knew who did it or what it was part of. Shepard's images are so compelling and straightforward that they stand on their own graphically. (I was also able to show Shepard an image I'd made in the early 1980s of some young schoolchildren holding the American flag and one kid holding up a sign that says "OBEY," proving once again that twisted minds run on the same channels.)

– Winston Smith

154.

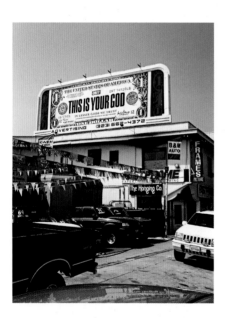

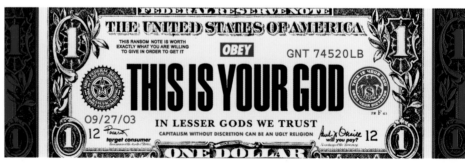

155.

154. **Dead Kennedys Album Sleeve,** 1981 (12.25 x 12.5") designed by Winston Smith

155. **Obey This is Your God Billboard,** 2003 (39' x 12'3")

156. **Obey This is Your God Dollar,** 2003 (18 x 24") screen print on paper

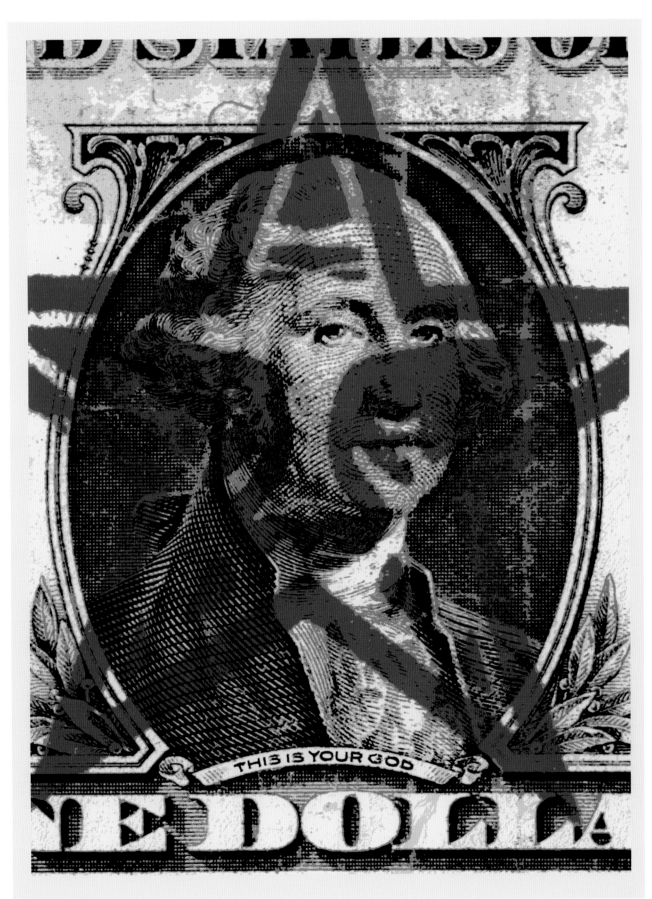

156.

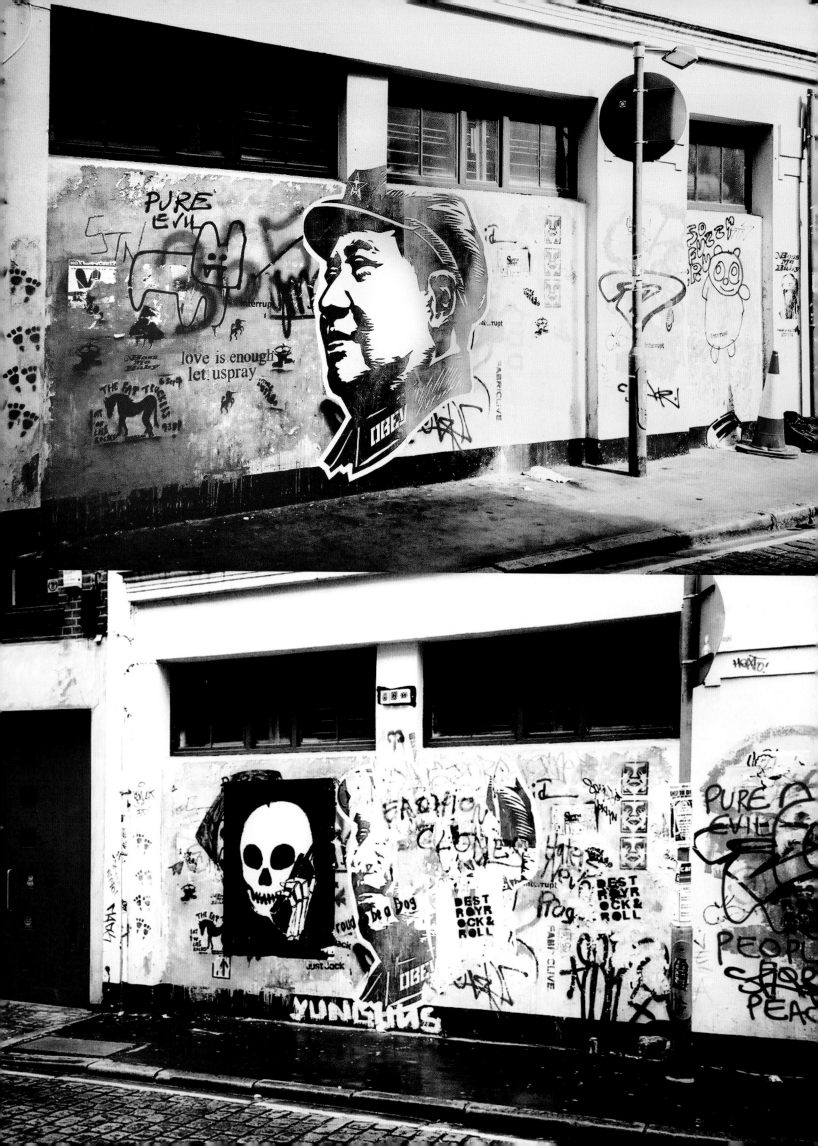

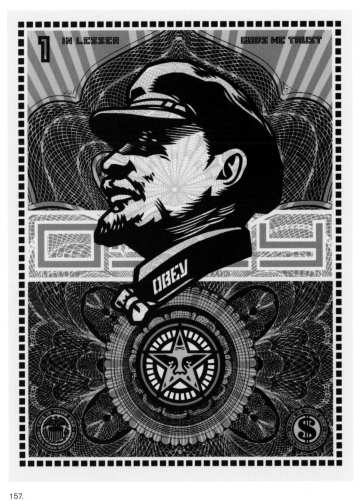

157.

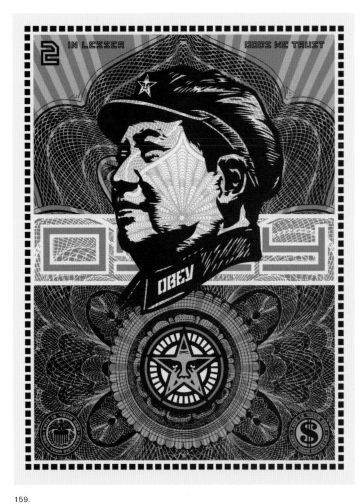

159.

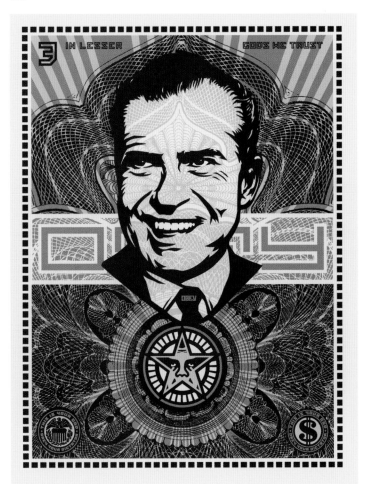

158.

157. **Obey Lenin Money,** 2003
(18 x 24") screen print on paper

158. **Obey Nixon Money,** 2003
(18 x 24") screen print on paper

159. **Obey Mao Money,** 2003
(18 x 24") screen print on paper

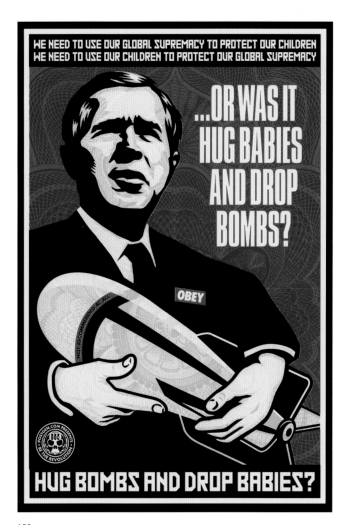

160.

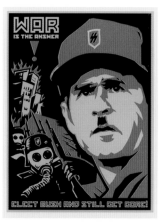

161.

162. I spent my senior year of high school at an art school in California. At one point we drove into L.A. for a big art fair, and as we drove around I kept seeing these posters on electrical boxes with an unflattering portrait of President Reagan (this was during the Iran Contra saga). I thought it was a cool painting and a clever use of wordplay. I had been excited by propaganda art before, but had never really seen much of it, and the experience planted a seed in my mind that eventually grew into the Obey campaign. The posters were the work of Robbie Conal, whom I had the privilege of working with on an anti–Bush campaign in 2004.

160. **Obey Bush Hug Bombs,** 2004
(24 x 36") lithograph

161. **Obey Bush One Hell of a Leader,**
2004 (18 x 24") screen print on paper

162. **Robbie Conal's "Contra Diction",**
1987 (18 x 24") screen print on paper

163. **Fear Bush,** 2003
(18 x 24") screen print on paper

164. **Obey New World Odor,** 2004
(18 x 24") screen print on paper

165. **Obey New World Odor Collage,**
2005 (30 x 44") Spray paint stencil and
collage on paper

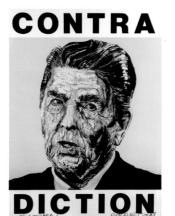

162.

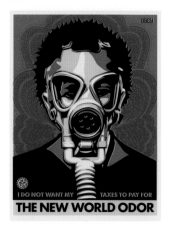

163.

164.

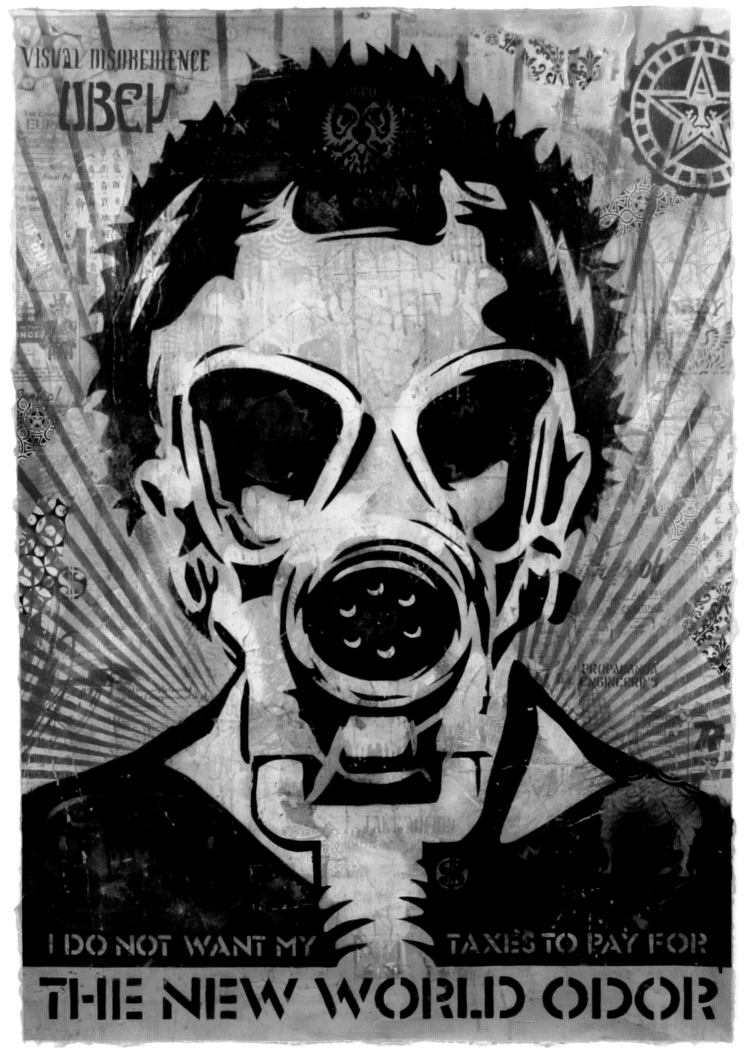

165.

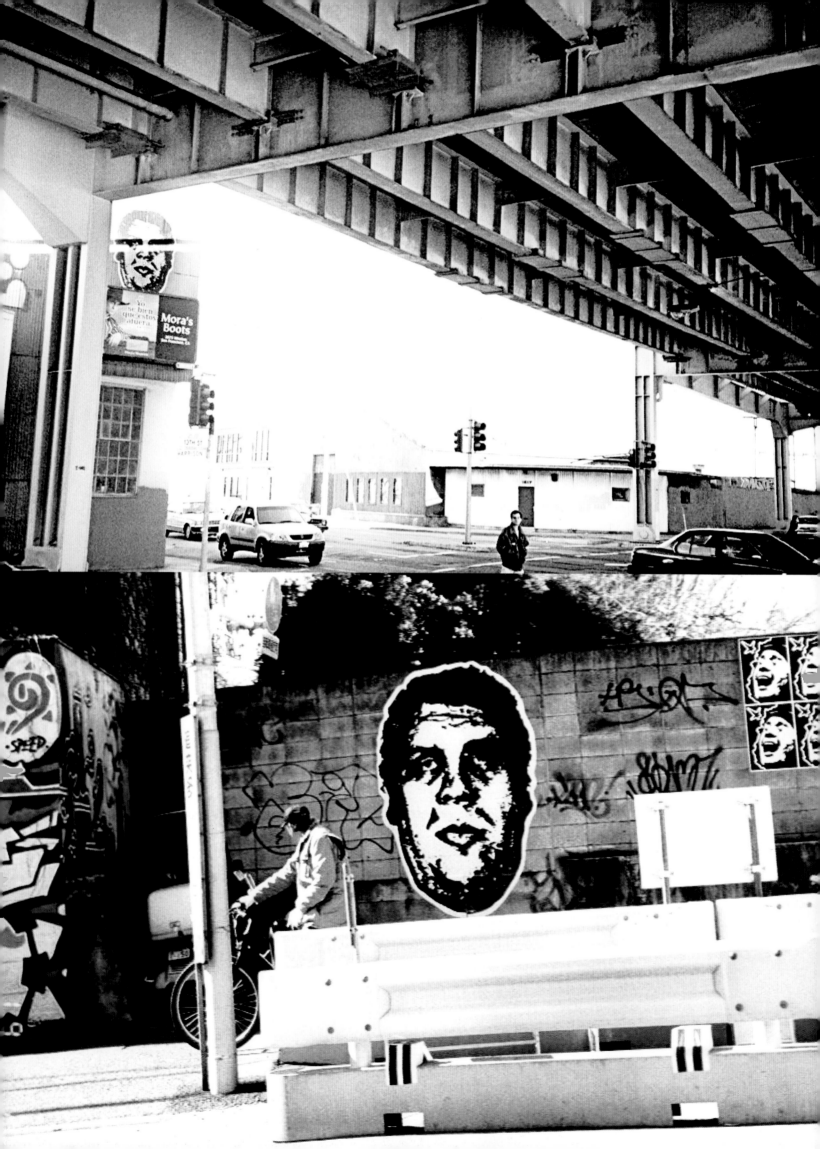

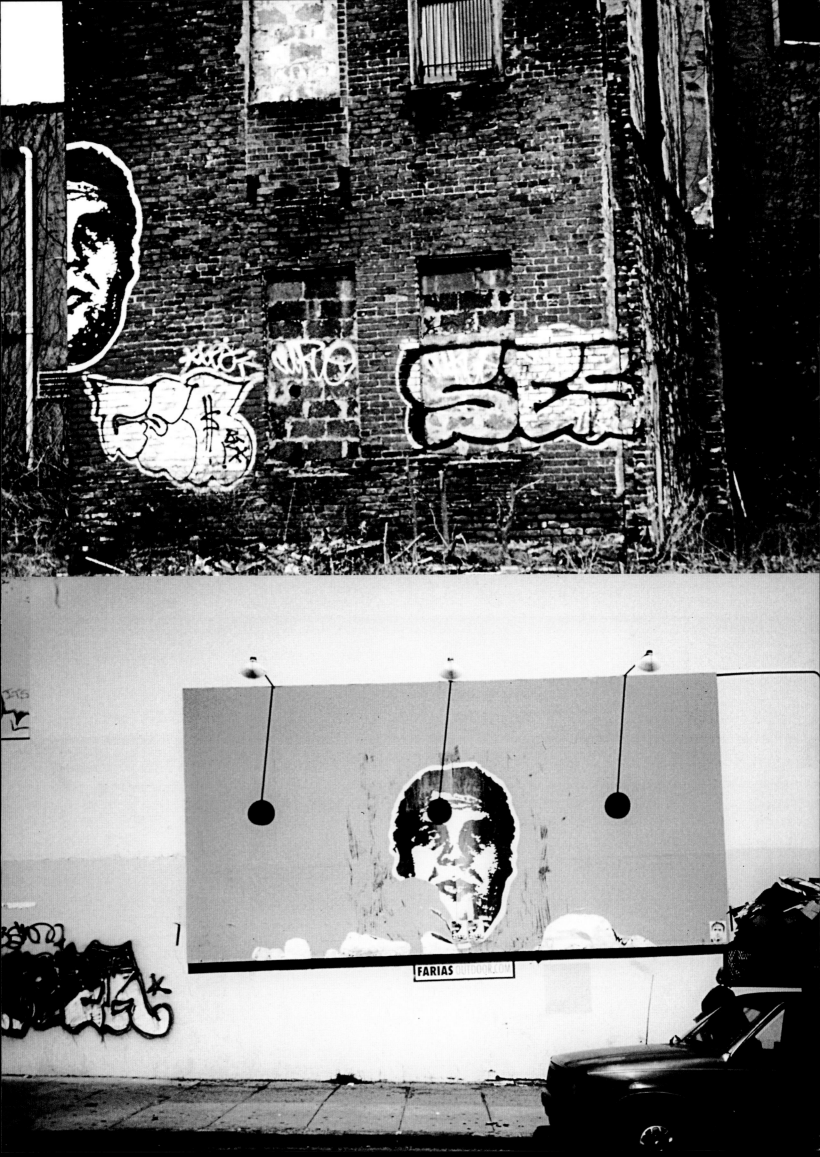

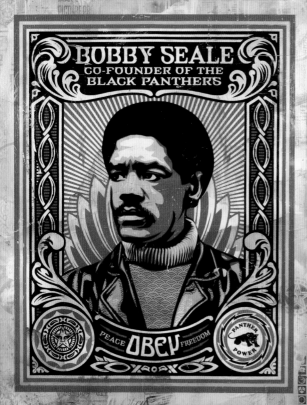

166.

1968. In 1969, Seale, as one of the "Chicago Eight," was charged with conspiracy to incite riots during the 1968 Democratic National Convention. Seale was bound and gagged for his courtroom outbursts during the trial, but the charges were ultimately dropped. In 1970, he was tried for the torture/murder of former Panther Alex Rackley. That trial ended in a hung jury; afterward, Seale moderated his militant views, leaving the Panthers altogether in 1974.

SHEPARD'S COMMENTS

Prior to reading Seale's book *Seize the Time*, I believed the hype and thought the Black Panthers were whitey–haters with a cool logo and cool outfits. The book gives a human side to the Panthers, chronicling black life in Oakland and the need for an organization to protect blacks from racist police and institute social programs the local government was not providing. Seale clearly stated that not all whites are the enemy, and though whites were not accepted in the organization because the black community needed black role models, white donations were graciously accepted. Seale also addressed the problems of having members joining for rebel status and others wanting the perks but not the workload. The Panthers had a positive idea, but couldn't withstand the strain of external oppression and infighting.

NOAM CHOMSKY

WORKERS' RIGHTS ACTIVIST

Noam Chomsky is widely considered one of the preeminent thinkers of the past 50 years thanks to his diverse range of study, from cognitive psychology and linguistics to politics. Raised in Philadelphia, he attended the University of Pennsylvania, where he received his PhD in Linguistics in 1955. Shortly thereafter, Chomsky joined the staff of the Massachusetts Institute of Technology, and in 1961 was appointed full professor in the Department of Modern Languages and Linguistics (now the Department of Linguistics and Philosophy). Chomsky has written and lectured widely on linguistics, philosophy, intellectual history, contemporary issues, international affairs, and U.S. foreign policy.

SHEPARD'S COMMENTS

Reading Chomsky's resume is intimidating, but his articles, books, and lectures are actually incredibly accessible. Being an expert in linguistics allows Chomsky to not only explain complex issues very clearly in simple language, but also see through doublespeak and language used as a form of deception and manipulation. Chomsky thoroughly understands that politicians and big businesses

166. *Obey Seale,* 2004
(35 x 47") mixed media and collage on paper

167. *Obey Chomsky,* 2004
(35 x 47") mixed media and collage on paper

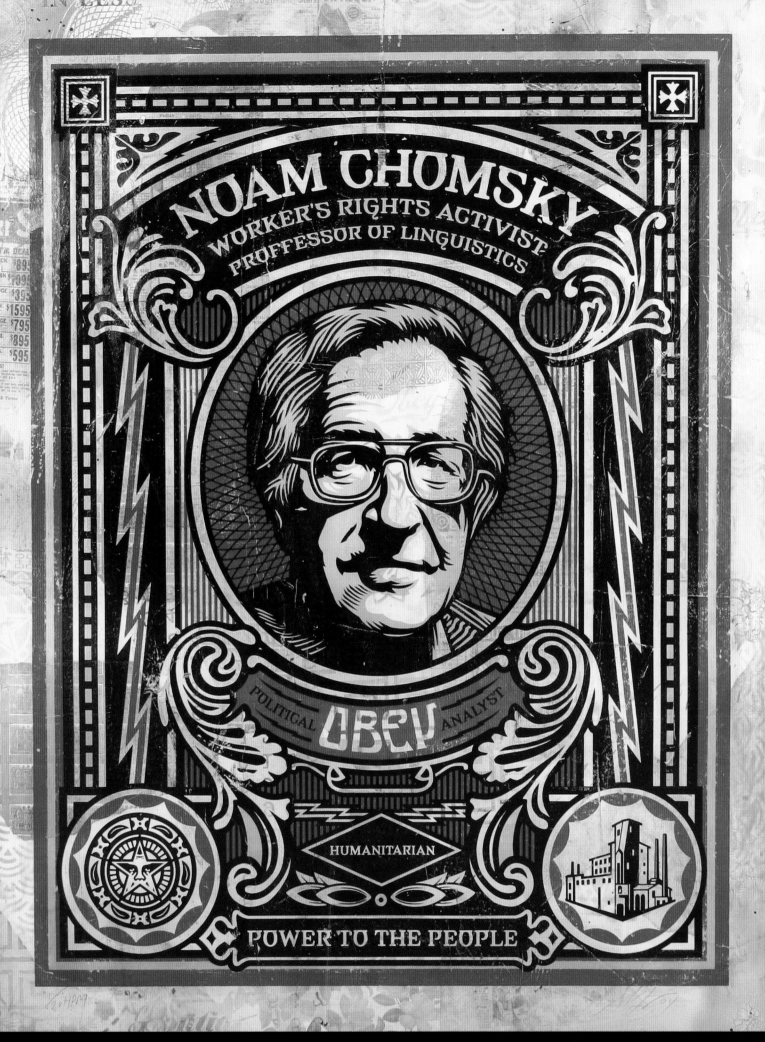

NOAM CHOMSKY
WORKER'S RIGHTS ACTIVIST
PROFFESSOR OF LINGUISTICS

POLITICAL OBEY ANALYST

HUMANITARIAN

POWER TO THE PEOPLE

167.

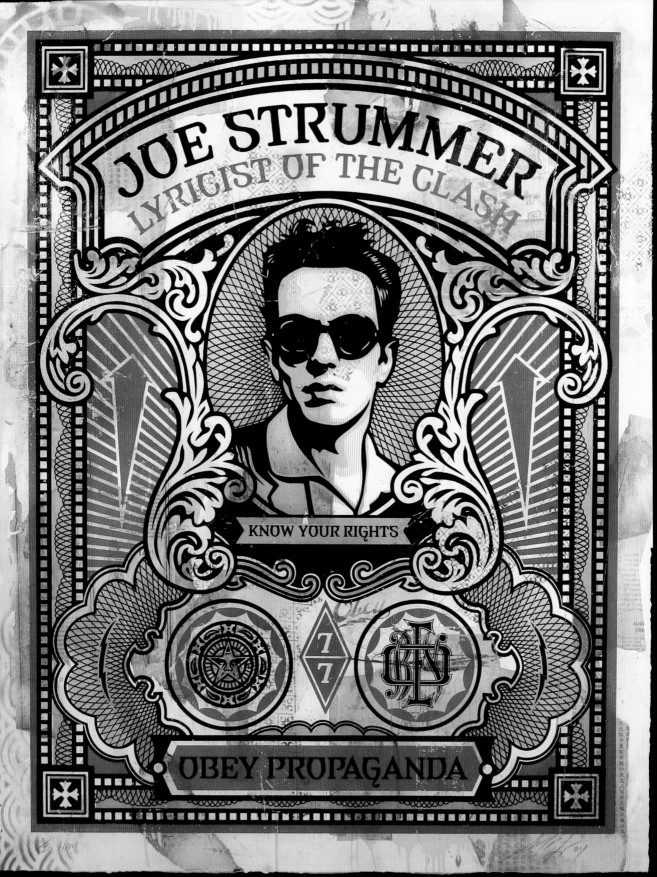

cal palette with his fondness for reggae and early rock, and his signature bellow lent an impassioned urgency to the political sloganeering that filled his songs. They attracted a growing following with songs like "Clash City Rockers" and "White Man in Hammersmith Palais," railing against unemployment and social inequality, but the band really announced itself to the world with the rallying cry "London Calling." The Clash ultimately dissolved over disagreements about musical direction in the mid '80s. Strummer rediscovered his passion for music in the late '90s and formed the Mescaleros, who were working on a third album when he died of a heart attack in 2002.

SHEPARD'S COMMENTS

The Clash, especially Joe Strummer, proved to me that it was possible to be cool and socially conscious. With great art, music, fashion, and ideals, they were incredibly well rounded role models. They earned the title of "the only group that matters." I play a Clash song every time I DJ, and with their diversity there is something that works for every crowd.

BOB MARLEY

MUSICIAN & HUMAN RIGHTS ACTIVIST

Bob Marley was more than just a reggae musician, though he was by far the most important and influential individual in reggae history; Marley used his fame to advocate peace and spread the teachings of his Rastafarian religion. Born in the tiny, impoverished island nation of Jamaica in 1945, many of his songs dealt with the hardships of the poor and the eternal struggle for universal freedom. After a decade of work, he and his band, the Wailers, achieved international success in 1975 with the *Natty Dread* album and the single "No Woman, No Cry." In 1979, they played to record–breaking crowds on their European tour and subsequently began an American tour, though Marley became seriously ill after only two shows and the tour was cancelled. Marley eventually succumbed to cancer in 1981.

SHEPARD'S COMMENTS

I bought Bob Marley's *Rastaman Vibrations* shortly after I started skateboarding in 1984, purely because the only good skateboard ramp where I lived was called "The Rasta Ramp." I had mostly been listening to punk rock, but I was excited to discover reggae, which even more boldly embodied many of the same elements of social protest as punk but in a way that was much more palatable to my parents. I think my parents bought me Bob Marley and the

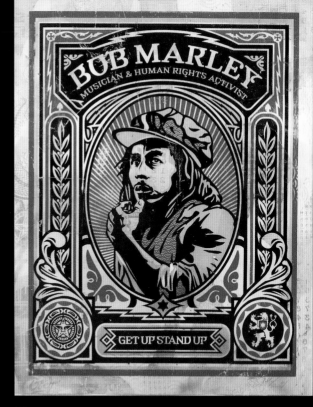

169.

168. *Obey Strummer,* 2004
(35 x 47") mixed media and collage on paper

169. *Obey Marley,* 2004
(35 x 47") mixed media and collage on paper

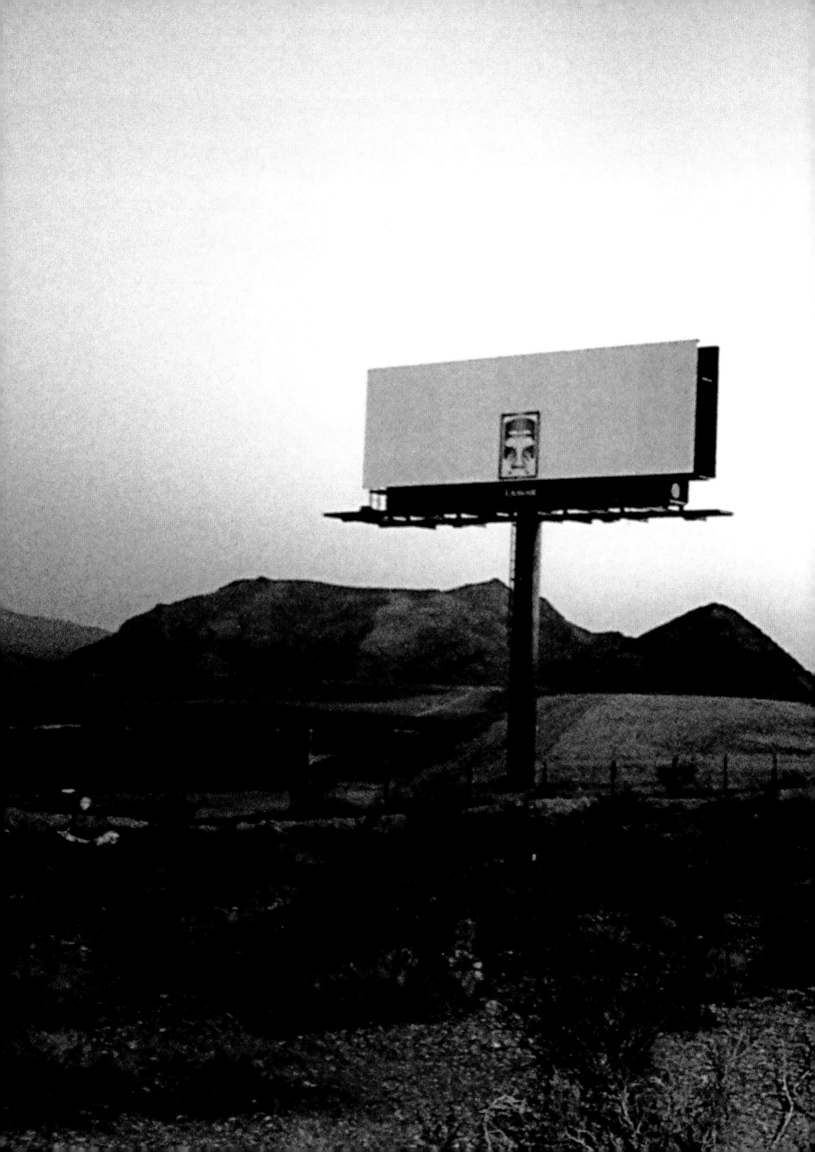

170. When I went to Hong Kong in 2001, I bought a propaganda booklet that Chairman Mao had issued to every household, and it was just two-color spot printing, black and red on off-white paper. A lot of the graphics were just red on off-white, but they were very striking. I decided to challenge myself to create such strong images while restricting myself to work in one color like that. I did a few different images in that format, and it seemed to really befit powerful seals and symbols such as this wreath.

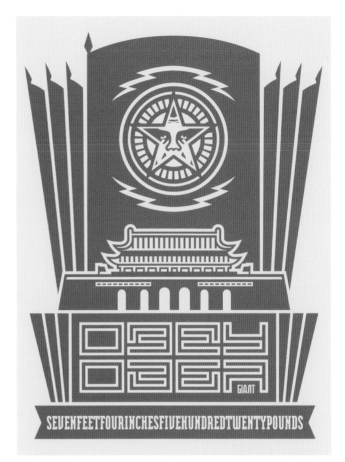

172.

171.

170. **Giant Wreath,** 2001
(18 x 24") screen print on paper

171. **Obey Star Sticker,** 2001
(2.5") screen print on vinyl

172. **China Banner 2,** 2004
(18 x 24") screen print on paper

173. **China Banner,** 2001
(18 x 24") screen print on paper

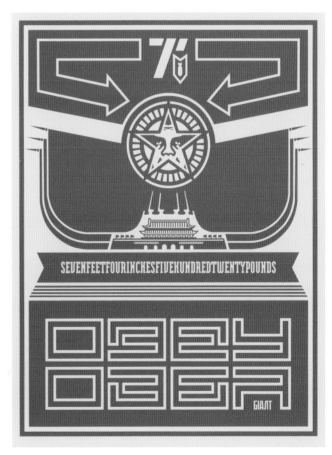

173.

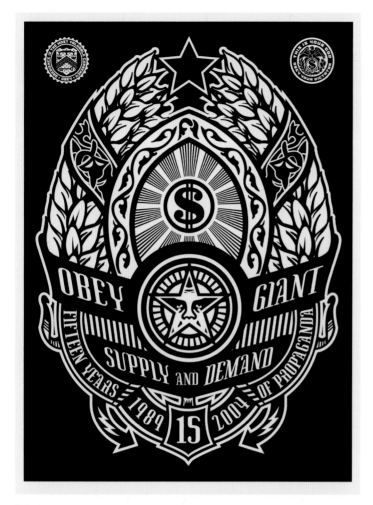

174.

176.

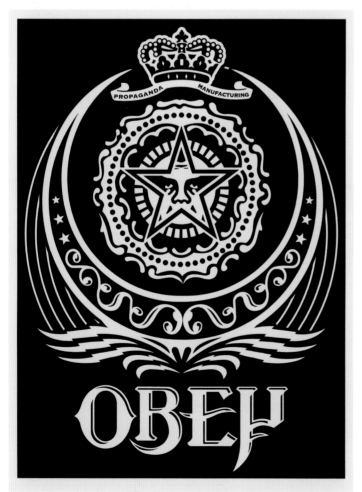

175.

174. **Supply and Demand Black,**
2004 (18 x 24") screen print on paper

175. **Obey Ankara Black,** 2005
(18 x 24") screen print on paper

176. **Obey Lions,** 2004
(18 x 24") screen print on paper

177. **Public Works Medal,** 2004
(18 x 24") screen print on paper

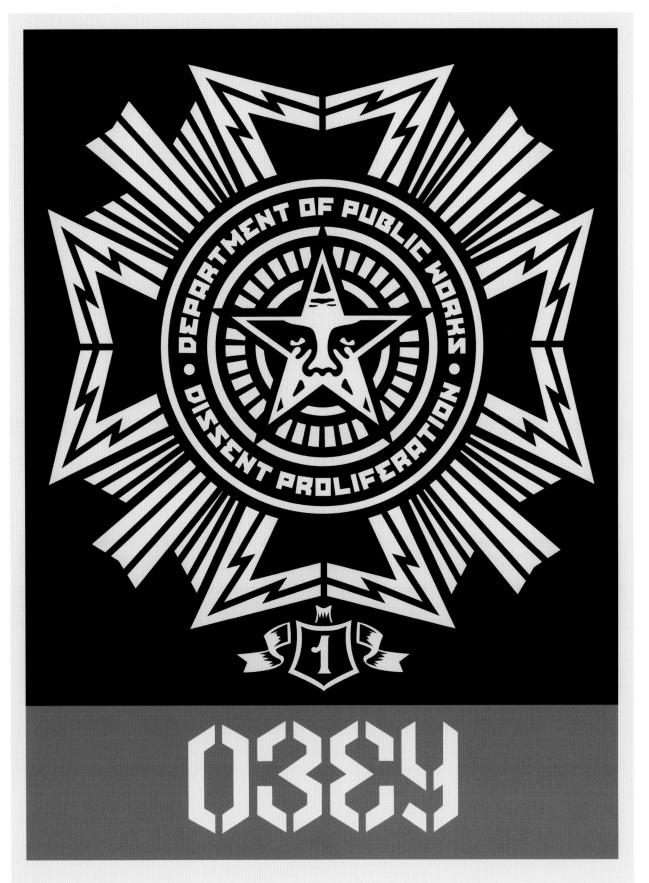

177.

178. **Lesser Gods Eagle,** 2003
(18 x 24") screen print on paper

179. **Bureau of Public Works,** 2004
(18 x 24") screen print on paper

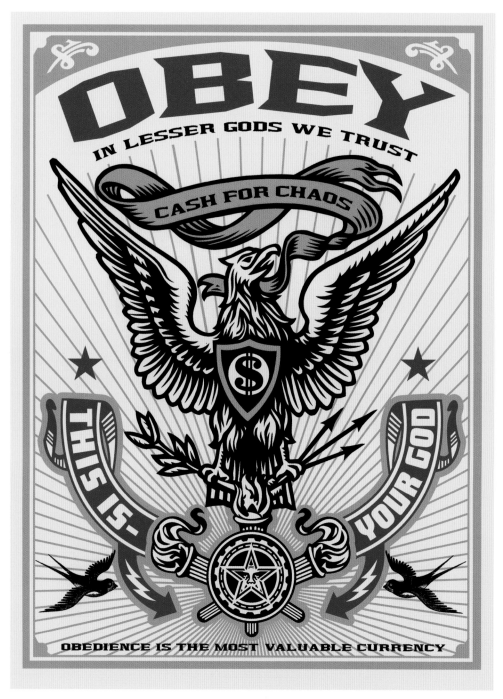

178.

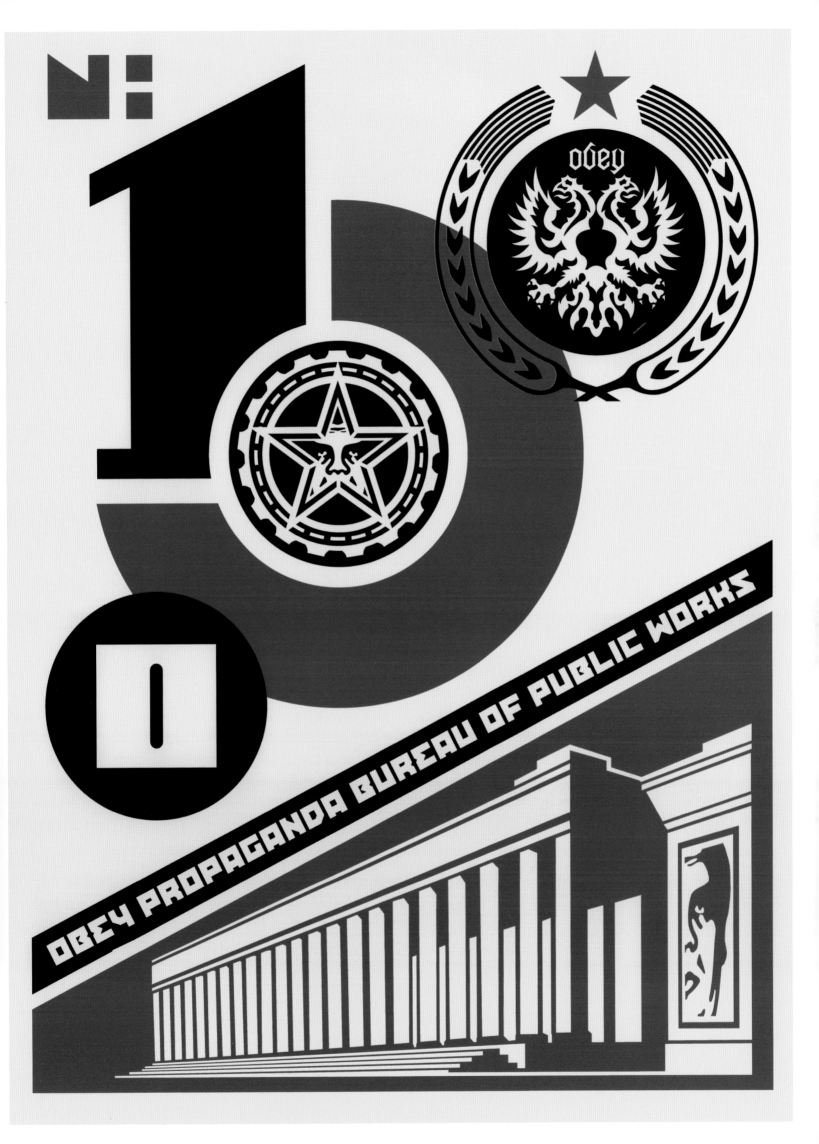

OBEY PROPAGANDA BUREAU OF PUBLIC WORKS

THE MEDIUM IS THE MESSAGE

THE MEDIUM IS THE MESSAGE

Shepard Fairey

When people look at my body of work and hear me talk about how "the medium is the message," they often perceive a calculated, premeditated attempt to create visual discord in the public eye–space. Although the Obey campaign has taken that shape, it was really a slow snowballing of ideas that meshed with my general belief that people should not submit to any attempts to herd and manipulate them. It actually started out completely by accident, with an innocuous attempt to get a few laughs and maybe a little recognition out of a silly sticker that was completely incongruous with any environment. I approached it with the punk–rock mentality that if the sticker pissed anyone off, they would be people who deserved to be offended, because they were the ones pissing me off with their authoritarian principles. I didn't do it with the intention of agitating people or making them question it, but it didn't take long to see those effects taking place.

The year after I made the first sticker, I was taking a course called "Dwelling Place and Environment," aimed at fostering an understanding of how our surroundings affect us. The professor encouraged us to look at it from the vantage point of our majors, and mine was illustration. I was having such a good time putting up the stickers, and in doing so I observed some interesting sociological phenomena, so I decided to use the sticker campaign as the basis for my first paper. One of the first things I came across in my research that seemed to fit with what I was doing was Heidegger's concept of phenomenology. The way I interpreted it, people become numb to their environment, and they need certain experiences to snap them out of their trance. One of Heidegger's analogies was that a hammer isn't a hammer because it looks like a hammer; it's a hammer because it hammers things. Things are defined by their function, not their face value, but people rarely think that way. I felt that people didn't really question things and thus allowed themselves to be manipulated by advertising and other social structures, and the idea of phenomenology, re-awakening a sense of wonder about one's environment, seemed to be the effect that my stickers had been having. I've always believed more in experience itself than theory. Theory was always a way for me to validate my experience, rather than trying to find the experience to validate a theory, so that's why I was initially captivated by phenomenology.

For me, what was really eye–opening was that once I started trying to be more analytical, looking at things within a broader context than just the here–and–now, it caused a chain reaction, where one thing I noticed led to another and another and another, and it was almost like going from being completely blind to being hyper–aware. I wanted to find out if anybody had done any empirical studies of the things I was observing and experiencing with the sticker campaign. One of the things I really liked about phenomenology was that it doesn't have to attack anything specific. I liked the idea of the sticker campaign being very open–ended, just serving to trigger dialogue. I felt that people want to come to their own epiphanies and reject ideas that are forced upon them, so when they choose to analyze and come to their own conclusion it's a little

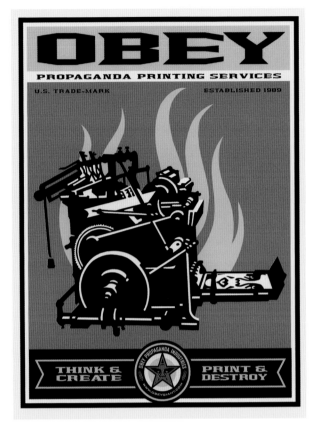

180.

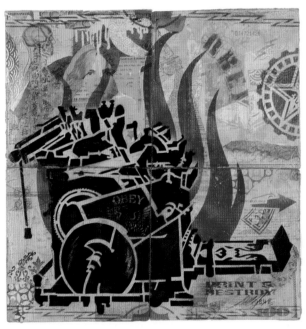

181.

180. ***Print and Destroy,*** 2000
(18 x 24") screen print on paper

181. ***Print and Destroy 4–Album Stencil,*** 2005 (24.5 x 25") spray paint stencil and collage on albums

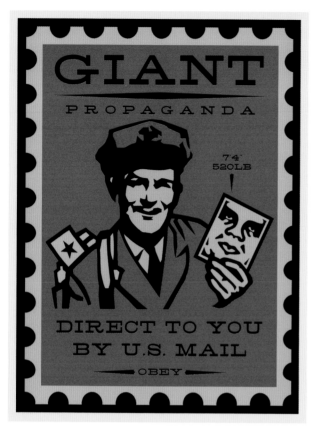

182.

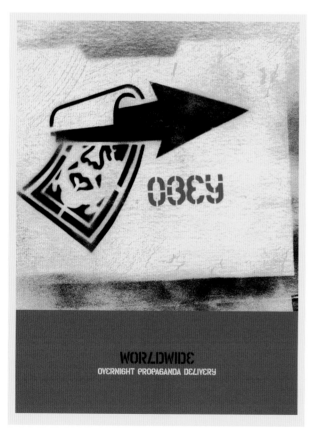

183.

personal victory, and I liked that phenomenology wasn't so didactic.

To me, the concept of the Situationists really connects with phenomenology. They believed that people's lives have become boring and people don't really question their condition as human domesticated livestock, and situations need to be created that snap people out of their boring day–to–day routine. The Situationists felt that art should be revolutionary and it should be a part of everyday life, and that's a major rationale behind street art. Malcolm McLaren and Jamie Reid were both big fans of the Situationists. I never realized that my love for the Sex Pistols and my interest in Heidegger were so closely linked. Sometimes you have to shake things up to see where everyone stands.

With Andre the Giant, several things fascinated me about him. For one, he's very distinctive–looking. When you're talking about a visual project, it has to be something memorable. Then there's the Rorschach test facet: any interpretation of an ambiguous image, whether it's an inkblot or a professional wrestler, is a reflection of someone's personality. That was very important to me. I felt like Andre sat in a very ambiguous zone where from one person's perspective he might be ugly, sinister, and scary, but from another perspective he's goofy and benevolent. In real life he had a disease that made him extremely big, and he was ridiculed in his hometown, but when he left the town he said, "When I come back I'm gonna be in a limo," and he did just that. He turned what a lot of people thought was a setback into an asset. A really important concept in my project is the idea of creating something from nothing, that no one is powerless, that without the greatest of resources you can still build something, and Andre is a good metaphor for that.

I use Marshall McLuhan's phrase "the medium is the message" in a lot of my work, especially street art. With street art, there's no committee deciding whether I can put my work up on the street, there's no censorship, and I have total freedom of expression, and that concept of freedom is expressed just by using the street as a medium. The methods I employ to apply the work to the street—stencils, stickers, and wheat paste—are really easy to use, and are generally associated with some sort of protest or rebellion. I associate "the medium is the message" with that street work, because the mere act of putting something up on the street is a defiant one: it shows that you're not willing to bow to the system. On top of that, the content can deliver another message, but purely the act in and of itself sends a message of defiance. I think McLuhan used the phrase to describe how communication systems affect the way people communicate. He called the TV and the telephone extensions of people's nervous systems, because they transmit messages but do so in a way where the features and limitations of the medium itself really start to affect the content. Corporations that control certain media have a huge voice that affects everyone else and drowns out every other voice, but with my project I'm saying that the individual can still make a strong impact and have a voice, it's just a matter of taking control of a medium.

People often feel like they don't have a voice because it requires some complex technical apparatus, whether they believe they need to have an inside connection at a TV station, or they think they can't print their own materials because that has to be done by an expensive machine that they can't afford. The methods I've used to get my work out to the public are accessible to anyone, and I think it's really important for people to realize that they're not powerless. A Xeroxed poster campaign can be incredibly effective and really cheap. There's an old saying that "freedom of the press is guaranteed to anyone who owns a printing press." But I didn't have a big old linotype machine; I started off just

182. *Giant Mailman,* 2000
(18 x 24") screen print on paper

183. *Obey Worldwide Delivery,* 2002
(18 x 24") screen print on paper

184. *Welcome Signs,* 1992

185. *Obey Altoids,* 1997

184. In '92, the summer after I graduated from college, my parents gave me $1,000 and told me to take some time off and do some traveling, so I decided to drive with my girlfriend from Boston to Miami and back, putting stickers up all along the way. Every time we came to a "welcome" state sign, we stopped and put a 12 x 12" sticker on the sign. I didn't know if people would notice the stickers as they drove past, since the stickers were so small relative to the lettering. Later that summer, a friend in New York City called me and said he saw one of the stickers on the news. Apparently Connecticut had legalized some casinos, and the reporter delivering the story stood under the "Connecticut Welcomes You" sign, right below the Andre sticker. A lot of what I do is about secondary impressions, affecting not only the people who see the sign in person, but also the people who see the sign on the news or wherever else it might appear. It's definitely a coup to be able to make something seem larger than it actually is.

185.

184.

185. The Altoids robot ad was a backlit poster inside a Plexiglas case facing out of a phone booth. I noticed that one of my stickers was almost the same size as the Altoids box in the ad, but I didn't want to just put it on top of the Plexiglas. A guy nearby was working outside a shop, so I borrowed a screwdriver from him, opened up the case, and put the sticker over the Altoids box. It was subtle enough that the sticker stayed there for a long time, but I essentially changed the entire meaning of the ad with that one little sticker.

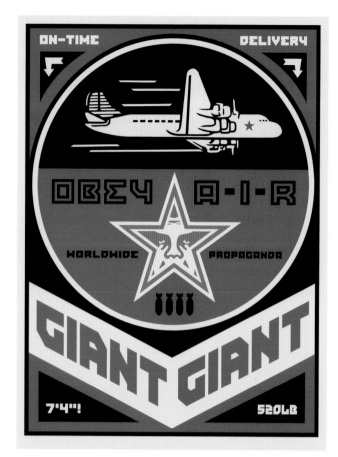

186.

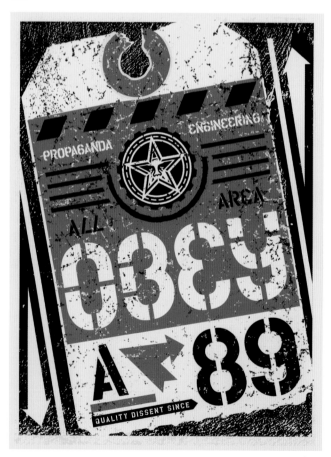

187.

using a Xerox machine and sticker paper and later moved up to screen–printing. If I hadn't learned screen–printing, I probably wouldn't be where I am now. I made stencils all along, since high school. The Internet has really leveled the playing field now, because most people have a computer and can build a website, and it's probably cheaper than a lot of the methods I used. It's great to see people generating new forms of media, because it just gives you more freedom to choose a fitting outlet for your voice.

Since every method of communication is loaded and lends itself to a particular slant, the medium you choose also affects the way people hear your voice. Something seen on a billboard is going to be seen as advertising, because that's what's usually there. Something in a gallery is generally going to be perceived as precious and potentially elitist or snooty, because you have to go through a process of submission and acceptance to get into a gallery. Both media come with preconceived ideas. Street art is accessible because of location and because people don't know if it's supposed to be an advertisement, a political statement, if it's art for the hell of it, if it's gang–related, or what, so they're prompted to scrutinize it. Street art raises a lot of questions about where the message comes from and what it means, and making people question things and creating an exchange of ideas is a lot stronger than delivering something predictable.

188.

186. **Obey Air,** 2000
(18 x 24") screen print on paper

187. **Obey Luggage Tag,** 2001
(18 x 24") screen print on paper

188. **Giant Airlines Stickers,** 2000
(2.5") screen print on vinyl

189. **Giant Airlines,** 2000
(18 x 24") screen print on paper

LOOMING SINCE 89

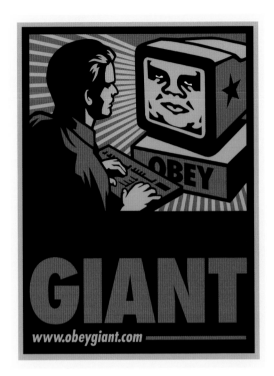

191.

192.

191. I made this poster not long after I created my website. I had always felt like sitting in front of a computer was a waste of time and the Internet was for geeks, and I had never been a big TV watcher either, so I had his concept of people being hypnotized by a screen. At the same time, I came to realize that the Internet is a great tool for information, and it really helped me be more independent and self–sufficient, allowing me to handle my own sales and not have to hound stores for money. This poster kind of makes fun of the idea that Big Brother is behind the screen, hypnotizing you, yet he's also promoting my website in the process.

190. **Obey Loom,** 2000
(18 x 24") screen print on paper

191. **www.obeygiant.com,** 1999
(18 x 24") screen print on paper

192. **Obey Conveyor Stencil,** 2002
(12.25 x 12.5") spray paint stencil and collage on album

193. **Alife Repetition,** 2000
(18 x 24") screen print on paper

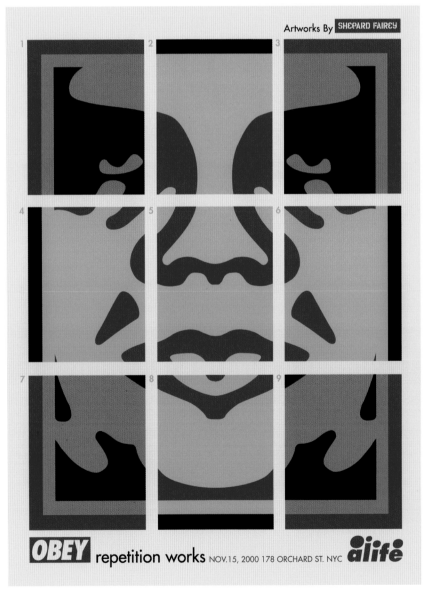

193.

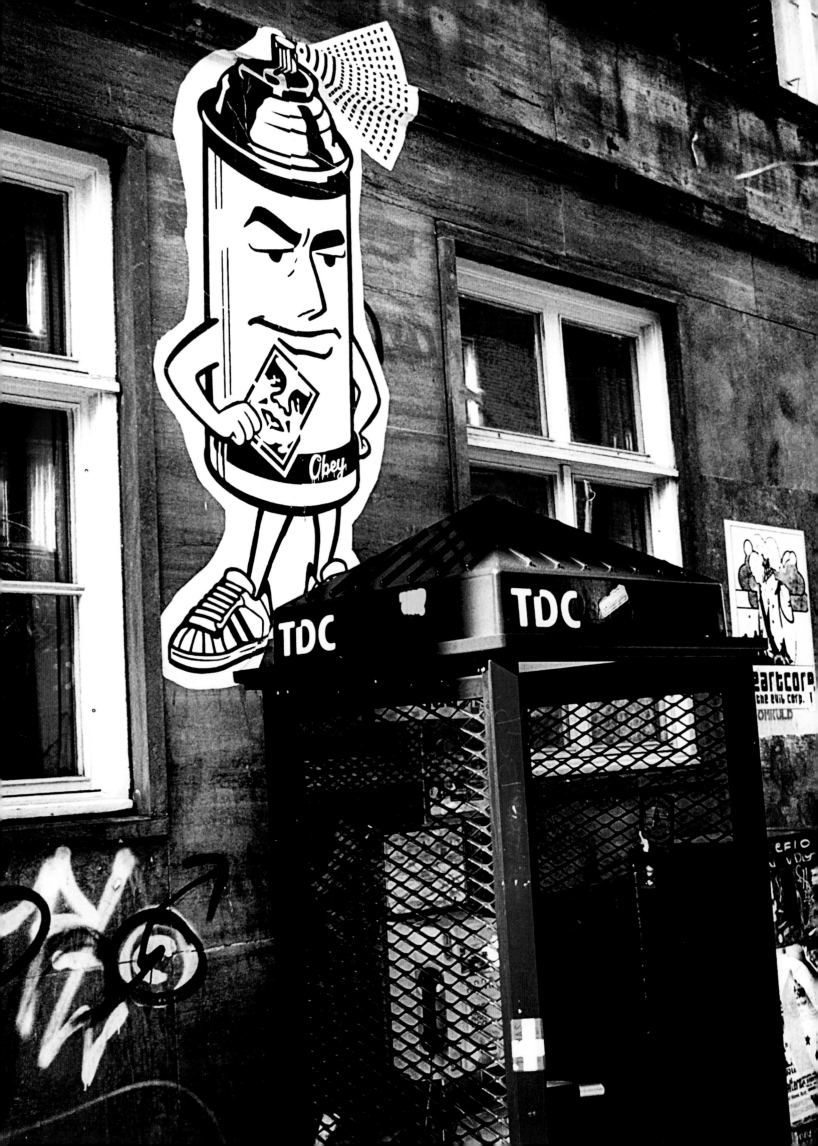

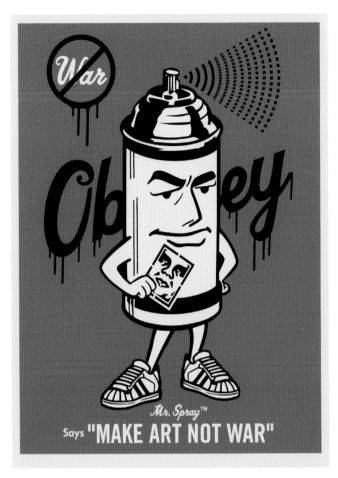

194.

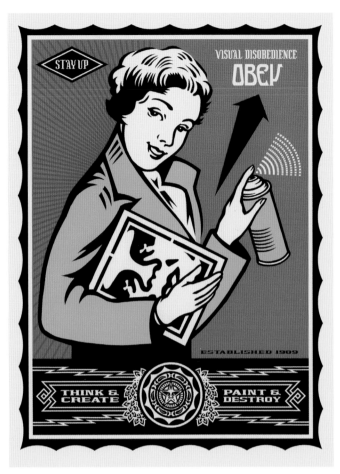

195.

194. **Mr. Spray,** 2004
(18 x 24") screen print on paper

195. **Stay Up Girl,** 2004
(18 x 24") screen print on paper

196. **Stay Up,** 2005
(18 x 24") screen print on paper

197. **Obey Runs Drips,** 1999
(18 x 24") screen print on paper

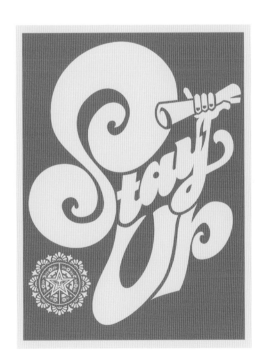

196.

197.

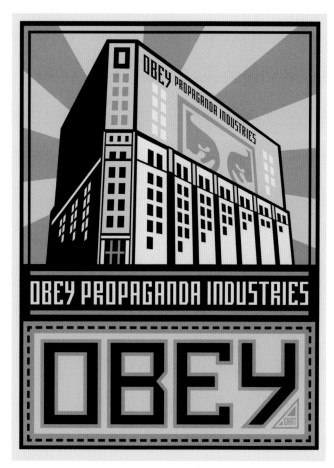

198.

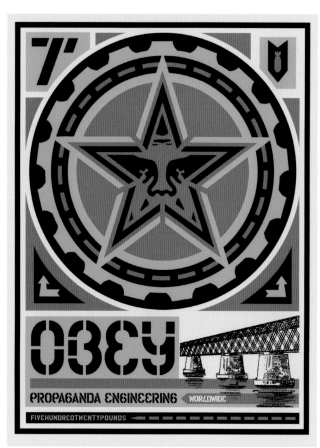

199.

198, 201. Production is the root of success of almost any movement or business entity. Without the ability to disseminate information or products, an organization or business is rendered power-less. Fortunately, access to mass production is almost universal these days. One way to guarantee freedom of the press is to own one (a press). The impact I have made with little money, using Xerox, screen–printing, and offset printing, should be encouraging to anyone who feels they can't make an impact in the face of the main-stream media and their powerful corporate sponsors.

Ingenuity can overcome a lack of cash. I've made 2.5 million stickers, 45 thousand posters, and thousands of spray paint stencils, by producing the stuff myself, bartering, or reinvesting money from posters sold. I know I've got-ten more mileage from my money than any corporation.

200.

198. **Obey Propaganda Industries,** 2001 (18 x 24") screen print on paper

199. **Obey Propaganda Engineering,** 2000 (18 x 24") screen print on paper

200. **Obey Phenomenology Album,** 2005 (12.25 x 12.5") spray paint stencil and collage on album

201. **Obey Factory,** 2000 (18 x 24") screen print on paper

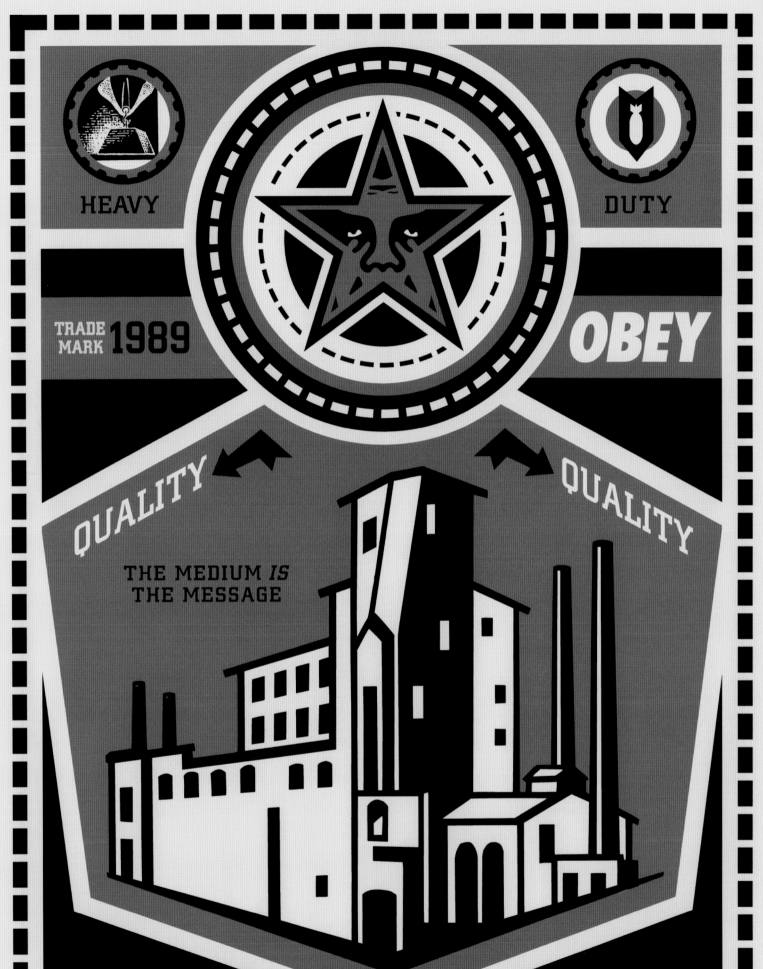

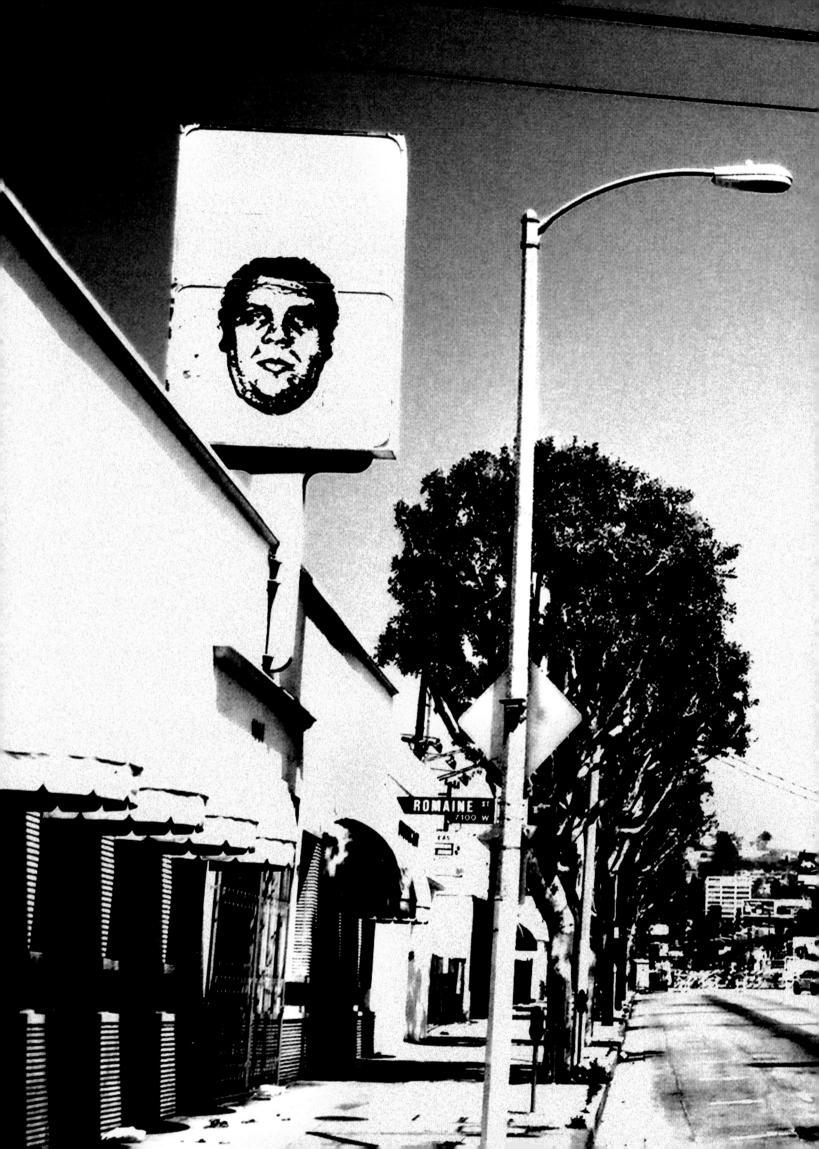

I like your idea of the posters so when ever i see one of
yours i will put mine over it cool huh well it s called kill
the giant so i dare u to put that shit up in scripps ranch
you loser it cool how people have to by your posters so you
can take credit

Greetings Shepard,

I am an individual associated with the "Disobey Giant Proj-
ect". We are a group of souls dedicated to wiping out the
"Obey Giant" industries. We work towards removing all "Gi-
ant" posters, and also replacing them with our own design
that we have formulated. This new design we call the"Disobey
Giant Project".

Word of our corporation is spreading amongst San Diego quite
rapidly. We are preparing to unvail our new industry within
weeks to come. My associate Phong and myself will, and I
mean WILL, wipe out the "Giant" organization in a matter of
weeks. This I am sure of.

We have the support of many of the youth of San Diego, and
they have agreed to assist us in overtaking your company.
I wish you the best of luck in your business ventures, al-
though at the rate we are at now that will fail to serve you
any purpose.

My Best Wishes To You And Your Company

******Reply If You Wish******

Dear Editor,

Our organization has recently posted a site relating to
graffiti and we would like to make a request for our site to
be placed on your links page. We are currently working on
our links page and think an exchange between both of our
sites would be benefitial. Although we are an anti-graffiti
organization, we plan to have a very diversified links page,
with about a 50/50 ratio of pro and anti graffiti links.
Please view our site and give us some feedback. The url is:

http://www.stopgraffiti.org

Thank you, and I hope you will take our request into consid-
eration.

Sincerely,

The Graffiti Abatement Task Force
topgraffiti@disinfo.net

Graffiti Folks,
I appreciate your request for a link but my site isn't
about graffiti so a link wouldn't make sense. Also you are
misinformed about alot of your connections between graffiti
and gang activity and your attempts to decode are inaccu-
rate. Though I don't approve of graffiti on private prop-
erty, I think it's nice to look at it in certain places like
along railway lines and in drainage ditches. There are many
battles one can fight in life and I think your energy is mis-
placed. No disrespect,

-Shepard Fairey

202.

203.

202. **Old-School Pasters,** 2001
(18 x 24") screen print on paper

203. **Giant Japan Stencil,** 2001
(18 x 24") screen print on paper

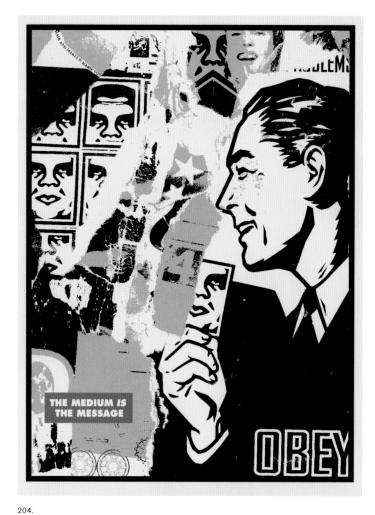

204.

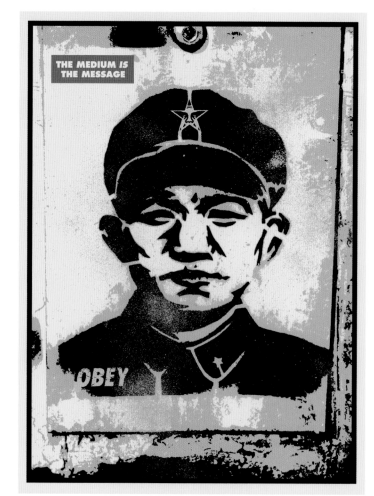

206.

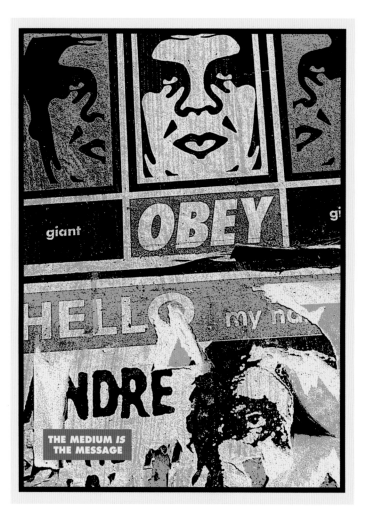

205.

204. ***Obey Obedience Collage,***
2000 (18 x 24") screen print on paper

205. ***Obey Hello Collage,*** 2000
(18 x 24") screen print on paper

206. ***Obey Chinese Stencil,*** 2000
(18 x 24") screen print on paper

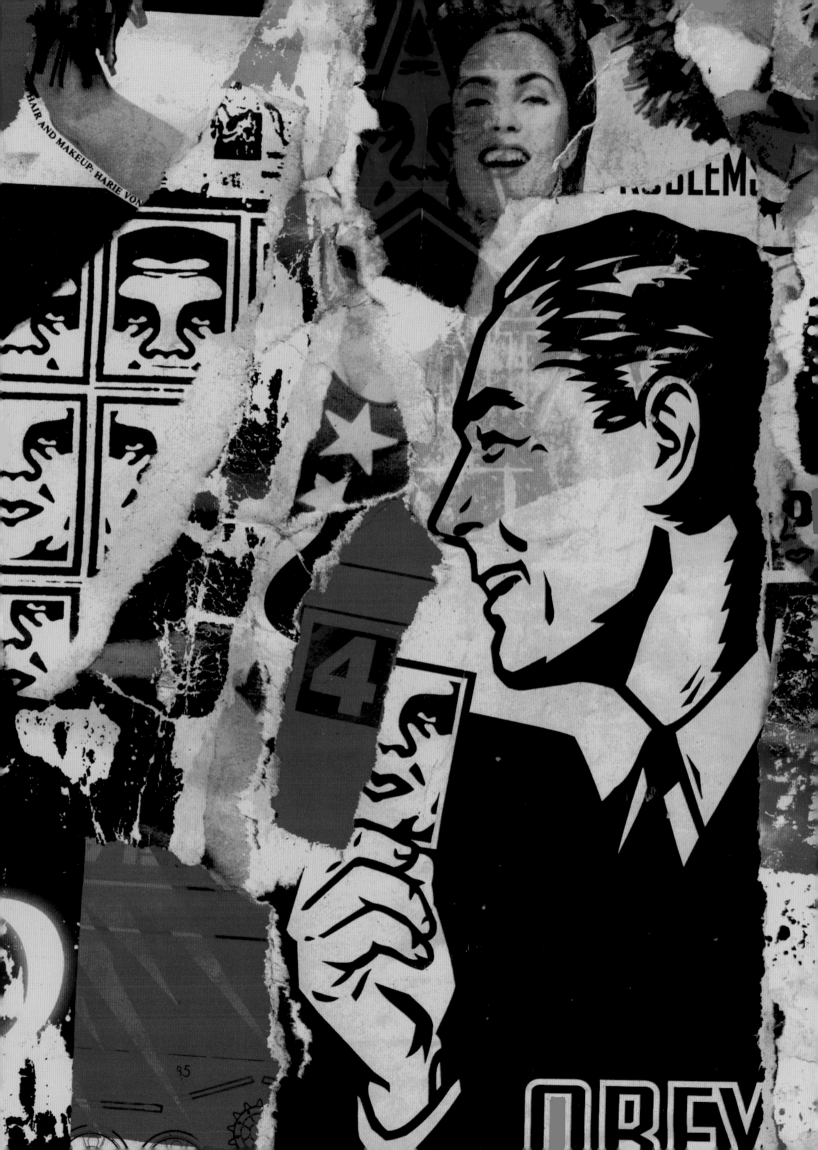

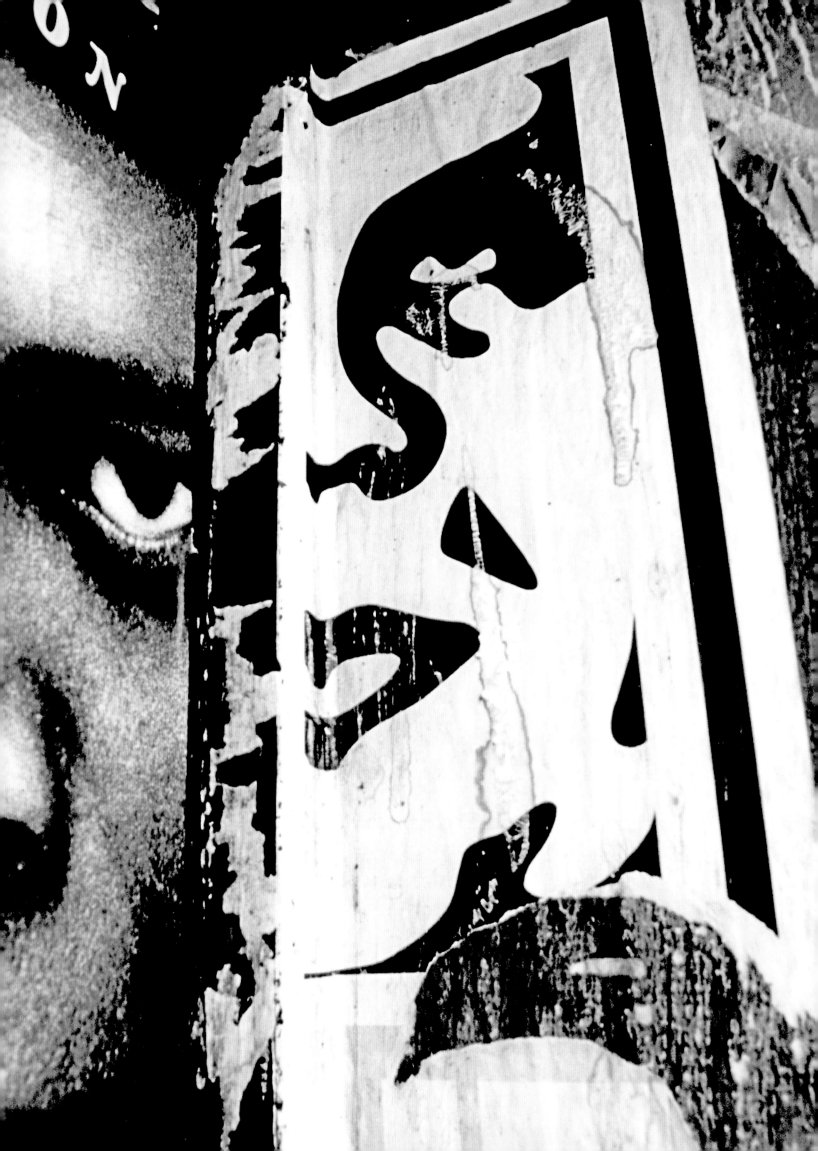

204–209. The *The Medium is the Message* series is similar to the *Urban Renewal* series, in that it's also about the reclamation of public space by the people. "The medium is the message" simply means that because street art is illegal there's a political statement imbedded in its process, even if there's no literal political message in the subject matter. Street art is a stellar example of actual free speech, but free speech is more of an idea than a reality. Street art is not only an act of expression, but also of defiance. I've been arrested 13 times for my street art and fined or threatened by multiple cities, but the freedom is well worth the sacrifice. If the presence of street art can inspire people to express themselves and/or question things, then arrests are not in vain. Power to the people!

208.

207.

207. **Post No Bills,** 2000
(18 x 24") screen print on paper

208. **OG Lamp Base,** 2001
(18 x 24") screen print on paper

209. **Obey Obedience Samuel,** 2000
(18 x 24") screen print on paper

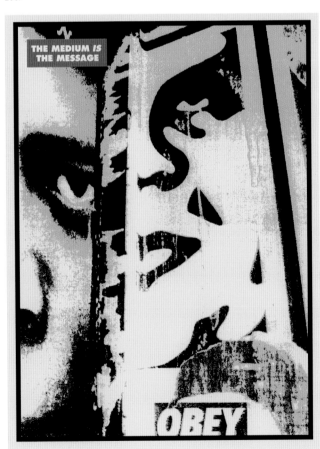

209.

210.

211.

210. **Obey Fiend Skull,** 2005
(18 x 24") screen print on paper

211. **Obey Chinese San Francisco,**
2004 (18 x 24") screen print on paper

212. **Paste Instructions,** 2001
screen print on t—shirt

213. **San Diego Billboard Ad,** 2000
magazine advertisment

212.

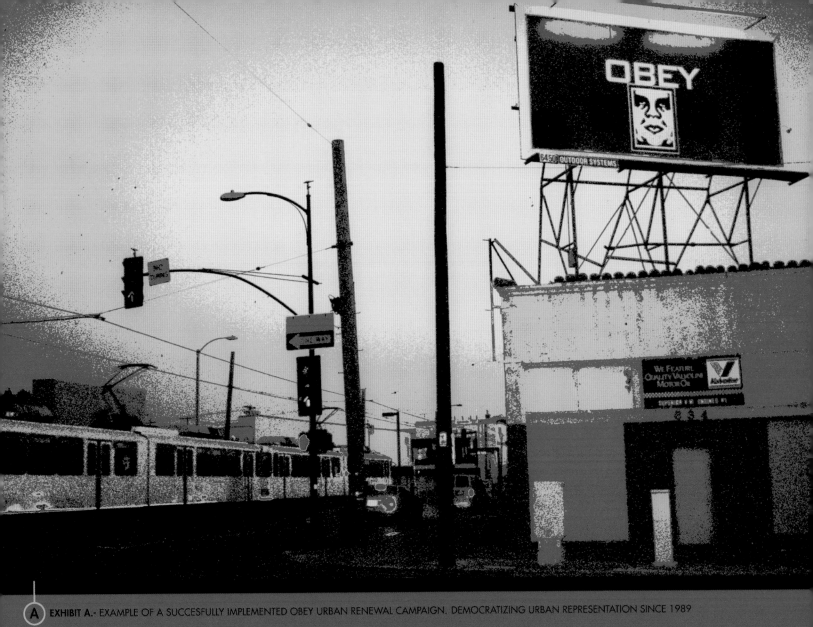

TOOLS NEEDED:

LARGE IMAGE
WALLPAPER PASTE
PASTE BRUSH
EXTENSION POLE
ROPE
LOOKOUT
BRAINS
SKILLS

WARNING:
(PROFESSIONALS RECOMMEND)
PASTE BLANK BILLBOARDS
NEVER COVER ADS FOR LOCAL BUSINESSES
DO NOT PASTE BILLBOARDS WITH ADS
(UNLESS YOU CAN AFFORD TO PAY FOR IT
OR YOU ARE SURE YOU CAN GET AWAY WITH IT)

YOUR AD HERE

EXHIBIT B.
EXAMPLE OF A TOOL OF URBAN RENEWAL **B**

HOW TO GET BUSY:

CHOOSE A HIGH
CONTRAST IMAGE.
CONVINCE DISGRUNTLED
EMPLOYEE OF "YOUR COPY
CENTER" THAT YOUR ART
PROJECT IS WORTHY OF A
LARGE DISCOUNT. MAKE A
HUGE COPY (OR COPIES)
OF YOUR IMAGE ON THE
BLUEPRINT COPIER. FIND A
DESIRABLE AND
ACCESSIBLE BILLBOARD.
PASTE BILLBOARD SURFACE.
ADHERE POSTER
EMPLOY ALL NECESSARY
COUNTER SURVEILLANCE
TECHNIQUES. JET.

HOW TO GET BUSY:

CUT OUT IMAGE WITH
X-ACTO KNIFE. SPRAY
PAINT DESIRED SURFACES.
EMPLOY ALL NECESSARY
COUNTER SURVEILLANCE
TECHNIQUES. JET.

SCALEABLE

OBEY

ALL CITY URBAN RENEWAL PROJECT

TOOLS NEEDED:

CARDBOARD OR
BRISTOL BOARD
#11 X-ACTO KNIFE
SPRAY ADHESIVE
OR GLUE
SPRAY PAINT
BRAINS
SKILLS

STENCIL INSTRUCTIONS

1) Use only flat spray paint.
 (it dries faster and does not drip as much)

2) Do not let wet paint build up on the stencil.
 Chill, let paint dry before each application.

4) The stencils are reversible, keep rotating
 sides from which you are spraying front/back

5) The stencil should be held flat to the surface to
 be painted with a light mist of spray adhesive
 (drippy stencils are for New Jack Sucker Toys).

6) Failure to obey local ordinances may result in
 prosecution(the powers that be do not approve
 of you subverting the dominant paradigm).
 Spray at your own risk!

WAR
(PROFESSIONA
ALWA
CAL

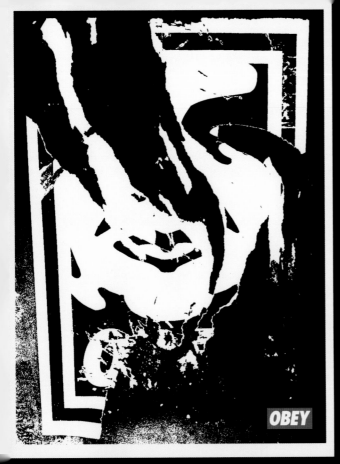

215.

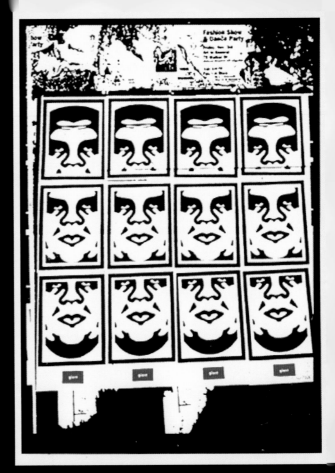

216.

214. **Stencil Diagram,** 2000

215. **Ripped Face,** 2001
(18 x 24") screen print on paper

216. **New York 3-Face,** 1997
(18 x 24") screen print on paper

217. **Garage Studio,** 2005

217.

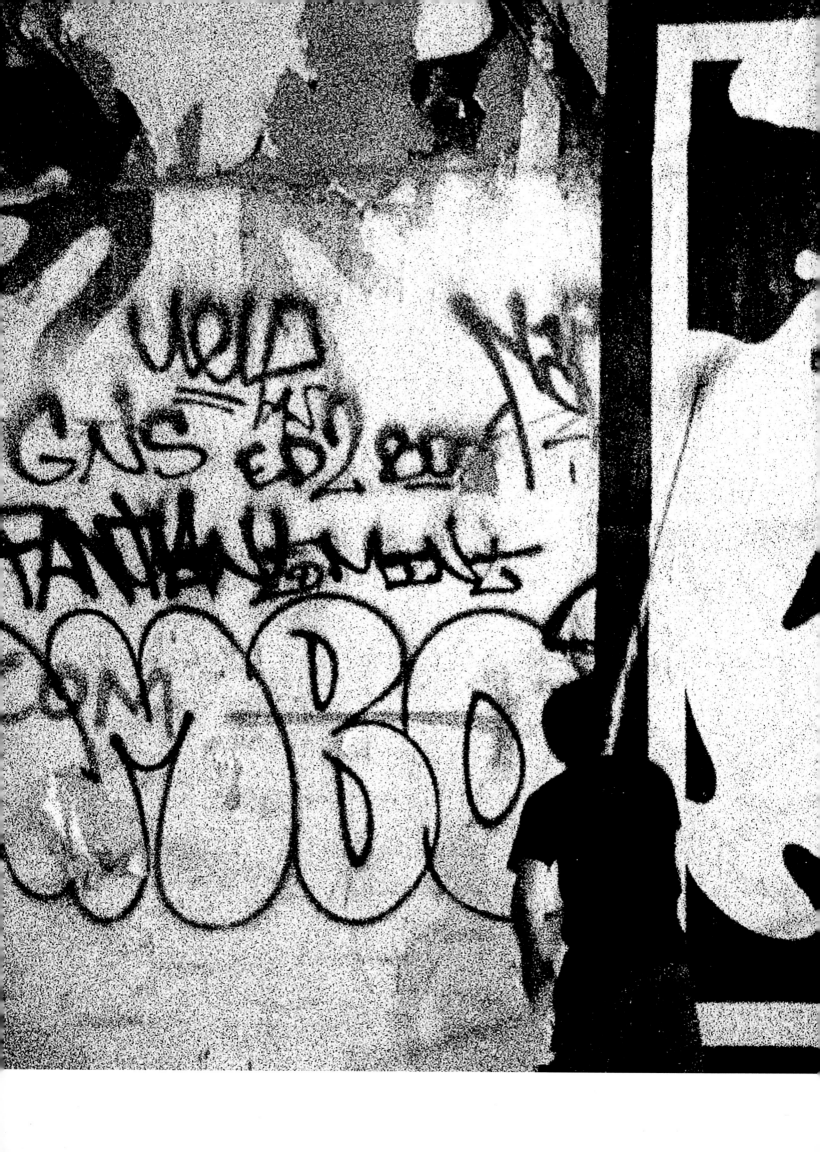

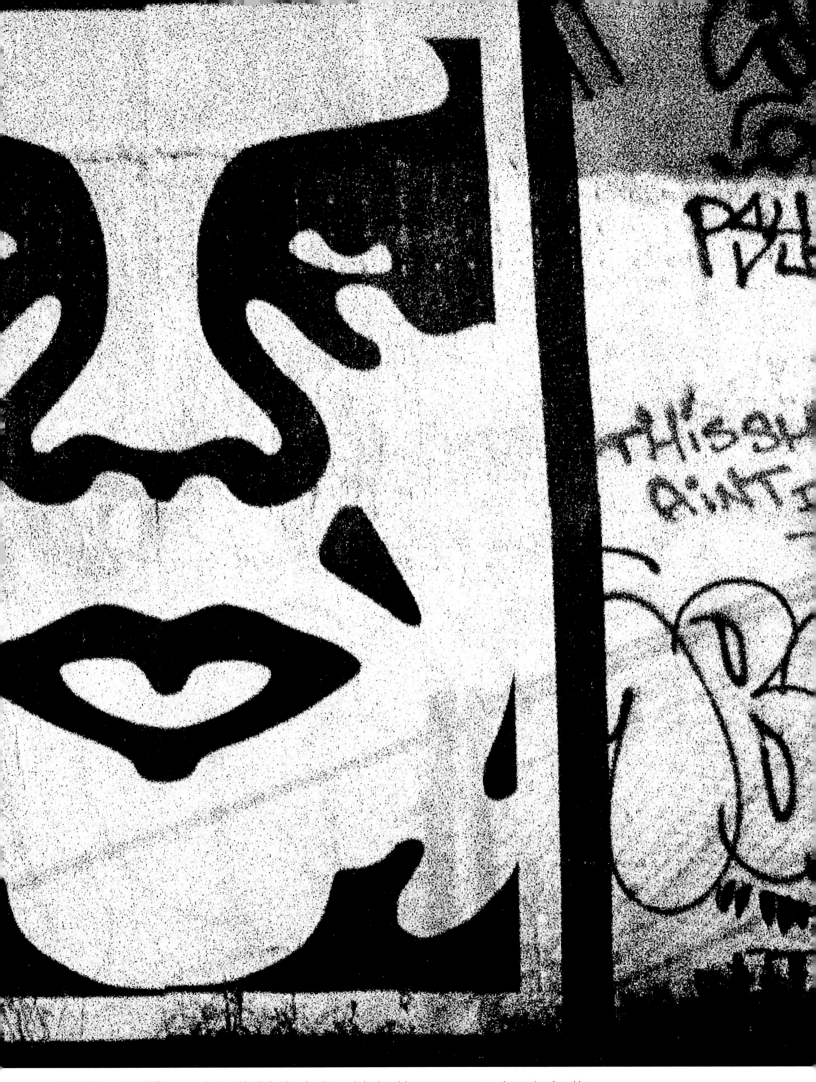

ABOVE: This spot is in NYC on 2nd Avenue and 2nd Street, now called Joey Ramone Place, right around the corner from CBGB's. I put up this 15–foot icon face in a vacant lot on that corner, and because it's so huge, anyone driving by on Houston Street can see it. It takes eight posters to create an image this big. I've reclaimed the spot year in and year out since 2000, and you can actually see the remains of an older, weathered face in the top left portion of the photo.

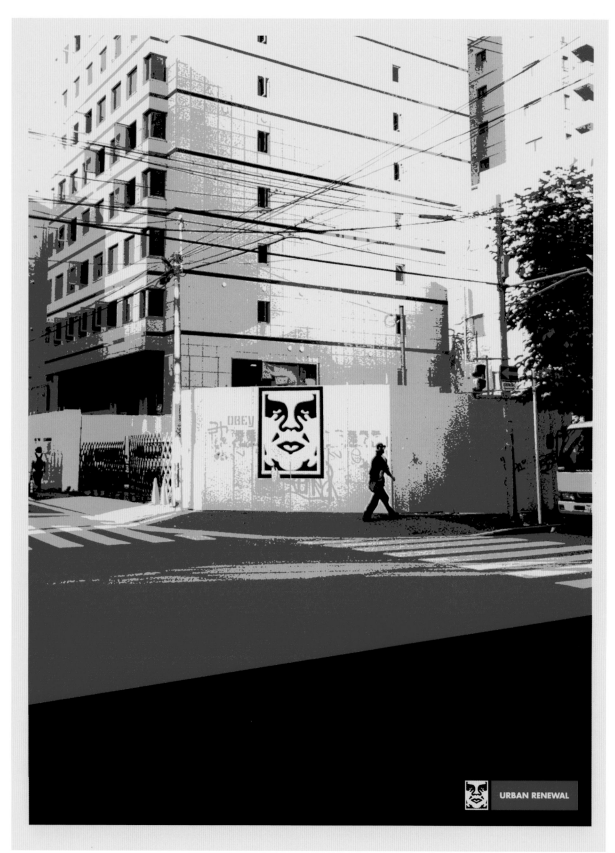

URBAN RENEWAL

218.

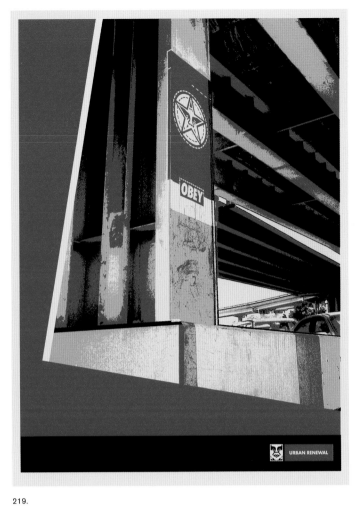

219.

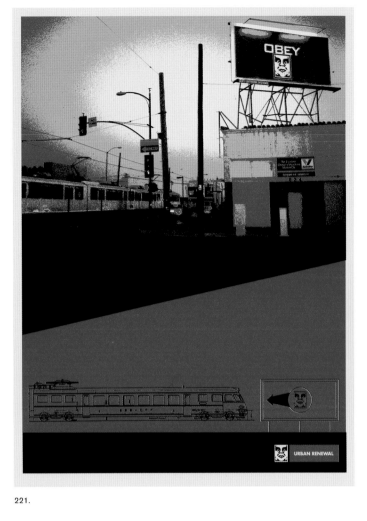

221.

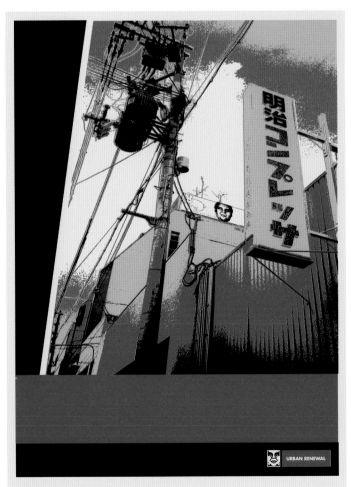

220.

218. **Obey Osaka White Wall,** 2000
(18 x 24") screen print on paper

219. **Obey San Francisco Banner,** 2000
(18 x 24") screen print on paper

220. **Obey Osaka Billboard,** 2000
(18 x 24") screen print on paper

221. **Obey San Diego Billboard,** 2000
(18 x 24") screen print on paper

222. *Obey Pole,* 2001
(18 x 24") screen print on paper

223. *Obey Osaka Roof,* 2000
(18 x 24") screen print on paper

218–227. The term "Urban Renewal" is typically used to suggest that part of a city that has been in decline is being restored. Sanctioned public art is sometimes part of this process. How ironic that street art is often considered a symptom of a neighborhood in decline. As taxpayers, we all own the public space, but the government and advertisers frequently control it. I prefer to see the public space used as a forum for expression. This, of course, has to be done in a logical and respectful way. Good street art, properly integrated, only enhances a city with visual stimulation and a flow of ideas. Advertisers, however, don't want any competition. Don't let the advertisers' agendas dictate how your streets are used.

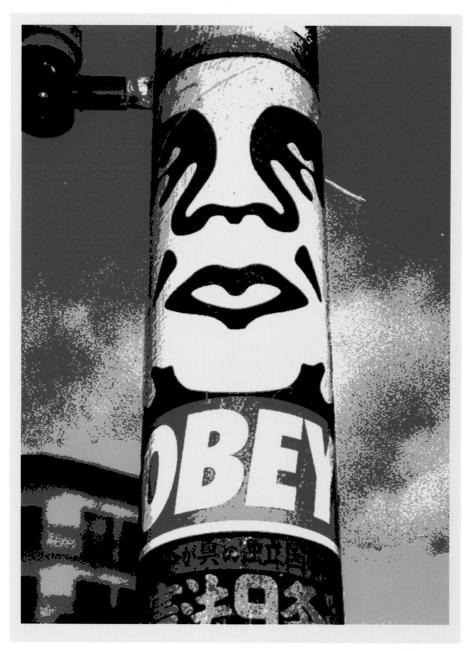

222.

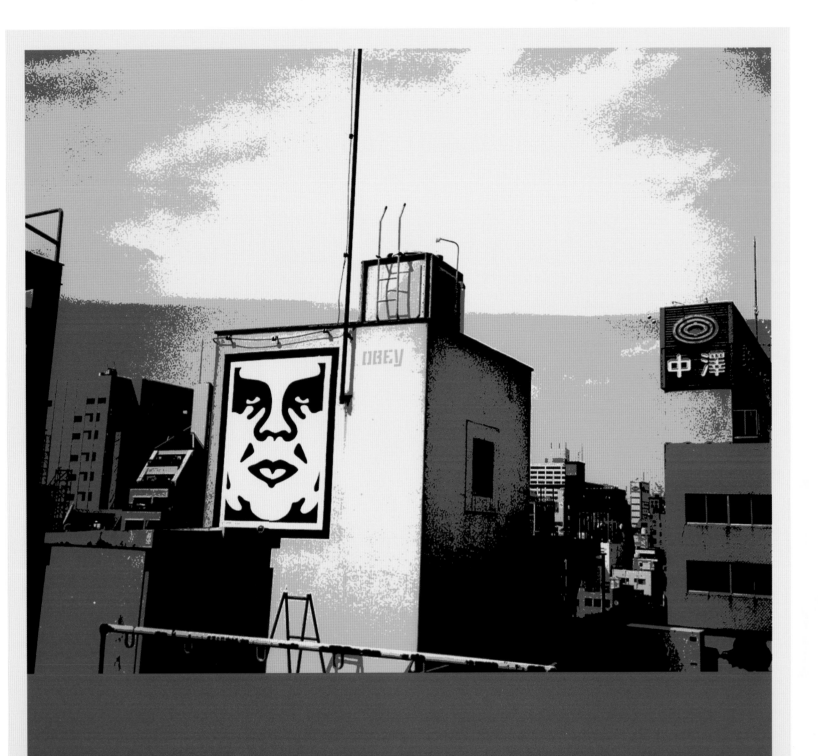
 URBAN RENEWAL

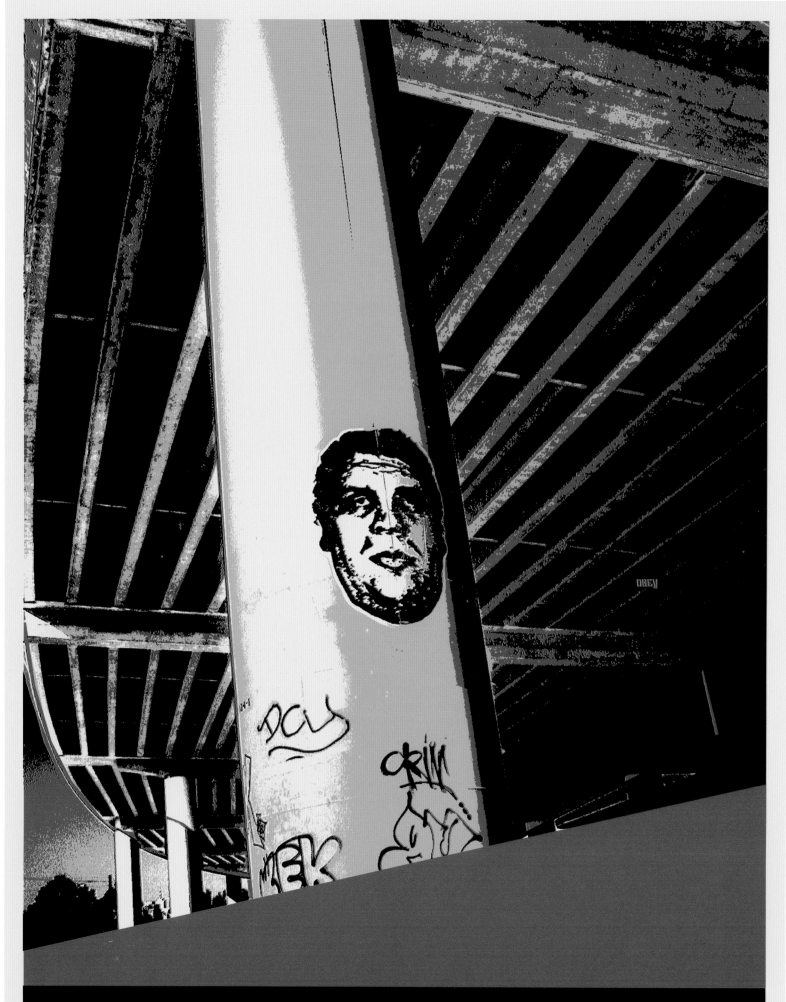
URBAN RENEWAL

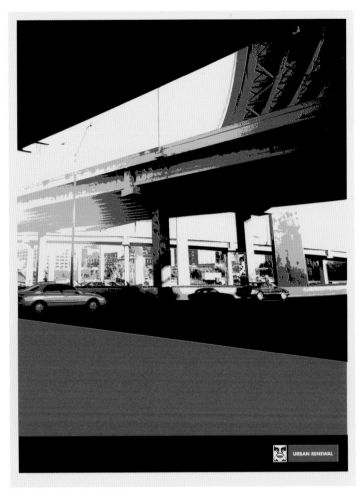

225.

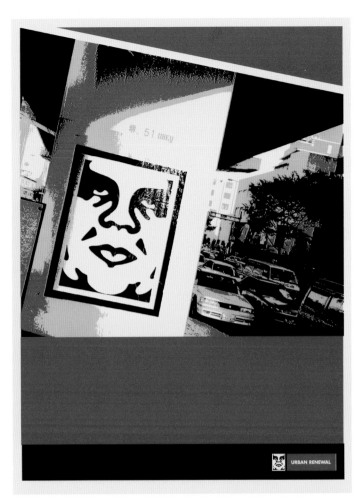

226.

224. **Obey San Francisco Tracks,** 2000
(18 x 24") screen print on paper

225. **Obey Dallas Highway,** 2000
(18 x 24") screen print on paper

226. **Obey Osaka Highway Wall,** 2000
(18 x 24") screen print on paper

227. **Obey Rhode Island Bridge,** 2000
(18 x 24") screen print on paper

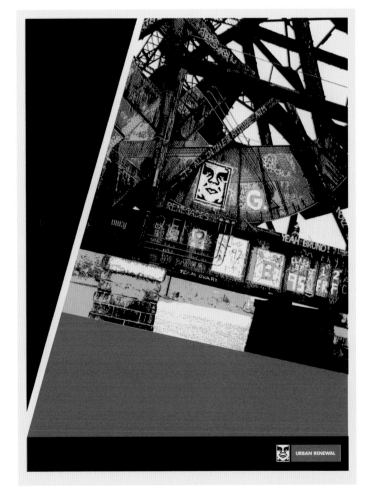

227.

ESTETICA

SOLARIUM

SOLEMANIA

SOLEMANIA

SOLEMAI

Solarium
Abbronzatura Viso
Abbronzatura Integrale

Estetica
Trattamenti Viso

Trattamento Corpo:
· Modellante
· Riducente
· An
· Ra

De

Tr

M

Regalati
un trattamento
diVino.

il cioccolato
che fa
bene alla
linea

Dal cacao
e dal cioccolato
emozioni
per l'estetica
e il benessere.

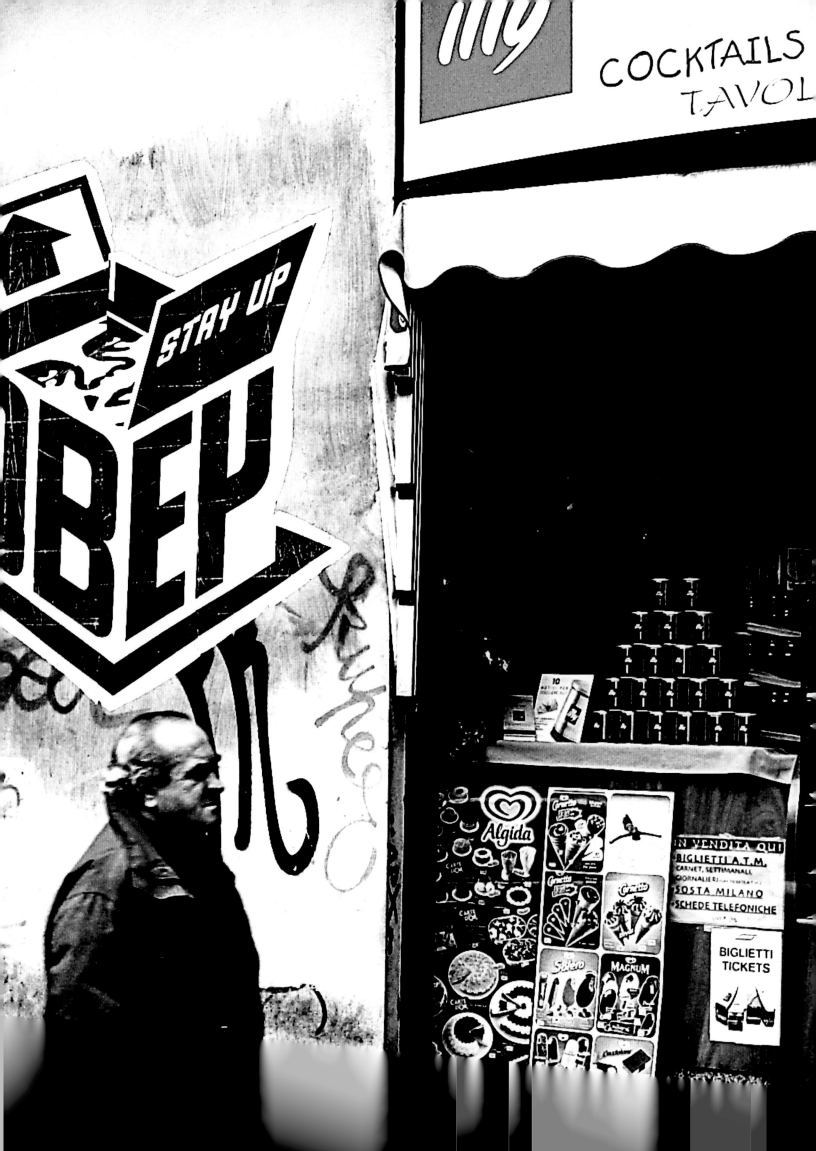

228.

229.

231. There's an 11–story building in Tokyo across a plaza from one of the busiest subway exits in all of Tokyo (and probably anywhere else in the world). I went up to the roof and leaned over, using a long extension pole to paste an eight–foot icon face. It only ended up staying up for about a week, but it was long enough for hundreds of thousands of people to potentially see it.

230.

228. **Giant Half Face,** 2000
(18 x 24") screen print on paper

229. **Obey Playboy,** 2001
(24 x 36") lithograph

230. **Obey Minnepolis Stay Up,**
2004 (18 x 24") screen print on metal

231. **Obey Tokyo Roof,** 2001
(18 x 24") screen print on paper

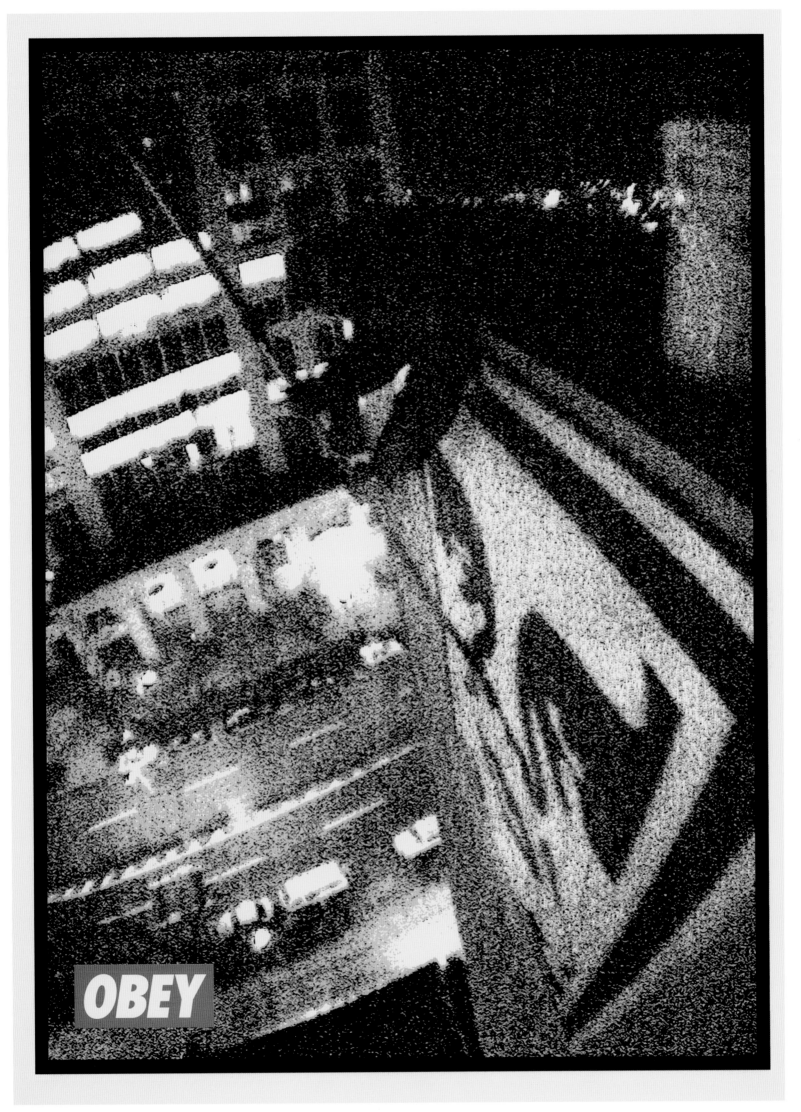

I've been called "obsessed" before; I may have even said it about myself once or twice. But all things are relative, right? Shepard Fairey is the most obsessed artist I've ever met. I don't believe there's anyone living as committed to spreading their art around the planet as Shepard is. Thank God he's a great fuckin' artist who does beautiful, thought–provoking work, or we might be bummin' out right now, begging him to stop. So thanks for doing your thing, Shepard, and stay safe out there. We need you to keep on doing it. But you're obsessed, so we know you ain't never gonna stop.

– ZEPHYR

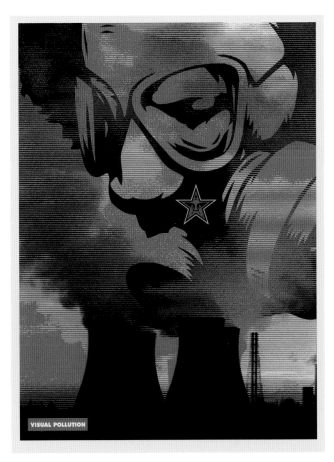

233.

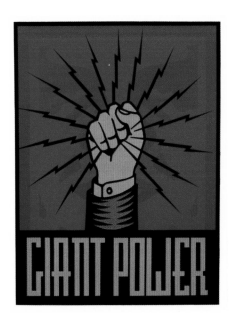

232.

232. **Giant Power,** 1997
(18 x 24") screen print on paper

233. **Obey Visual Pollution Gas Mask,**
2001 (18 x 24") screen print on paper

234. **Obey Visual Pollution,** 2001
(18 x 24") screen print on paper

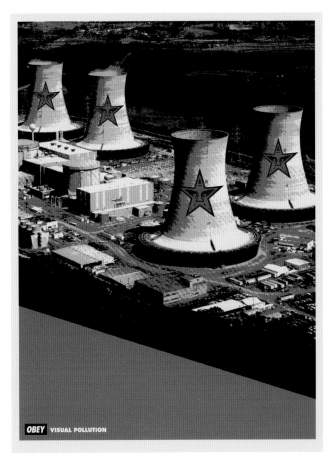

234.

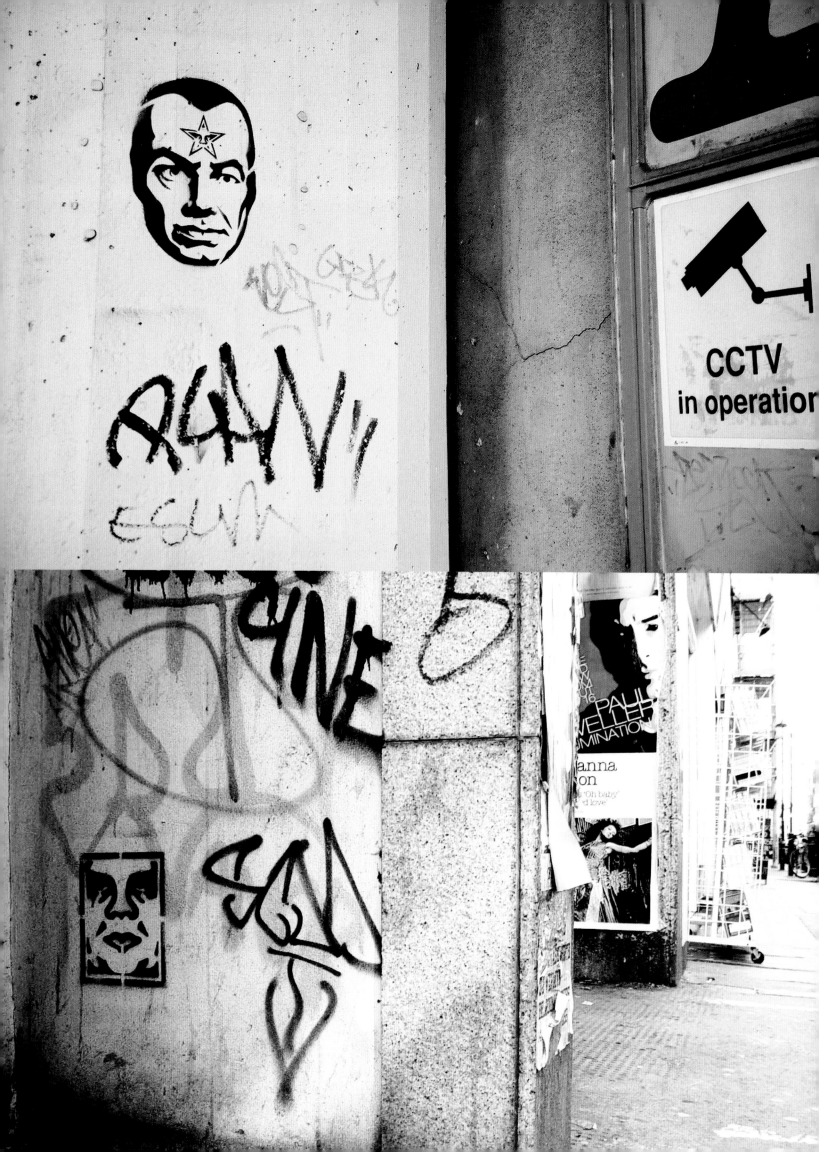

CCTV
in operation

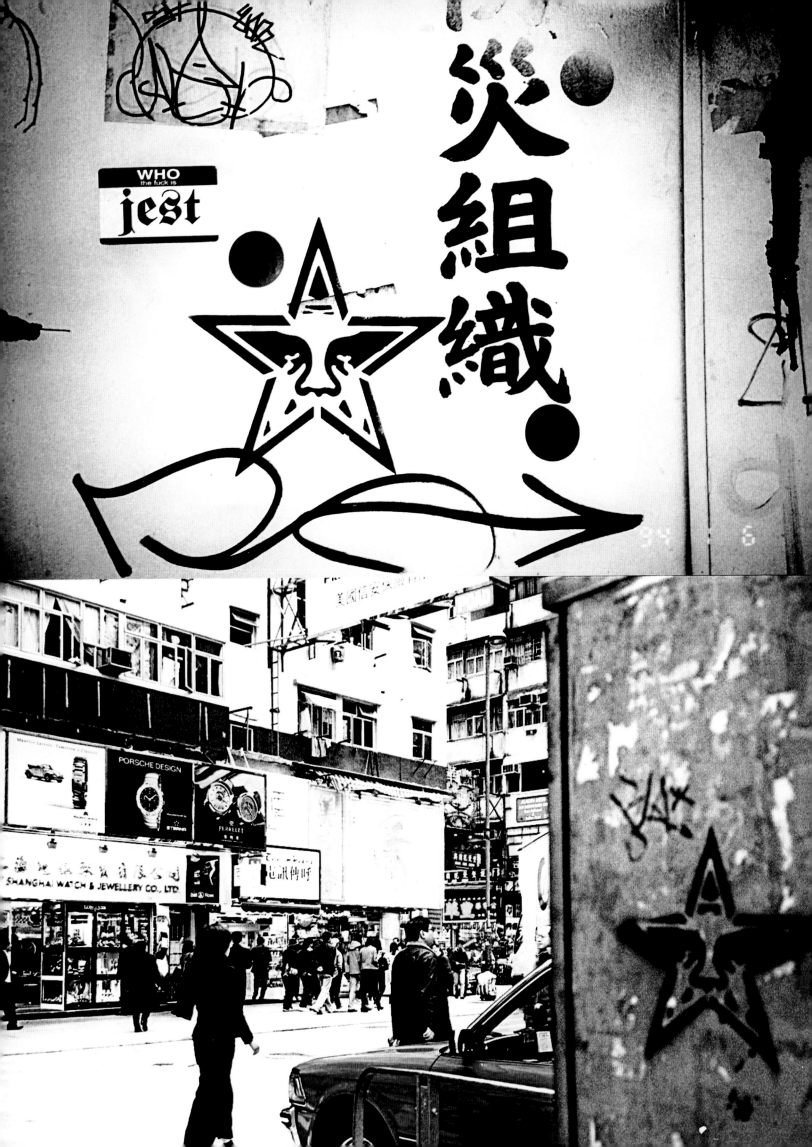

ANDY WARHOL

POP ARTIST

Andy Warhol started his art career as a commercial illustrator for magazines like *The New Yorker* and *Vogue*, and designed advertising and window displays. Warhol received acclaim for his commercial work in the late '50s, but his early paintings of Campbell's soup cans and Coca–Cola bottles in endless rows were disliked by critics. However, his second New York show in 1962 was a success, and launched him into the spotlight as the brightest star in the burgeoning pop art movement. Warhol moved into the realm of film in 1963, ultimately making 66 bizarre, experimental movies over the following decade. Warhol's work always carried an impassive yet bold edge, curiously studying his subjects within the context of a banal and monotonous culture while representing pervasive images as larger than life, fame superseding reality. In 1965, he hooked up with Lou Reed and the Velvet Underground and produced their first album, often considered one of the most influential of all time. Warhol suffered a near–fatal shooting in 1968 at the hands of Valerie Solanis, founder and sole member of SCUM (Society for Cutting Up Men). Throughout the 1970s, Warhol continued to show his work in galleries around the world, and spent much of his time working on commissioned portraits of celebrities and publishing *Interview* magazine. In the '80s, Warhol shifted his focus to a new generation, working with younger artists like Keith Haring and Jean–Michel Basquiat and creating two cable television shows. Warhol died unexpectedly in 1987 from gallbladder surgery complications.

SHEPARD'S COMMENTS

Warhol, for me, represents an incredibly important step for fine art away from aristocratic elitism. In a world about sophistication and superiority, what a coup to be able to elevate mundane items, to which any poor American had access, to the level of fine art! What an incredible way to refute the elitism of that world and create a dialogue about the role of art in society! Warhol's art was accessible – hence the term "pop art." Warhol also understood the importance of creating a culture around his art and utilizing pop mediums such as music, television, and film to do so. Warhol's connection with the Velvet Underground gave them instant credibility, and gave Warhol an association with a hip, rebellious audience. Warhol's embrace of the media, and his calculated aloofness in their presence, only helped to grow people's fascination with him and his work. Warhol's distance and mystery created room for anyone to make Rorschach–test–like interpretations of him or his work. Whether people liked or disliked Warhol, he brought up important issues of art and culture.

236.

237.

235. **Obey Warhol Stencil,** 2004
(30 x 44") spray paint stencil and collage on paper

236. **Obey Soup Can,** 2005
(18 x 24") screen print on paper

237. **Andre Warhol Invite,** 1995
(5.5 x 8.5") screen print on paper

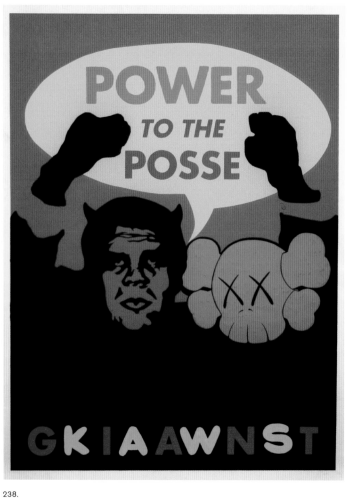

238.

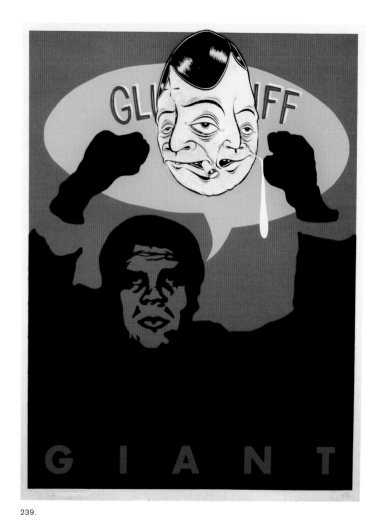

239.

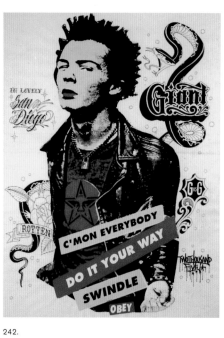

242.

243.

240.

241.

238–241. I did a poster with Andre–as–Black–Power–guy holding up his fists and saying "Power to the Posse," though the original image I appropriated said "Kill Whitey." As I was printing the posters, I got the idea to leave the thought bubble blank and paste them up on the street as a pseudo–Rorschach test to see what people would write in them.

I tried it out, and although I never saw anything particularly awesome written in, it inspired me to hand the posters over to some of my artist friends–KAWS, TWIST, Andy Howell, Tommy Guerrero, and Aaron Rose–and give them carte blanche with it. It's always fun to find ways to create that sort of confluence of styles.

238. **Giant Power to the Posse KAWS,** 1997 (18 x 24") mixed media

239. **Giant Power to the Posse TWIST,** 1997 (18 x 24") mixed media

240. **Giant Power to the Posse Andy Howell,** 1997 (18 x 24") mixed media

241. **Giant Power to the Posse Aaron Rose and Tommy Guererro,** 1997 (18 x 24") mixed media

242. **Sid Giant,** 2005 (18 x 24") mixed media collaboration with GIANT

243. **Giant vs Giant,** 2005 (18 x 24") screen print on paper

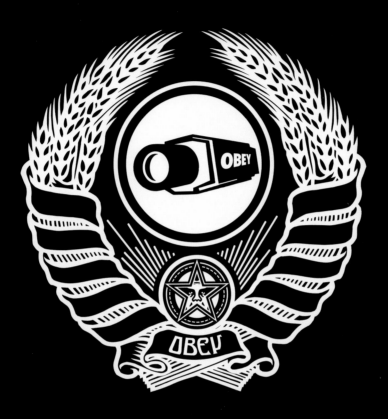

SURVEILLANCE

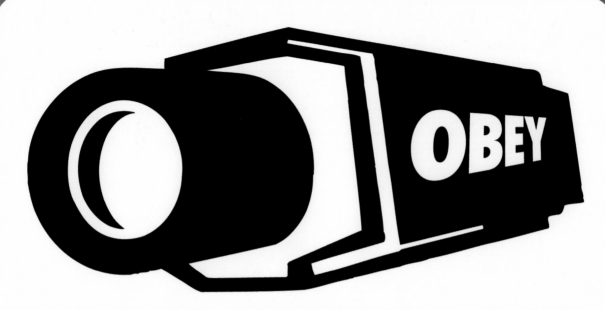

WARNING

YOU ARE UNDER SURVEILLANCE

ALL ACTIVITIES ARE RECORDED TO AID IN THE PROSECUTION OF ANY CRIME COMMITTED AGAINST GIANT PROPERTY.

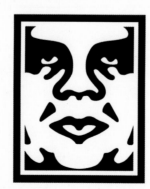

7'4"520LB

244.

WOULD DA REAL GIANT GUY PLEASE STAND UP...

Shepard Fairey

It seemed a fitting irony that I would get thrown in jail the day after writing a lengthy rant about cops for *Tokion*. Maybe I had bad karma for spouting my smug psychological profiling of the pigs. I had come with my cousin Charles to NYC for two–and–a–half days, aiming to complete 20 large street art installations as well as whatever less–ambitious acts of urban beautification we could fit in. Things were going perfectly as planned until the last night. We had completed 14 of the large installations around Manhattan and Brooklyn, including the thus–far crowning jewel of the trip: an eight–foot Giant icon face above the landmark DKNY mural on the corner of Houston and Broadway. Charles and I had hooked up with my friend Mike, who happened to be in town and helped us execute the DKNY piece. It was beautiful: I had been wanting to do this spot for five years and that night we walked in the building with all of our gear, right past the security guard, went to the roof, hung over the edge, busted it, and were out. Mike had bought some 22–ounce Asahi's in preparation for celebration, which we were brown–bag–sipping as we basked in the glory of our success.

Standing on the crowded corner, out of habit we each put up a sticker. The next thing I knew, we were surrounded by three dorky guido guys who proceeded to pull out badges. I immediately thought they were only going to hassle us for the open beers, so I didn't run. Wrong guess: they were vandal squad and they had seen us put up the stickers. We were asked to empty our pockets, and they found several–hundred stickers. Surveying the pile of stickers, the fearless–leader cop surmised, "If we didn' stop dese guys, every one uh dese Giant stickers woulda ended up graffitied around da city." The 90/10 mullet (90/10 refers to the ratio of hair in back to on top) sidekick cop with obligatory gold chains and tight jean shorts chimed in: "No way, Giant stickuhs! I been wantin' one uh dose fuh my tool box fuh years." Despite my plea that I had a flight in six hours and I was the sticker gang leader, the cuffs were slapped on all three of us as the leader explained this was a "Mayor Giuliani Quality–of–Life crime" and there was no way to get out of "gettin' put t'rough da system" (booking, jail, court, etc.). We were pushed into the back of a Taurus wagon while the cops talked about the body parts of various female passers–by. They also talked to us through the car's open windows, asking us questions like "Why are you guys doin' dumb shit like dis when you could be out at a bar gettin' a broad drunk and takin' her home?" (I guess borderline date rape is favorable to street art!?) By his voice and his mannerisms first, and then his physical features, I began to panic as I realized that the leader cop was the same guy who had arrested me putting up posters in Soho four years earlier. He validated my fear by saying he had caught the "real Giant guy" before and that

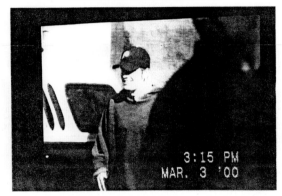

Friday, March 3, 2000 – Michael Siddal (left) and Frank Fairey as they were released by police. The large posters and graffiti stickers Fairey posted have been found all over the city. Many of the larger posters with the face and word "obey" have been found glued to signs atop area business'. Another poster has a picture of a video camera with the words "under electronic surveillance." MP-00-061666.

Don Davis & Associates, Inc.

245.

246.

244. ***Obey Surveillance Warning,*** 2000
(18 x 24") screen print on paper

245. ***Minneapolis surveillance stills,*** 2000

246. ***Obey Law Enforcement,*** 1998
(18 x 24") screen print on paper

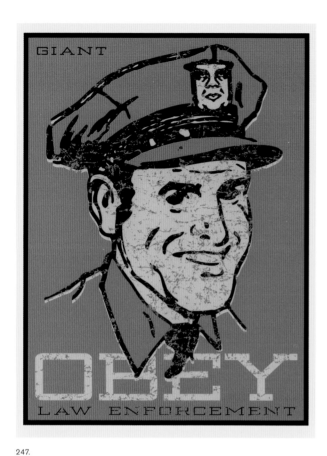

247.

the guy had an art show down the street (I had some collaborative stuff with Deform furniture at the New Museum). Would he remember me?

The leader cop was standing outside the car, tapping his fingers on the roof, when he paused and said, "I'll be damned! Would you look at dat! What a coincidence! Hey Frank (Cops call me Frank because my ID reads Frank Shepard Fairey), ya nevuh gonna believe what I'm lookin' at. I bet you had nuttin' ta do wit' dis." I knew he had finally seen the Giant face above the DKNY mural but I played dumb. He then pulled me out of the car to point out the face, while his mulleted sidekick brilliantly observed, "That's the same face on duh stickuhs." I said, "I had nothing to do with that, it must be a promotion for the museum show down the street." I was thinking they didn't have any proof anyway, when I remembered I still had half an eight–foot Giant face rolled up in my backpack, just like the one up on the building. I knew it was only a matter of time before they discovered the contents of the backpack, so with my hands cuffed, I leaned over the open backpack, pulled the poster out with my teeth, and kicked it under the seat of the car as the leader cop stood inches away.

When they searched the backpack they found nothing. We went to jail for 36 hours for putting up a couple stickers, but at least the leader cop was dumb enough to tell me his schedule and territory so I could steer clear of him during future visits to NYC. It's pretty funny now, but I'd like to thank my wife, Amanda, for all her help with phone calls and flight rescheduling while it wasn't so funny being stuck in "da tombs."

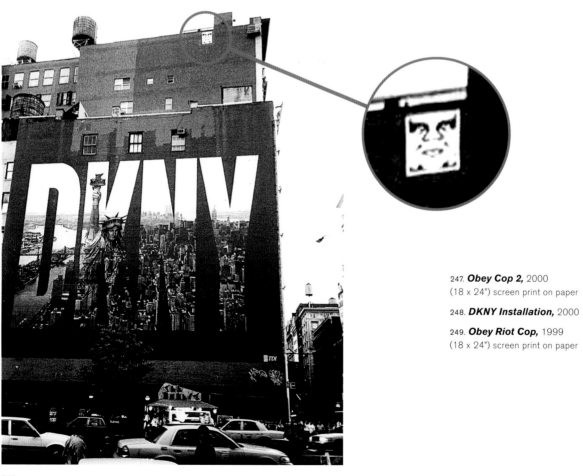

248.

247. **Obey Cop 2,** 2000
(18 x 24") screen print on paper

248. **DKNY Installation,** 2000

249. **Obey Riot Cop,** 1999
(18 x 24") screen print on paper

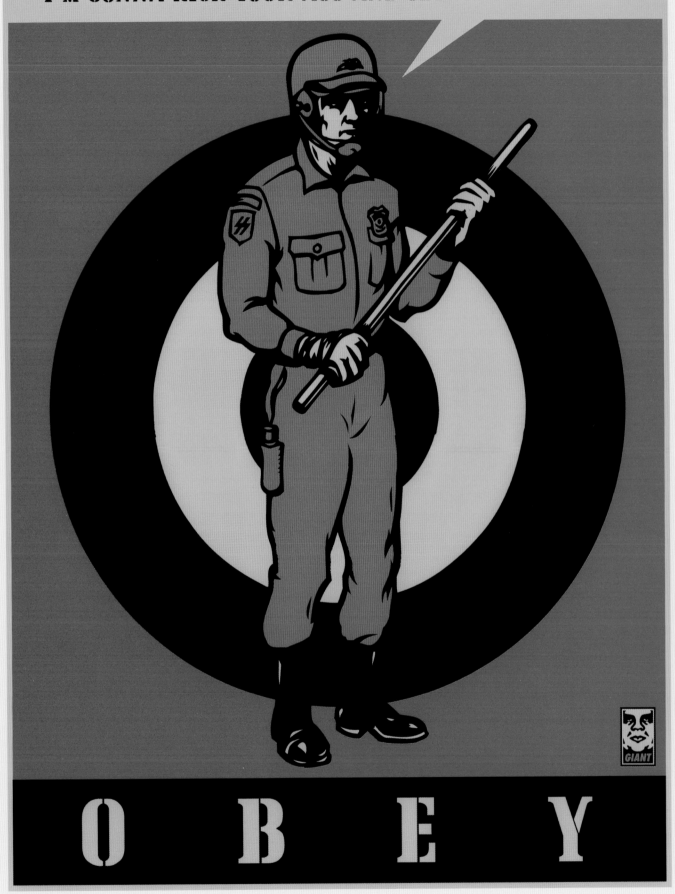

CHINATOWN ARREST

I was in New York in September 2003, speaking at the *Tokion* Creativity Now conference on the commercialization of street art. Some girl at the conference stood up and called me a rich, white male who would never have to worry about anything in his life, which was completely ridiculous at the time but proved to be even more erroneous that night.

I drove to Brooklyn to pick up a couple friends, and as we were driving back into Manhattan I noticed a blank billboard level with the Brooklyn Bridge, which meant it was at eye level for every car and subway passenger coming over the bridge. We scoped it out, and although there was no fire escape on the building I knew that there was a way up, because there was graffiti at the bottom of the billboard. We looked around and noticed a wide-open door to the building, inviting us to climb the stairs up to the roof. I put up an eight-foot icon face while one of my friends did graffiti on another part of the billboard.

I had finished my work and my friend was almost done with his piece when I looked over and saw flashlights on the roof, and I knew there had to be cops behind those flashlights. The billboard was about 40 feet wide and I was at the far end. There were three-foot-high metal beams running across the roof that supported the billboard, and the cops were slow in approaching as they wove through the beams. I had been arrested in New York before and I wasn't prepared to go through the ordeal again, especially since I'm diabetic and it's even more of a living hell to sit in a jail cell when you're deprived of insulin.

I knew I had to get away at any cost, so I went to the edge of the building and jumped down to a balcony 10 feet below, then swung myself over that balcony and dropped to the next one, doing this six or seven times until I reached the ground. The cops were too scared to do the same, so they stood at the edge of the roof yelling at me. One of them even threatened to shoot me if I didn't stop, but I knew he wouldn't dare shoot me just for graffiti, so I kept going. I had to climb a barbed-wire fence very delicately, and as soon as I got over the fence the backup cops were pulling up. I was completely hemmed in.

I put my hands up in surrender, but one of the cops ran up and tackled me anyway. I didn't resist, yet he kept punching me in the back of the head even as he had me cuffed, face-down on the ground. He must have swung and missed at some point, punching the ground instead of me. I was covered in blood and couldn't figure out whose it was, but I figured it out when I saw the other cops bandaging his hand.

More cop cars showed up, and as they were holding me up against one of the cars the sergeant who had threatened to shoot me from the rooftop—a 5'4", Napoleon-complex prick—waddled his way over and started punching me in the stomach. "You like this? Well this is as good as it's gonna get," he shouted, but he wasn't very strong so I just tensed up my stomach muscles and pretended it hurt. He was like, "Yeah, we were gonna let you go, but now you're gettin' B&E (breaking and entering), resistin' arrest, and assaultin' an officer." They didn't realize that a couple of my friends were right there witnessing the whole thing, which came in pretty handy later on.

I went to jail, and since they never give me insulin when I'm in jail I always end up getting really sick and going to the hospital. When I got to the hospital, they cuffed me to the bed and had a cop watching over me. While the doctor was examining my condition, he lifted up my shirt to check my heart

250.

250. *Chinatown Installation,* 2003

251. *Boston Evidence,* 2002

252. *Traffic Cop photo by Monica Hoover,* 2000

253. *America's Finest Cop,* 2000
(18 x 24") screen print on paper

rate and noticed all the bruises on my chest. He asked me what happened, so I told him about the cops beating me up, and he said it looked pretty bad and wanted to get me x–rayed. After I got x–rayed, a nurse came into my room and was filling out a form about my health, and I saw the cop whisper something in the nurse's ear. I couldn't hear him, but it wasn't too tough to figure out what he told her.

After I got out of the hospital, they took me back to jail, and then I had to go to court to face the charges. Assaulting an officer is a really serious felony charge, so I had to hire an expensive attorney, but he was great and got my bail reduced to $1,000. I shot photos of my bruises as proof of being beaten, but after spending two–and–a–half days in jail they didn't look so bad. So I went back to the hospital to get my records. I found the form that the nurse had filled out, and in the section where it asked if the patient had any contusions, lacerations, or abrasions, I saw that she had checked "no" for all of them. Clearly, the cop had told her to do so. Fortunately, the cops never realized that I had been x–rayed, so they never had a chance to manipulate that evidence. The guy at the hospital wouldn't give us the records at first, since in a criminal case the only people who can access records are the cops, but my wife, Amanda, told him that the cops were trying to cover this up, and basically sweet–talked him into giving us the records. I also had my friends as witnesses to the whole beating, in case I needed any more evidence. As for the breaking and entering charge, I went back to the building and took pictures of the wide–open door. When the district attorney's office found out that I had a good lawyer and could back up my case with all this evidence, they probably realized that a trial would make the cops look worse than me, so they essentially dropped the charges. But since they didn't want to let me get off that easy, instead of formally dropping the charges they just let the time limit expire. So I had to appear in court every few months, or else forfeit my bail and have a warrant on me for contempt of court, which meant I had to fly across the country and pay my attorney $400 an hour (grand total: $10,000) to hear the judge tell me that my trial was re-scheduled. It just goes to show how shady the legal system really is, when they can simply not do anything and still screw you over in the process.

251. In October 2001, I was in Boston putting up posters in an area called Brighton, which, unbeknownst to me, had had problems with wheat–pasting and had recently installed kiosks for posters and fliers. A couple cops saw me and ran up on me. "You punk," they yelled, "we just put up these kiosks for you, and here you are putting your poster on an electrical box." I told them I wasn't from around there, but they weren't buying it. I had a ton of stickers on me, which they confiscated and put in an evidence bag. I was arrested, but didn't even have to go to court; I paid a $100 fine and they released me and gave the stickers back. It was like a parking ticket: they were only enforcing the law to generate revenue for themselves.

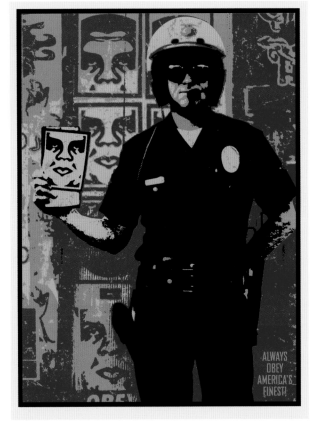

253.

251.

252.

STICKER PROBLEMS?

TO: ALL GASLAMP MERCHANTS
FROM: GASLAMP QUARTER ASSOCIATION
RE: GRAFFITI TASK FORCE

PLEASE Join us as we take on the newest form of graffiti to deface our district. The sticker problem is rampant and Andre the Giant will not go away on his own.

Representatives from the Business Improvement District, San Diego Police and Code Enforcement will be there to discuss this important issue.

Merchant support is essential. Call us for more information or RSVP Tricia 233-5227.

BYB
PARKING
ANY
TIME

GRAFFITI TASK FORCE

OCTOBER 19, 1999
11:00 a.m.
HARBOR CLUB
2nd & J Street,
6th Floor

STOP

Chronic Fatigues
URBAN ATHLETICS

telephone
(310) 452 7978

October 25, 1999

Paul C. Janson
Attorney At Law
213 Rose Avenue, Suite B
Venice, California 90291

(310) 4

Shepard Fairey & Philip DeWolff
Black Market
705 12th Avenue
San Diego, California 92101

Via Facsimile
(619) 544 9594
One (!) Page Total

Re: Unauthorized Postings

Dear Mr. Fairey and Mr. DeWolff:

As you know, I represent National Promotions & Advertising, Inc. ("NPA"). I previously wrote regarding your company's vandalizing and affixing advertising over NPA's posters in and around Los Angeles. Unfortunately, it has recently come to NPA's attention that Black Market is engaging in the same acts in San Francisco on sites owned and/or controlled by NPA, including without limitation the site at 1501 Howard Street. Please be aware that NPA has numerous other rented sites throughout San Francisco with exclusive posting rights and full rights of subrogation to commence and control all necessary and appropriate legal proceedings against unauthorized postings. You should also be aware from my prior letter that NPA has obtained court protection in California prohibiting vandalism against all their posted sites, rented and otherwise.

In light of the foregoing, I hereby demand that you immediately cease and desist posting over NPA's posters. If you fail to do so, NPA will take immediate and appropriate legal action, which will include seeking an injunction and a claim for damages and costs against you, your organization and your employees.

NPA appreciates your respecting their property and other rights in Los Angeles and hopes that you do so with regard to their San Francisco locations as well to forestall further legal action.

Nothing contained here... py of NPA's rights or remedies, all of which are hereby expres...

Very Truly Yours,

Saul C. Janson

cc: P. Zackery
 S. Nemit

Subject: Decals pasted to City of Savannah Property
Date: 03/24 5:05 PM
Received: 03/27 10:34 AM

Mike Weiner, City of Savannah Traffic Engineer, has asked that you or your associates stop installing your decals on the City's traffic control cabinets. These are the silver cabinets at traffic light intersections. So far, the City has had to remove the decals from 13 locations throughout the City. The Traffic Engineering Department has incurred a cost of $910.00 to remove the decals.

The City of Savannah Traffic Engineering Department is requesting reimbursement of the $910.00.

... for the City, I am informing you that
...ers, etc. to City property is a
...ance. Pleas...
...hed to City

...ached at
...ached at

Your Actions Are Not Welcome

Over the past month or so, hate signs have appeared in a few places on the Ranch. The signs, which have been pasted on utility boxes and near schools, are somewhat innocuous, sometimes having a face and the phrase "Obey."

I hope and am reasonably confident that the perpetrators do not reside in Scripps Ranch. But if somehow they should read or hear of this, I want to make it abundantly clear to them that their actions are not at all welcome in our community. SRCA will respond forcefully to this new cowardly threat to our residents.

As with all other forms of graffiti, we will photograph and remove the signs as soon as they are reported to us. Further, we will report all signage and suspicious activity to the police, and we will request and pursue the fullest prosecution of anyone caught placing these signs. If you have information about the signs, please call Bob Dingeman at 566-6083 or the Police Department Community Service Office at 538-8120.

on page 15 for all the detail...

Unfortunately, summer also seems to bring out the bad guys. See Bob Dingeman's article on page 9 about the **vandalism** we've suffered lately. I'm also very disheartened to report a high incidence of **illegal postings by an aggressive hate group**. Ever wonder where your $15 SRCA membership goes? Part of it goes to remove hateful posters such as these that are affixed to concrete poles and utility boxes with an adhesive that is very difficult and expensive to remove. If you see illegal postings, please contact the Police Department Community Service Office at 538-8120.

December 19, 2000

Shepard Fairey
1286 University Ave.
San Diego CA. 92103-3392 USA

SUBJECT: Citywide Posting of Stickers / Posters

CITY OF
ESCONDIDO
201 NORTH BROADWAY
ESCONDIDO, CA 92025

The City of Escondido is very concerned about preserving and maintaining safe, healthy, clean and well-kept neighborhoods for all residents and businesses to enjoy. Recently, we received a request for investigation that alleges that numerous stickers / posters are being posted in the right-of-way areas of our city. Not only are these posters unsightly they are also consuming inordinate amount of man hours to remove. If this does not cease we will have no recourse but to assess fines to recoup the cost of removal.

Please contact either **Susan Oliver** at (760) 839-6377, or **Albert Bates** at (760) 839-6373 upon receipt of this notice to informally discuss this matter. Your cooperation to expedite the resolution of this complaint will be greatly appreciated. your efforts to preserve our community. We look forward to working with you.

Sincerely,

Oliver, Manager
Bates, Senior Code Enforcement Officer
Escondido
Code Enforcement Division

DAT ARREST PACKAGE
PD 200-123 (1-93)-h2

Defendant's Name Fairey, Frank S
Date of Arrest
Return Date
DAT Number
Co-Defendant's Names
Will a Civilian Witness appear in ECAB?

HC 4567 (6/99)
STATE OF MINNESOTA
COUNTY OF HENNEPIN
DISTRICT COURT

UNIFORM CITATION NO. *100030854*
1000309854

The issuing officer states that the person named below committed the offense described in violation of the section indicated.

DRIVER'S LICENSE NUMBER
B 719322 MN

NAME : LAST, FIRST, MIDDLE/MAIDEN
FAIREY, FRANK SHEPPARD

ADDRESS & CITY
3770 GEORGIA ST. #2 SAN DIEGO MN 92103

DATE OF BIRTH 02 57 EYES BRN HGT 5-10 WGT 165 SEX M

NEIGHBORHOOD DATE OF OFFENSE 5 03 03 00 TIME 1424

VEHICLE LICENSE PLATE

COLOR LOCATION & CITY W 26TH ST @ NICOLLET AVE

STATUTE OR ORDINANCE NO. 109.70 DESCRIPTION POSTING SIGNS
ON PUBLIC PROPERTY

COM CODE 0501 ACTIVITY

BADGE NUMBER 4831 ORI NUMBER MN 00-061666

WARNING:
1. Failure to respond to this citation within fourteen (14) days will result in increased penalties and fees assessed; a WARRANT may be issued for your ARREST and your Driver's License may be SUSPENDED. The amount due may be referred to the Minnesota Department of Revenue, which may access non-public government data for the purpose of expediting collection.
2. Failure to appear for a trial will be considered a Plea of Guilty and waiver of your right to trial unless the failure to appear is due to circumstances beyond the person's control (M.S. 169.91)

...fail to appear or to comply with orders of the Court relating to a Motor Vehicle your license will be suspended by the Commissioner of Public Safety (M.S.

...LE ON THE BACK OF THIS

WD 215559
...OD

...OF VIOLATION ☐ Order To Remedy* M/PM
To Pay† 9.05
...2003 Time

Last Giant Art B 10
...07 Wilshire Blvd. ste. 1045
...Angeles State: CA Zip: 90010 Class:

Sex: M/F Hair: Eyes:

ID: Weight: 9091 Race: Santa Monica A

DOB: **Violation**

Height: Fine $ 150.00

Violation Location: 9091

Number of Citations for same violation within last twelve months
WHMC: 19.34.090.A.2 Fine $ 50.00

Description of Violation: Prohibited Sign 50.00

ADD ADMINISTRATIVE FEE $ 150.00

Total Penalty: $

Notice posted on wall of wall without approval of planning cease activity.

**CORRECTIVE ACTION REQUIRED: immediate

*PERSON REQUIRED TO COMPLETE ACTION: Jeff Strong

*DATE ACTION IS REQUIRED TO BE COMPLETED: immediate

SIGNATURE OF OFFICER: [signature] Jeff Strong

PRINT NAME: DATE:

Payment must be made not later than 15 days from the date of this citation.
request for a hearing must be made not later than 15 days from the date of this citation.
*See reverse of this citation for additional information

...KNOWLEDGE RECEIPT OF THIS CITATION

WHITE / PINK - OFFICE

POLICE DEPARTMENT
PROPERTY CLERK HOLDING ACCOUNT
AS CUSTODIAN
POLICE DEPARTMENT
CITY OF NEW YORK - MANHATTAN

75168

FRANK SHEPARD FAIREY

DATE OCT 06 2003 1-2-35/210

THE SUM 334 DOLS 00 CTS $ **334.00**

JPMorgan Chase Bank
280 Broadway
New York, NY 10007

NOT VALID AFTER 90 DAYS

DOLLARS

[signatures] Richard Wierzbicki

CITY OF
WEST HOLLYWOOD

CITY HALL
8300 SANTA MONICA BLVD.
WEST HOLLYWOOD, CA 90069-4216

CODE COMPLIANCE DIVISION

hey man, admirer of your work, blah, blah, blah...anyway-
I got pulled over about a month ago in north park. The pair played good cop bad cop with me about the various GIANT stickers on the back of my Eclipse. One guy (good cop) asked me "what's this whole giant thing, I don't get it". then after I gave an answer about how images can mean alot of different things to different people the other guy asked me "what's street art? - is sheppard ferry in town?" (I hadn't mentioned your name, so it kind of suprised me). I said "how should I know, he's easy to find...he's got a website".

Then they arrested me for a 1991 San Mateo (bay area) warrant (never been a problem before), asked me what my tatoos meant and put me in the gang/grafiti database. The sheriffs let me go about 3 hours later but the fuckers towed my car for $250....anyways, thought you'd like to hear the story.

You got any angela davis posters left???

★ CERTIFICATE OF COMPLETION ★

This certificate is awarded to

Frank S. Fairey

in recognition of successfull completion of

"It's In Your Hands"
Self-Development Program!

Obstructing A PO

Case# 05M03801X
Referring Judge/Agency: Nancy Oesterle
Date Case Received: 04/31/2005
Date Materials Sent: 05/06/2005
Date Completed: 07/12/2005

[signature]
Steven E. Bron, General Manager
United States Justice Associates

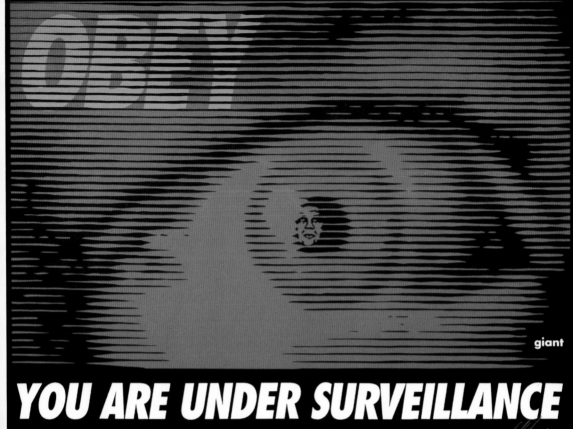

256. I made the Giant City print for Helen Stickler for a screening of the documentary she made about me. The print was designed to be placed in the storefront windows of some of Helen's friends' shops in New York City, and the postcard–sized images at the bottom were cut out and mailed as invitations to the screening. I was so poor at the time that I couldn't afford to make real postcards, so I just combined the postcards and the posters onto the same sheet to save money.

254. **Obey Surveillance Eye,**
1996 (24 x 18") screen print on paper

255. **Obey Television,** 1996
(24 x 18") screen print on paper

256. **Giant City,** 1996
(24 x 18") screen print on paper

257. **Giant in NYC,** 1996
(24 x 18") screen print on paper

258. **Giant NY Show,** 1998
(9 x 24") screen print on paper

256.

257.

258.

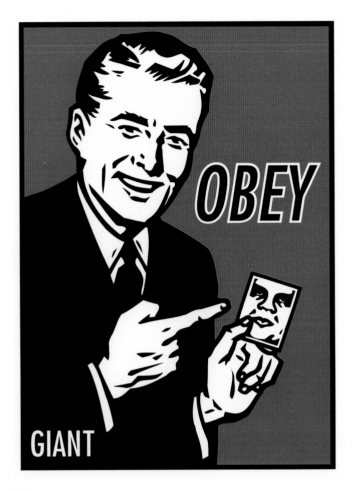

259.

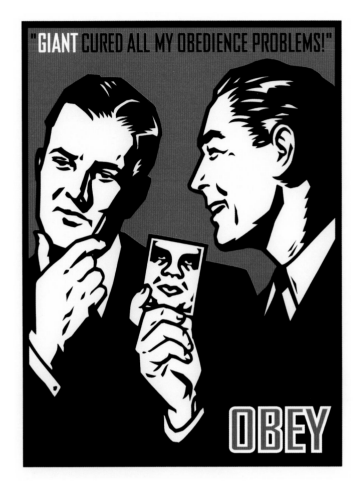

260.

261.

259. *Obey '50s Guy,* 1997
(18 x 24") screen print on paper

260. *Obedience Problems,* 1999
(18 x 24") screen print on paper

261. *Obey Skyline,* 2000
(18 x 24") screen print on paper

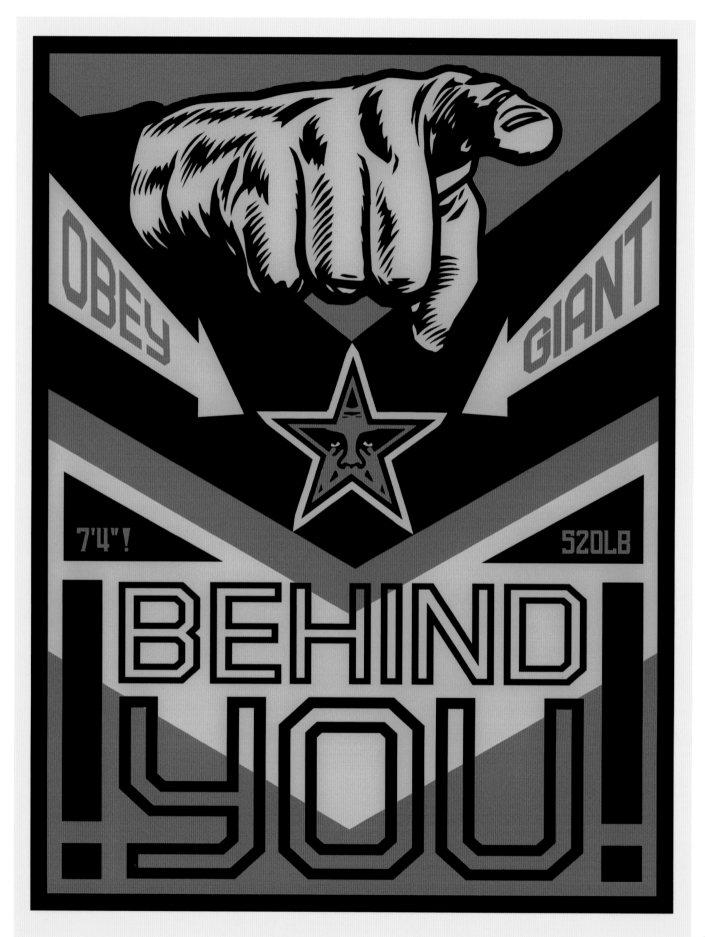

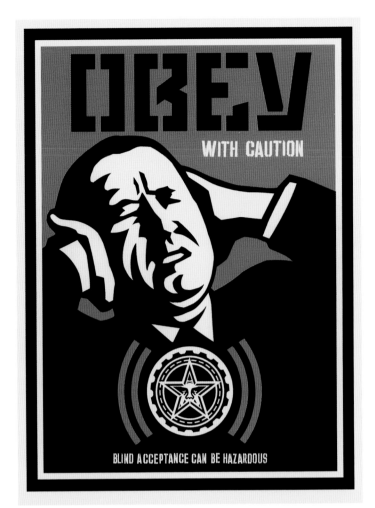

264.

265. This image came from a photograph I took in San Francisco. There was a paste–up of a guy in a suit holding a sign, and I pasted one of my 11 x 17" Obey posters over the sign. Someone had already scratched the head off the businessman, which was interesting because I noticed a lot of the Obey images I put up would be scratched immediately. I guess people don't like to be told to obey, so they react by scratching out the image. In the case of this businessman, someone apparently didn't like whatever he represented so they scratched him out. I thought it was cool to have the two images combined, since there's clearly a face associated with Obey but no one sees the face that propagates it.

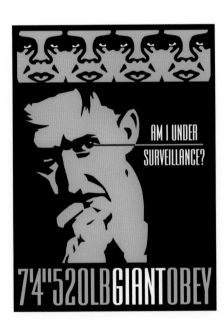

263.

262. **Giant Behind You,** 1999
(18 x 24") screen print on paper

263. **Giant Under Surveillance,** 1998
(18 x 24") screen print on paper

264. **Obey With Caution,** 2002
(18 x 24") screen print on paper

265. **Obey Suit,** 1999
(18 x 24") screen print on paper

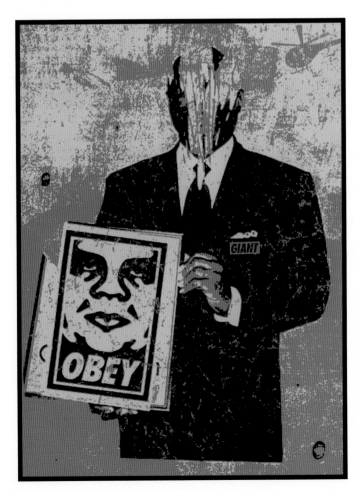

265.

266. The "Obey Big Brother" image was based on the actual Big Brother poster from the 1950s' movie version of *1984*. I thought it was the most recognizable manifestation of Big Brother, as opposed to the Big Brother image that I created as a personal reinterpretation of the concept. Orwell's ideas always resonated with me, so I thought it fitting to pay homage, especially since many of those ideas were already integrated into the Obey campaign.

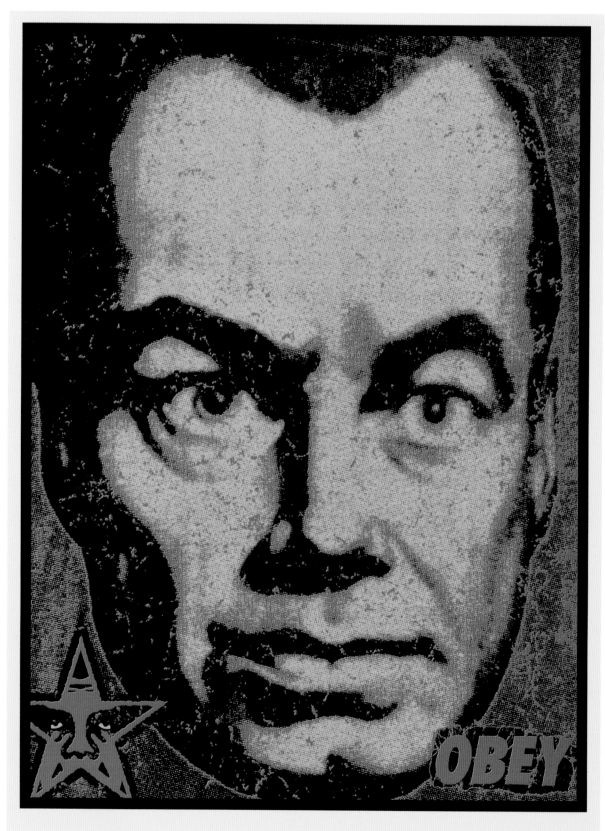

266.

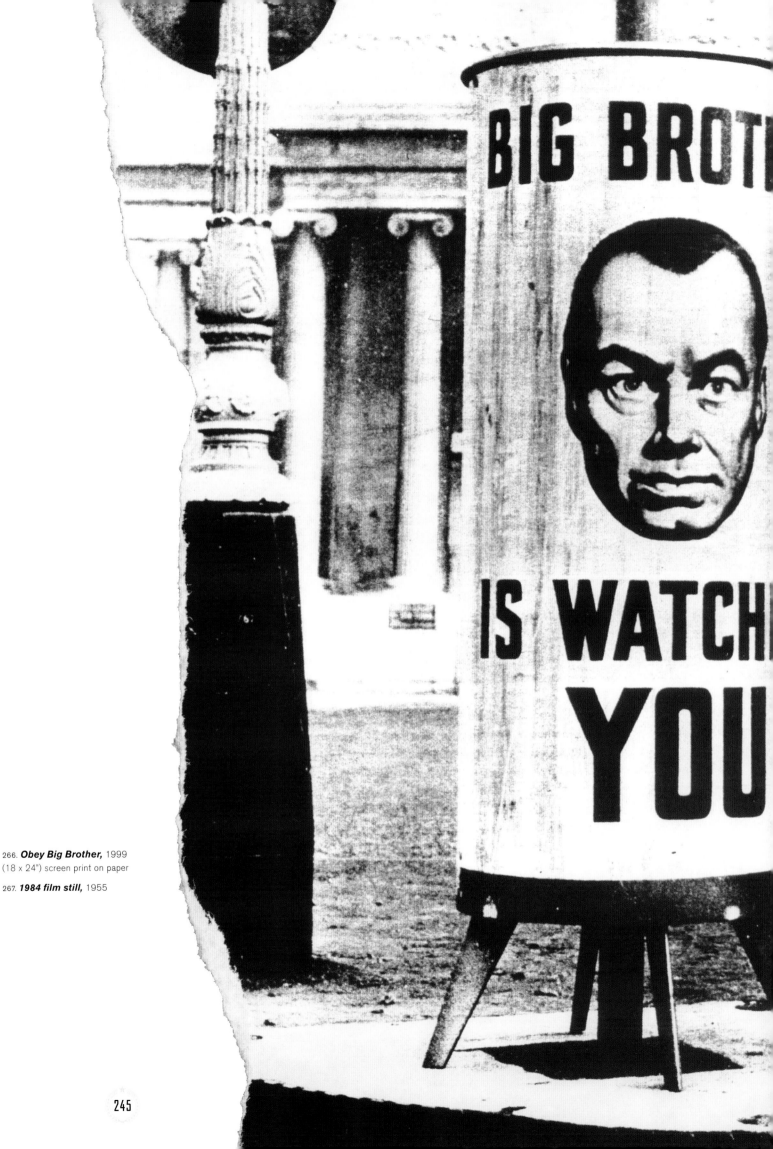

266. **Obey Big Brother,** 1999
(18 x 24") screen print on paper

267. **1984 film still,** 1955

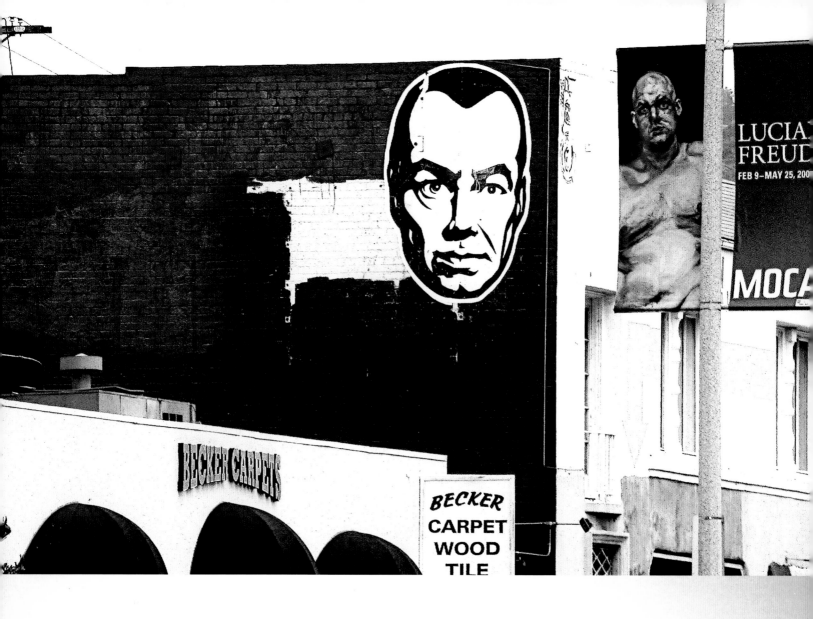

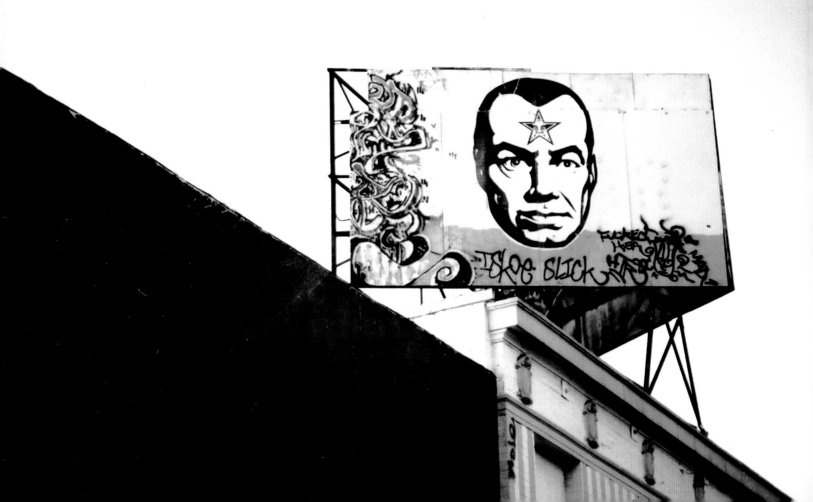

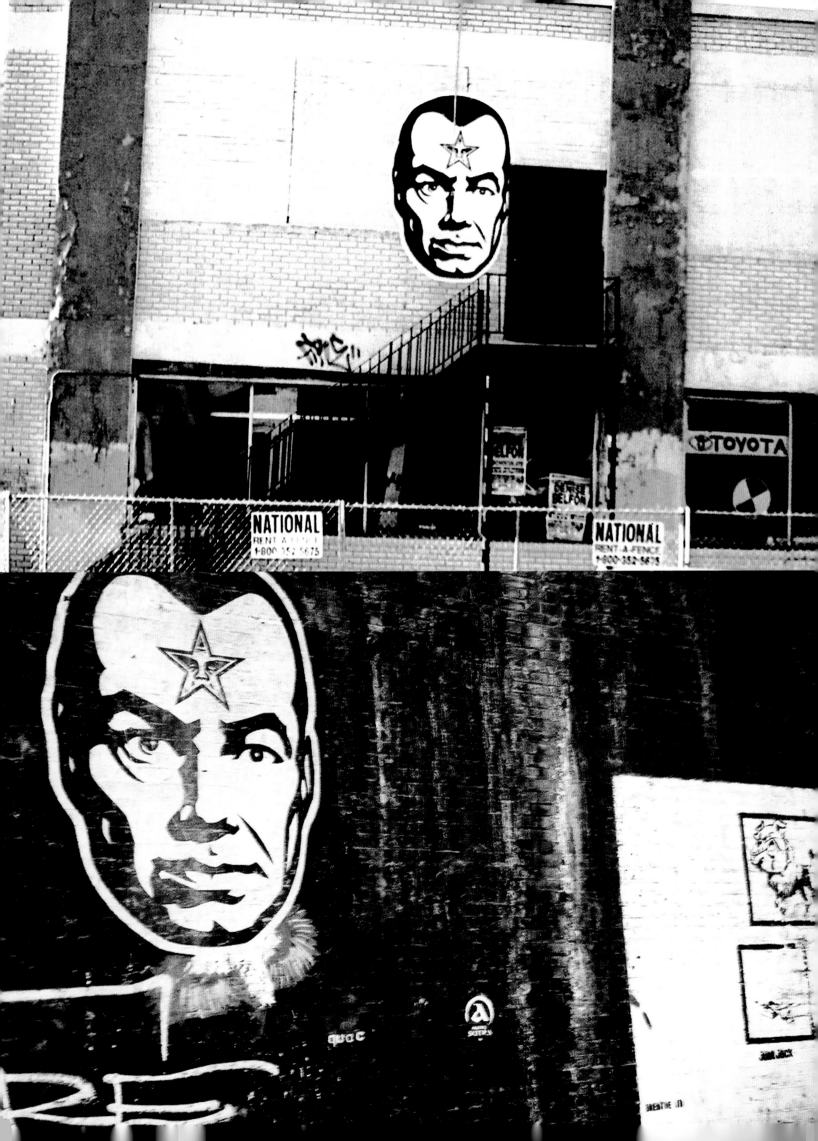

270. This image is an illustration I drew of a guy with somewhat of a creepy face, which I called "Giant Brother" as a reference to George Orwell's *1984*, where the government has everyone under surveillance and their slogan is "Big Brother is watching you." I illustrated half the face and then mirrored it, and I discovered that since no face is perfectly symmetrical, the symmetry introduces an inhuman, sinister aspect to a picture that might not be as disturbing otherwise. I thought the guy looked creepy to begin with, but it turned out even scarier than I had predicted.

269.

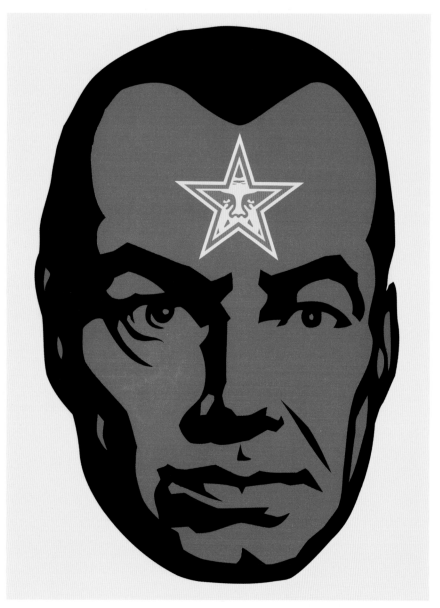

268. ***Obey Big Brother 2,*** 2001
(18 x 24") screen print on paper

269. ***Obey Big Brother Stickers,*** 2001
(2.5") screen print on vinyl

270. ***Giant Brother,*** 1999
(18 x 24") screen print on paper

268.

248

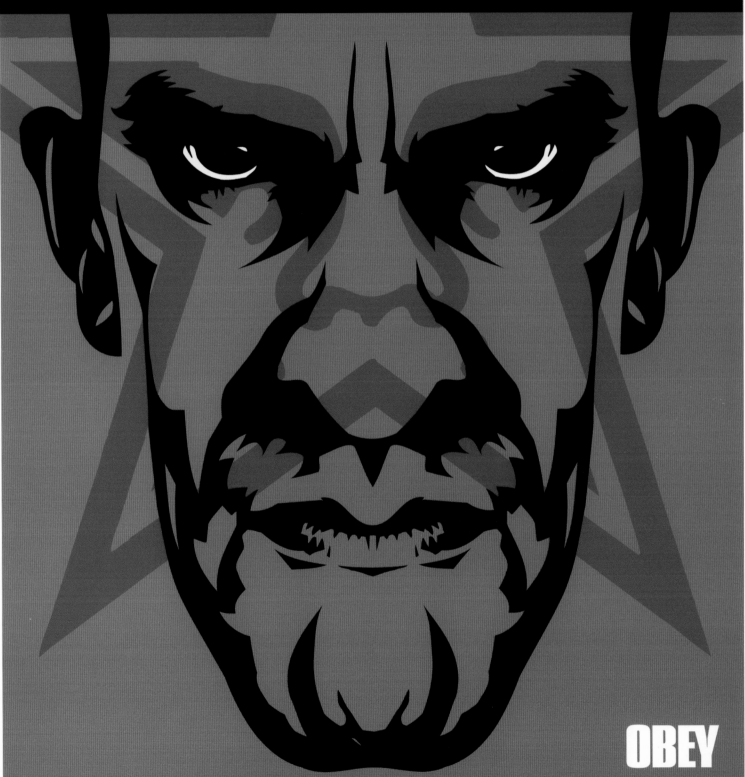

MUSIC

MOST OF MY HEROES DON'T APPEAR ON STAMPS (OR IN ART GALLERIES)

Shepard Fairey

No matter how much I love art, or try to convince myself of its relevance in society, the fact remains that music is a lot cooler and way more able to reach people's hearts and minds. When I'm asked about my biggest influences, my interrogator is often surprised to hear "The Sex Pistols, Black Flag, Public Enemy," generally expecting me to list off visual artists. I guess I feel like the power of something comes from the feelings it conjures, emotionally first and intellectually second. I've never been to an art show and felt like the art had a hold over every person in the room, much less looked over my shoulder to see 50,000 lighters held up in a show of solidarity for Ozzy's cause. Have you ever seen someone come out of an art show pouring with sweat, a glazed look in their eyes, throwing their fist in the air like they just had a religious experience? Art shows don't seem to elicit that level of enthusiasm. Actually, at a lot of art shows people are more worried about checking out the crowd than checking out the art. I can't really blame them when the art itself is less engaging than the written description on the wall next to it. In fact, I'm yawning just thinking about it. The truth is, I always fell asleep during art history lectures in college, but I've never fallen asleep at a single concert. Am I the exception? I don't think so. Art is just outgunned in the battle for the senses.

Music has the ability to stimulate on so many levels and I'm not just talking about live music. Music provides a cultural ecosystem in and of itself. There's the actual music, the lyrics with their content and politics, the style and personalities of the band members and the politics implicit in their lifestyles, and lastly, their art, album packaging, and graphics. I've had some very moving encounters with art, especially on the street, but nothing can compare with the first time I heard the boots marching and first chord of the Sex Pistols' "Holidays in the Sun," or the air raid sirens leading into "too black, too strong" on the intro to Public Enemy's *It Takes A Nation of Millions to Hold Us Back.* Those songs made my arm hairs stand up. Some music has affected me so powerfully that the mere sight of the album packaging induced a Pavlovian response (scientific analogy makes it sound less pathetic) of air guitar or drums! I mean, come on, who hasn't secretly but wholeheartedly identified with Beavis and Butthead imitating Sabbath's "Iron Man"? Bob Ross could only have dreamed of as many people watching his painting show as watch Beavis and Butthead, or now more likely The Osbournes.

Let's face it, music is a huge influence on popular culture, and even Andy Warhol, the most successful of "pop artists," is less widely known than musical acts comparably much lower on the totem pole. Warhol can actually be credited with exploiting the potential to connect with a broader audience through pop. His collaboration with the Velvet Underground led to the iconic banana album cover. That graphic would be just another part of the Warhol "let's make a mundane object into high art" schtick (not that that's a bad thing) if it

272. I've been a fan of Black Sabbath for a very long time. Coincidentally, a friend of mine happens to work for Ozzy, and has planted a lot of my art in the Ozzy camp, whether simply showing it to Sharon and Ozzy or getting Jack to wear Obey shirts on the TV show. In 2004, they asked me to make the VIP band and crew shirts, which said "Black Sabbath has a Posse," with each member of the band in the original Andre sticker format. This piece here is from the poster and T-shirt I designed for Sabbath's 2005 tour.

272.

271. **Obey Ozzy,** 2001
(18 x 24") screen print on paper

272. **Obey Black Sabbath Red,** 2005
(18 x 24") screen print on paper

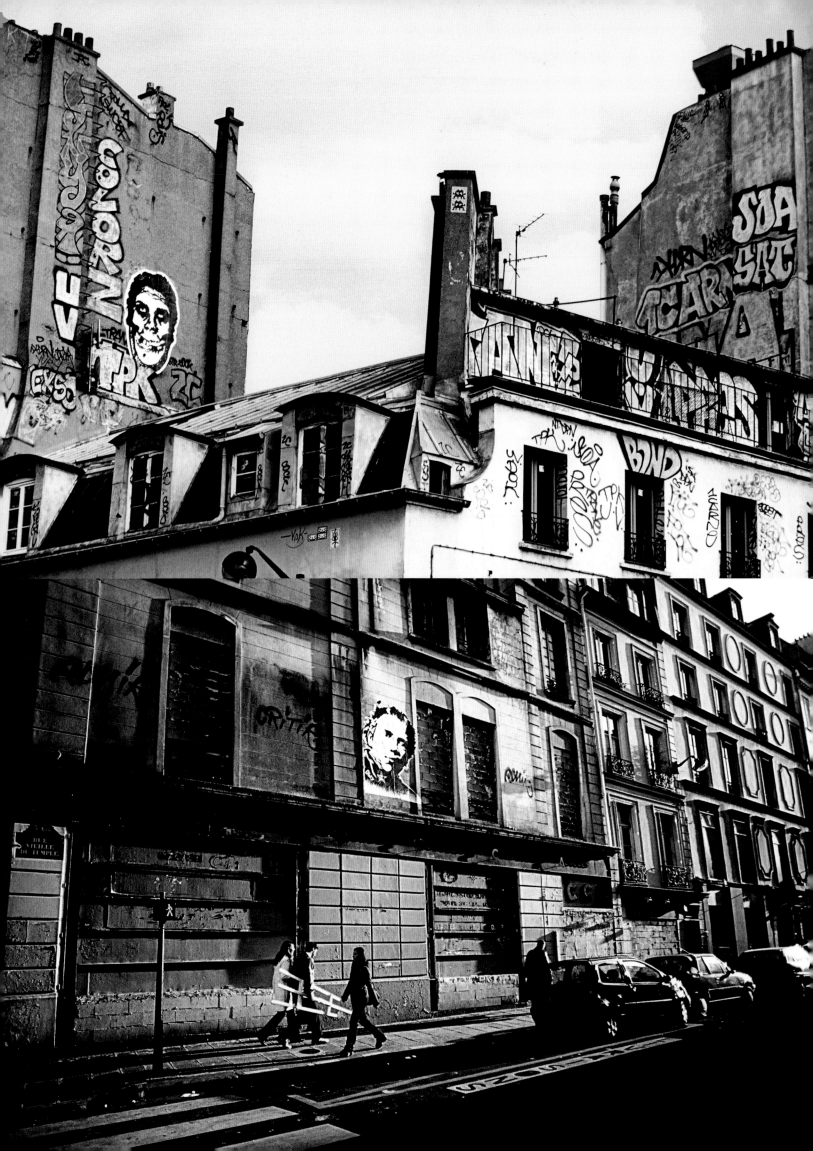

weren't associated with such an influential and enduring band. The marriage of great art, great music, and great ideas is an incredibly powerful one. Hell, even two of those elements converging harmoniously yields something whose whole is more than the sum of its parts.

I used Public Enemy to illustrate this spread because they are one of the rare acts, along with bands like The Clash and the Sex Pistols, who brilliantly crafted every aspect of what they were doing and maximized the results. Great name, great beats, great rhymes, provocative politics, powerful graphics and presentation (can't front on the S1W), and a defiant attitude that scared The Man made Public Enemy a force to be reckoned with. They probably raised more issues in the three years following their debut than the world's visual artists will during their lifetimes. For a visual artist such as myself, this harsh reality provides the challenge to make my art as much of an engaging, stimulating, provocative, visceral experience as possible. To quote Chuck D, "I want to reach the bourgeois and rock the boulevard." I don't want people to only experience my art in the safe, tame confines of the gallery, which is why I put my art up illegally in the streets. I'm a populist and I look at it this way: I may not play an instrument, but I'm gonna rock it hard as nails anyway.

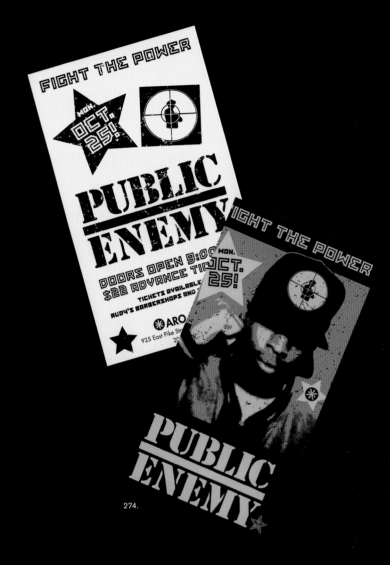

274.

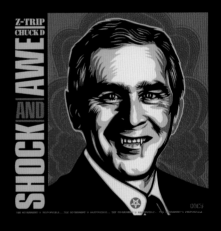

What can I say about Shep? Having grown up being a graphic nut myself, my appreciation is especially sprung out on his work. He's Warhol–Rockwell to me on a radical tip, slapping propaganda with an eye on protecting all of our futures.

– Chuck D

273. ***"Shock and Awe" 12" Single (Front and Back),*** 2005
(12.25 x 12.5")

274. ***Public Enemy Postcard,*** 2000

275. ***Obey Flavor Flav,*** 2002
(18 x 24") screen print on paper

276. ***Obey Chuck D,*** 2002
(18 x 24") screen print on paper

273.

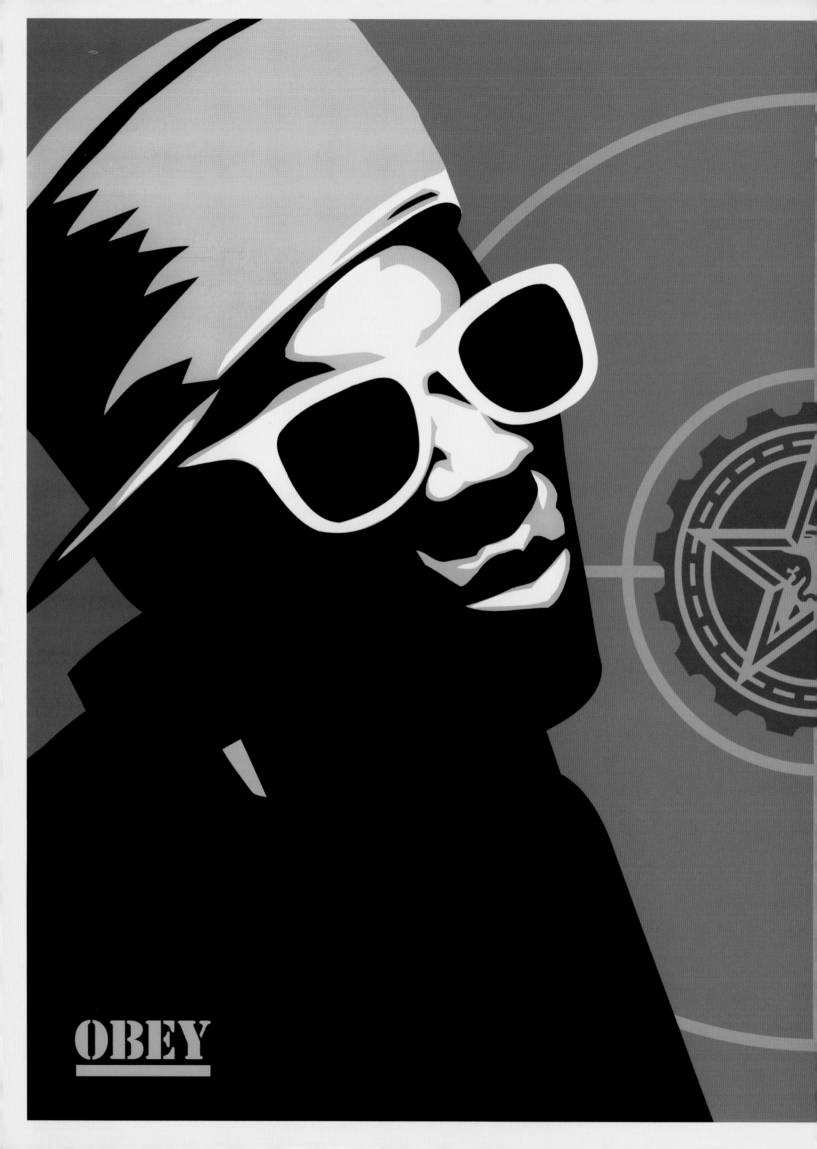

OBEY

OBEY

278. When I decided to do a KISS poster, I chose Gene Simmons because he was always my favorite member. I thought he had the coolest makeup, and I liked the blood dripping from his mouth and the pyrotechnics he always had around him. I threw Andre's face in there with Gene's makeup and hair, and did the Giant type to look like the KISS type. I tried to capture all the campiness of Gene Simmons and KISS and appropriate that for myself.

277. *Obey Kiss Destroyers,* 2001 (18 x 24") screen print on paper

278. *Obey Kiss,* 2000 (18 x 24") screen print on paper based on Obey Kiss t-shirt made in 1995

278.

279.

280.

279. *Giant Beatles John,* 1997
(18 x 24") screen print on paper

280. *Giant Beatles Ringo,* 1997
(18 x 24") screen print on paper126.

281. *Giant Beatles,* 1997
(18 x 24") screen print on paper

282. *Giant Beatles Andre,* 1997
(18 x 24") screen print on paper

283. *Giant Beatles Paul,* 1997
(18 x 24") screen print on paper

THE
GIANT
7'4"

281.

279–283. With the Beatles series, I again hijacked something with more cultural clout than Andre the Giant or professional wrestling, or my dada art project for that matter. In a sense, the Beatles are such a venerated pop culture institution that replacing George Harrison's face with Andre's is kind of irreverent, but people also have such a positive association with the Beatles that there's somewhat of a Pavlovian euphoria to just produce portraits of the Beatles and associate Andre with it. That was one of my most sought–after sets of work, another example of my piggybacking onto the cultural cache of something and benefiting from it, but I don't really feel guilty about it because that's the currency out there, and there are lots of exchanges of cultural currency.

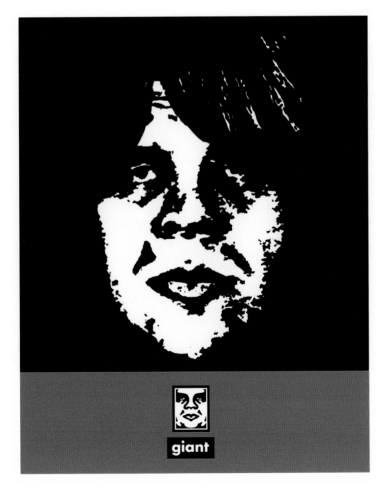

282.

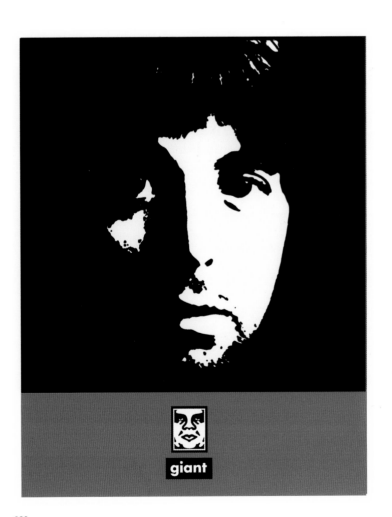

283.

284. **Obey Motörhead Album Stencil,**
2003 (12.25 x 12.5") spray paint stencil
and collage on album

285. **Obey Prints and the Revolution,**
2003 (18 x 24") screen print on paper

286. **Obey Freedom at 33 1/3 ,**
2004 (18 x 24") screen print on paper

287. **Obey Motörhead,** 2002
(18 x 24") screen print on paper

288. **Obey Bad Brains,** 2002
(18 x 24") screen print on paper

285. I was doing a show in Minneapolis, and I decided to use the opportunity to create a web of puns with this poster. Prince is one of the most famous figures from Minneapolis, and I create screen *prints*, often of pop icons; his band in the '80s was called the Revolution, and my work uses a lot of revolutionary material like the Che Guevara image; so it all seemed to fit together nicely.

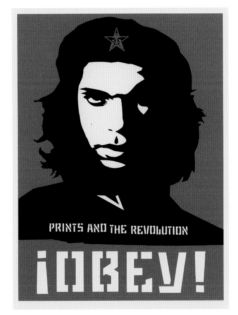

285.

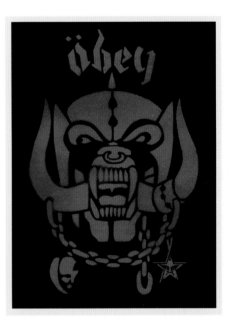

287.

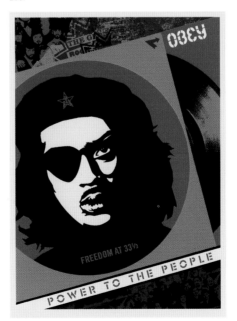

286.

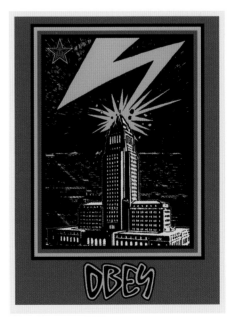

288.

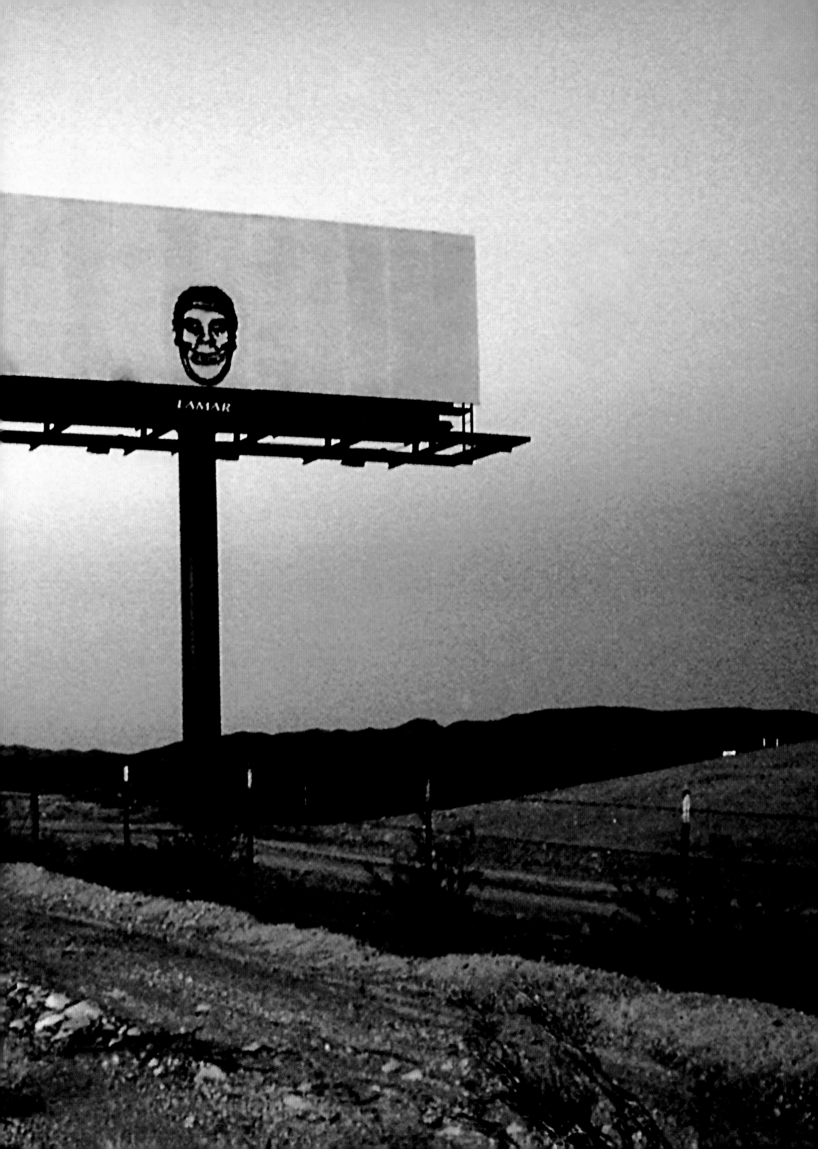

287–292. The *Punk Pioneers* series started with Joey Ramone, lead singer of the Ramones, who I considered the first punk band (even though Iggy Pop and the Stooges came before and were punk in their own respect, I felt like the Ramones really set the wheels in motion). After Joey Ramone came Johnny Rotten of the Sex Pistols, Joe Strummer from The Clash, Glen Danzig from the Misfits, Henry Rollins from Black Flag, and Ian MacKaye from Minor Threat. I felt like all those guys were individuals who helped blaze a trail in the punk rock scene. In punk's family tree, those guys were the patriarchs of each branch.

288.

287.

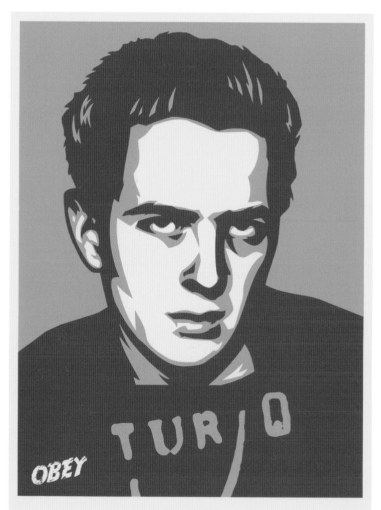

289.

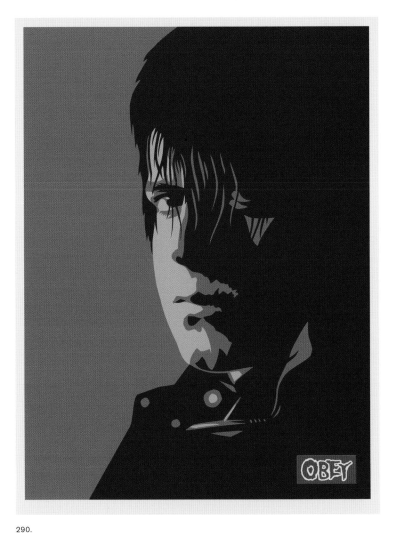

290.

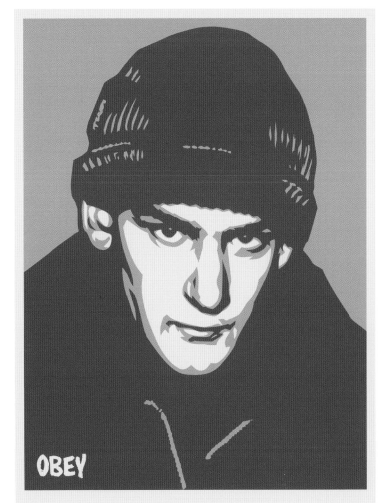

292.

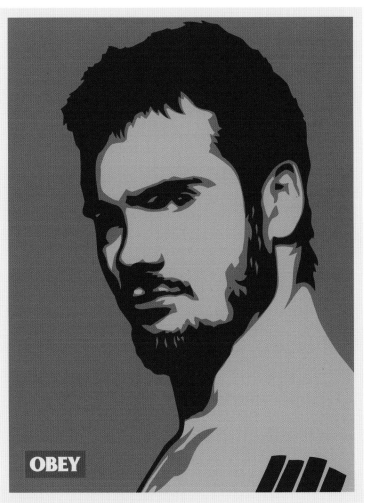

291.

291. Henry Rollins did a benefit CD called *Rise Above*, with various artists performing Black Flag covers, in order to raise money for the West Memphis Three, a trio of young men from West Memphis, Arkansas, who were arrested and imprisoned as teenagers in 1993 for killing three eight-year-old boys in what is believed to be a vastly corrupted case. The proceeds from the CD went to the West Memphis Three's legal defense fund, and I donated all the proceeds from the Rollins posters to the defense fund as well.

287. **Obey Rotten,** 2002
(18 x 24") screen print on paper

288. **Obey Ramone,** 2002
(18 x 24") screen print on paper

289. **Obey Strummer,** 2002
(18 x 24") screen print on paper

290. **Obey Danzig,** 2003
(18 x 24") screen print on paper

291. **Obey Rollins,** 2003
(18 x 24") screen print on paper

292. **Obey MacKaye,** 2003
(18 x 24") screen print on paper

296. The day that Jam Master Jay was killed, Glen E. Friedman was coming out to L.A. for a photography show of his and wanted to do a commemorative piece for Jay. Glen asked me to make a portrait out of a jpeg image, because there was no way he could print the photo in time for the show, but I could digitally output the portrait really quickly. Later on, adidas decided to use the portrait for the hangtag on the Jam Master Jay commemorative shoe.

294.

295.

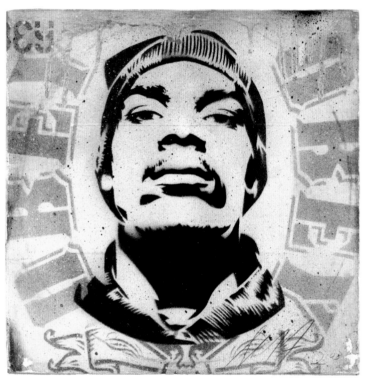

293.

293. **Obey Snoop Album,** 2003
(12.25 x 12.5") stencil on album

294. **Obey Big Brother Sub,** 2004
(15.5 x 13.5 x 15") spray paint
stencil and collage

295. **Obey Biggie Sub,** 2004
(15.5 x 13.5 x 15") spray paint
stencil and collage

296. **Jam Master Jay Sticker,** 2002
(2 x 3") screen print on vinyl

297. **Obey JMJ RIP Album,** 2002
(12.25 x 12.5") stencil on album

296.

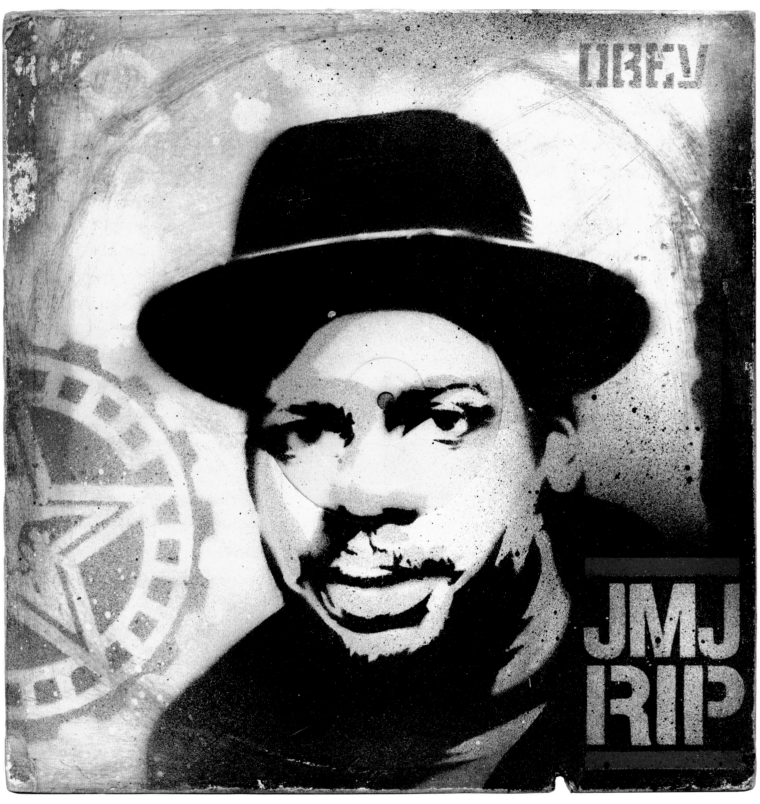

297.

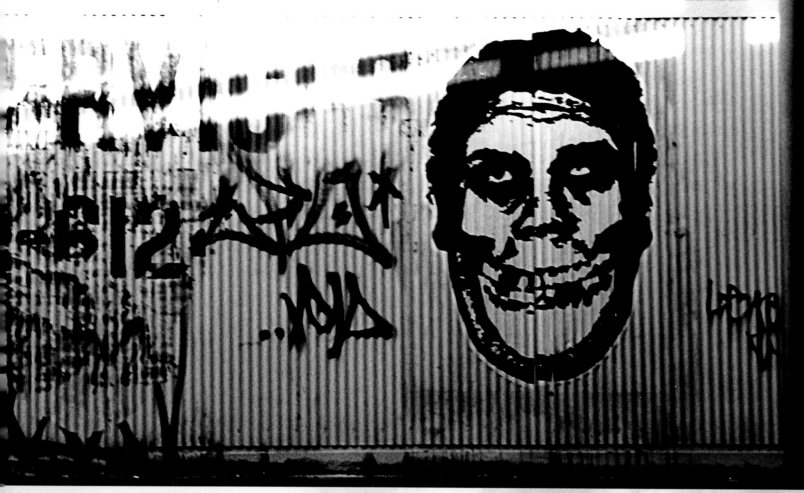

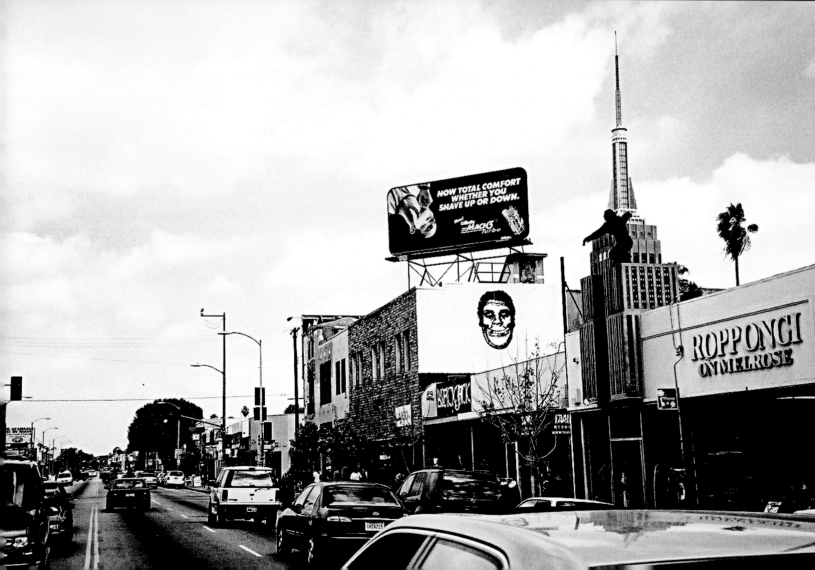

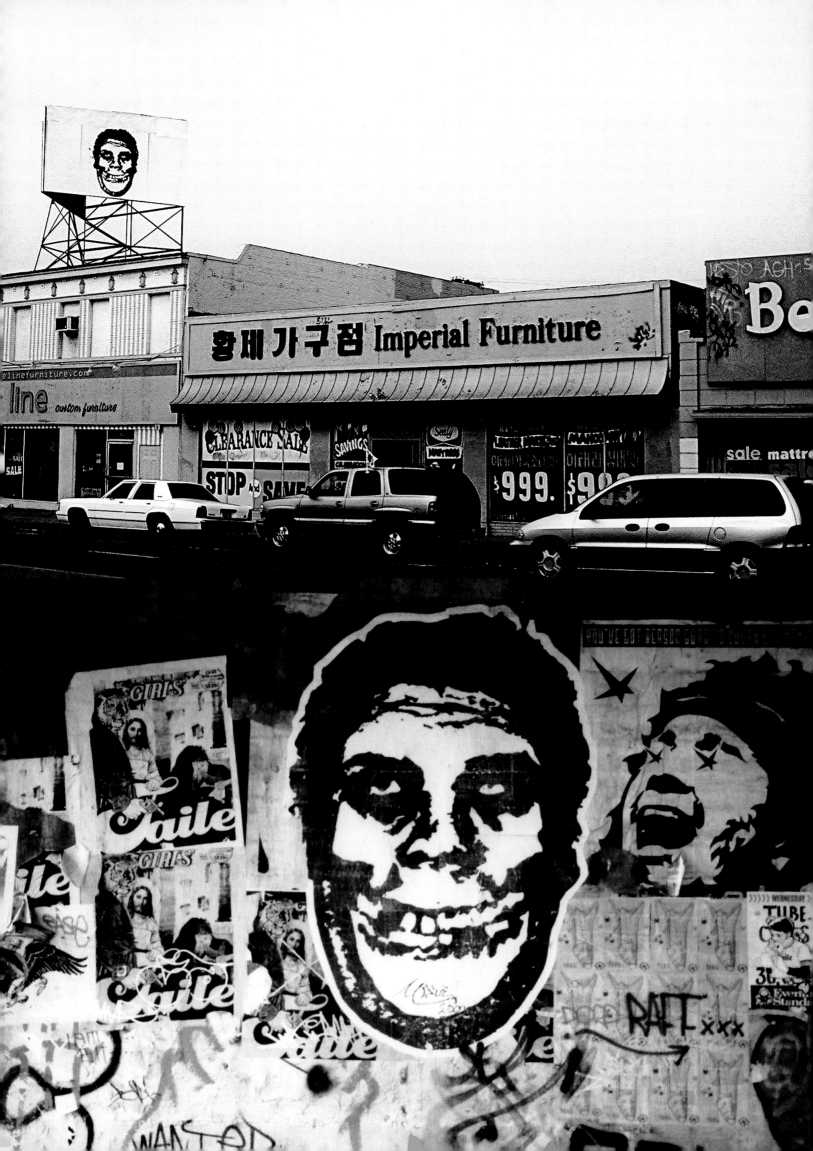

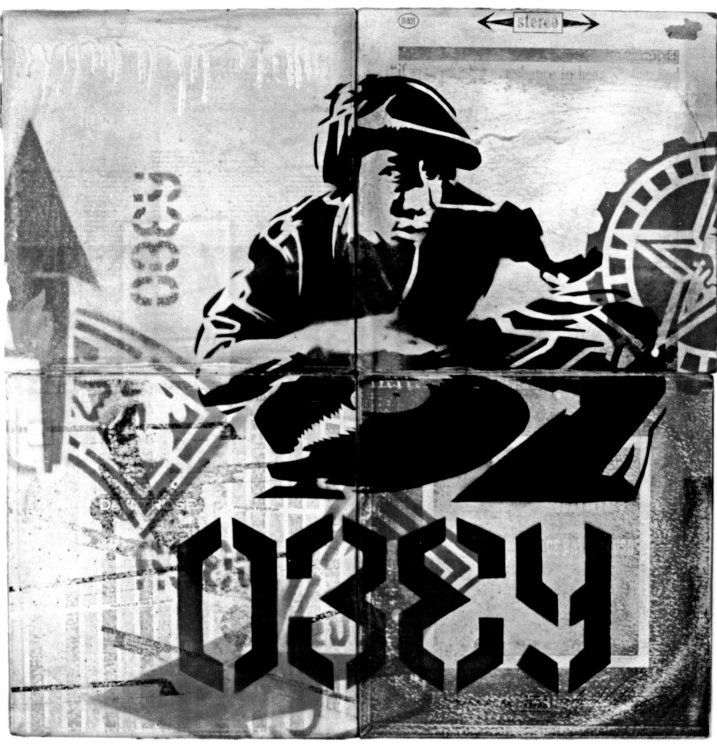

298.

298. **Obey Bring the Noise 4–Album,**
2003 (24.5 x 25") spray paint stencil
and collage on albums

299. **Sugarhill Gang Fax,** 2004

300. **Sugarhill Gang,** 2004
(18 x 24") screen print on paper

301. **Obey Bring the Noise,** 2002
(18 x 24") screen print on paper

299–300. The Sugarhill Gang came out with "Rapper's Delight" in 1979, the first hip–hop single to crack the Top 40. I was commissioned to do this poster by Warner Brothers and the promoter of the party (at the 2004 South by Southwest Music Festival in Austin, Texas), and because their graphic design budget was so slim I asked if I could use the artwork for posters to sell on my website. About a year and a half later, I got a letter from Sugarhill Records' lawyer threatening to sue me over this poster, which I had permission to do, though they denied any knowledge of it. As it turned out, they just liked the design and wanted to use it, and the only way to force me to let them use it was by suing me, even though I would have (and ultimately did) let them use it anyway.

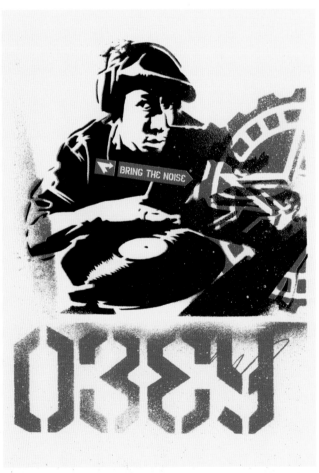

300.

05:52p Cinque & Cinque

AGREEMENT

WHEREAS Obey Giant Art ("Obey") produced a limited run of 200 posters containing the "Sugar Hill Gang" trademark and the likenesses of the individual members of the Sugar Hill Gang (the "Poster"); and

WHEREAS the Sugar Hill Gang has asserted a claim against Obey for its manufacture and distribution of the Poster without the consent of the Sugar Hill Gang; and

WHEREAS the parties wish to resolve all disputes between them relating to the Poster.

NOW THEREFORE IT IS AGREED:

1. Obey will ship to the Sugar Hill Gang, at an address to be supplied, all Posters presently in Obey's possession, custody or control.

2. Obey will change the Poster's art work in the following respects:

(a) the phrase "Charles Attall and Charlie Jones invite you and one guest to attend" will be replaced by "Harold Miles and Sylvia Robinson Productions Presents;"

(b) the words above the three pictures will be replaced by "Rapper's Delight," "8ᵗ Wonder," and "Apache."

(c) the photograph to the extreme right will be replaced by a photograph to be supplied by the Sugar Hill Gang.

The Poster as changed above will be referred to as the "Revised Poster."

299.

301.

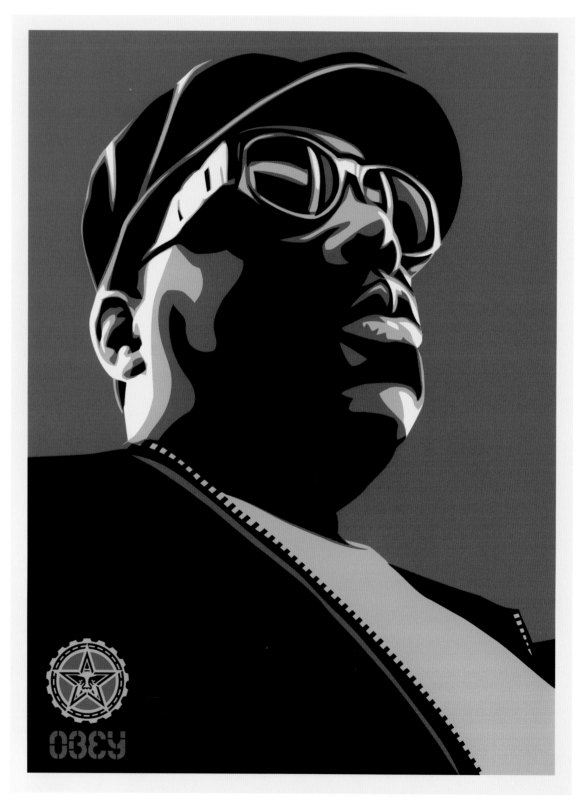

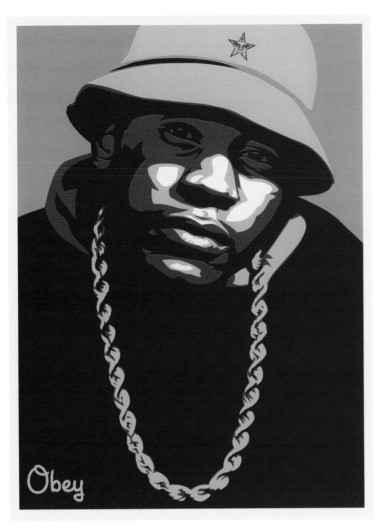

303.

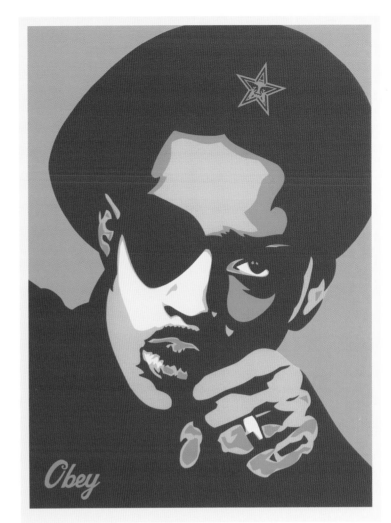

304.

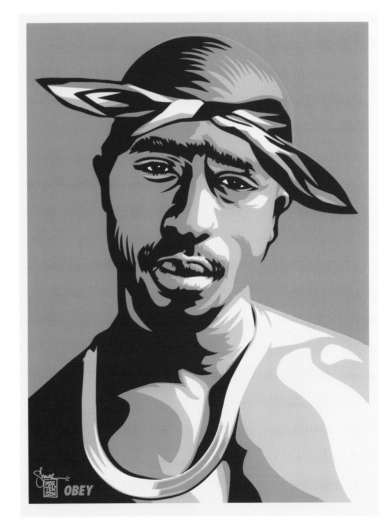

302. **Obey Biggie,** 2004
(18 x 24") screen print on paper

303. **Obey LL Cool J Blue,** 2004
(18 x 24") screen print on paper

304. **Obey Slick Rick,** 2004
(18 x 24") screen print on paper

305. **Obey Tupac Blue,** 2004
(18 x 24") screen print on paper

305.

ABOVE: This billboard is in Austin, Texas, just off the freeway near the main exit for downtown that people would take for the South by Southwest festival. The billboard is in a really great spot, but I don't know Austin that well so I had no idea what I was getting into. I saw that it was blank (besides the phone number to rent it) and decided I was going to get it one night while I was in town for the festival. As soon as I got up to the top, I noticed that a cop car had pulled up right below the billboard, and I thought I was busted. But I was really quiet and I laid down, and the billboard was unlit so it would have been hard for anyone to see me. Then the cop car

pulled up to a gas pump and another cop car pulled in behind it, and it was then that I realized it was the fueling station for the

police. After both cars left, I pulled up my bucket of paste (which had been sitting on the ground at one end of a rope, with the other

end tied to my belt) and rocked the piece, always looking over my shoulder to make sure there were no cops coming (I estimated that

there was a cop coming through there every 10 minutes or so). I totally didn't anticipate the risk factor of hitting this billboard, but

I'm sure the police saw the piece before long and wondered, "How the fuck did that happen?"

306.

306–307. I was always into music as a kid, but the first group that got me into a subculture of music was the Sex Pistols. From then on, all I cared about was punk rock. At first I just dug the music, but as I learned more about them I realized that they created an incredible cultural upheaval, and there were talented people involved not only in the music but on the art, fashion, and business ends. I used that as a template for what I tried to do: make solid art, but also manipulate the media and cover every variable in pop culture; work all the angles.

Cultivate the curiosity of the press.

Concentrate on creating generation gaps.

You've become a novel idea. You've got people wanting to join in. You've gained credibility from nothing – use this as a story you can sell. Terrorize, threaten, and insult your own useless generation.

– Malcolm McLaren

306. *Obey Rotten 4–Album Stencil,*
2004 (24.5 x 25") spray paint stencil and collage on albums

307. *Obey Sid Do It Your Way,* 2003
(35 x 47") screen print on paper

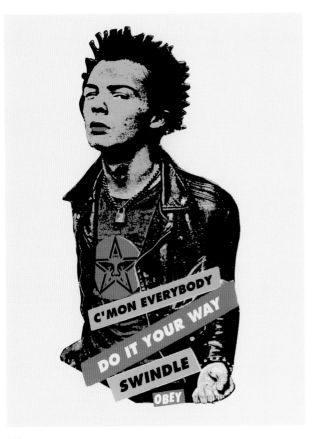

307.

JAMIE REID
SEX PISTOLS' ARTIST

Reid, an artist and activist who found his calling in the student protest movement, began making agitative, situationist graphics in 1968. "Subvertising" was Reid's answer to the new shopping age, and he used ripped–up advertisements and corporate logos to design the anti–corporate posters he would post around London. When Malcolm McLaren asked Reid to be the graphic designer for the Sex Pistols in 1976, Reid's style acquired an audience, and his ransom note lettering and safety pins became defining visual elements of the punk movement. Reid's irreverent graphic of the queen with a safety pin through her lip made the entire Sex Pistols camp hated by the establishment. More than just a design aesthetic, Reid believed in the crude approach to his work as a manifestation of the punk attitude to make something from nothing. The DIY musical and graphic approach to punk made the movement very accessible.

SHEPARD'S COMMENTS

If you've never heard of Jamie Reid, you've undoubtedly seen his work and/or its far–reaching influence. Malcolm McLaren is often credited with inventing punk as we know it, but I would argue that Reid deserves the lion's share of credit for punk's enduring image. I can credit Reid's Sex Pistols graphics as an early inspiration for me to dabble in making my own t–shirts and stickers. I think my parents, 18 years ago, considered punk a "gateway drug." Punk was a drug for me. As clichéd as the punk look and graphic formula may have become, I will always remember the roots of the style, representative of people who had very few resources attempting to shake the system. If it can serve as a reminder of this, let the punk look symbolize aggressive three–chord music and ideas for the next 25 years.

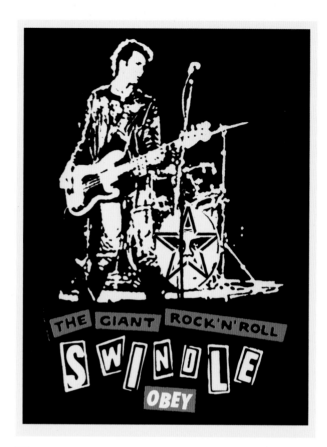

308.

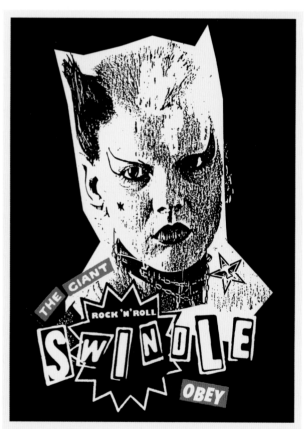

309.

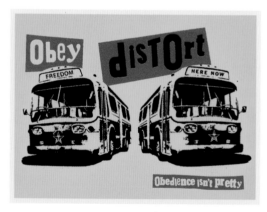

310.

308. **Obey Sid Swindle,** 2002
(18 x 24") screen print on paper

309. **Obey Catwoman Swindle,** 2002
(18 x 24") screen print on paper

310. **Obey Pistols Distort,** 2001
(18 x 24") screen print on paper

311. **Obey Vicious Subversion,** 2001
(18 x 24") screen print on paper

Sid Vicious was born John Simon Ritchie in 1957 in London; his father deserted him and his mother shortly thereafter. He spent his teen years in Hackney, East London, where he met John Lydon, a.k.a. Johnny Rotten, in 1974. That same year, Vicious began shooting heroin with his mother. A year later, Rotten was recruited by Malcolm McLaren to become the lead singer of the Sex Pistols. In 1977, after the band had been dropped by EMI and bassist Glen Matlock had left, McLaren endorsed Vicious as a replacement, due to his emblematic punk–rock look and attitude and in spite of his lack of musical talent. Sid's bass parts on studio recordings were actually played by guitarist Steve Jones, and on stage he played with his instrument unplugged. Sid met American groupie Nancy Spungen in November 1977, and the two junkies quickly developed an amorous and codependent relationship. Less than a year later, on October 12, 1978, New York City police, responding to a domestic dispute at the Hotel Chelsea where Sid and Nancy had taken up residence, found Nancy dead from a single stab wound to the abdomen. Sid, lying dazed nearby, was arrested and charged with her murder, despite having no recollection of the incident. Four months later Sid died of a heroin overdose, widely speculated to have taken his own life because he couldn't withstand the pain of living without Nancy. To this day, Sid Vicious is considered the epitome of the violent, anarchistic, "live fast, die young" punk lifestyle.

SHEPARD'S COMMENTS

This Sid image (#314) is a stencil I made from a portrait by Jim Jocoy, who was kind enough to let me use this recently–published photo as a reference. The interesting thing about Sid is that he didn't really do much to shape punk music, yet he remains one of its most enduring images. Sid really had the fashion image down, but he only actually played on two songs on *Never Mind the Bollocks*. Sid is a classic example of style over substance. I was a sucker for his image. At age 15, one of the first stencils I ever made was Sid with the spiky hair, lock chain, and snarled lip. I look at Sid as less cool and more tragic these days, but he has still sold more t–shirts than anyone else in punk rock. Sprite was wrong – image is everything!

313. *The Giant Rock 'N' Roll Swindle* is a collaboration CD I did with Fork In Hand Records. I've always been influenced by music and the graphics that go with it. The album combines the images that I've incorporated into my underground movement with music that also falls into the underground category. The CD contains 20 tracks covering a variety of styles, from punk rock to indie rock to electronic music; instead of using 20 bands that all sound similar, we tried to change things up by combining all styles of underground music. On the packaging end, the jewel case is surrounded by a cardboard cover with a perforated image of the Obey Giant face, which can be punched out to use as a stencil.

313.

312. **Swindle Ad Signed by Sex Pistols,**
2002 (8.5 x 11") lithograph

313. **Obey Giant Rock 'n' Roll Swindle CD,**
2002 (5 x 5.25")

314. **Obey Sid Stencil Print,** 2003
(35 x 47") screen print and spray paint on paper

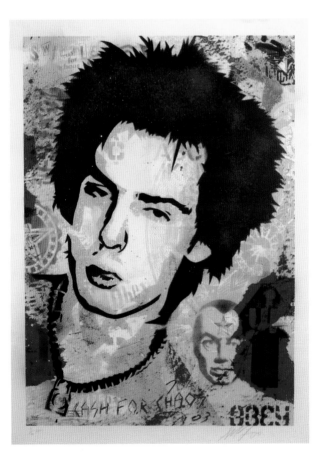

314.

Although he only appeared on a few singles, one full–length album, and one movie documentary during his short life, Germs frontman Darby Crash certainly left his mark on the punk rock world. Few rock "singers" pushed themselves to such dangerous and fearless extremes as Crash did at just about every show he performed, indulging in confrontations with audience members, engaging in obnoxious and drunken behavior, singing off–key and off–mic, and never above smearing peanut butter on himself or cutting his torso mid–performance. A fine example of the Germs' unforgettable stage act (as well as one of the only Crash video interviews in existence) can be sampled in the 1980 Penelope Spheeris–directed documentary, *The Decline of Western Civilization*.

The Germs became one of the frontrunners of the emerging L.A. punk/hardcore scene (which also included such acts as Black Flag, Circle Jerks, X, and Fear), as their one and only album, 1979's *(GI)*, became an underground hit. But Crash's intake of heroin reached deathly proportions just as their recording career began, and he split from the band to visit England for an extended period in 1980. On December 7, Crash was found dead from a heroin overdose at only 21 years of age.

SHEPARD'S COMMENTS

I totally missed out on the Germs while I was primarily listening to L.A.'s second wave of hardcore. Not until I heard the Melvins' cover of "Lexicon Devil" did I look for the Germs catalog, which had been out of print but, conveniently, recently re–released on CD. Of all the punk bands, I think the Germs most embody the "if there's a will, there's a way" punk spirit. In my opinion, they were outsider artists who used instruments and vocals as paintbrushes. Though their work may have been sloppy, sometimes there is charm in a gesture that transcends craftsmanship and could even be compromised by it. It is this same gestured whimsy that can make people self–destructive and susceptible to vice. Darby's virtues in one area were his demons in another.

315.

315. Vivenne Westwood was the clothing designer for the Sex Pistols and co–owner of the shop SEX with Malcolm McLaren, the Sex Pistols' manager. She came up with all the outfits for the band, and essentially created the fashion look that defines punk to this day.

Unlike most of the people from the first wave of punk who burned bright and fizzled fast, she is still a successful designer and her work has taken many forms over the years. I should also note that my daughter is named after her.

316.

315. ***Vivienne Westwood Stencil,*** 2005
(30 x 44") spray paint stencil and collage on paper

316. ***Darby Crash by Gary Leonard,*** 1980

317. ***Darby Crash Stencil,*** 2004
(30 x 44") spray paint stencil and collage on paper

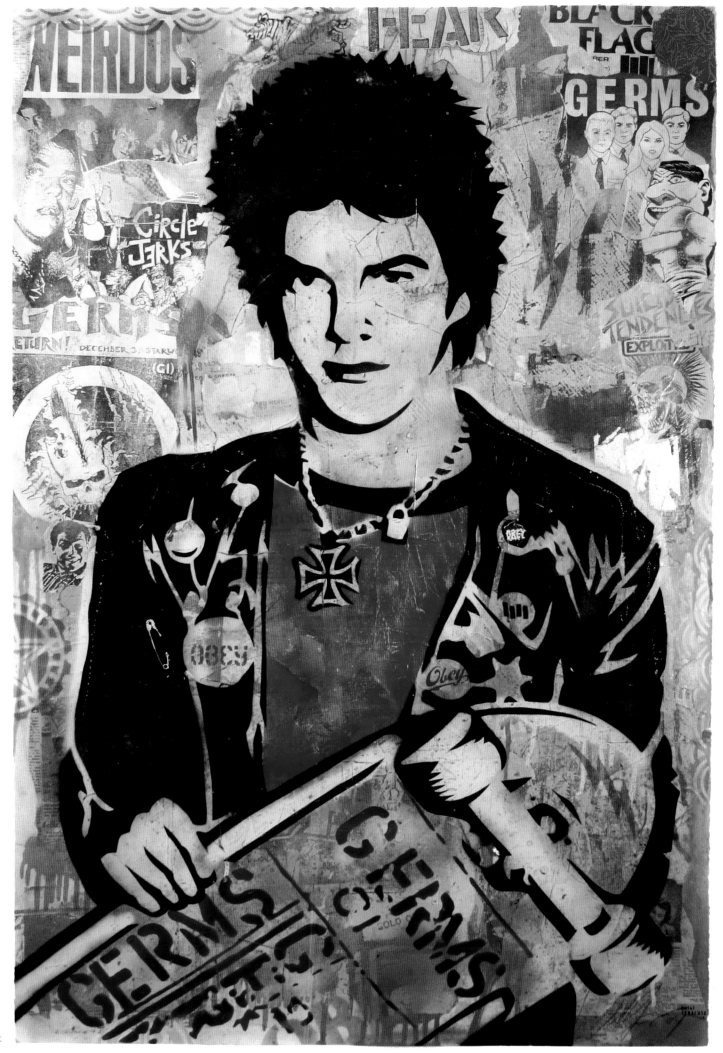

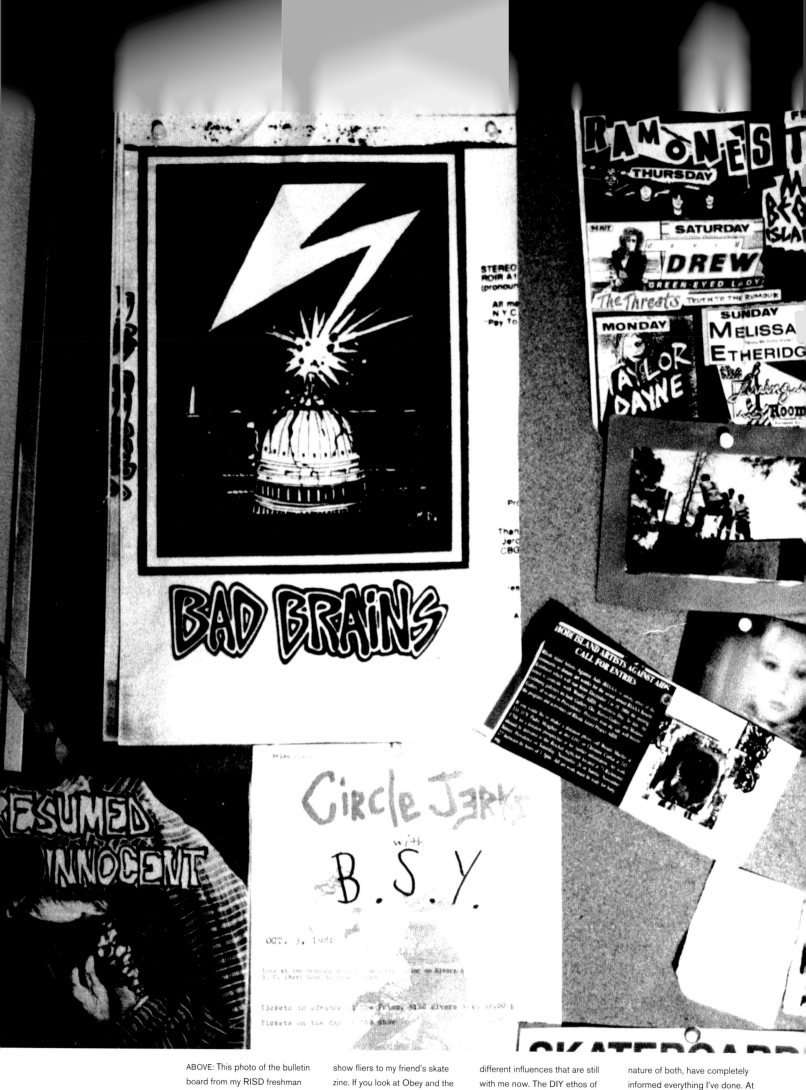

ABOVE: This photo of the bulletin board from my RISD freshman dorm room shows a collection of stuff I was into, from punk show fliers to my friend's skate zine. If you look at Obey and the influences I've had, the bulletin board encapsulates a lot of the different influences that are still with me now. The DIY ethos of punk rock and the creativity of skateboarding, and the rebellious nature of both, have completely informed everything I've done. At the time, the bulletin board was just a random collection of stuff

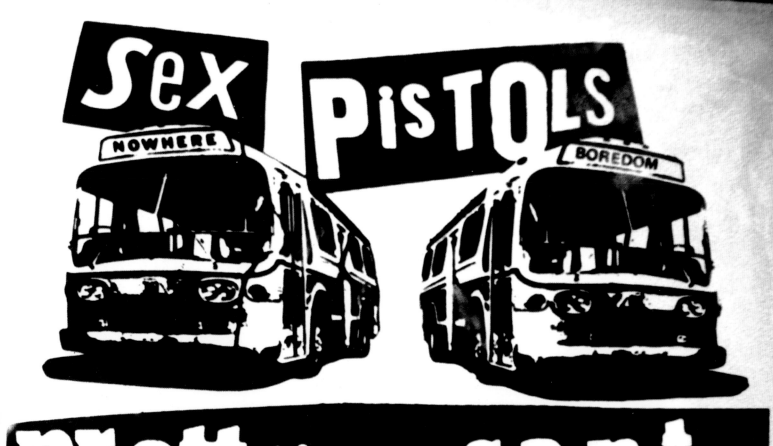

that was accumulating organically, but since then I've made knockoff variations of almost all the imagery within it. It just shows that either I'm really boring or I had it planned out right from the start.

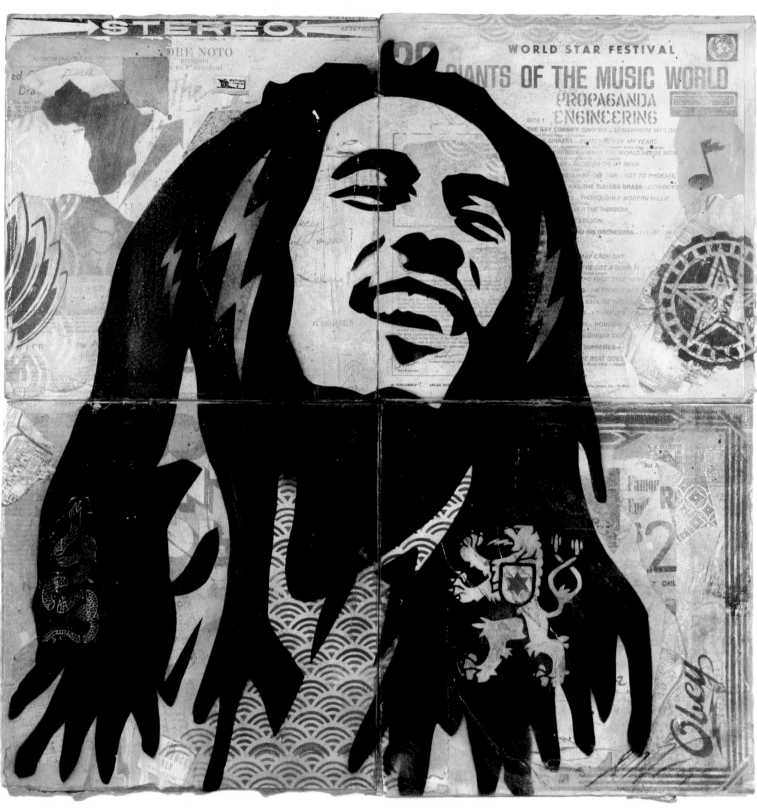

318.

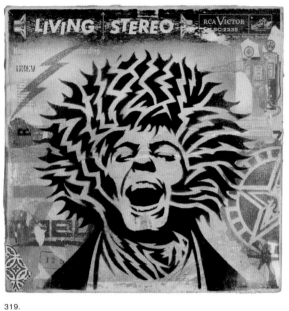

319.

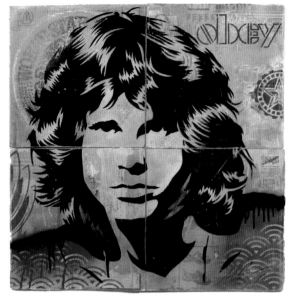

320.

318. **Obey Bob Marley 4–Album Stencil,**
2004 (24.5 x 25") spray paint stencil and
collage on albums

319. **Obey Pretty Vacant Album Stencil,**
2004 (12.25 x 12.5") spray paint stencil and
collage on album

320. **Obey Jim Morrison 4–Album Stencil,**
2004 (24.5 x 25") spray paint stencil and
collage on albums

321. **Obey Pretty Vacant,** 2004
(18 x 24") screen print on paper

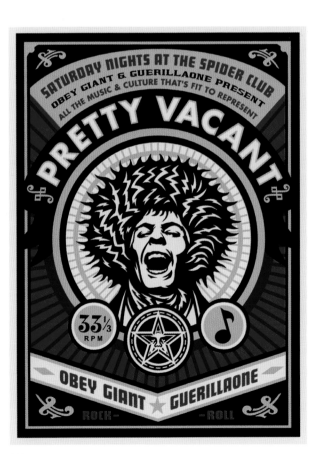

321.

DEBBIE HARRY
VOCALIST FOR BLONDIE

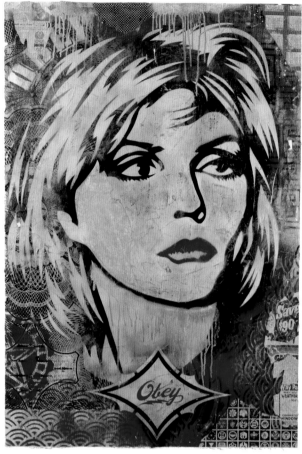

322.

Deborah Harry was born in 1945 in Miami, Florida, and adopted three months later by the Harry family of Hawthorne, New Jersey. She moved to New York City in 1965, where she eventually found work as a "bunny" at the Playboy Club, and became a regular at Max's Kansas City and CBGB's. Her professional singing career started in 1968 with a folk band called Wind in the Willows, singing backup on their first and only album. In 1973, she began dating Chris Stein and the two formed the Stilletoes. A year later, they created Blondie, struggling for a few years in the downtown New York scene before finally breaking through in 1978 with their third album, *Parallel Lines*. Harry was the quintessential ultrachic, sophisticated downtown girl of the post–Warhol era, with sharp wit and supermodel looks. At the forefront of the new wave movement, Blondie fused experimental rock with disco and punk, and was one of the first pop groups to adopt rap and reggae sounds; their 1980 single "Rapture" was the first rap song to make it to #1 on the charts. Harry had already started a successful solo career when Blondie broke up in 1982, and she subsequently cut her workload, which had come to include film and television roles, for three years to care for Stein, who had become seriously ill (he eventually recovered). In 1998, Blondie reunited for a European tour, and recorded a new album, *No Exit*, the following year.

SHEPARD'S COMMENTS

I loved Blondie as a little kid. From "Heart of Glass" to "Call Me" to "Rapture" to "The Tide is High," Blondie rocked styles as disparate as disco, rock, hip–hop, and calypso. At the time, I did not understand how amazing it was that Blondie had also emerged out of the guy's world of the NYC punk scene. There were plenty of female vocalists, but Debbie Harry and Joan Jett were two of the only women who rocked hard enough to front bands in a male–dominated genre. Debbie Harry was able to maintain her dignity and be both a sex symbol and feminine role model.

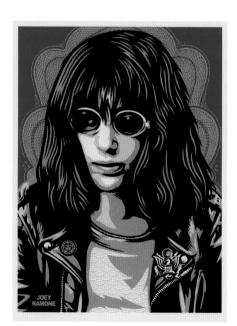

323.

322. **Obey Debbie Harry Stencil,** 2004
(30 x 44") spray paint stencil and collage on paper

323. **Obey Joey Ramone Red,** 2005
(18 x 24") screen print on paper

324. **Obey Joey Ramone Stencil,** 2005
(30 x 44") spray paint stencil and collage on paper

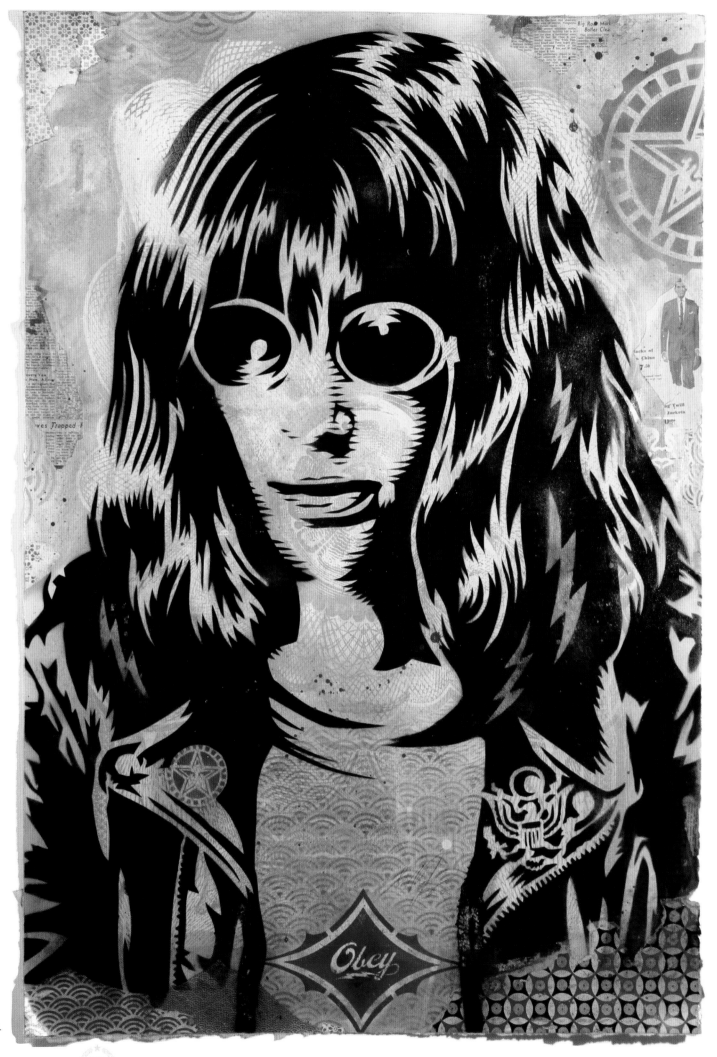

324.

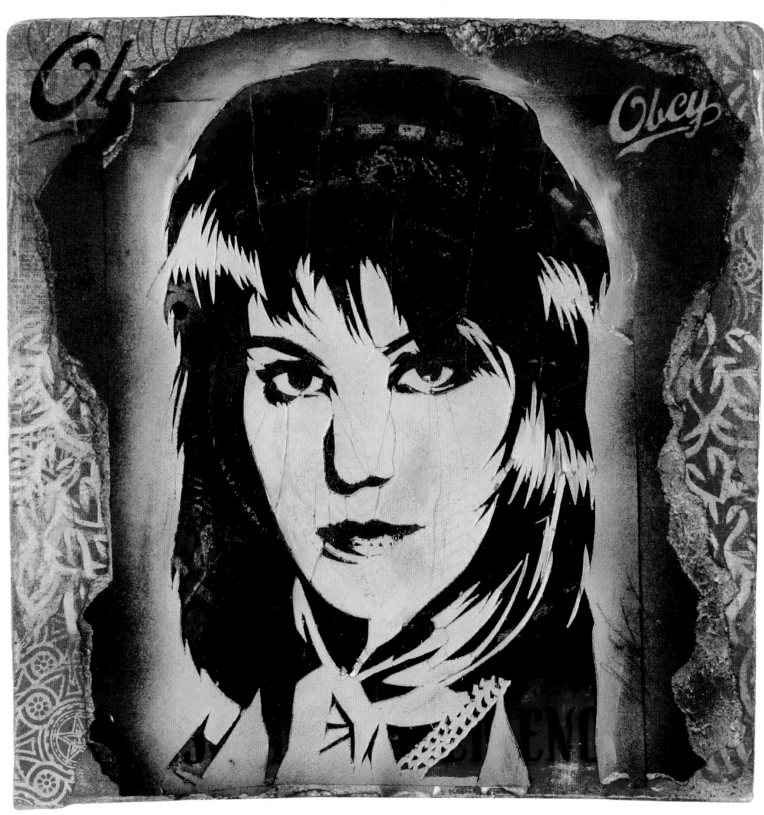

325.

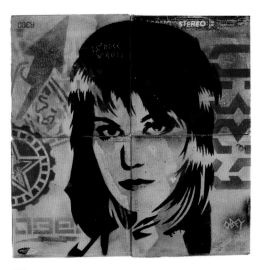

326.

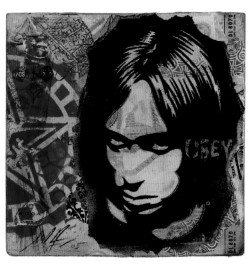

327.

325, 326, 328. Joan Jett is really a bad-ass woman. She never tried to play the role of demure sex kitten. She has always been more like one of the guys, not just some rock groupie. Not only does she sing and play guitar, she co-owns a record label and acts in movies and on Broadway. She also has produced various punk albums, including the Germs' one and only record. Joan Jett and the Blackhearts' "I Love Rock N' Roll" was the third record I ever bought with my own money, and I still love that record to this day.

325. **Joan Jett Album Stencil,** 2005
(12.25 x 12.5") spray paint stencil and collage on album

326. **Joan Jett 4-Album Stencil,** 2003
(24.5 x 25") spray paint stencil and collage on albums

327. **Iggy Pop Album Stencil,** 2005
(12.25 x 12.5") spray paint stencil and collage on album

328. **Joan Jett Pink,** 2003
(18 x 24") screen print on paper

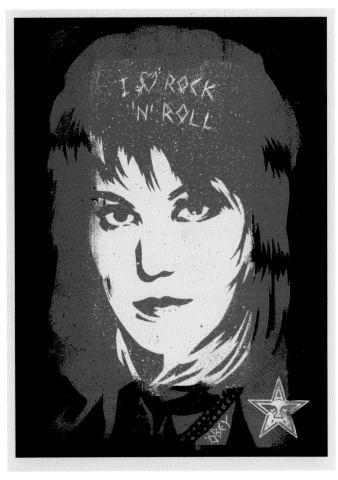

328.

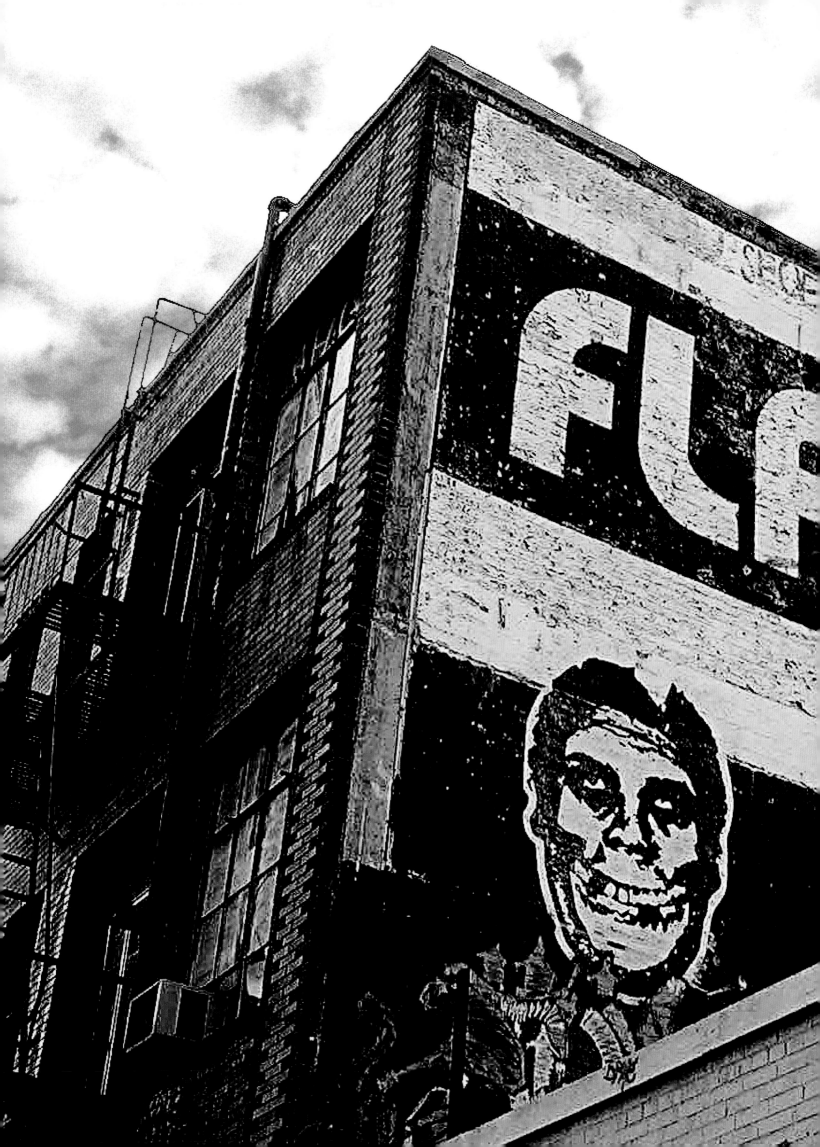

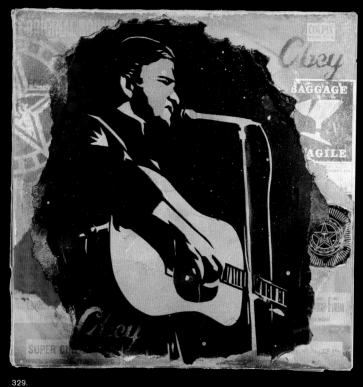

329.

329, 332. To memorialize Johnny Cash, I did a stencil of him for an art show, after which I was asked to create the poster and some marketing materials for *Walk the Line*, the Johnny Cash life story. When I made the illustrations, I used a hint of Joaquin Phoenix, who portrays Johnny Cash in the movie, but mostly based them on the look of Johnny Cash, in order to create something that would appeal to both Johnny Cash purists who don't care about Joaquin Phoenix and fans of the movie.

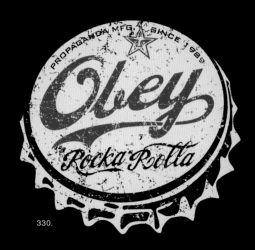

330.

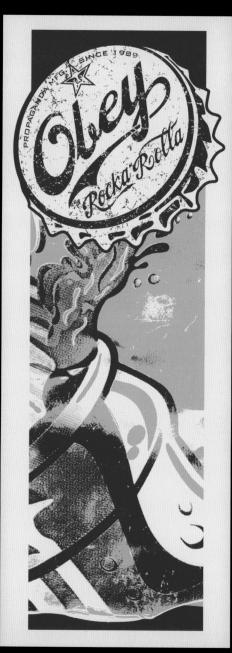

331.

329. **Obey Cash Album,** 2004
(12.25 x 12.5") spray paint stencil
and collage on album

330. **Obey Rocka Rolla Cap,** 2003
screen print on t–shirt

331. **Obey Rocka Rolla,** 2003
(12.25 x 12.5") screen print on paper

332. **Obey Cash Walk the Line *Stencil,***
2005 (35 x 47") spray paint stencil
and collage on paper

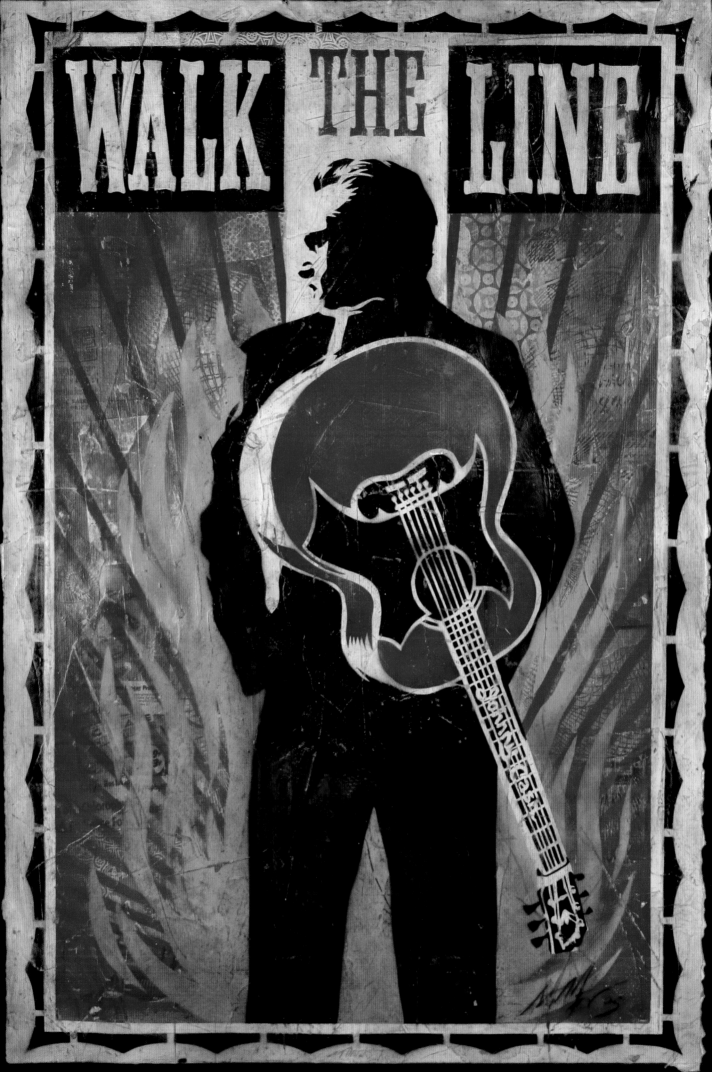

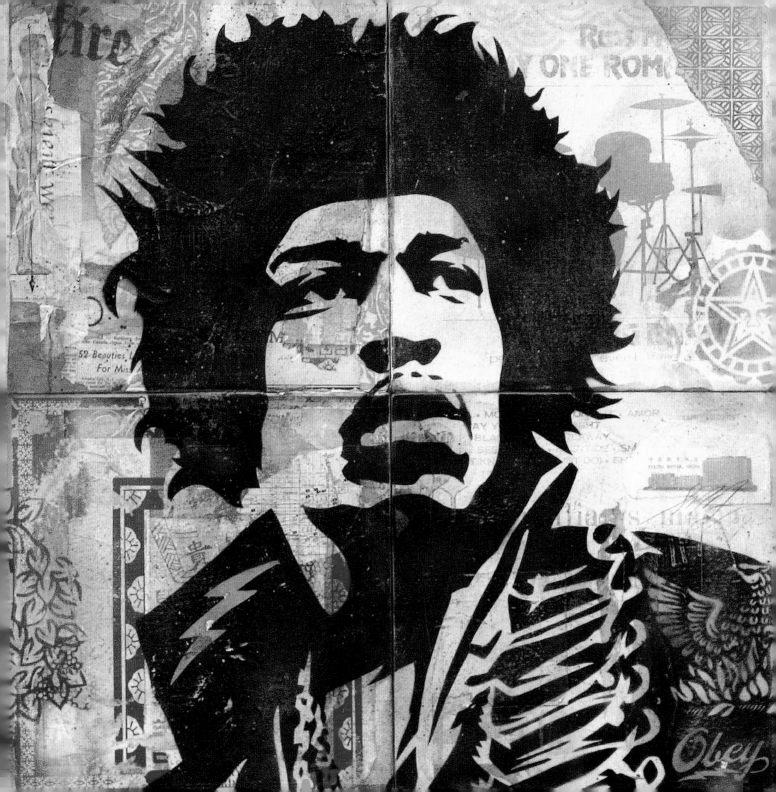

334.

333-336. I've been a fan of Jimi Hendrix for a long time – I even made bootleg Hendrix shirts when I was in high school just to have one for myself. More recently, I did a portrait of him for a poster and a four–panel album cover. A friend of mine at Guitar Center saw the portrait and liked it, and pitched to the Hendrix estate the idea of having me create some limited–edition art pieces on Marshall amplifiers and Gibson guitars for a Guitar Center contest. The contest ended up getting a record number of entries. I thought it was pretty cool that over 100,000 people wanted to win the pieces.

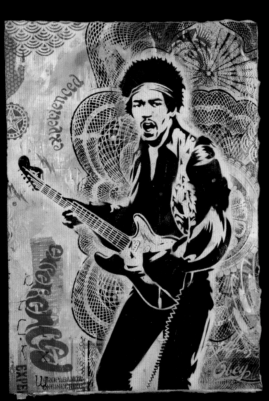

335.

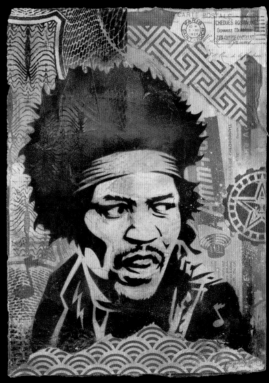

336.

333. **Obey Jimi 4–Album Stencil,** 2004
(24.5 x 25") spray paint stencil and collage on albums

334. **Obey Jimi Poster,** 2004
(18 x 24") screen print on paper

335. **Obey Hendrix with Strat,** 2005
(30 x 44") spray paint stencil and collage on paper

336. **Obey Hendrix Paper,** 2005
(30 x 44") spray paint stencil and collage on paper

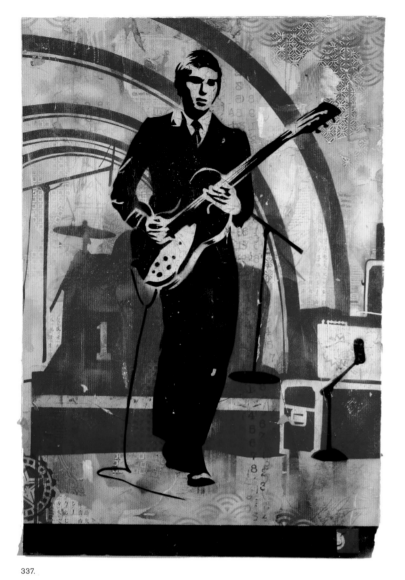

337.

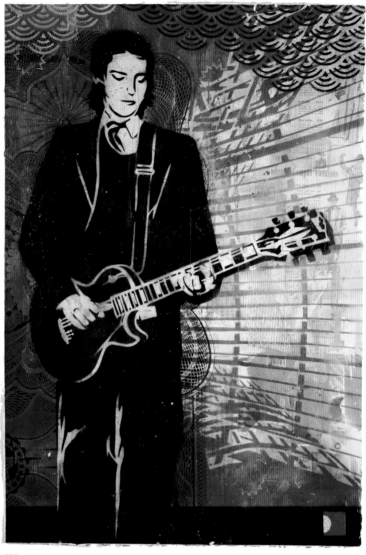

338.

337–340. Interpol is one of my favorite bands to come out in the last few years, and I approached Paul Banks, the singer, after a show a few years ago and told him I was a big fan and offered to do some artwork for them. We became friends, and eventually he called me and said that Interpol was releasing a new record, and to promote the release they didn't just want to throw a party, they wanted to have art spaces, and they wanted me to create artwork and curate the spaces. I shot some photos of the band and borrowed some photos from them, then re-illustrated all of it and made mixed-media pieces that combined my drawings with the original photos, and finally deconstructed everything by showing the photos and the process along with the new pieces.

339.

340.

337. **Obey Interpol Daniel,** 2004
(35 x 47") spray paint stencil
and collage on paper

338. **Obey Interpol Paul,** 2004
(35 x 47") spray paint stencil
and collage on paper

339. **Obey Interpol Sam,** 2004
(35 x 47") spray paint stencil
and collage on paper

340. **Obey Interpol Carlos,** 2004
(35 x 47") spray paint stencil
and collage on paper

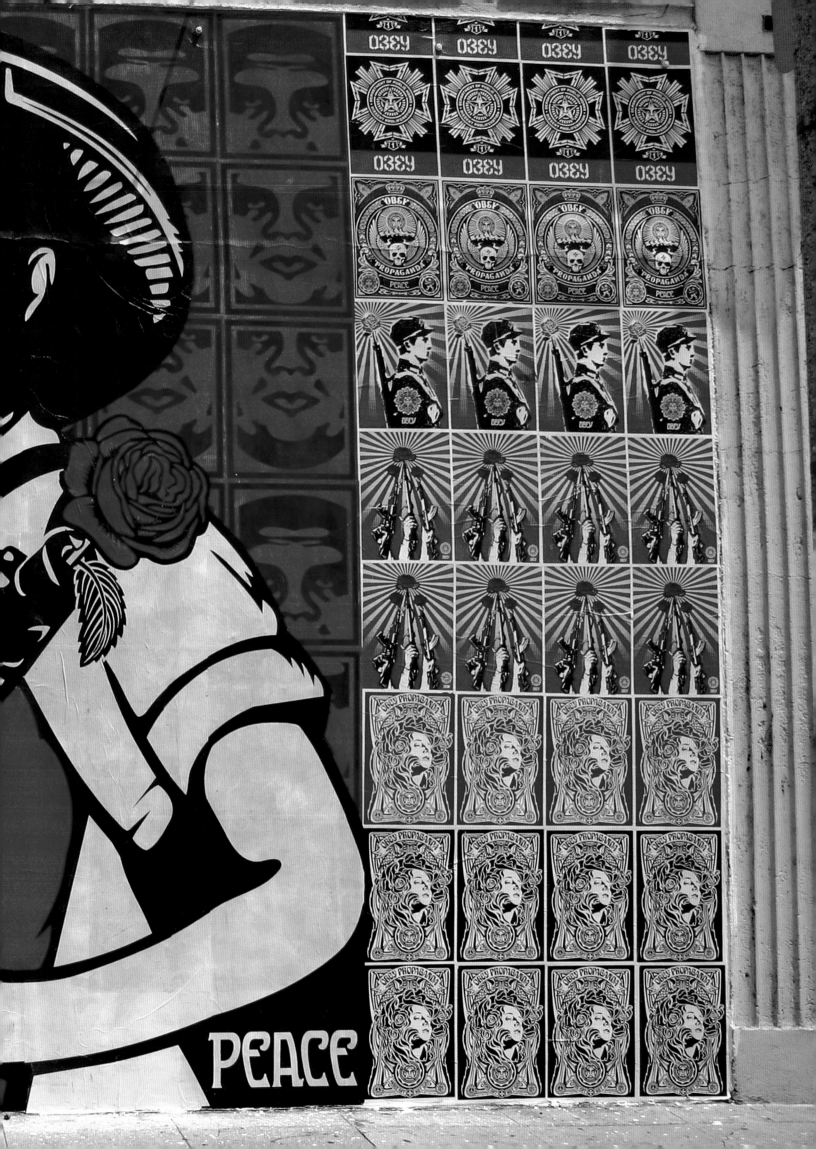

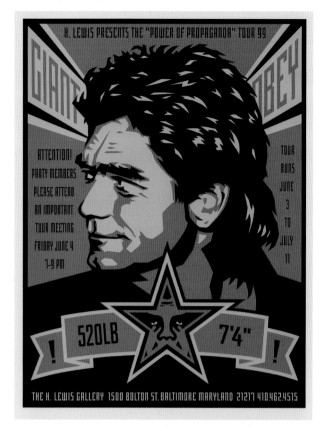

341.

343.

344.

345.

342.

346.

341. **Obey H. Lewis,** 1999
(18 x 24") screen print on paper

342. **Petty and Dylan,** 2003
(18 x 24") screen print on paper

343. **Slayer,** 1997
(9 x 24") screen print on paper

344. **The Cows,** 1997
(9 x 24") screen print on paper

345. **Unsane,** 1995
(9 x 24") screen print on paper

346. **Heartbreakers Logo,** 2003

347. **The Cult,** 1999
(18 x 24") screen print on paper

THE CULT

CULT RISING

IAN ASTBURY , BILLY DUFFY
MATT SORUM, MARTYN LENOBLE

AUGUST
16,19,20,21,22,23,25
1999

HOUSE OF CULT AT

HOUSE OF BLUES

SUNSET STRIP

348.

349.

350.

351.

352.

354.

353.

348. **Flat Duo Jets,** 1997
(18 x 24") screen print on paper

349. **Modest Mouse,** 2000
(18 x 24") screen print on paper

350. **Rustic Overtones,** 2000
(18 x 24") screen print on paper

351. **Reggie & the Full Effect,**
2001 (18 x 24") screen print on paper

352. **The Pattern,** 2003
(18 x 24") lithograph

353. **Perry Farrell,** 2000
(12 x 18"") screen print on paper

354. **Ozzfest,** 2001
(18 x 24") lithograph

355. **Queens of the Stone Age,** 2005
(18 x 24") screen print on paper

356. **The Flaming Lips New Year's Eve,** 2003
(18 x 24") screen print on paper

355.

COMMERCIAL WORK

STUDIO

NUMBER ONE

PHN - 213.383.9299 WEB - STUDIONUMBER-ONE.COM

ABSOLOOT SPONSORSHIP

Shepard Fairey

The other day I was flipping through a "lifestyle" magazine when an Absolut Vodka ad caught my eye. This particular ad was basically a verbatim reproduction of the classic *Never Mind the Bollocks, Here's the Sex Pistols* cover, with the sole modification to the original Jamie Reid art being a cut–paper–style Absolut bottle silhouette behind the Sex Pistols type instead of the usual simple rectangle. The type at the bottom of the page read "Absolut Pistols" in the typestyle they have branded for years. At first, I had my typical Pavlovian response of jubilation seeing a Sex Pistols graphic. The Sex Pistols are close to my heart as an important step in the evolution of who I've become today. As what I was seeing really started to sink in, my emotions became more mixed. In a sense, an Absolut ad is a definitive statement of someone or something's pop culture significance. In this regard, I was pleased that the Pistols had finally reached a certain level of mainstream critical mass. Yet, it was for this exact same reason that the ad made me uneasy. The Sex Pistols used to be very "outsider" and "dangerous": the very album cover being endorsed had been banned 25 years prior. An ad for a very established company is not too punk. I thought to myself, "Would I have looked at the Pistols differently if their Anarchy tour had been the Absolut Anarchy tour?" Maybe not, because the Pistols were the originators of the Great Rock 'n' Roll Swindle, but who knows? (Historical note: The Sex Pistols were paid advances by both A&M and EMI records and promptly dropped for being too controversial before finally settling at Virgin records. Whether or not it was intentional, the Pistols made a decent chunk of money without doing much work until they reached Virgin.) To my point: this essay is about sponsorship, so let me be more specific about how sponsorship relates to the Pistols. The Sex Pistols certainly knew how to work the press, but by keeping chaos high in the mix, sponsorship by a corporation was not even an option. As the Absolut Pistols ad demonstrates, things have changed since those days.

On the surface, sponsorship is a fairly simple relationship; however, the true outcome of sponsorship is determined by an often–unpredictable web of social constructs and perpetually shifting variables. Culture is constantly shifting, not always in the ways one might prefer, but evolving/devolving nonetheless. Would Absolut have taken the chance to endorse the Sex Pistols 25 years ago at the height of their controversy? Maybe not, but today corporations have learned the marketing value of aligning themselves with things that are cutting–edge, rebellious, and even controversial. Bands, actors, athletes, artists, and anyone else that has the potential to influence popular culture will be presented with corporate sponsorship opportunities. It is a calculated risk to sponsor someone or something controversial, and corporations sometimes withdraw from a sponsorship if they feel an artist's negative publicity could be damaging to their brand. Even with an album at the top of the charts, R. Kelly will be lucky to find a sponsor, due to his past indiscretions. Ludacris lost his Pepsi sponsorship for behavior that fell wide of the "family values" target. Today's sponsorship game is high–stakes. Though controversy may sell rap records, it

358.

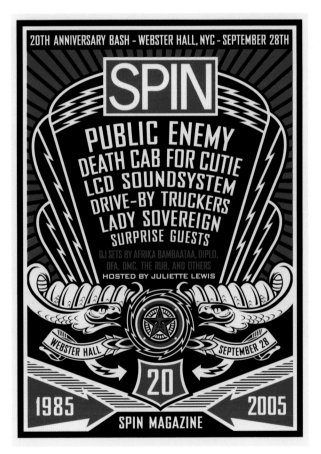

359.

357. **Studio *Number One* Crest,** 2004
(18 x 24") screen print on paper

358. ***Inland Invasion 2,*** 2002
(20 x 24") lithograph

359. **Spin *20th Anniversary,*** 2005
(24 x 36") screen print on paper

ANDYLIVES.ORG

ANDY LIVES

360.

ANDYLIVES.ORG

361.

still may not offset the financial rewards Ludacris was offered by Pepsi.

Merriam–Webster's Dictionary defines a sponsor as "a business that finances a program in return for advertising" and "a godparent." These are two different definitions, but in some instances sponsorship can provide both. Ideally, sponsorship benefits both parties and compromises neither. However, sponsorship often connotes backroom dealings, hidden agendas, and an overall loss of credibility for the sponsorship recipient. Some partnerships are more logical than others. Sporting goods companies' sponsorship of athletes makes sense and is very accepted. When it comes to companies sponsoring art shows, the art crowd seems to have greater reservations, no matter how genuinely altruistic the company's motives are. My theory on the hyper–scrutiny of sponsorship within the art community has to do with the idea that true art has no master but the artist. With art, the viewer wants purity, free of compromise, which is difficult to find anywhere else in society. Since the introduction of pop art, and the entrance into the postmodern era, the only distinction between "fine" and "commercial" art is not style but intent. The idea that art is the artist's personal vision—in no way tainted by a corporate agenda—is central to the definition of "fine" art. Most artists would probably prefer to avoid sponsorship and the related issues it raises. Some artists have no choice but to use sponsorship to facilitate a project that could not happen otherwise. Artists are compelled to produce their work by any means necessary. Sometimes this solution is as simple and earnest as "This art show was made possible by a generous contribution from Company X." Sometimes the solution requires an artist to negotiate shark–infested waters.

The artist's methods and agenda can be as covert as the corporation's. A great example is LL Cool J's Gap commercial. In the ad he dropped the name of a competing clothing line with which he was affiliated. In the ad, his words "for us, by us" referenced FUBU clothing, but Gap didn't figure out the coup until it was too late. Self–deprecating humor and honesty can also improve the public's perception of a sponsorship. For an art show I did in Philadelphia that Urban Outfitters wanted to sponsor, I actually designed the flier to make the sponsorship aspect a conceptual asset. Paying homage to the Sex Pistols, the masters of the swindle, I complemented the Urban Outfitters logo on the flyer with the text "Cash for chaos provided by Urban Outfitters." Urban had paid for my trip to Philly, where I would, of course, post my images in the street illegally. Willingly or unwillingly, Urban Outfitters were my facilitators and accomplices.

Sponsorship can be a compromise for an artist due purely to the public's opinion and not to actual pressure from the sponsor to cater to their agenda. A perfect example of this phenomenon involves a poster I did for a show, which DC Shoes sponsored. DC is a very respected "core" company, but the poster from my show, which included a half–inch DC logo, sold less briskly, even at a lower price, than an identical poster I released later. Some people obviously aren't comfortable with, or at least prefer not to see, the mix of art and corporation.

When Ryan McGinness brought BLK/MRKT his proposal for the Sponsorship art show, I thought it was brilliant because it was so simple. Ryan's idea reduced sponsorship to a purely reflexive equation with the artist removed entirely except as "project director." There were no smoke and mirrors, or art

for that matter, just a display of logos and product whose hierarchy was determined by their associated sponsors' level of contribution. The sponsors were given a description of what the show entailed upfront. To their credit, most wanted to be part of this self-parodying idea without knowing how it might be received by the public. As unconventional an art show as this was, facets of the companies' sponsorship goals would still be served. The logos received prominent placement, and the hip tastemaker crowd was treated with a euphoric evening, complete with free booze and multiple free products with which to associate the logos present. If that weren't enough to satisfy the sponsors, Keanu Reaves was allegedly staggering around in a drunken stupor just before the evening's notoriety was sealed by the intrusion of the fire marshal. The very book in which this essay appears was funded by the sponsors and continues to place them in front of people long after the Sponsorship art show has ended.

The Sponsorship art show succeeded because the sponsors themselves had no control over the show except to participate or decline. The sponsors involved were not afraid to embrace a good coup, even at their own expense (or they weren't paying attention to what the show was about). Ryan's Sponsorship art show reminds us that the attraction to art and artists in the first place is often their freshness, passion, unpredictability, and ability to challenge the status quo. Sponsors who embrace this beautiful chaos head-on are the likely leaders of the next commercial generation. The National Endowment for the Arts is basically dead, so sponsorship is likely to play an even more prominent role in the lives of exhibiting artists. Artists: give the companies credit for taking risks. Companies: give the artists money for taking risks. Everybody wins in this equation.

360–361. The Andy Kaufman/Tony Clifton posters were commissioned by Universal Pictures to be part of a secondary promotional campaign for the movie *Man on the Moon*, in which Jim Carrey played Andy Kaufman. Their concept was inspired by the Obey campaign: they knew that Andy Kaufman had a cult following, and something more subversive would be a good way to promote Andy Kaufman to his die-hard fans, who have a strong word-of-mouth network where they can publicize the film. I made these iconic portraits and printed the posters, and hired some of my friends to put the posters up in 15 different cities. It really helped promote Andy Kaufman, and I was glad to be a part of that because I thought he was an interesting guy, and whether people saw the movie or not I hoped it would prompt people to learn more about him.

362.

360. *Andy Kaufman Andy Lives,*
1999 (24 x 36") lithograph

361. *Tony Clifton Andy Lives,* 1999
(24 x 36") lithograph

362. *Lebowski Fest,* 2003
(18 x 24") screen print on paper

363-370. My friend Adam Werbach, who went to Brown University in Providence and became familiar with my work while living there, became the president of the Sierra Club, an environmental organization founded by naturalist John Muir. Adam asked me to design several things for the Sierra Club, as well as the cover of his book and the logo for his current company, Act Now (also the title of the book). I'm into doing pro bono or cheap work for environmental causes, not because I'm a hippie tree-hugger, but because I think it's common sense that if we overpopulate the planet and use up all our resources we're essentially bringing our own demise more quickly. It's logical self-preservation, and I hope people realize that.

364.

363. ***Act Now Book Jacket,*** 1997 (8.5 x 5.57")

364. ***Act Now Logo,*** 1997

365. ***Sierra Water,*** 1996 (18 x 24") screen print on paper

366. ***Sierra Air,*** 1996 (18 x 24") screen print on paper

363.

365.

366.

367. **The Paper Campaign,** 1999

368. **Operation Democracy,** 2005

369. **Save the Arctic Refuge,** 1999

370. **Save Our Environment,** 2000

367.

369.

368.

370.

371.

373.

372.

374.

371–374. I was asked to do some pro bono work for the Children's Museum in San Diego, making decorations for the front windows. I decided I would make really colorful images of people who were controversial when they first became famous, yet now, in retrospect, have been accepted as positive contributors to society. They also share the common achievement of breaking down barriers and bridging racial, religious, artistic, and intellectual gaps. I chose these images because I feel like they're really strong icons, and when parents bring their kids to the museum, the kids will say, "Mommy, Daddy: who is that?"

371. **Children's Museum MLK,**
1999 (48 x 48") lithograph

372. **Children's Museum Albert Enstein,**
1999 (48 x 48") lithograph

373. **Children's Museum Rosa Parks,**
1999 (48 x 48") lithograph

374. **Children's Museum Andy Warhol,**
1999 (48 x 48") lithograph

SURFACE EFFECTS

Rob Walker

The story goes like this. Some 15 years ago, when Shepard Fairey was a student at the Rhode Island School of Design, a friend wanted to know how to make stencils. Fairey offered to show him, using a picture of the wrestler Andre the Giant, chosen basically at random from the newspaper. Later, they made some stickers, slapped them up here and there around Providence. That might have been the end of it, except that Fairey overheard strangers at the grocery store, discussing what the stickers might "mean." So he put up more stickers, and a prank turned into a campaign. In a way, it's a story that has everything: the never–ending river of pop culture flotsam; the mastery and teaching of a skill; the seductiveness of persuasion; the power of repetition; and the curious human yearning for symbolic meaning. That crude early image has long since shifted to a more stylized visage—the icon face—and is now most familiarly paired with the words "Obey Giant," or simply "Obey." It has been reworked dozens and dozens of ways and spread by countless volunteer confederates all over the world. The icon face has been in movies, in art museums, it has been tattooed onto people's bodies, and, yes, it has even appeared in commercial messages. People are still arguing about what it might "mean." In 1990, Fairey wrote a manifesto that called the campaign an experiment in phenomenology. "Because Obey has no actual meaning," he wrote, "the various reactions and interpretations of those who view it reflect their personality and the nature of their sensibilities." Does that explanation satisfy you? I suppose it depends on your personality and sensibilities.

I first encountered the Obey campaign in the early 1990s in New York. Like most people at the time, I had no idea who was behind it. It wasn't until years later that I met Shepard Fairey himself, and wrote an article about him – for a business magazine. By then he had been doing design work for corporate clients like Levi's and Universal Pictures for several years, yet he was still extremely active on the street, and in fact he had recently been arrested for the seventh time. "Sometimes I feel like a double agent," he had said, and I was interested in that. I was falling back on a familiar way to frame almost any pop–culture or sub–culture or alt–culture debate: Who is authentic and who is a sellout? Who is hardcore and who is a poser? Who is an outsider and who is commercial? Who is an originator and who is a biter? These are all variations on the same theme—the conflict between the real and the artificial. Which, of course, is not just a conflict within art or self–expression; it's a conflict within life.

This debate has been going on for a long time, and one of the places it is documented is in a book called *Fables of Abundance*, by Jackson Lears. Although the book is billed as "a cultural history of advertising in America," Lears has a lot to say about why those "familiar dualisms" are limiting, even false, in suggesting that we have only two choices. For starters, the 100–plus–year–old romantic vision of the artist as a pure, outlaw being, apart from the crass culture of the marketplace, has generally been a dead end, just another marketable pose. Meanwhile, the need for the marketplace to invent

375–376. *Swindle* is a quarterly magazine I co–founded with Roger Gastman, intended to be a non–disposable lifestyle periodical. The content is designed to both acknowledge what's going on in the world that's important currently and explain how it fits into the evolution of pop culture historically. I look at *Swindle* as an extension of what I'm trying to do with the Subliminal Projects gallery in my studio: shining the spotlight on things I think people deserve to see or would find entertaining. It's kind of like my art, where there's a range of styles and subject matter, from political topics to art, fashion, and humor. I think Roger and I have made something that reflects our personalities, that doesn't chase trends or pander to celebrities and mainstream culture.

375.

376.

375. **Swindle Magazine Issue #1,**
2004 (8.785 x 9.28")

376. **Swindle Magaziner Issue #4,**
2005 (8.785 x 9.28")

STOKED

THE RISE AND FALL OF GATOR

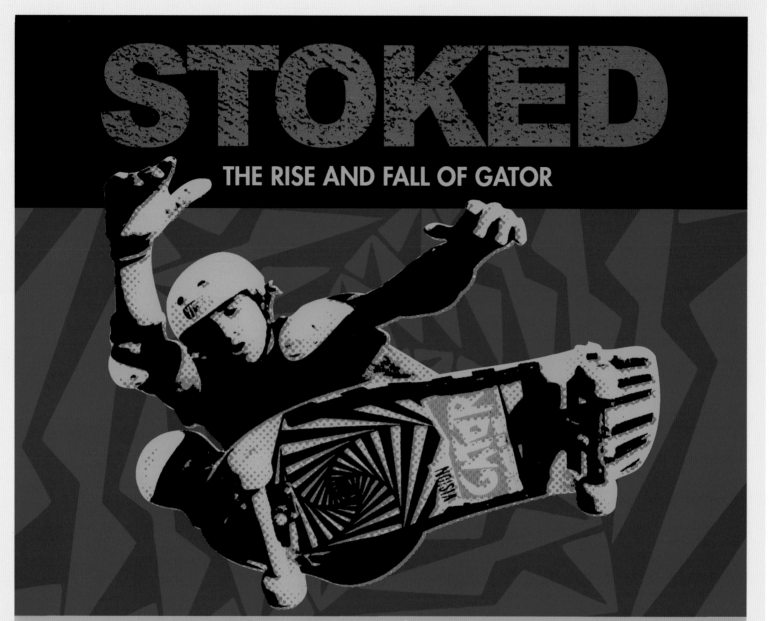

A FILM BY HELEN STICKLER

meanings for increasingly interchangeable commodities meant that "the orchestration of surface effects became a major industry." The idea of "surface effects" is, obviously, a pretty compelling one when you're talking about a campaign that manifested itself on neglected urban streetscapes, on buildings, on billboards, on signs, and on the bases of lampposts. The whole point of graffiti, really, is to give fresh meaning to surfaces – and in the process promote the graffiti artist as the author of that meaning. Today, if you go to any of the best–known street–art spots in New York, the walls that people come from all over the world to hit, you'll see who else has figured this out: the "street teams" of the marketing industry.

When I interviewed Fairey for that magazine article, I of course asked him about the contradictions involved in, say, being someone who has both wheat–pasted the icon face over Sprite billboards and actually done professional design work for the company that owns Sprite. "People make this very black–and–white delineation," he said. "But I say, 'How would you feel about it if it were a little more ambiguous, if all companies had marketing materials that didn't insult the consumer, that were somewhat creative and intelligent and almost like an art piece with a product behind it?'"

In other words, instead of responding to the encroachment of evil branding into the supposedly pristine authenticity of the street by withdrawing, why not engage? If the idea of spreading the Obey image is to see how far the Obey image can spread, doesn't it make a certain sense for it to show up on apparel that is sold in chain stores? If a multinational can put its icons on the street, maybe the street should put its icons into the shopping mall. A hero in Lears's book is Joseph Cornell, whose meticulously–constructed boxes, painstakingly filled with materials at hand, "demonstrated that it might be possible for the artist to reclaim the most forlorn, forgotten, and banal fragments of commodity civilization… and resituate them in the architecture of the imagination, transforming them into numinous artifacts," kind of like a DJ digging out beats from a record store basement, from the junk that has so little market value that it doesn't even make it to the selling floor. Or like clipping a random picture from the newspaper and turning it into an icon.

Lears also writes that while Andy Warhol's Brillo Box "aimed to demystify museum art by assimilating commodities into it, Cornell pushed his aesthetic in the opposite direction, toward the reanimation of the commodity world." This seems, to me at least, like the kind of ambiguity that Shepard Fairey is engaged in, and that the Obey project ought to make the viewer consider, wherever he or she encounters it.

Of course, I could be way off. (Ever get the feeling you've been cheated?) Probably, it should go without saying by now that there is no "right answer" to the questions that the icon face silently raises. Presumably, you have your own worldview and ideology and set of rules and guidelines for how to evaluate the symbols and the surfaces around you. So all you have to do is look inward, and obey.

377. *Stoked: The Rise and Fall of Gator* was a film by Helen Stickler about Mark "Gator" Rogowski, the pro skateboarder who was convicted of killing his ex–girlfriend's friend. I created the art for the film, but I also helped inspire Helen to make the film. When she was making her documentary about me in 1995, I had a sticker that took the old Gator graphic, with the type changed to "Giant" and Andre's face added to the psychedelic swirl in the background. Helen asked what the deal was with that, and I told her the story of Gator. She was fascinated by the story, enough so to research it and ultimately make this movie.

378.

377. **Stoked,** 2003
(18 x 24") screen print on paper

378. **Jay Adams collaboration with photographer Craig Stecyk III,** 2003
(18 x 24") screen print on paper

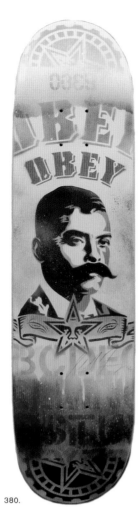

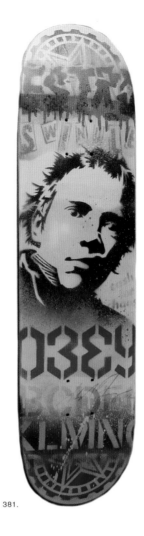

379.

380.

381.

379. **Obey Bring the Noise Skateboard,**
2003 spray paint stencil and collage on skateboard

380. **Obey Zapata Skateboard,** 2003
spray paint stencil and collage on skateboard

381. **Obey Rotten Skateboard,** 2003
spray paint stencil and collage on skateboard

382. **Santa Monica Airlines Natas by Wes
Humpston,** 1987 screen print on skateboard

383. **Obey/Designarium Natas,** 2004
screen print on skateboard

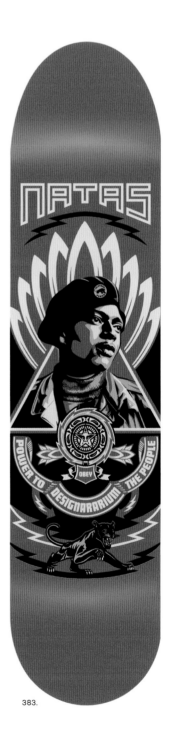

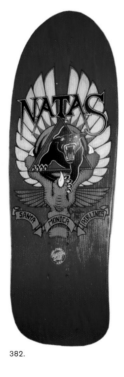

382–383. Natas Kaupas was the first skateboarder to do a boardslide down a handrail, and I had a few of his pro model boards back in the mid to late '80s. He contacted me about doing a board for a company he started called Designarium, where he had different artists designing boards (and getting the royalties a skater would typically get for a pro model). My board was a reinterpreta-tion of Natas's old graphic that he used on several of his original boards, with a black panther (the cat) emerging from a triangle sur-rounded by jungle leaves. I used a Black Panther (the militant activ-ist) with more propaganda-style leaves and some colors and ban-ners that are typical of my work. It was definitely an amazing honor to work on a board for one of my original skater idols.

382.

383.

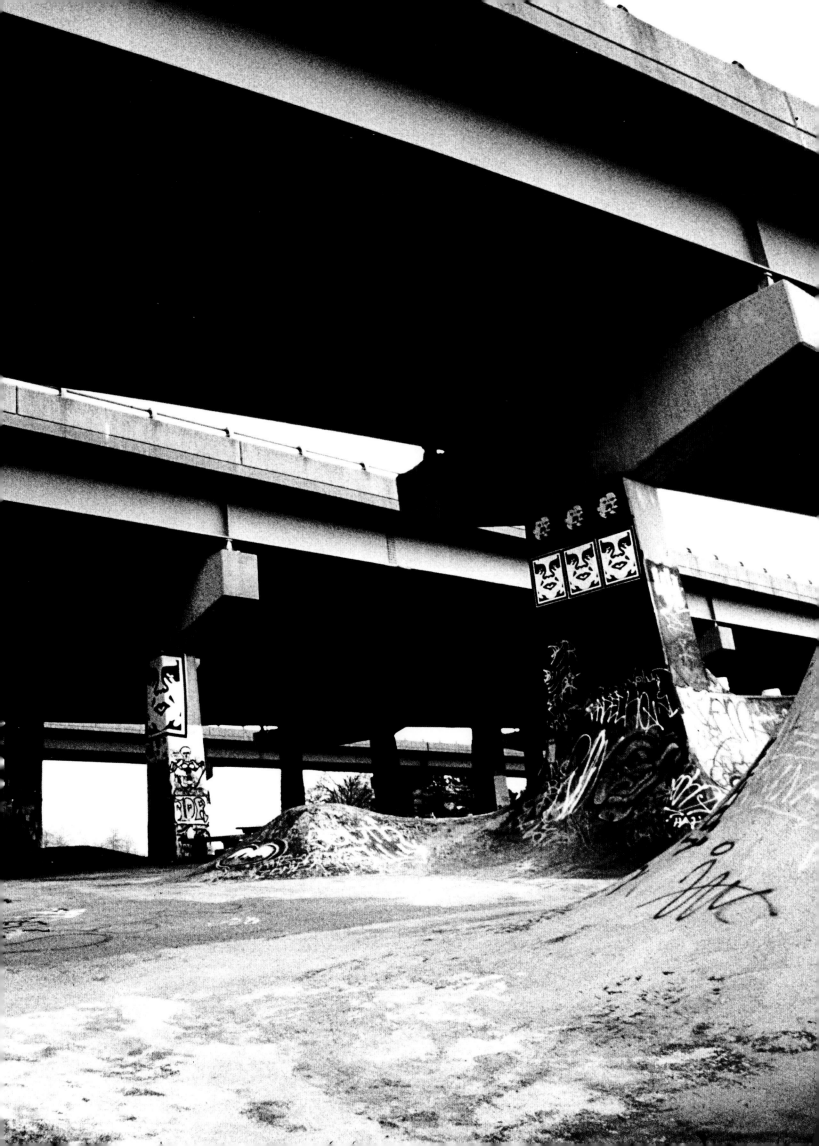

385.

386.

387.

388.

384. **Obey Bones,** 2005 (18 x 24") screen print on paper

385. **Giant Skateboards Skyline,** 1997 screen print on skateboard

386. **Giant Skateboards Exclamation,** 1997 screen print on skateboard

387. **Giant Skateboards Devil Flames,** 1995 screen print on skateboard

388. **Giant Skateboards Classy,** 1995 screen print on skateboard

389. **Obey Angela Davis Skateboard,** 2003 spray paint stencil and collage on skateboard

390. **Obey JMJ RIP Skateboard,** 2003 spray paint stencil and collage on skateboard

391. **Obey Burning City Skateboard,** 2003 spray paint stencil and collage on skateboard

389.

390.

391.

392.

393.

394.

397.

398.

395.

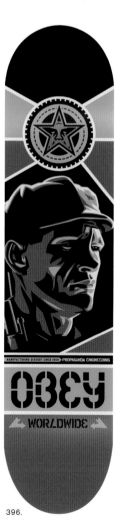

396.

399.

400.

401.

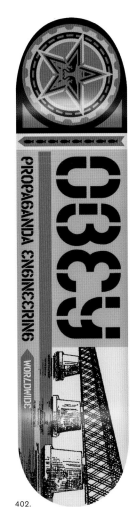

402.

403.

404.

392. **Obey Skateboards Bouncng Souls,**
2004 screen print on skateboard

393. **Obey Skateboards Stencil,** 2000
screen print on skateboard

394. **Obey Skateboards Factory,** 2003
screen print on skateboard

395. **Obey Skateboards Arrow Icon,** 2000
screen print on skateboard

396. **Obey Skateboards Obey Worker,** 2001
screen print on skateboard

397. **Obey Phillips,** 2005 screen print on t–shirt

398. **Obey Dogtown Crest,** 2005
(3 x 4.5") screen print on vinyl

399. **Obey Lester Splash,** 2005
screen print on t–shirt

400. **Obey Hawaii Skater,** 2005
(18 x 24") screen print on paper

401. **Obey Skateboards 3–Face,** 1996
screen print on skateboard

402. **Obey Skateboards Engineering,** 2000
screen print on skateboard

403. **Obey Skateboards Delivery,** 2000
screen print on skateboard

404. **Obey Skateboards Obey Airlines,** 2000
screen print on skateboard

405.

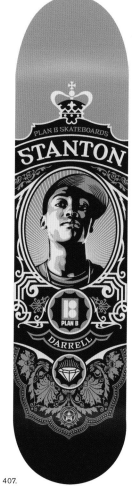

406.

407.

411.

412.

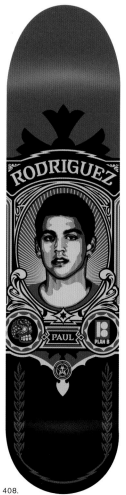

408.

409.

410.

405. *Plan B Colin McKay,* 2005
screen print on skateboard

406. *Plan B Danny Way,* 2005
screen print on skateboard

407. *Plan B Darrell Stanton,* 2005
screen print on skateboard

408. *Plan B Paul Rodriguez,* 2005
screen print on skateboard

409. *Plan B Ryan Gallant,* 2005
screen print on skateboard

410. *Plan B P.J. Ladd,* 2005
screen print on skateboard

411. *Obey DC Collaboration,* 2002

412. *Obey Destructo,* 2005

413. *Obey Roskopp Sticker,* 2005
(3 x 4.5") screen print on vinyl

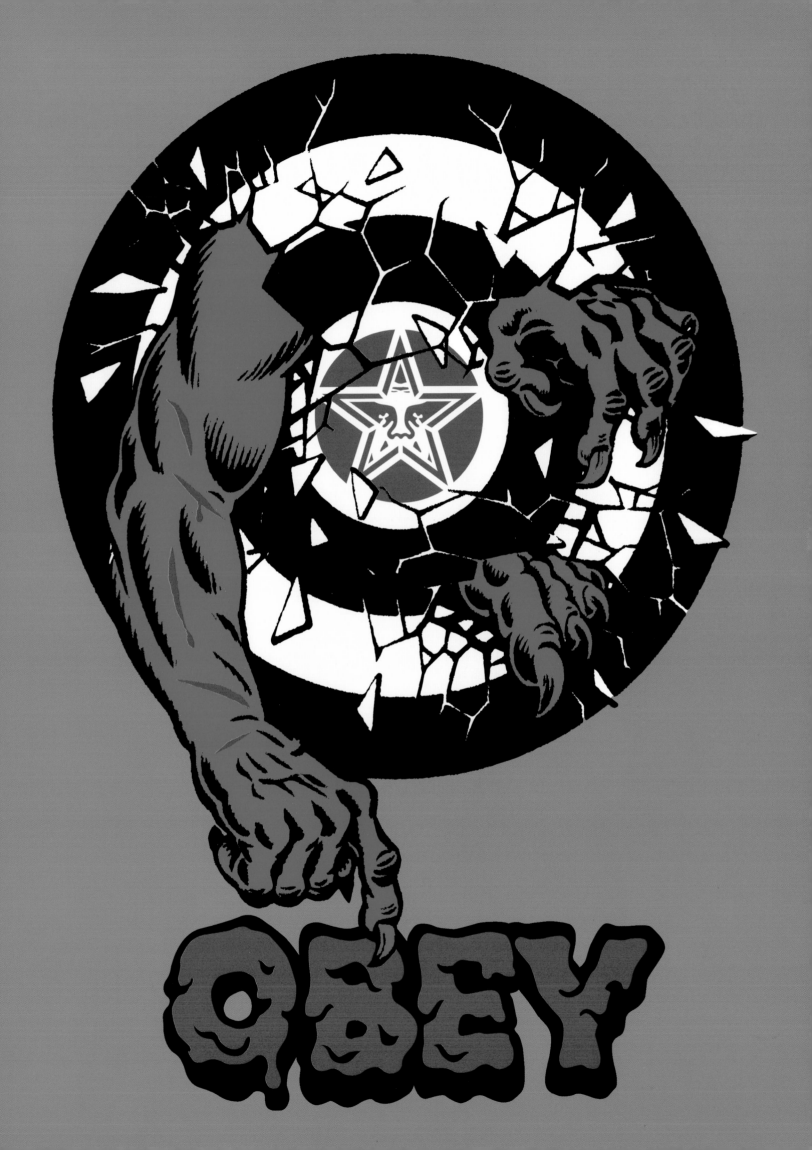

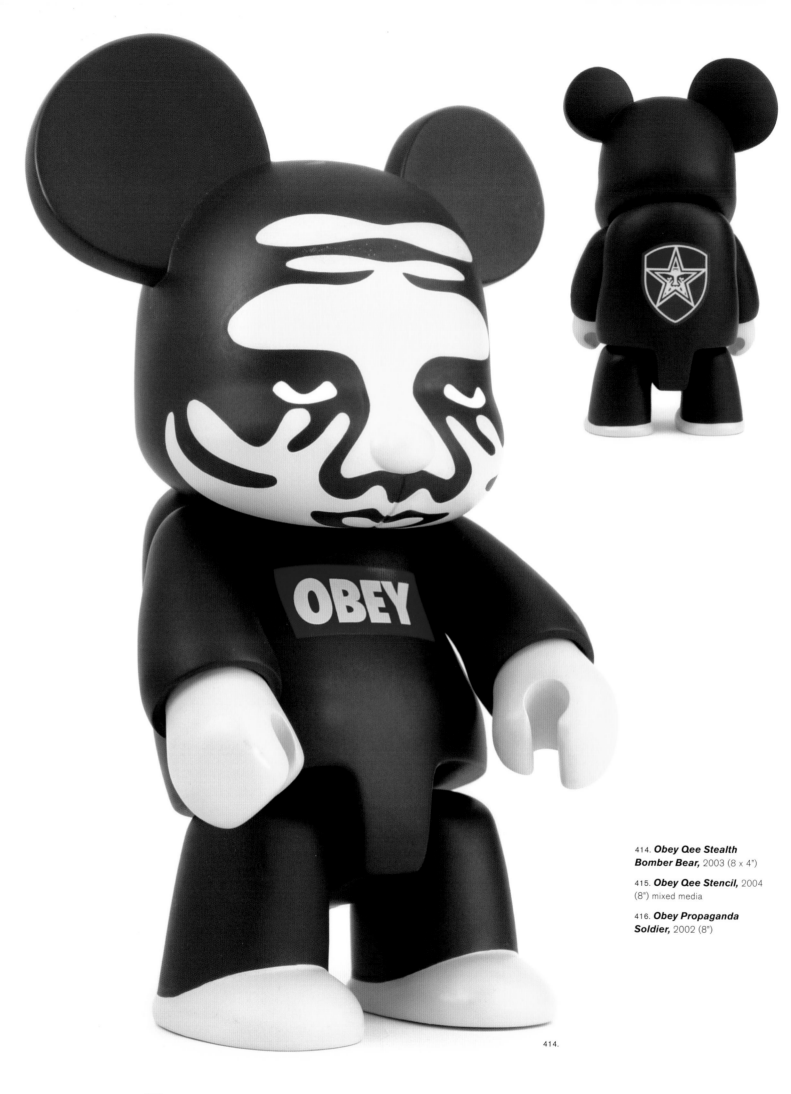

414. **Obey Qee Stealth Bomber Bear,** 2003 (8 x 4")

415. **Obey Qee Stencil,** 2004 (8") mixed media

416. **Obey Propaganda Soldier,** 2002 (8")

414.

332

415.

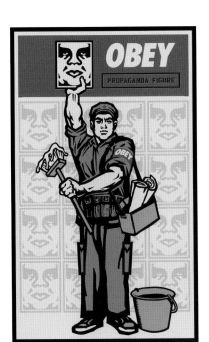

416. For the Tokion neo-graffiti project, I created this toy, a little propaganda wheat-paste character, primarily based on the Red Army uniform, but instead of a gun the guy has a brush and a bag full of posters, and he's in the act of putting one of them up.

I had to draw the original illustration and have someone sculpt it, then work with the sculptor to iron out the details. I wasn't sure exactly what it would look like when I started, but it was pretty cool to be able to bring a three-dimensional object to life from scratch.

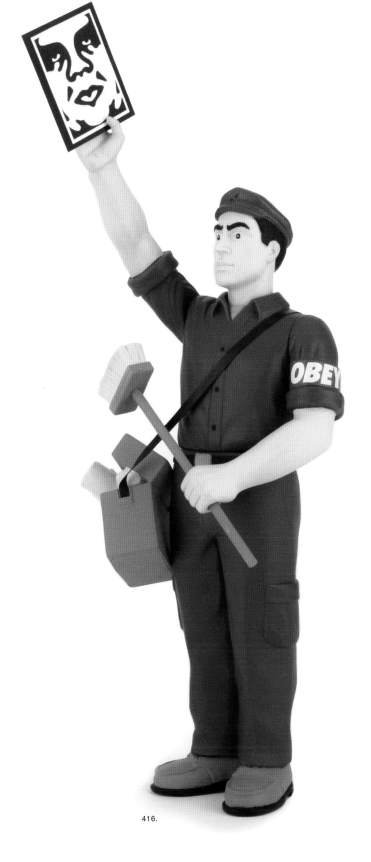

416.

T-SHIRTS

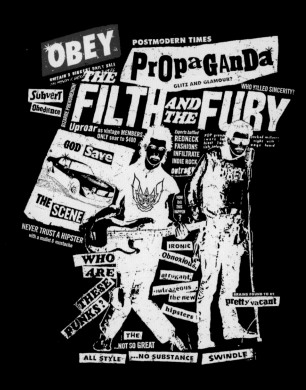

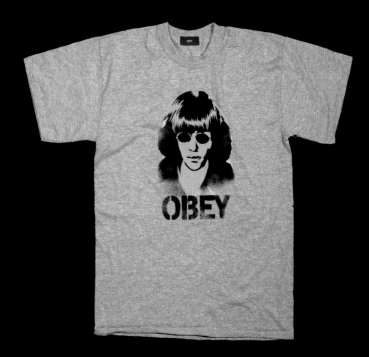

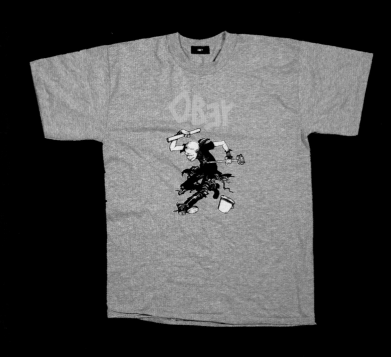

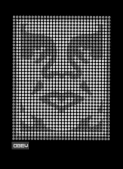

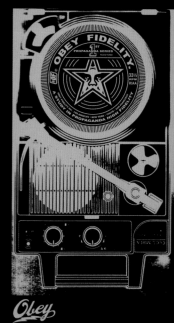

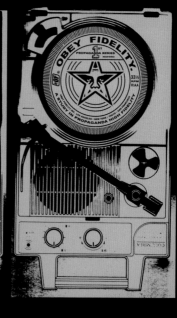

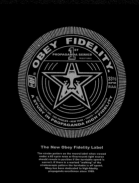

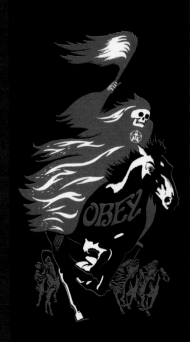

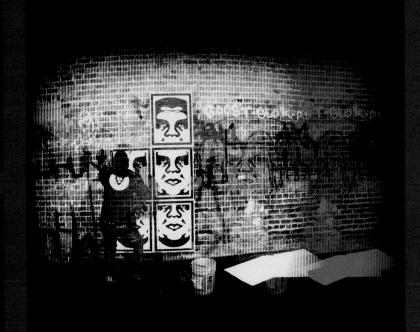

BOOTLEGS

Within three months of the OG Andre sticker's debut in the summer of '89, reinterpreted bootlegs of the sticker began popping up in Providence. The first one I saw read "Paul's Planet has a Posse," a reference to a Providence artist named Paul, whose "Paul's Planet" stickers could be found all along Thayer Street, the hip hangout street where I'd put up a good number of my own stickers. I guess Paul or one of his friends wanted to show that Paul's crown wasn't for the taking, but it drove home the idea that my effort, a total goof at the time, had made a difference. All the things that inspired me over the years, from punk rock to skateboarding to random pop–culture quirkiness, had filtered into my output; now that I was feeding that cycle with my own work, it made me that much more motivated to put work out in the public space, because I felt it was actually a productive application of artistic effort that anyone could observe and absorb. I began to see the Andre sticker campaign's potential for exponential growth, because from my own experience I knew that whenever I learned that something I thought was totally original was actually a reference to something else, I would immediately become curi-

ous and highly aware of the original source. Essentially, the bootlegs were putting my stickers into many people's cultural frame of reference before those people even saw one of my stickers.

Because culture exists on so many different levels, references to culture can appeal to audiences as broad as the whole world or as narrow as the clique of Paul's supporters that spanned all of two blocks. I originally came up with the "posse" line as a joke about associating with something new and cool, and it seems like much of the appeal of ripping off the phrase is its declaration of a community centered on a reference point. By using my template, the bootleggers make my work a secondary reference point, so in a sense they're becoming part of my community and I'm becoming part of theirs. The template also provides a stylistic context with several implicit themes—DIY ethic, fabricated iconography, absurd humor—all of which, to me, are validated by the fact that these bootleggers get my message and want to perpetuate it in their own way.

–Shepard Fairey

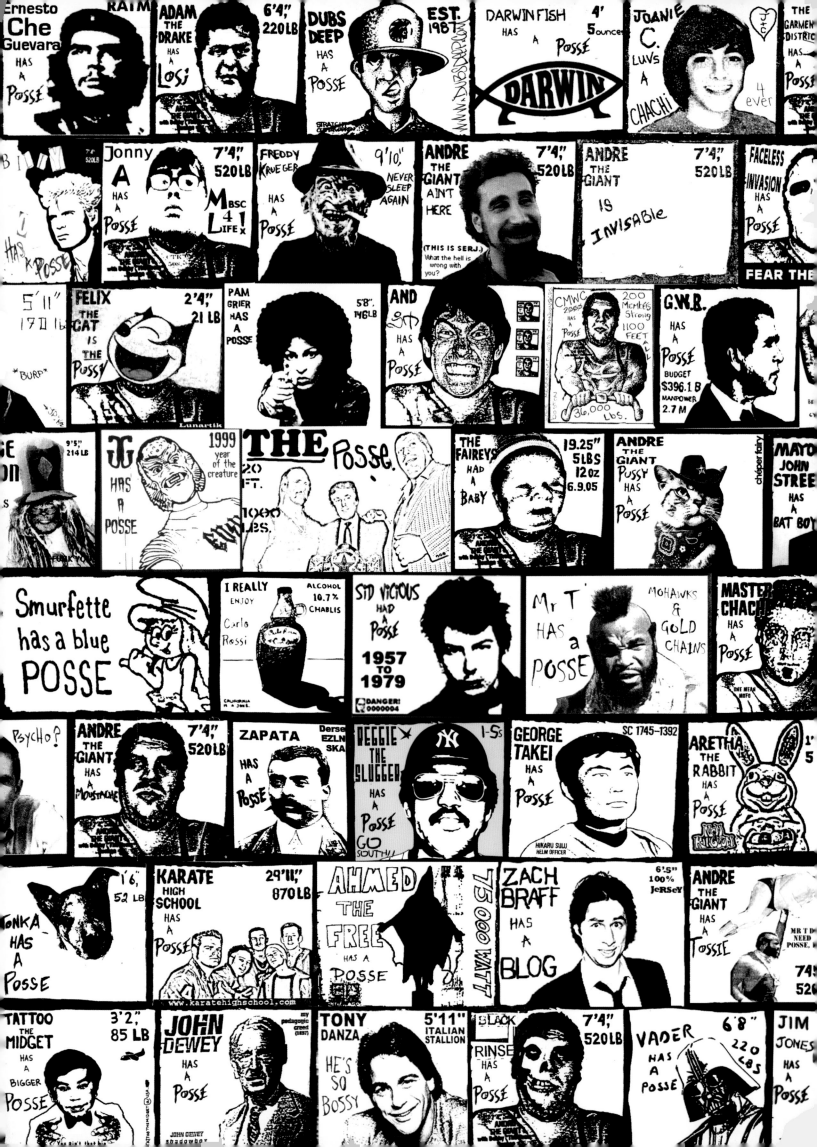

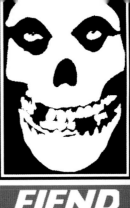

ELUSHI OBEY MOBUTU SPIKE FIEND OP

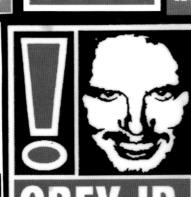

WWDN OBEY JR. uptothesky HUEY P. OBI 服

WHO IS ARTHUR NIX?
W.ARTHURNIX.COM
巨人 ICE KG LAPD MIDGET SVSW

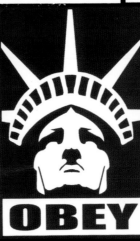

OKAY SEXY YBEO OBEY DGBT JOW!

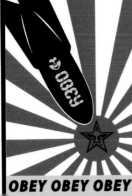
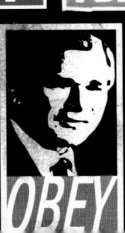

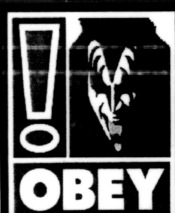

JB OBEY OBEY OBEY OBEY OOOH MARY! OBEY OTAY

417.

417–419. When I was asked by The Contemporary Museum in Honolulu to do a residency, I was presented with a unique conundrum: Hawaii doesn't have outdoor advertising, which my street art was designed to compete with and make people question. After visiting Hawaii, I realized that the primary form of propaganda was not advertising but the clichés of Hawaii itself – Coke machines have palm trees instead of Coke logos on them, phone booths have floral patterns running down the side, and everyone wears Aloha shirts. All the clichés of Hawaii's picturesque beauty are perpetuated to encourage tourism. So for once I got to make stuff that was decorative and beautiful, but still, if you examine it closely, skewers the Hawaiian clichés.

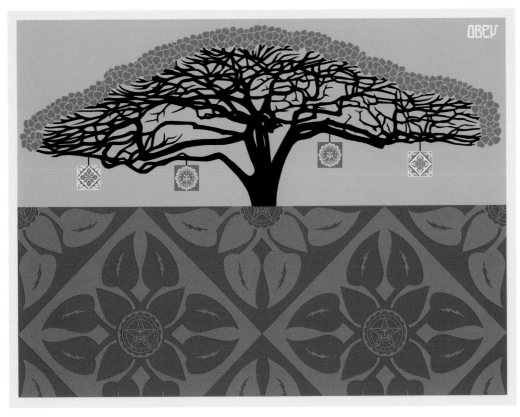

418.

417. **Obey Flower Patterns,** 2005
(54 x 36") mixed media

418. **Obey Monkey Pod Tree,** 2005
(24 x 18") screen print on paper

419. **Obey Flower Pattern,** 2005
(18 x 18") mixed media

419.

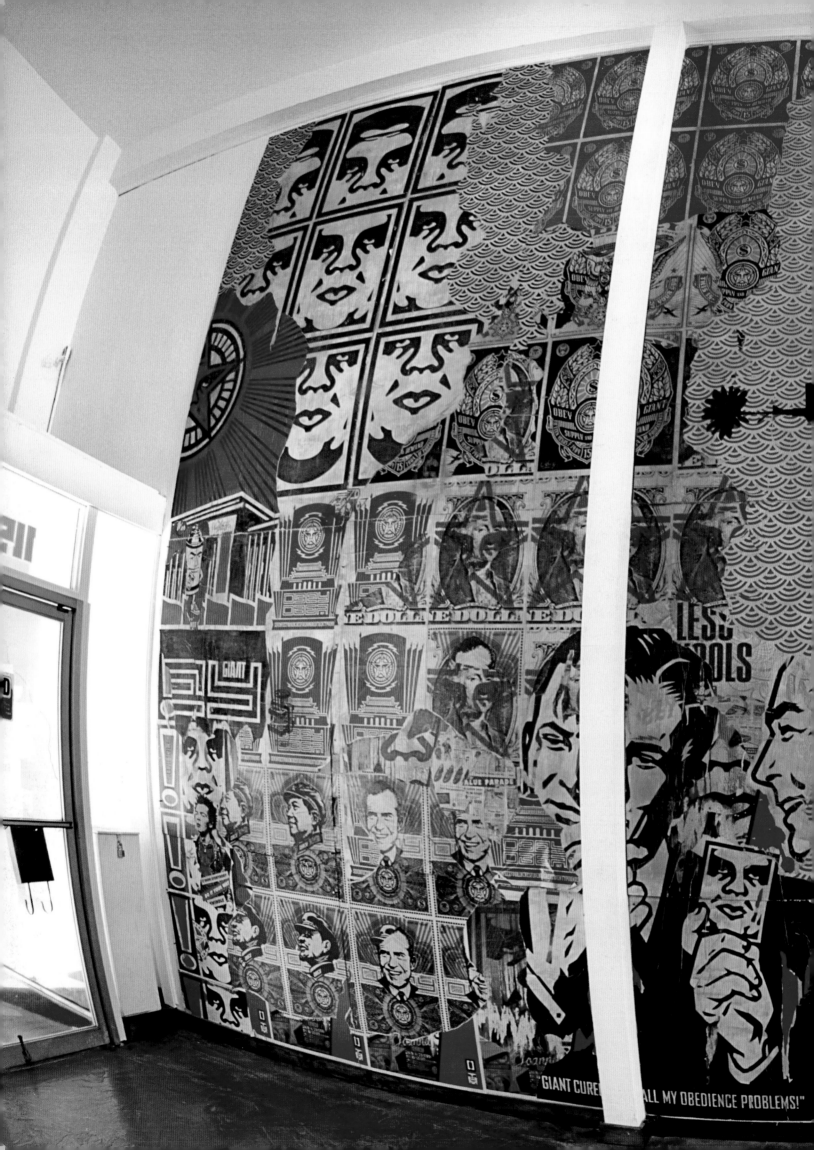

THE SUPPORT OF THESE PATRONS WAS CRUCIAL TO BRINGING THIS BOOK TO LIFE:

Marc Ecko

FAILE

Chris and Tiffany Greer

Thierry Guetta

Andrew and Sunshine Jackson of Outer Edge Studio

Drew Katz of Gallery Katz

Jordan Kurland of Zeitgeist Artist Management

Norse Projects, Denmark

Jonathan Tavss

AN INCOMPLETE LIST OF THOSE WHO HAVE SUPPORTED AND INSPIRED ME OVER THE YEARS:

Katherine Ahn, the Alife NYC Crew, Jeff Alulis, Alex Aranovich, Thomas and Charles Atherton, Paul Banks, BANKSY, Derek Bauermann, Blaize Blouin, Sean Bonner, Bryan from the Bouncing Souls, Julia Briggs, Chris Broders, Colin Burns, Ryan and Raibyn Cabling, Alex Calderwood, April Canalas, Caryn Colman, Richard Colman, Morgan Corum, Chuck D, Robbie Conal, John Cox, DALEK, Elizabeth Daniels, Lance De Los Reyes, Philip DeWolff, Amy Jo Diaz, DJ Shadow, Eddie Donaldson, Richard Duardo, Jesper Elg, Eric Elms, Ron English, Delphine Ettinger, Amanda Fairey, Charlotte and Strait Fairey, Jason Filipow, Dan Flores, Tracy Foreman and Scott Snyder, Paul and Debbie Formal, John Freeborn, Glen E. Friedman, Phil Frost, FUTURA, Roger Gastman, Mathew Gibson, Shirley Gibson, Jay Giroux, Jeanie Gleaton, Adam Glickman, Yosef Glushien, John Goff, Marsea Goldberg, Matt Goldman, Brian Grazer, Mikkel Groennebaek, Brad Grossman, Tommy Guerrero, Geoff Hahn, Alfred Hawkins, Tom Hazelmeyer, Evan Hecox, Richard D FACE Hennings, Jose Hernandez, Paul and Kris Hitopoulos, Misha Hollenbach, Monica Hoover, Jim Houser, Andy Howell, Stephanie Hutin, David J, Jim Jacoy, JR, Don Juncal, Justin and Brandon from San Bernardino, Merry Karnowsky, Naomi, Kazama, Dave Kinsey, Dave Koenig, Serena Kojimoto, Frank Kozik, Justin Krietmeyer, Curtis Kulig, Jordan and Tara Kurland, Lase, Andrew Lee, Jay Leritz, Ryan Lesser, Lori from NY Adorned, David Lopes, Mark the Cobra Snake, Blake E. Marquis, Carlo McCormick, Justin McCormack, Ryan Mcginness, David McWane, Steve Melgren, Mikey from Limitpoint, Garrett Morin, Sean Mortensen, Dave Moscato, Sage Nagai, Naomi of 5 South, Neckface, Linda Nguyen, Stuart Noble, Yoshi Okano, Patrick and Aiko from Faile, Chris Peasley, Olivia Perches, Cleon Peterson, Danny Power, Larry Queen, Sumie Quiriault, Al Reid, John Reigart, Rich Reigart, Grant Reinero, Aaron Rose, Casey Ryder, Eric Singer, SKOL, Winston Smith, Hedi Sorger, Space Invader, Stash, Craig Stecyk III, Helen Stickler, Simon Steinhardt, Amy Swenson, Kevin Taylor, Mike Ternosky, Steve Ternosky, Sheri Timmons, Romeo Trinidad, Justin Van Hoy, Adam Wallacavage, Damon Way, Adam and Lynn Werbach, Wes Winship, Jerry Waddle, Erin Wignall, Neil Whiting, Brian Weitman, WK Interact, Ben Woodward, Andrew Jeffrey Wright, Gerardo Yepiz, Dave Young, Florencio Zavala, Zephyr, DJ Z–Trip

Thank you to everyone who has stood up for an opinion they felt with conviction
even if they knew this opinion would be unpopular.

Second Printing

Gingko Press, Inc.

5768 Paradise Drive, Suite J

Corte Madera, CA 94925, USA

Phone (415) 924 9615

Fax (415) 924 9608

email: books@gingkopress.com

www.gingkopress.com

ISBN: 1-58423-244-7

ISBN 13: 978-1-58423-244-5

LCCN: 2006921174

First Published in the United States
of America, September, 2006

Published in association with
Obey Giant

Printed in Hong Kong

© 2006 Frank Shepard Fairey

www.obeygiant.com

Designed by Cleon Peterson

Edited by Simon Steinhardt

Photography by Elizabeth Daniels,
Amanda Ayala Fairey, Shepard Fairey,
Bill Farroux, Jason Filipow,
Peter Funch, Thierry Guetta,
Richard Hennings, Monica Hoover,
Curtis Ross Kulig, Kyle Oldoerp
Mark the Cobra Snake, Chris Martin
of MadGods, Will Meeker, SCS,
Willie Sions, and Adam Wallacavage